MIRÓ IN AMERICA

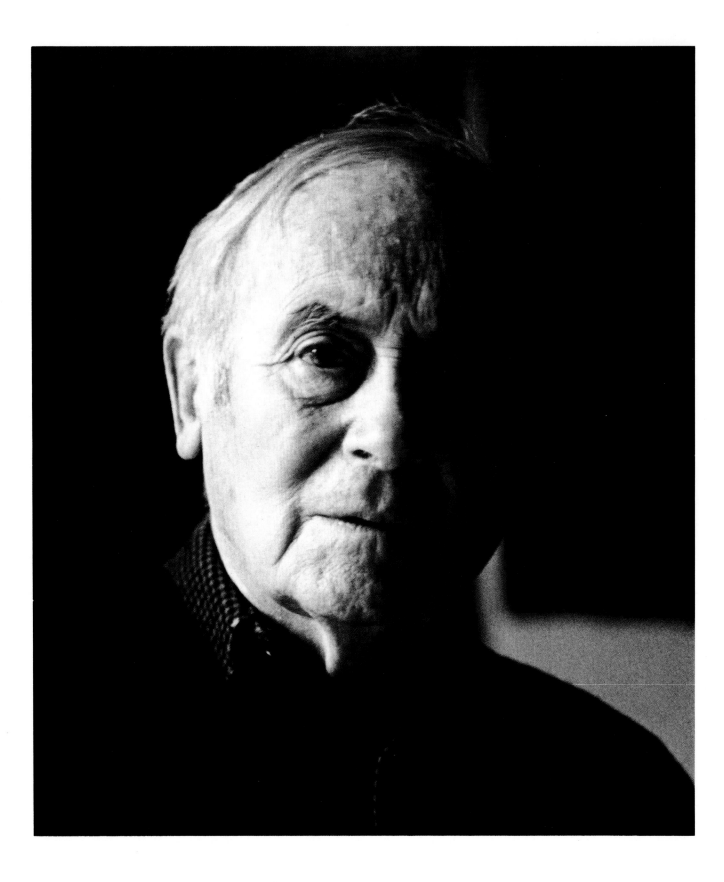

IN AMERICA

BARBARA ROSE

with essays by

JUDITH McCANDLESS

and

DUNCAN MACMILLAN

THE MUSEUM OF FINE ARTS, HOUSTON

Copyright © 1982 by The Museum of Fine Arts, Houston

This book and the exhibition which accompanies it have been funded by
Texas Commerce Bancshares, Inc., United Energy Resources, Inc. and Gerald D. Hines Interests

Exhibition dates at The Museum of Fine Arts, Houston:
April 21 - June 27, 1982

Designed by Peter Layne

Typeset by Wordseller, Houston, Texas

Printed and bound by Motheral Printing Company, Fort Worth, Texas

Printed in the United States of America

Cover: *Personage and Birds,* 1970

Frontispiece: Joan Miró, n.d.

Library of Congress Catalog Card Number 82-81357

Clothbound ISBN 0-89090-066-X/Paperbound ISBN 0-89090-007-8

The Museum of Fine Arts, Houston, 1001 Bissonnet, Houston, Texas 77005

C O N T E N T S

LIST OF COLOR PLATES

ACKNOWLEDGMENTS

We wish to thank the lenders who have made this exhibition of Miró's works possible.

We are particularly grateful to Pierre Matisse, Miró's American dealer for fifty years, who has been responsible for introducing Miró to the American public; more than anyone, he made this exhibition possible, and we are deeply in his debt. Arnold Herstand of Galerie Maeght in New York, Francisco Farreras of Galerie Maeght in Barcelona, Miró's great friend and biographer, the poet Jacques Dupin of Galerie Maeght in Paris, Rosa Maria Maalet of Fundació Miró in Barcelona, and Miró's personal photographer, Catalá-Roca, have been of inestimable assistance in helping us locate and obtain paintings and documents. Jacques Dupin's monograph, *Miró,* provided invaluable information and was of incalculable help in locating works by Miró.

Others who have been important in helping us organize the exhibit, *Miró in America,* are Klaus Perls, William Acquavella, Jeffrey Loria, Paul Haim, and LeRoy Makepeace.

We could not have attempted to document Miró's impact on American art without the cooperation and advice of William Rubin, Chairman of the Department of Paintings and Sculpture of The Museum of Modern Art, which has generously loaned the core of their collection of Miró's works which have been such an inspiration to American artists. Dr. Rubin's monograph on Miró in the collection of The Museum of Modern Art has been a primary source for our research.

We are very grateful to Thomas Messer, Director of The Guggenheim Foundation, for making it possible to include Miró's important *Seated Woman II,* not seen in this country for decades.

We would like to offer special thanks to Ron Jarvis for his heroic efforts in coordinating the production of the catalogue. Linda Shearouse merits special recognition for her diligent and tireless editorial assistance. We would also like to thank Jill Flake for compiling the chronology and bibliography, and Maggie Olvey, Charles Carroll, Charlotte Callager, Donna Fleming, Dorwayne Clements, Scott Ruczko and Pat Rohrer for their unflagging and valuable aid.

We also wish to thank Professor Duncan Macmillan of the University of Edinburgh for his essay on Miró's public art, which places the new Houston monumental sculpture, *Personnage et Oiseaux,* in its proper context as Miró's most recent public work of art.

Without the encouragement and far-sightedness of Ben Love, Chairman, Texas Commerce Bancshares, Inc., Hugh Roff, Chairman, United Energy Resources, Inc., and Gerald Hines, Gerald D. Hines Interests, who have made Miró a permanent presence in Houston for all future generations, we would not have been able to do the exhibition, *Miró in America,* and this accompanying catalogue.

Barbara Rose
Judith McCandless

LENDERS

William R. Acquavella, New York
Alsdorf Foundation, Chicago
Mr. and Mrs. Harry W. Anderson
Mr. and Mrs. Perry O. Barber, Jr., Houston
Mr. and Mrs. Gordon Bunshaft, New York
Estate of Alexander Calder
Stefan Edlis, Chicago
First City National Bank, Houston
Helen Frankenthaler
Joel Friedland, Miami Beach
Lenore and Burton Gold, Atlanta
James and Katherine Goodman, New York
Mr. and Mrs. W. J. Hergenrader, Memphis
Dr. and Mrs. Robert Levy, Chicago
Alexander Liberman
Mrs. H. Gates Lloyd, Haverford, Pennsylvania
Jeffery H. Loria, New York
Mr. and Mrs. LeRoy Makepeace, Washington, D. C.
Sara and Moshe Mayer, Geneva, Switzerland
Menil Foundation, Houston
Mr. and Mrs. Morton G. Neumann, Chicago
Bernard Pfriem
Estate of Jackson Pollock
Lee Krasner Pollock
Francoise and Harvey Rambach
Robert Rauschenberg
Estate of Mark Rothko
Estate of Mary Alice Rothko
Dr. Leonard Siegel, Maine
Mr. and Mrs. Gustav Stern, New York
Dr. and Mrs. Paul Sternberg, Glencoe, Illinois
K. Takagi, Nagoya, Japan
Eugene Victor Thaw
Thyssen-Bornemisza Collection, Lugano
Emerson Woelffer, Los Angeles
Mr. and Mrs. Jimmy Younger, Houston
Richard S. Zeisler, New York
Donald Zucker, New York

Allen Memorial Art Museum, Oberlin College, Oberlin, Ohio
The Art Gallery of Ontario, Toronto
The Art Institute of Chicago
Blanden Memorial Art Gallery, Fort Dodge, Iowa
The Cleveland Museum of Art
Des Moines Art Center
The Peggy Guggenheim Collection, Venice,
 The Solomon R. Guggenheim Foundation
The Solomon R. Guggenheim Museum, New York
The High Museum of Art, Atlanta

Hirshhorn Museum and Sculpture Garden, Smithsonian
 Institution, Washington, D. C.
Indiana University Art Museum, Bloomington
Krannert Art Museum, University of Illinois, Champaign
Meadows Museum, Southern Methodist University, Dallas,
 Texas
The Metropolitan Museum of Art, New York
Milwaukee Art Center
Munson-Williams-Proctor Institute, Utica, New York
Museum of Art, Carnegie Institute, Pittsburgh
The Museum of Fine Arts, Houston
The Museum of Modern Art, New York
National Gallery of Art, Washington, D. C.
Nelson Gallery-Atkins Museum, Kansas City
New Orleans Museum of Art
Philadelphia Museum of Art
The Phillips Collection, Washington, D. C.
San Francisco Museum of Modern Art
University Art Museum, University of California, Berkeley
University of Iowa Museum of Art
Washington University Gallery of Art, St. Louis
Whitney Museum of American Art, New York
Wichita State University Art Collection, Edwin A. Ulrich
Museum of Art,
 Wichita, Kansas
Yale University Art Gallery, New Haven

Acquavella Galleries, Inc., New York
John Berggruen Gallery, San Francisco
Blum-Helman Gallery, New York
Andrew Crispo Gallery, New York
Betty Cunningham Gallery, New York
Davlyn Gallery, New York
Martin Diamond Fine Arts, New York
Patricia Hamilton Gallery, New York
Harcourts Gallery, San Francisco
Ivory/Kimpton Gallery, San Francisco
M. Knoedler & Co., Inc.
Pierre Matisse Gallery, New York
Galerie Maeght, U. S. Office
Meredith Long Gallery, Houston
Betty Parsons Gallery, New York
Perls Galleries, New York
Reiss-Cohen Gallery, Inc.
Washburn Gallery, New York
Zabriskie Gallery, New York

INTRODUCTION

Miró in America is not a retrospective in the ordinary sense. Rather it is the record of the immense and decisive influence of the great Catalan master on modern American art. When William C. Agee asked me to curate a Miró exhibition for The Museum of Fine Arts, Houston, I searched for a new approach to Miró, a fresh angle of vision that would yield new insights about Miró's enormous achievement. I decided to organize an exhibition that would reveal, as fully as possible, Miró's unique contribution to American art. Seen from the point of view of the American artist, his work might look different, and a new interpretation might emerge.

Like his friends, Picasso and Matisse, Miró was appreciated earlier and collected with more enthusiasm in America than he was anywhere else. Consequently, much of Miró's greatest work is in American collections. However, in addition to Miró's works from American collections, paintings seen in the United States now in foreign collections have also been borrowed to document his influence as completely as possible.

During the course of organizing this show, I grew more firmly convinced than ever that Miró is not only one of the daring pioneers and great innovators of twentieth-century art, but also a giant of world art history. His imagination has spawned an entire universe peopled with the creations of his own restlessly inventive intelligence. The purity of his spirit has preserved him from the many compromises, political, economic, intellectual and moral, that most artists finally are forced to accept in making their bargain with history. In a climate of grossest materialism, Miró's art is a shining spiritual force, a constant example of a conscience that cannot be purchased. This was one of the main reasons he became and has remained an unassailable hero for the American avant-garde. His contradictory spirit, ''the negation of negation,'' as he describes it, is a continuing and necessary antidote to artistic entropy and demoralization.

I am indebted to many people for helping me realize what has been a life-long dream of organizing an exhibition of Miró's art. In addition, I am grateful for the Fulbright scholarship that permitted me to study in Catalonia, Navarre, Castille and Andalusia. As a student in Spain, I perceived many curious similarities between

American and Spanish art. These similarities, I believe, account for the importance of Miró's art in America, where his views on nature, religion, and aesthetics were compatible with analogous feelings among American artists. Numerous similarities between Spain and the United States can be found: both countries were cut off from continental European culture — America by the Atlantic Ocean, Spain by the Pyrenees; both countries were deeply religious and drawn toward a transcendent, visionary art. At the same time, both cultures often expressed a naive perception of reality that was extremely literal, perhaps because both Spain and America were dominated historically by puritanical and repressive sexual mores which rejected non-conformism. In America, as in Spain, geographic isolation, augmenting a national tendency to extremism, militated against producing a continuity of competent artists; instead, it created an intensely charged psychological climate within which the isolated individual genius could emerge to tower over his contemporaries. In their isolation, Eakins, Ryder, and Pollock are, like El Greco, Goya, and Miró, individualistic eccentrics of a totally unpredictable originality.

My love for Spanish art was nurtured by the late Dr. Walter W. S. Cook, founder of the Institute of Fine Arts, who was instrumental in introducing Catalan art to America. He convinced me to go to Spain and write on Spanish art. Through Dr. Cook's enthusiasm for Catalonia, I came to appreciate the art that formed the basis for Miró's work and was a continuing source for his original vision. Meyer Schapiro's lectures on Catalan Romanesque frescoes and Spanish manuscript painting and his insistence on the link between medieval and modern art also prepared me to appreciate the powerful spirituality that is the essence of Miró's visionary art.

In tracing Miró's influence on American art, I have chosen to concentrate on his painting and sculpture. Excluded are the multiple works, graphics, and textiles through which his imagery has received a wider diffusion to the public at large. The focus is rather more precisely on what Miró contributed to the aesthetic dialogue of the American avant-garde as it evolved over the course of the last half century.

It is especially gratifying to me that *Miró in America*

celebrates the erection in Houston of a monumental public sculpture by Miró. In a sense, it is an ironic finale to a series of events that first focused my attention on Miró as a public artist. Some years ago, as a member of the Visual Arts Committee of the New York Cultural Council, I suggested that we ask Miró, who was known for his generosity and his love of America, to donate a maquette to New York City to be transformed into a public sculpture. Margit Rowell was seeing Miró. She returned from Barcelona with a maquette as Miró's gift to the people of New York. Despite Miró's generosity, we were never able to raise the funds to erect the sculpture. It was a terrible disappointment. Today, I share Houston's pleasure and pride on seeing Miró's gigantic, playful, optimistic *Personnage et Oiseaux* take its place as a landmark and a symbol of civic pride.

I wish to thank Professor Duncan Macmillan of the University of Edinburgh for his permission to use an excerpt from the extensive catalogue of his proposed exhibition of Miró's public art.

Barbara Rose
Houston, Texas
April, 1982

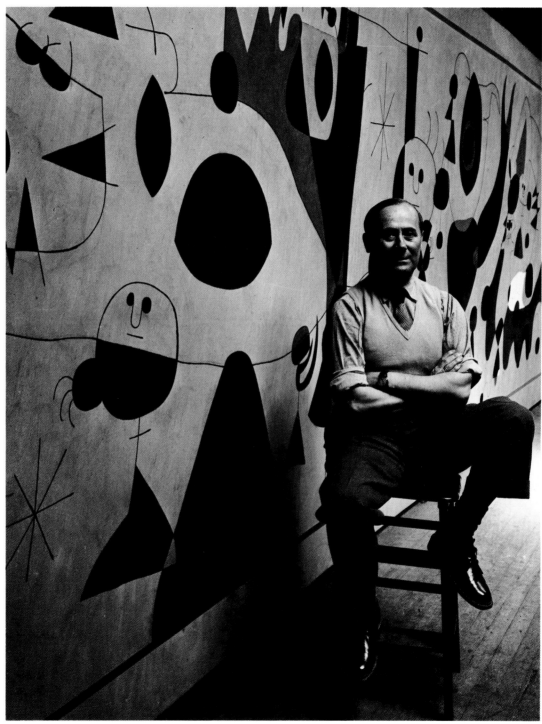

MIRÓ IN AMERICA

- I like everything about Miró — his clear-eyed face, his modesty, his ironically-edged reticence as a person, his constant hard work, his Mediterranean sensibility, and other qualities that manifest themselves in a continually growing body of work that for me, is the most moving and beautiful now being made in Europe. A sensitive balance between nature and man's work, almost lost in contemporary art, saturates Miró's art, so that his work, so original that hardly anyone has any conception of how original, immediately strikes us to the depths.

 Robert Motherwell, ''The Significance of Miró,'' *Art News,* May 1959.

- Thus the fact that good European moderns are now here is very important for they bring with them an understanding of the problems of modern painting. I am particularly impressed with their concept of the source of art in the unconscious. This idea interests me more than the specific painters do, for the two artists I admire most, Picasso and Miró, are still abroad.

 Jackson Pollock, interview in *Arts & Architecture,* February 1944.

Looking back at the history of modernist American art, it becomes increasingly clear that its major goals and aesthetics were principally shaped by the art of Picasso, Matisse, Mondrian, and Miró. Many European modern artists, like Léger and Mondrian, spent the years of World War II in New York; but Matisse, Picasso, and Miró, the three artists most stimulating to the emergent New York avant-garde, did not leave Europe. Matisse and Picasso apparently remained in France by choice. Miró, who planned to emigrate to New York, was trapped in Europe. Originally, he had decided to accompany his friend, the architect José Luis Sert, to the United States. When the Nazis marched on Paris in 1940, Miró was living in Normandy in the house of the American architect, Paul Nelson, in Varengeville, near the painter, Georges Braque. Miró intended to sail for New York, where he was better known than in Paris, with his wife, Pilar, and their young daughter, Dolores. However, like many European refugees, they were denied an exit permit, and Miró and his family secretly made their way back to Spain. Crossing the border was difficult. Miró was a known

anti-Fascist opponent of the Franco regime who had supported the Republican cause with his art. However, his reputation as an artist was non-existent in Spain, and he spent the war years in Barcelona and Majorca without being recognized. Miró made his long-dreamed-of visit to the United States in 1947. To his suprise, he had become, *in absentia,* a hero of the American avant-garde.

Though Miró himself was not in America during World War II, the crucial years during which the American avant-garde broke away from late Cubism and appropriated more painterly techniques and more open formats, his works were recognized for their originality and perceived as a road to a post-Cubist style. Many artists saw in Miró's painterly, tactile surfaces and swinging, organic rhythms a key to loosening up the tight geometric style that dominated the Cubist art of the American Abstract Artists. His apparent solution to the problem of reconciling figuration with the flatness demanded by modernist painting suggested an avant-garde alternative to abstract art that was eagerly explored by the New York School.

Naturally, the presence of Mondrian in New York between 1941 and his death in 1944 heightened the influence of neo-Plastic geometric abstraction in America during those years. However, Miró's freer, more romantic, subjective art posited a challenging alternative to both Picasso and Mondrian. It is coincidental, but significant, that important shows of Miró's recent works represented both the last news from Europe before America entered World War II and the first information about European avant-garde art to reach New York after the war. New York was cut off culturally from Europe for the war's duration: Miró's 1941 Museum of Modern Art retrospective organized by James Johnson Sweeney and his 1945 exhibition of the *Constellations* bracketed the blackout of World War II, giving Miró's art special prominence in America at a critical moment of artistic evolution.

In the thirties, Picasso was virtually synonymous with the idea of the avant-garde in New York. However, a number of artists, including John Graham, Picasso's most articulate New York disciple, began to experiment with organic forms, as Picasso himself did at the time.

These bulbous, so-called "biomorphic," shapes were originally popularized by the Swiss Dadaist, Hans Arp. They were related to nature as well as to the human anatomy rather than to the mechanical forms of industry. In the late thirties, Gorky, de Kooning, as well as some of the more orthodox abstractionists of the American Abstract Artists, such as George L. K. Morris, Esphyr Slobodkina, Harry Bowden, Ilya Bolotowsky, Byron Browne, and Rosalind Bengelsdorf experimented with biomorphic imagery. Even A.E. Gallatin, the Cubist painter-collector, incorporated a few gourd-like biomorphic shapes in his paintings. Gallatin disliked Surrealism but expressed his admiration for Miró by including a photograph he had taken of Miró during a trip to Paris in 1936 in the catalogue of his Gallery of Living Art. These artists used irregularly curved biomorphic forms, but their shapes were essentially flat and hard-edged. Their formal syntax remained as classically Cubist as that of Mondrian's most faithful American followers.

Both Miró and Mondrian, although diametrically opposed in their attitudes toward abstraction, were committed modernists, and the battle lines were not so strictly drawn as to prohibit a certain crossover from time to time. Ilya Bolotowsky, a neo-Plastic painter who publicly acknowledged Miró's influence on his art, began to paint biomorphic shapes on transparent grounds, which created a more indeterminate space than the dense opacity of the Cubist backgrounds. Leon Kelly and Byron Browne also adopted the vocabulary of biomorphism and began to use automatic gesture in the late thirties.

In the thirties, Miró's art came to the attention of Howard Putzel, a young writer who advised Peggy Guggenheim on her pre-war buying spree in Paris and later became her secretary in New York. Putzel organized Miró's first shows on the West Coast: a 1934 exhibition at the East-West Gallery in San Francisco, a retrospective in October-November 1935 at the Stanley Rose Gallery in Los Angeles, and then exhibitions in 1937 and 1938 at his own Los Angeles gallery, previously known as the Hollywood Gallery. In 1938, Putzel left Los Angeles to travel in Europe. He returned to New York at the outbreak of the war. In 1941, Putzel and Surrealist painter Gordon Onslow-Ford arranged, for the New School of Social Research, a series of lectures and exhibitions, which formally introduced Surrealism to the New York School. One of the exhibitions, which opened in February 1941, contained ten works by Ernst and six by Miró, including

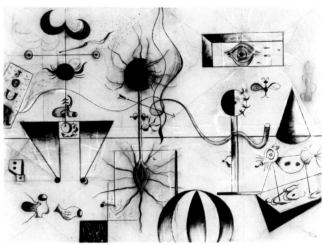

Fig. 1. Joan Miró. *The Family*, 1924.

The Family [fig. 1] and *Maternity*.[1] It is likely that most of the New York avant-garde saw this show, since they took every opportunity possible to see new work from Europe.

Shortly before his sudden death in the summer of 1945, Putzel organized an historic exhibition, *A Problem for Critics,* for his Gallery 67, which he opened after leaving Peggy Guggenheim. Putzel's exhibition was in many respects a parallel to John Graham's 1942 exhibition, *French and American Painting.* However, the Europeans Putzel showed were Surrealists, whereas Graham exhibited the French Cubists with young Americans. Gorky, de Kooning, Pollock, and Krasner, whom Graham had selected for his 1942 show, were included along with Gottlieb, Hofmann, and Pousette-Dart; the Americans were paired against Matta, Masson, Picasso, Tamayo, Arp, and Miró. Putzel identified Arp and Miró as precursors of the movement he christened the "new metamorphosism." In his review of the exhibition in *The Nation*, Clement Greenberg perceived a return to representation and academic illusionism in some of the Europeans but identified Arp and Miró as closer to Cubism.[2] According to Greenberg, biomorphism was the important new element in abstract art.

Miró's interpretation of biomorphism was far more radical than Arp's hard-edged organic shapes. Miró expressed his philosophy regarding the interaction of man with nature literally. His biomorphic forms were more than abstractions of natural forms; they were symbols of the generative processes in nature. He often used biomorphic forms in mutation, as if they were

sprouting or growing. Rather than illustrate the nature of creation in the manner of the more literary Surrealists, Miró invented new processes of creating forms so that images were organically generated from the materials with which he worked. This involvement with materials as the point of departure for imagery has been a lifelong preoccupation for Miró. The way he worked the *matière* became in itself a major metaphor in his work. Miró's procedures in generating images were doubtlessly related to automatism. However, they differed from Surrealist practice in a number of crucial respects. The subject of Miró's ambivalent relationship with Surrealism and how closely it paralleled the ambivalence, if not outright hostility, of the New York School to the doctrinaire theories of Surrealism is a subject to which we shall return.

In his widely read catalogue preface, Sweeney quoted Miró's refusal to join the Paris-based geometric artists' Abstraction-Creation group. (Similarly, Gorky and de Kooning had rejected the overtures of the American Abstract Artists.) "Have you ever heard of greater nonsense than the aims of the Abstractionist group? And they invite me to share their deserted house as if the signs that I transcribe on a canvas, at the moment when they correspond to a concrete representation of mind, were not profoundly real and did not belong essentially to the world of reality! As a matter of fact, I am attaching more and more importance to the subject matter of my work," Miró claimed.

These words had special meaning in New York at the time of Miró's Museum of Modern Art retrospective in 1941. The questions of "reality" and "subject matter" in art were much discussed in the informal meetings among artists in their studios or in local bars and cafeterias. They continued to be essential issues during the forties, the decade when many of the New York School artists switched from representational to non-objective styles.

Hans Hofmann's lectures, later published as *The Search for the Real,* were a topic of conversation not only among his students but also in advanced art circles generally. However, Hofmann's "reality" was a materialist and pictorial idea, not a metaphysical or poetic concept. His notion of the concrete "reality" of the work of art was derived primarily from the Cubist identification of the art work as a real object in the world, as opposed to an imitation of reality. Miró, on the other hand, was concerned with a metaphysical definition of the real that led him to substitute signs and symbols for objects.

Early in his career, Miró painted hyper-realist landscapes and still lifes in a sharp-focus, sculptural style that has been called "detailist" because of his concentration on the microscopic detail. In his paintings, Miró gave equal emphasis to the large and small, the near and far. This absence of hierarchical distinction is a characteristic of primitive styles of representation which Miró adopted as an anti-naturalistic device.

The hyper-realism of such "detailist" paintings as *The Farm, The Carbide Lamp,* and *The Ear of Grain* has a precedent in the Catalan Gothic retables by the Hispano-Flemish painters Rafael Vergos [fig. 2], Bartolomeo Bermejo, and Bernardo Martorell, a Catalan primitive artist Miró admired. The crisp, linear style of these densely filled paintings is one of sharp relief and decorative richness created by meticulous attention to fabric and architectural pattern and detail. The sculptural quality of Catalan primitive painting is reflected in early paintings by Miró like the 1921 *Standing Nude,* once owned by Miró's American friend, the sculptor Alexander Calder.

Fig. 2. Rafael Vergos. *Dominican Saint,* ca. 1490.

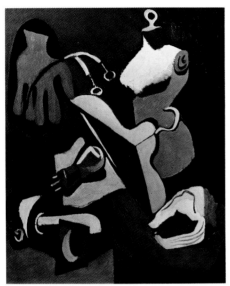

Fig. 3. Jan Matulka. *Still Life with Coat Hanger,* n. d.

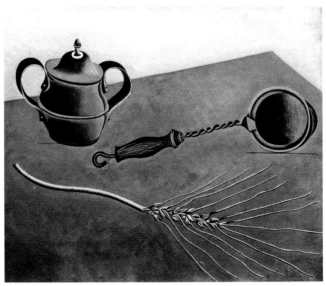

Fig. 4. Joan Miró. *The Ear of Grain,* 1922-23.

The "detailist" paintings, seen in New York in the thirties, apparently influenced artists like Czech-born Jan Matulka [fig. 3]. The vivid hyper-realistic, sculptural quality of Peter Blume's Magic Realist paintings, like *Parade,* reflect Miró's "detailist" style. Neither American painter, however, achieved the hallucinatory vividness of a heightened reality, which was more than real, that Miró created in these early works.

Miró's still life paintings of the "detailist" period are related to the tradition of the *bodegón,* a Spanish still life painting of food and kitchen utensils that often masked a religious theme. The intactness and separation of the objects in Miró's still life paintings *The Carbide Lamp* and *The Ear of Grain* [fig. 4], which Sweeney included in his show, remind one of the austere, mystical still lifes of the seventeenth century *bodegón* painter Sanchez-Cotan. In interviews, Miró has often spoken of his regard for the humble, the modest, and the everyday, as well as his respect for all of nature's creation. In a sense, the lack of hierarchies of distinction expresses the attitude that all natural creation is of equal value. This is the opposite of the classical anthropocentric world view.

Because of the primitive, Gothic character of his early works, Miró was launched as a naive painter. Pierre Loeb, his Parisian dealer, convinced American art critic Henry McBride that Miró was the Douanier Rousseau of his time. Sweeney accepted and elaborated this idea. The concept of Miró the *naif* obscured the enormous

sophistication of his work and the degree to which his entire oeuvre was based on a complex and interlocking system of metaphors involving the themes of creation, evolution, instinct, and animism.

Ernest Hemingway bought the most famous of the "detailist" paintings, *The Farm,* from Miró for two reasons: love of the painting and charity, since Miró could sell nothing. Painted in 1921-22 at the family farm at Montroig, outside of Tarragona, where Miró spent much of his life, *The Farm* is an ode to the heroism of the Catalan peasant, the theme of many of Miró's works. Crammed with life, *The Farm* is like a dictionary of Miró's imagery: the dog, tilled field, tree, ladder, rooster, farm animals and machinery, sun, bird, peasant woman, horse are all present. Despite the profusion of growth and activity, *The Farm* is strangely static, a quality of primitive painting to which Miró aspired. The forms are sharply silhouetted against the cloudless sky, whose brilliant blue ultimately filled the entire field of Miró's paintings with the blinding light of a Catalonian summer day. In the harsh sunlight of Montroig, objects are outlined in sharp relief, as they are also depicted in the crisp linearity of Catalan Gothic painting.

Given his personal philosophy, there are many reasons that this painting of an agricultural society appealed to Hemingway. Hunting and farming were two basic activities of primitive man; and Hemingway, the hunter, obsessed with earthiness and the

uncorrupted values of simplicity and directness, found in Miró a kindred masculine spirit with whom he could identify. There were differences in their world views, of course, which determined the types of imagery each chose to depict. In Hemingway's hunter's world, women had little place. Miró's agricultural dream kingdom, on the other hand, was a peaceful, non-violent world shared by women and domesticated animals, like the cat and rabbit who reappear in *The Farmer's Wife,* one of the paintings that selects and enlarges motifs from *The Farm.*

After his first trip to Paris in 1919, Miró spent his summers at the family farm in Montroig and his winters in Paris. These seasonal moves, like Persephone's annual return to Ceres, kept him in touch with the land and with his native culture. This constant distancing of himself from the Parisian milieu was a process of purification, explaining the distinctive originality of his art, whose sources lie as much outside as within French culture. During the summer of 1924, Miró painted *The Hunter (Catalan Landscape).* The painting was a turning-point for Miró. Alfred Barr purchased it for The Museum of Modern Art in 1936 and included it in the ground-breaking first exhibition of *Fantastic Art, Dada, Surrealism* that year. The painting exerted a continuing influence on the New York School.

In *The Hunter (Catalan Landscape),* Miró uses calligraphy as a major pictorial element for the first time. This idea had ramifications for artists as diverse as Stuart Davis, Robert Motherwell, and Larry Rivers.[3] The elaborately decorative script of the word "sard" in the lower right-hand corner and the extremely attenuated black lines connecting the solid shapes referring to

body parts are more like writing than drawing in the conventional sense. Indeed, the reduction of motifs, like the simplification of the body of the hunter to a stick-figure, indicates Miró's growing concern with picture writing. His incorporation of writing as a graphic element shows that he was already involved with the idea of a picture poem.

During the two years between *The Farm* (1922) and *Pastoral* (1924), Miró changed his style radically. Rejecting the densely packed Cubist space, sculptural modeling, and "detailist" ornamental style of *The Farm* and the subsequent paintings derived from its hyper-realist imagery, such as *The Tilled Field, The Farmer's Wife, The Carbide Lamp,* and *The Ear of Grain,* Miró left the world of fact and entered the poetic world of metaphor and symbol. The hyper-real images of *The Farm* were converted into ideographic signs. As it developed, his new style grew more radically reductive until it evolved into simple zones or fields of color.

There appears to be a sharp break between the hyper-realism of *The Farm* and the abstracted, symbolic content of *The Hunter (Catalan Landscape),* which is a kind of inverse pendant to *The Farm,* but the two are linked in an attitude toward the "real" that is transcendental and visionary. The transitional works in which object gradually becomes sign, painted in 1923-24, are *The Tilled Field* [fig. 5] and *Pastoral* [fig. 6]. Like *The Hunter (Catalan Landscape),* they are horizontal landscapes which become progressively emptied and distanced from reality. Each was revolutionary in a different manner. *The Tilled Field* is the first example of the mixture of landscape with anatomy, which levels the distinction between man and

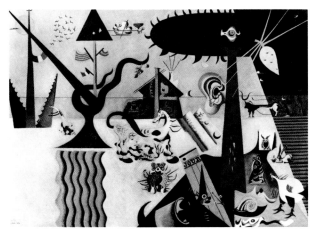

Fig. 5. Joan Miró. *The Tilled Field,* 1923-24.

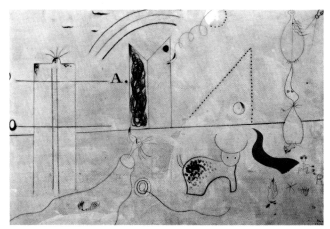

Fig. 6. Joan Miró. *Pastoral,* 1923-24.

nature by grafting parts of the human anatomy — in this case, the eyes and ears that grow magically out of a tree — to natural forms.

The process of grafting is part of the vast agricultural metaphor in which Miró equates tilling, seeding, and harvesting with the processes of painting itself. Sometimes using his fingers directly to apply paint, he claimed he "works like a gardener."[4] We shall see how profoundly Miró's literal translation of the canvas into a "field" affected American art.

Miró's absorption with agriculture as a metaphor brought him close to the New York School, which despite its urban situation, was paradoxically intensely anti-industrial and anti-mechanistic in its outlook. One reason for this antipathy toward industrial civilization was the identification of modern technology with the causes and horrors of World War II.

Another, perhaps more profound, cultural link between Miró and American art was the anti-progressive, environmentalist attitudes of Transcendentalism, linking the New York School with the earlier American avant-garde centered around Stieglitz and O'Keeffe.[5] O'Keeffe's literalist view of reality coincided with Miró's. In her paintings of the thirties, she combined disparate natural forms, isolating them on ambiguous, neutralized grounds. It is hard to doubt the connection between Miró's *Dog Barking at the Moon* and O'Keeffe's *Ladder to the Moon*. Each painting shows a way to escape the material dross of earth and ascend to the celestial, i.e., spiritual realms.[6]

In *The Farm* and *The Tilled Field*, objects, although fantastic and grotesque, are still basically solid. *The Hunter (Catalan Landscape)*, however, suggests a new concept of "reality." Free of the responsibility of defining contour, line becomes a shorthand, which reduces objects to signs and rejects realistic detail in favor of abstract detail that is purely pictorial and ornamental. The refinement of the curlicues and spirals, the attention to each tiny hairline protruding from forms, like individual eyelashes or hairs, are details only a *trompe l'oeil* artist would normally depict. In a certain sense, by isolating and enlarging a single element, the paintings become *more* detailed. However, the details are recombined in bizarre scale so that any normal sense of reality is totally contradicted.

The intercalation of anatomical parts with landscape, the refusal to distinguish between man and nature, became a hallmark of New York School painting in the forties in works by Pollock, Gorky, and de Kooning [fig. 7], whose subjects are frequently the body as landscape. Later, Helen Frankenthaler [fig. 8] fused body and landscape imagery. Miró's all-seeing eyes are found in paintings of the forties by Bradley Walker Tomlin and Adolph Gottlieb [fig. 9], whose pictographic compartments, taken from Torres Garcia, are often filled with anatomical fragments derived from Miró. In his later "burst" paintings, Gottlieb's debt [fig. 10] to Miró's symbols for heaven and earth is even more obvious.

The fragmentation of the anatomy was not originally a Surrealist concern. Various religions, including primitive Catholicism, have used anatomical *ex-votos* in rituals. Fragments of anatomy occur frequently in Dada works, such as Man Ray's *Object to be Destroyed* (1923) [fig. 11], with its eye clicking back and forth atop the metronome's stem. *Object to be Destroyed* recalls the diagonal stick bodies topped by eyes in Miró's paintings like *Maternity* and the *Person Throwing a Stone at a Bird*.

The latter, bought by The Museum of Modern Art in 1937, established the image of the *personnage* in New

Fig. 7. Willem de Kooning. *Secretary*, 1948.

Fig. 8. Helen Frankenthaler. Untitled, 1950-51.

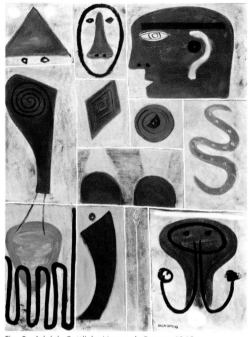

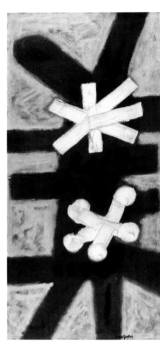

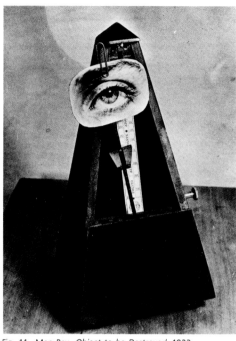

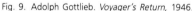

Fig. 9. Adolph Gottlieb. *Voyager's Return,* 1946. Fig. 10. Adolph Gottlieb. *W,* 1954. Fig. 11. Man Ray. *Object to be Destroyed,* 1923.

York before the arrival of the Surrealists. The *personnage* was a hybrid creature, usually part human and part animal or vegetable, typical of Surrealist figure-painting. Miró's individual, isolated *personnage* was a source of greater consequence for New York artists than Ernst's or Tanguy's multi-figure groups in which figures inhabit, rather than combine, to breed with landscape.

I. THE POET'S PAINTER

- Miró is the most Surrealist of us all.
 André Breton
- A Spaniard does not need to be a Surrealist: he is already irrational.
 Joan Miró, interview with the author, Barcelona, June, 1981

There is a fundamental misunderstanding regarding Miró's relationship with the Surrealists; as a result of that misunderstanding, the role of the Surrealists-in-Exile (i.e., those who lived in New York during World War II) has been exaggerated, while Miró's contribution, which was greater than the sum total of Surrealism, has not been adequately acknowledged. One need not look far to understand why this

happened: the academic, literary Surrealists specialized in manifestoes, group activities, propagandizing their own publications, sensationalism, and partying with the wealthy and powerful. Miró is unsocial (one hesitates to say anti-social because that is not quite accurate), laconic, a private individualist who spends much of his life in monastic solitude.

Miró is an exceptionally honest man with an excellent memory. Since he says little, his few statements are significant. He has always maintained that he was influenced by prehistoric cave painting, Catalan Romanesque murals, and Catalan Gothic retables. He saw all these during his youth in Barcelona. Later, he said that he was influenced by contact with reproductions of Klee's work and Klee's paintings which he saw in Paris. Kandinsky's work and ideas were important to him as well. Of the old masters, the Barbizon landscape painter Corot was the one he admired most. He also admitted a debt to Picabia and an interest in Dada.[7]

My thesis is that Miró, the "Surrealist" not exiled in New York, was actually the channel through which the genuinely innovative forms, techniques, and attitudes we identify as "Surrealist" passed into American art. Miró was a Surrealist by association. It was never an allegiance he quite denied, but neither did he embrace

a Surrealist identity.

Because Miró exhibited in the first Surrealist exhibition in Paris in 1925 and was then seen in the context of Peggy Guggenheim's Surrealist collection in New York, his influence in the New York School has usually been seen in relationship to automatism. This is an erroneous perception. Breton publicly annexed Miró to Surrealism, although privately he complained that Miró was too involved with the processes of painting alone. This obscured the extent to which Miró's art was transformed through his contact with Kandinsky, as well as the degree to which his art stands outside Surrealism and represents a far greater, more directly emotional, and genuinely revolutionary art than Surrealism. Indeed, a major difficulty in understanding Miró's art has been his confusing identification with the Surrealist movement.

Miró counted only one Surrealist painter — André Masson, with whom he shared a studio in the early twenties—among his friends. Breton was, at best, ambivalent and frequently openly hostile to Miró. Recognizing the originality of Miró's art, however, he attempted to co-opt his immense gifts to aggrandize the Surrealist movement he founded by claiming Miró as "the most Surrealist of us all." However, Miró does not speak of Breton's "pure psychic automatism" as having greatly impressed him. Repeatedly, when questioned regarding his relationship to Surrealism, he has answered that he was interested in Surrealist poetry, not Surrealist art. In fact, Miró's drawing has little in common with Surrealist drawing, which essentially remains on the surface plane or parallel to it. Miró's line meanders in and out of a continuous atmospheric space related to the mysterious atmospheric vapors of Kandinsky's cosmic plenum rather than to the fixed and finite depth of shallow Cubist space.

The origin of Miró's "automatic" drawing, insofar as it is automatic, is the way he was taught to draw as a youth in Barcelona by Francisco Galí, who required his students to feel objects blindly and then to draw them without looking. Based on the translation of a tactile into an optical perception, Miró's line does not remain contiguous with the surface: it curves and cuts through space in a way that contributes to the sense of a color volume as an atmospheric continuum of indeterminate depth. In alluding to tactility, without fulfilling its sculptural promise, Miró reduced modeling to a sign of itself. He avoids the completed expression of volume that shadow would indicate by freeing line

from its traditional descriptive function in representational art. This was no minor feat. It enabled Miró to push Kandinsky's improvisational drawing farther in the direction of using line as an autonomous pictorial element to activate the sensation of depth in a color field.

Here, we should distinguish between "automatic" drawing to create new shapes, and line as an autonomous pictorial element fundamentally related to rhythm, not imagery. The two are different concepts. Automatic drawing is descriptive: non-objective drawing is not. Presumably, automatic drawing records imagery generated by the unconscious. Non-objective drawing, on the other hand, frees line from its descriptive function. Non-objectivity begins in the isolation of the plastic elements into their components of point, line, and plane, which Kandinsky first investigated. Miró began to dissect form into component line, point, and plane in *The Hunter (Catalan Landscape)* in 1925. Kandinsky's book on the subject, *Punkt und Linie zu Fläche (Point and Line to Plane),* did not come out, even in German, until 1926. Therefore, we must look elsewhere for Miró's decision to reduce the divergent elements of representation to signs.

The declaration of the autonomy of line, first by Klee and Kandinsky, then by Miró, rather than Surrealist "pure psychic automatism," is the most important precedent for converting non-descriptive, non-objective drawing into the physical gesture of "action painting." However, Miró's reduction of the illusionistic content of painting, its tactility, and sculptural three-dimensionality into a sign referring to, but not completing, the original tactile, sculptural experience was far more sophisticated than the superficial existentialist rationale of "action painting." This explains why Miró's paintings maintain themselves structurally and conceptually, whereas much "action painting" fails to cohere pictorially in a totally convincing manner.

The essential philosophical content in Miró's work is related to his initial formation, not as a psychoanalytical Surrealist, but as a conceptual Dadaist. According to Miró, Dada, not Surrealism, initiated him into the avant-garde. As Miró tells it, the Dada idea of "shock" became for him central to the work of art. The splatter, the spot, the anti-art look, the ugly, and the brutal were acceptable first within the Dada context. In contrast with Dada, Surrealism was a reactionary movement that sought to define "shock" in terms of erotic or sado-masochistic subject matter, which had

nothing in common with Miró's sensibility. Regarding his relationship to Surrealism, Miró has said that the rupture in his work did not come with reading the 1924 Surrealist Manifesto. "In Barcelona, I had already received a shock from Picabia, from Apollinaire. . . They confirmed for me that painting was not only a plastic problem," he told Georges Raillard.

Miró saw exhibitions in Barcelona of post-Impressionist and Fauve painting, but his first contact with an actual member of the avant-garde was his meeting with the Cuban Dadaist, Francis Picabia in 1917. Picabia spoke Spanish, and Miró developed a close relationship with this extraordinary artist. Through Picabia, Miró met other members of the international avant-garde taking refuge from World War I in Barcelona. Although Barcelona was not a Dada center like Zurich or New York, Spanish artists and poets were aware of Dada.

An important source for Dada ideas in Spain was the Chilean poet, Vincente Huidobro. Duchamp admired the free-associative poetry of Huidobro, which antedated Surrealism. One of the editors of the avant-garde poetry magazine, Nord-Sud, Huidobro explained his theory of poetry in his book, Horizon Carré (Square Horizon), which appeared in 1917. The essence of Huidobro's principles were to humanize the object, to make the indefinite precise, to make the abstract concrete, and the concrete abstract. "Whatever is too poetic to be created is transformed into something created by changing its common value, so that if Horizon was poetic in itself, if Horizon was poetry in life, by qualifying it with square, it stops being poetry in art. From dead poetry it becomes living poetry," Huidobro wrote.[8] This inversion of abstract and concrete is close to Miró's procedure.

During his stay in Spain in 1918, Huidobro evolved a theory of poetry called Creationism, which identified the poet as "a little God" with the means to fashion an entire cosmos in his own image.[9] Essentially, this is the dream of the child's omnipotence, to control the universe through aggressive power as opposed to impotent passivity. In a world in which the artist counts for little, the creation of a parallel universe becomes the means for sustaining a healthy ego, a sense of the self and its personal power to change the world, if not outside the canvas, then within the limits of the artist's parallel universe.

Creationism too had its influence on Miró. The completeness and continuity of the universe of repeated signs and symbols Miró created is part of the power of his work. His emphasis on the creative

process, as it reveals itself in the manipulation of materials, is another instance of the literal incarnation of the principle of creativity.

In 1921, Huidobro began to publish Création, a magazine which elaborated his philosophy of Creationism. He exhibited calligrammes, inspired by Apollinaire, which he called "painted poems," in Paris in 1922. Miró referred to Huidobro as an advanced Spanish poet, and on several occasions Huidobro praised Miró's art. Apparently, Huidobro was the first to mention Miró in Paris.

Huidobro's "painted poems" are more literally "painted poems" than Apollinaire's calligrammes. For example, Moulin [fig. 12] from Huidobro's 1922 exhibition has the words in the shape of a windmill. Huidobro's use of words in art was related to Picabia's and antedated Surrealist peinture-poésie.

Several paintings by Miró, including Pastoral and Le Renversement, are pictorial extensions of the calligramme. They are in the form of picture-poems, incorporating words or letters in the painting, and they prove that Miró's interest in the relationship between words and images antedates his exposure to Surrealism.

Indeed, the catalogue of Miró's first exhibition at Dalmau's Gallery in Barcelona in 1918 included a calligramme by his friend, the Catalan poet Junot. He

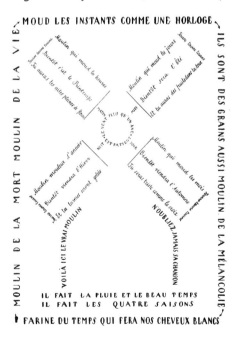

Fig. 12. Vincente Huidobro. "Moulin" (Picture-poem), 1922.

was already familiar with Apollinaire's and Huidobro's *calligrammes,* pictorial poems in which words took on a concrete visual presence by being dispersed on the page in a manner intended to enhance their significance through a visual expression of their meaning.

Both Huidobro and Picabia, like many avant-garde artists during and just after World War I, were fascinated with the image of New York and America as symbols of modernity. In his poem *Cowboy* (for Jacques Lipschitz), Huidobro gives a Dada description of New York.

> . . . a few kilometers
> in the skyscrapers
> the elevators rise like thermometers

Thus, Miró's introduction to the fantasy (as opposed to the reality) of New York took place during his early years as a young artist in Barcelona through two Spanish-speaking Dadaists. Miró's curiosity about New York, satisfied later in his life, is documented by the inclusion of an advertisement for the New York "Novelty Shop" collaged into the painting *Still Life with Coffee Mill* (1918) [fig. 13]. The motif of the coffee mill recalls Duchamp's chocolate grinder. However, Duchamp's treatment of the common object is cold, austere, and mechanical, whereas Miró uses an old-fashioned version that is explicitly turned by hand.

Still Life with Coffee Mill is one of Miró's first Cubist paintings. It shows the artist exchanging Impressionist and Fauve concerns for the architectonic and structural emphasis of Cubism. An awareness of the geometric forms underlying Cubist construction is apparent. Miró moved quickly beyond Cubism in the next few years, but this painting reveals that he had mastered its basic concepts, with which the majority of artists connected with Surrealism never concerned themselves. Miró's experience with the early modern movements of "pure painting" — Impressionism, Fauvism, and Cubism — provided him with a grounding in the fundamental formal concepts of modernist painting that Dadaists, Surrealists, and other anti-formalists lacked. This made his style unique.

Miró's debt to Dada, which he freely acknowledged as a major influence, was considerable. Arp pioneered the biomorphism and chance procedures Miró adopted, and Hans Richter's *Dadaköpfer,* echoed in Miró's *Portrait* (1927), are ancestors of the *personnage.* Dada claimed to be anti-art. Miró, at his most radical, joined

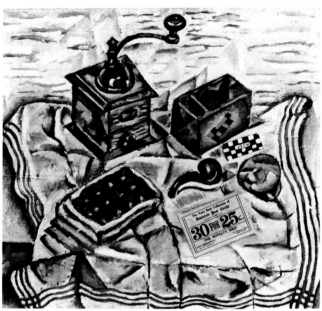

Fig. 13. Joan Miró. *Still Life with Coffee Mill,* 1918.

the movement "to assassinate painting" in the thirties. However, his way of killing painting was to find another way of creating images through manipulating materials until they yielded images. These images were derived from the process of creation, rather than devised *a priori* to the process.

Sympathetic to the Dadaist spirit of protest, Miró adopted the attitude of anti-art. As he puts it, in "negating negation," he produced an affirmative style expressing a rebellious stance in positive terms.[10] Rather than as a Surrealist, Miró should be viewed as an artist capable of converting Dada contrariness into a monumental art of great formal consequence. His closest ties with artists were with the Dadaists, Picabia, Arp, Man Ray, and Duchamp. The wit and irony of Dada stayed with him all his life. It was through Dada, specifically New York-Barcelona Dada, that he evolved the concept of the symbolic portrait *personnage* and the picture-poem.

The Cubists had previously incorporated block letter words into their paintings as geometric formal elements. Miró first used words in his 1917 Cubist painting, *Nord-Sud,* the name of the review Huidobro helped found in Paris, which published *calligrammes.* However, Picabia's Dada incorporation of his own handwriting as a form of drawing, which had ironic overtones, was quite different from Cubist block

lettering. For example, in *L'Oeil Cacodylate,* a light-hearted group effort of signatures by artists assembled one evening at the studio of Robert and Sonia Delaunay, Picabia equates writing with drawing, words with images, and symbolizes the fusion of seeing and reading with a big, disembodied eye. This prefigured the equation of word and image the Surrealists refined in their doctrine of *peinture-poésie.* Miró anticipated this development of verbal-visual association in paintings like *The Hunter (Catalan Landscape), Pastoral,* and *Le Renversement.*

II. THE SPACE OF THE SPIRITUAL

Le Renversement [fig. 14] was the first painting by Miró seen in the United States. It was a picture so radical in its conception of space, drawing, and imagery, it had no effect on American art until decades later. Perhaps to identify his artistic roots, Miró always titles his paintings in French. Purchased from Miró by Katherine Dreier in 1927, this painting is called *In Reverse* in English. Sometimes it is translated as the *Somersault,* as if to relate it to Miró's circus themes. There is no English equivalent for *renversement,* which means overturning, reversing, overthrowing, confusion, upending, disorder. All these words connote revolutionary upheaval and a reversal of normal expectations, which Miró intended to imply in the upside-down imagery of the tumbling horse and wheel. In *Le Renversement,* space, for the first time, becomes a *field* coextensive with the surface. No longer a curtain-like backdrop against which objects are silhouetted like figures in a proscenium box, space in Miró's work now becomes an indeterminate atmosphere, free-floating and intangible, unmeasurable and vast as the sky itself.

The iconography of *Le Renversement* is specifically, as its title indicates, the iconography of conversion. The overturned horse with its surprised rider refers to the standard representation of the *Conversion of St. Paul.* The rider, identified with the attributes of the ubiquitous Catalan peasant, reacts with expletives of astonishment, crying, "Ah! Hoo!" The green smear in the center, under the stylized mountains reminiscent of the hills outside Tarragona, may refer to a patch of green grass at Montroig. (Legend has it that Miró carried Montroig grass back to Paris, as Duchamp imported bottled Paris air to New York.) The image of the flaming heart, which appears more literally in the 1925 *Painting with a Hand,* recalls the mystical vision of

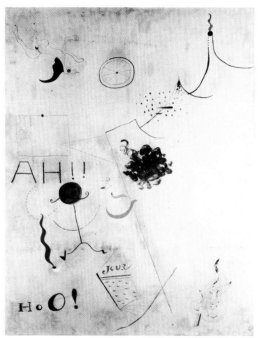

Fig. 14. Joan Miró. *Le Renversement,* 1924.

divine union in love described by St. John of the Cross in *The Living Flame of Love.*

Miró's first years in Paris between his arrival in 1919 as a twenty-six-year-old Catalan who preferred farm life until his first Parisian show in 1925 were extremely difficult. He was literally starving to death and undergoing a profound artistic and spiritual crisis. This period was one of several "dark nights of the soul" that deepened the mystical side of Miró's nature. He has described his state of mind during the period when he experienced what can only be described as a spiritual conversion, causing him to transform his hyper-real "detailist" style into an elliptical, ambiguous, metaphoric style that depicted an internal rather than an external reality. Recalling the winter of 1925, he remembers, "I was drawing almost entirely from hallucinations . . . Hunger was a great source of these hallucinations. I would sit for long periods looking at the bare walls of my studio and try to capture these shapes on paper or burlap."[11]

Miró's claim to have painted his hallucinations may sound far-fetched. However, given the tradition of Spanish mysticism, which specialized in visual apparitions, it has a precedent. Even in the twentieth century, mystical hallucinations and visionary experiences were common in provincial villages in

Catalonia. Miró was familiar with the visionary experiences of the great Spanish mystics like St. Teresa. Regarding his own hallucinations, Miró has said:

> It is very difficult for me to talk about my own painting because it is always conceived in a state of hallucination created by a shock either objective or subjective, of which I am utterly irresponsible. As far as means of expression are concerned, I am striving to attain more than ever the maximum of clarity, power and plastic aggressiveness, first to create a physical reaction and then to reach to soul.[12]

These hallucinatory experiences led Miró to conceive painting in a new way and to identify pictorial space as a color field. This was a significant innovation with repercussions for American art.

Miró's invention of a new kind of pictorial space places him firmly within the context, not of Surrealism, but of the great metaphysical modern painters — Klee, Kandinsky, and Pollock. Miró appears to have arrived at the concept of space as a field through which objects buoyantly float instead of a backdrop against which they are deployed during the critical years of 1923-25.

A key to the nature of Miró's conversion from literalist to symbolist is contained in the identification of the images in *The Hunter (Catalan Landscape)* that Miró provided for William Rubin. The hunter's heart is identified and referred to as "flaming." The flaming heart is the crucial image of spiritual union and enlightenment in the poetry of the great Spanish medieval mystic, St. John of the Cross. Miró has referred on several occasions to his readings of the barefoot poet-saint, who evidently influenced Miró's iconography as well as his religious views.

A painting that expresses these views, *Ceci est la Couleur de mes Rêves (This is the Color of my Dreams)*, is simultaneously a Dada statement and a refutation of the Dada negation of painting. On a stark white field, chalky as the plaster of a monk's cell, Miró has painted only two elements: the word *Photo* in script in the upper left and a smear of blue in the lower right, which turns the canvas into a literal palette on which Miró is trying out a color. The emptiness of the painting is startling, as is the combination of the absence of imagery with the mysterious presence of the word "Photo."

In 1925, when Miró painted *This is the Color of My Dreams,* photography was the new god. The Dadaists were giving up painting for photography, and the Surrealists were painting their dreams like photographs.

Picabia made a cynical statement in *La Veuve Joyeuse (The Merry Widow).* A crude drawing next to a photograph of the same subject — himself at the wheel of one of the sportcars that were beginning to interest him more than art — indicates photography is the surviving "merry widow" of dead painting. It was the moment Miró had to strike out on his own.

The challenge that photography posed for pictorial art in the twenties convinced many painters to turn in other directions. In 1925, for example, Duchamp spent the year playing tournaments and won the chess championship of France. Miró, however, rose to the challenge of photography, which is boldly confronted in *This is the Color of My Dreams.* Miró exposes the imaginative limitations of photography, since dreams, like angels, cannot be photographed. By projecting a world beyond that which could be photographed, Miró once again bears witness to his faith in another world beyond this one, a world of transparent spirit, not dense matter.

It was during the desperate period of 1923-25 that Miró developed the idea of the monochrome color field that led him to paint a new kind of space. In *Le Renversement* Miró tinted the entire field a pale golden yellow. Several other paintings, like *Le Sourire de Ma Blonde,* of the same period, have yellow backgrounds. Miró had, of course, looked for years at the gold-leafed backgrounds of Catalan retables, which create a strange, indeterminate space behind the figures. The monochrome fields of the early picture-poems are reminiscent of the neutrality of these anonymous backgrounds.

The strongest influence on Miró's paintings of the mid-twenties is Picabia's series of symbolic portraits which he painted in Barcelona. These paintings include *L'Enfant Carburateur,* which uses gilt paint to create a flat, monochrome background; and the *Portrait of Marie Laurencin, Four in Hand,* Picabia's witty commentary on the complicated love life of Marie Laurencin, who was also living in Barcelona during World War I. Another painting by Picabia, *Abstract Lausanne,* with its dotted, spiral, ideographic stars, suns, and mountains would be a specific source for Miró's new symbolic imagery if it actually was painted in 1918, as it is dated.[13] During this period, Picabia was interested in exploring the relationship between music and painting, referred to in his watercolor *Music is like Painting.* Later Miró, who loved music, became interested in abstract rhythmic patterns. This interest was strengthened by his meeting with Kandinsky in

1933.

Several writers have understood that Miró, like Kandinsky, is essentially a religious artist. However, since his is an eclectic view of religion, as much related to animistic agricultural fertility cults as to Christianity, Miró's religiosity has been difficult to discuss. He was not a Theosophist, like Kandinsky or Mondrian, but a kind of pantheist, another reason his art was accessible to American artists, many of whom were influenced by Transcendentalist pantheism.

Miró first saw Kandinsky's works in Paris in 1924. He had seen reproductions of Klee's works the previous year. One of the things André Breton held against Miró was that his work reminded him of Klee, and Breton insisted he could not bear to be in the same room with a Klee painting. Miró, on the other hand, has stated his admiration of Klee. Miró claimed that Klee made him feel something different from pure painting: "he went farther to attain zones that were more moving and more profound."[14] Miró never knew Klee. However, when he met Kandinsky in 1933, he was delighted to hear that Klee had confided to Kandinsky at the Bauhaus, speaking of Miró, that "one must watch what that boy does." He felt he was on the right track.

Miró's deep admiration for Kandinsky is expressed in an emotional letter to Kandinsky's widow written on January 1, 1966, over twenty years after the death of the master who was still much in Miró's thoughts.

> I had the honor of seeing Kandinsky often after he left Germany and installed himself in Paris on the banks of the Seine . . .
>
> At that time, all the great masters politely refused to receive him, the critics called him a school teacher and labeled his paintings "woman's work."
>
> This great prince of the spirit, this great nobleman, was very isolated; he saw only the few rare people who were entirely devoted to him . . .
>
> I remember his little exhibitions at the Galerie Zack and at Madame Jeanne Bucher on the Blvd. Montparnesse. His gouaches touched me to the bottom of my soul: at last one was allowed to listen to music and at the same time to read a beautiful poem. This was certainly more ambitious and profound than a cold calculation of the Golden Section.
>
> Now, the radiance of his work becomes more and more blinding. Alas, most of the masters lately leave us without feeling, without any electrical shock, or at any rate a very diminished one. I wish to pay homage,

my dear Nina, to your devotion to Kandinsky. Every time I came to your house as a pilgrim, I was moved . . . and I kiss you Nina, his dear companion.[15]

Miró's relationship with Kandinsky was one of profound and total respect. This was hardly true of his relationship with the Surrealists. "With Breton, I was always a bit careful. He was too dogmatic, too closed, he did not give me the chance to expand myself freely. I think he saw ideas behind painting . . . He was always waiting for the proof of what he had written to help himself as a theoretician. As far as I am concerned, theory escapes me completely."[16] Although he exhibited at the first Surrealist exhibition in 1925, Miró did not normally socialize with the Surrealists, who amused themselves by taking drugs and arranging seances. "It was not that I felt ill at ease, but I work very hard . . . I cannot permit myself to break up the day."[17]

Miró cared more for the opinion of poets than painters. He was delighted when his friend, the poet and ethnologist Michel Leiris, brought the avant-garde writer, Raymond Roussel, to his first show at the Gallery Pierre in 1925. Roussel's remark, "This goes beyond painting," pleased Miró greatly, since this was precisely his ambition, as it has been the ambition of generations of avant-garde artists.

At this point, we should make a distinction between modernist painters and sculptors who are content to work within the limitations of their media, which they strive to define, and the avant-garde, which has traditionally sought "to go beyond painting." It was Miró's paradoxical wish to go beyond painting, to operate in a metaphysical dimension, and simultaneously to underscore, as explicitly as possible, the specific physical properties of his medium. This literalist side of his personality often operated with great originality. For example, it led Miró to transform the field of the painting into an actual "field," which the artist, like the farmer, literally "tills" by manipulating the canvas physically, rubbing in color with his hands, rags, or other instruments, or applying foreign substances, sometimes dirt. We may identify as the first field painting his first poem-picture *Pastoral,* painted in 1924. In *Pastoral,* the metaphor of *The Tilled Field* becomes literal fact: the monochrome canvas becomes the field itself, and Miró, its gardener.

In an article on Miró's "realism" as a form of literalism, Huidobro describes Miró's capacity to effect "transubstantiation."[18] This is a religious term identifying

the moment in the Mass when the Eucharist is transformed into the blood and flesh of Christ. In paintings of the *Mass of St. Gregory,* a mystical theme represented in Spanish Gothic retables, the full figure of Christ appears literally in the flesh before St. Gregory performing the Mass. Miró's transformation of the painting into a tilled field is a form of literalist transubstantiation. One senses this equation as well in Jackson Pollock's "drip" paintings. Pollock, a farmer's son, shares with Miró the literal equation of painting and farming, recreating the seamless life of agricultural societies in which art and nature are one.

Writing about Robert Rauschenberg, Leo Steinberg speaks of the "flatbed" picture plane, i.e., the painting that appears to have been conceived by having been looked down on.[19] In a sense, this change in the orientation of painting from vertical to horizontal begins in Miró's ideographic picture-poems of the twenties. In these works, Miró, for the first time, identifies the canvas as the field to be cultivated. As he elaborates his technique, he goes to work in the painting field, scratching and rubbing and smudging, grating, scattering, "sowing" paint, and digging furrows of lines, as the farmers in Montroig plant. In this way, the agricultural metaphor central to Miró's work is concretized.

The austere emptiness of *Le Renversement,* with its tiny, faintly drawn, ideographic figures tumbling in space, was prophetic of Miró's future direction. The gold ground color, coextensive with the entire field of the painting, is like a blaze of sunlight. From that point on, one of Miró's principle subjects is the sky, the realm of the spirit, the infinity of space itself. "The spectacle of the sky moves me," Miró has said. "I am moved when I see in an immense sky the crossing of the moon or the sun. In my paintings there are tiny forms in big empty spaces. The empty spaces, the empty horizons, the empty plains, all that is stripped bare has always impressed me."[20] That immensity, that vastness implied in Miró's skies, impressed American artists like Newman, Rothko, and Still, for whom Miro's most radically reduced formats of color zones as spatial volumes were an inspiration for a kind of contemplative painting, immobilized and timeless in its stasis. The silence of these works was only one aspect of Miró's multifaceted personality. In America they were often the totality of an artist's expression.

III. SUBJECTS OF THE ARTISTS

A large body of literature exists regarding Miró's primitivism. Obviously cave painting helped him to develop his vocabulary of symbolic motifs. However, Miró has dismissed the influence of prehistoric art *per se* by claiming that the cave paintings were too "realistic" — a criticism he made of Picasso's art as well. Like Pollock, who collected ethnological material and books on primitive life rather than books on primitive art, Miró appears more interested in animism, which imbued everything with its own soul.

There are certain obvious resemblances between Miró's stick-figure, cartoonish *personnages* and Klee's fantastic elves and gnomes. The interest of Klee and Miró in prehistoric art is reflected in the interest of American artists in the artistic expressions of primal man. The elevation of the art of the caveman above that of "civilized" man expresses a fundamental pessimism regarding civilization, which has removed man from nature and destroyed the natural religions and relationships which maintained the equilibrium between body and mind. Miró's constant attempt to restore this equilibrium was understood by American artists as their own goal as well.

Miró's identification with the innocence of the Golden Age before the dawn of history and historical consciousness has a long lineage in American art. Nineteenth-century American landscape painting frequently depicted "natural" nature uncorrupted by civilization. Another popular American landscape theme was the world at the moment of Creation, an important subject of Miró's art as well. In the thirties and forties, the American avant-garde, searching for appropriate symbols and images, became involved with the art and religion of native American Indians. Their search for the primordial roots of art as a religious consciousness that placed man within natural creation, as opposed to controlling nature, coincided with Miró's views. Consequently, they were prepared to act on Miró's intuitions and to understand his message as European artists could not.

We have seen in the early twenties, Miró found a way of transforming reality into a parallel universe of signs and symbols, which had concrete referents and, consequently, were not abstract. Miró's conception of a metaphysical reality condensed into pictographic sign language gave American artists a philosophical alternative to both Cubist empiricism and Mondrian's

neo-Platonism. It should be stressed that Miró's symbol system was not based on abstraction from reality, but on archaic and prehistoric ideographic picture writing.[21] A means of communicating esoteric mysteries, these symbols presumably could be decoded by the initiated to unlock a more fundamental and universal spiritual reality than that of worldly flux and matter. That these signs stood for Miró's "subject matter," as he referred to it, appealed greatly to younger American artists seeking a new visual language charged with symbolic meaning.

In the eyes of the intense, restless New York School artists, abstraction had begun to be synonymous with empty decoration. They continued to revere the purity of Mondrian's spirit, but around 1940, even some of the faithful members of the American Abstract Artists began to think that hard-edged geometric abstraction lacked moral or philosophical content. These artists wanted to find a way to express the urgency of the historical moment. As Barnett Newman pointed out, 1940 was one of those moments in the history of modern art when painting itself seemed in jeopardy.[22] The advent of World War II heightened the need to find potent "subject matter."

Certainly, the presence of *Guernica* in New York had an energizing impact. However, it was too melodramatic and too personal to imitate, although its black and white palette had repercussions for later New York School painting. With no local heroes to lead them, the American avant-garde split into two opposing camps: those who believed that there was still life in Cubo-constructivist geometric art and the more romantic, individualistic artists like Gorky, de Kooning, Pollock, Gottlieb, Rothko, Still, Baziotes, and Newman, who maintained that abstract art was not capable of delivering a strong enough emotional message in a time of emergency. For this group, Miró's poetic, psychological art was a revelation and an inspiration.

In the retrospective he organized for The Museum of Modern Art, Sweeney included many of Miró's most innovative and original works. Some triggered an immediate response among American artists. In other cases, years passed before the significance of Miró's invention was perceived. In 1941, the burning question among the American Abstract Artists was still whether to choose the vocabulary of Arp's and Miró's organic biomorphic forms or that of Mondrian's architectonic, straight-edged geometry. Some artists like Charles Howard and Alice Trumbull Mason [fig. 15] attempted

to synthesize elements of the geometric and the biomorphic in a compromise between Purist abstraction and the more allusive vocabulary of biomorphism.

Sweeney's show established Miró as a major figure in the modernist pantheon and focused concentrated attention on his art. Coinciding with a moment of decision for the New York avant-garde seeking to break away from Cubism, the retrospective consecrated Miró as a major artist, officially annointed by Sweeney, whose opinion as a critic and connoisseur counted greatly in aesthetic matters. Miró's subjective, fantastic art was interpreted by Sweeney as an antidote to the sterility of geometric abstraction. A poet himself, Sweeney presented Miró not only as a painter's painter but also as a poetic painter, raising the possibility that New York artists might turn to poetry rather than to art for fresh ideas. This suggestion was especially appealing to artists like Robert Motherwell, William Baziotes, and Lee Krasner, who were reading Baudelaire, Rimbaud, and the Symbolist poets Miró himself found inspiring.

Miró's dictum, quoted by Sweeney in his catalogue, that "painting or poetry is made as we make love, a total embrace, prudence thrown to the wind, nothing held back," provided a rationale for the intense abandon and total emotional involvement demanded by the group that included personalities as troubled and desperate as Pollock, Gorky, and Rothko. They, like

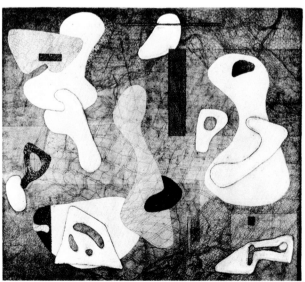

Fig. 15. Alice Trumbull Mason. *Interference of Closed Forms,* 1945.

virtually every ambitious New York School artist, were profoundly affected, to an extent that altered the course of their art, by the 1941 Miró retrospective.

To these searching artists, Sweeney's full-scale presentation of Miró's development from the early sharp-focus "detailist" pictures of the Barcelona period, to the "oneiric" or dream paintings, to the *peintures sauvages,* "savage paintings," produced during Miró's exile in France during the Spanish Civil War, was a revelation. They had seen Miró's work in the almost annual exhibitions he had at Pierre Matisse's gallery beginning in 1932 and knew the Miró reproductions Zervos published in *Cahiers d'Art,* which devoted a special issue to Miró in 1934. However, they had not experienced the full range of Miró's expression, which Sweeney's text helped to explain.

> Because of his fundamental devotion to painting, Miró has been able to recognize the value of the lessons learned by those generations immediately preceding his who sternly emphasize the formal bases of painting. Because he was a poet, he saw the weakness of a pictorial expression which discouraged any enrichment by means of extra-pictorial suggestion. Through the combination of these two sides of his talent, he has been able to bring a new tonic element into contemporary painting without compromising an essential pictorial approach.[23]

Through Sweeney's 1941 catalogue text on Miró, the concept of *peinture-poésie* officially entered the consciousness of the New York School. Sweeney's interpretation of Miró as an essentially dialectical synthesizer articulated the direction the New York School took as it attempted to combine "subject matter" with formal values assimilated from past art in what Harold Rosenberg termed "the tradition of the new."

Sweeney's insistence on Miró's roots in the local Catalan tradition meshed with the ambition of American artists, expressing a growing sense of cultural awareness, to create an art that was distinctively American. These artists could identify with Miró's provinciality and find hope in his career that they too might absorb the lessons of the School of Paris without sacrificing their own unique cultural experience.

A sign of the importance of Miró's exhibition and the amount of discussion it generated is that when Francis V. O'Connor catalogued Pollock's library, he found two copies of a single book: Sweeney's 1941 Miró catalogue.[24] Both Lee Krasner and Jackson Pollock had

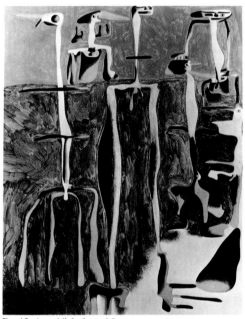

Fig. 16. Joan Miró. *Seated Personages,* 1935-36.

separately seen the exhibition. They had little to spend on books at the time, but each had bought and saved a Miró catalogue. (After they moved to Springs, East Hampton, in 1945 and merged their libraries, they kept both copies.)

Krasner, a former Hofmann student and American Abstract Artist member, tried unsuccessfully, as Ilya Bolotowsky recalled, to interest Pollock in Mondrian.[25] They agreed about the dominance of Picasso, but Pollock was already involved with a turbulent, subjective, expressionist art of psychological content. Miró was a major catalyst, if not in fact *the* catalyst, in freeing Pollock from Picasso and the Mexican muralists, who dominated his work until 1941.

A number of Pollock's gouaches and paintings of the early forties reflect Miró's biomorphic imagery, the violence and directness of Miró's *peintures sauvages,* "savage paintings," and the stick-figure totemic *personnages,* as well as his rich, painterly style. Although Krasner remained devoted to Mondrian's structural and architectural style throughout the forties, she experimented with *personnages* figures in a series of works in the late forties. These works she cut up and used as raw material for collage paintings such as *Promenade,* a work which resembles a frieze of the elongated *personnages* of Miró's *peintures sauvages* [fig. 16].

Although interested in Miró, Krasner remained firmly in the classical camp of Mondrian, whereas Pollock felt more kinship with the dream imagery and volcanic, passionate art of the Catalan. In this Miró vs. Mondrian choice that many artists felt they had to make, taste, not morality, was the issue. On the other hand, when Miró was matched against his fellow Catalan, Salvador Dali, who was out to capture New York with sensational stunts, the opposition was more than aesthetic. Dali represented the academic branch of Surrealism, which interpreted dream imagery as license for rehabilitating the deep perspective space, photographic realism, and stale rhetorical compositions of nineteenth-century academic art.

In 1941, the two Catalans, both equally categorized by the Museum and the press as Surrealists, had simultaneous retrospectives at The Museum of Modern Art. Dali's retrospective was organized by James Thrall Soby in tandem with Sweeney's Miró exhibition. The art magazines ran features on Miró vs. Dali, as if it were the artistic competition of the century. In a way, it was.

From a contemporary perspective, the notion of a match between Miró and Dali seems like pitting a theologian against a buffoon. However, during World War II, the two represented opposing interpretations of Surrealism. While Miró starved in Barcelona, hiding out and painting in the tiny room that was his old nursery, Dali was grabbing headlines, confusing the issue of the meaning and import of Surrealism. Even André Breton, the self-styled ''black pope'' of Surrealism who had accompanied Peggy Guggenheim, her husband, Max Ernst, and their Surrealist entourage to New York, was so disgusted with these antics that he began referring to Dali as ''Avida Dollars.'' Consequently, Dali had a coterie of Café Society collectors and academic followers, but the absent Miró was the hero of the ''forty or so modern artists'' Motherwell counted as constituting the New York avant-garde in the forties.[26]

At the time, the New York avant-garde had such difficulty in achieving any kind of recognition or attention that they mainly showed their works only to each other. Suddenly, the Surrealists, with their talent for theater, backed by Miss Guggenheim's fortune and her new gallery, Art of This Century, created the first real ''art scene'' America ever knew. Miró played no part in this scene; yet, ironically, his work was more influential in America than that of any of the artists involved with Miss Guggenheim.

To understand properly the context within which Miró's art had its initial impact on the New York School, it should be remembered that his retrospective was hanging at The Museum of Modern Art at the very moment, in December 1941, that the bombing of Pearl Harbor finally forced the United States to declare war on the Axis powers. The images of violence, upheaval, and brutality in Miró's works of the late thirties, especially as they were summed up in the menacing, diabolical *personnages* of this period, expressed the sense of apocalyptic catastrophe that weighed heavily on the conscience of those artists who lived through the war years, expressing their sense that if Western civilization were to survive, it would be on American soil that the renewal would take place.

IV. ART OF THIS CENTURY VS. ART OF ALL CENTURIES

- If they really paint in this manner because they see things that way, then these unhappy persons should be dealt with in the Department of the Ministry of the Interior where sterilization of the insane is dealt with, to prevent them from passing on their unfortunate inheritance. If they really do not see things like that and still persist in painting in this manner, then these artists should be dealt with by the criminal courts.

 Adolf Hitler, Munich, July 18, 1932.
 Quoted in *Art of This Century,* 1942.

- The play of lines and colors, if it does not lay bare the drama of the creator, is nothing more than a bourgeois pastime. The forms expressed by an individual attached to society should disclose the activity of a mind wishing to escape from present reality, which today is particularly ignoble, and seek out new realities, offering other men a possibility of elevation.

 If we do not attempt to discover the religious essence and magic meaning of things, we will do nothing but add new sources of brutishness to those which are offered today to countless peoples.

 Joan Miró, statement in *Cahiers d'Art,* 1939
 Quoted in *Art of This Century,* 1942.

In the opening exhibition of her own collection at Art of This Century in the spring of 1942, Miss Guggenheim included three paintings by Miró: *Two Personages and a Flame* (1925), which was a gift from her husband, Max Ernst, *Dutch Interior* (1928), and *Seated Woman II* (1938-39). The novel installation,

designed by Viennese architect Frederick Keisler
[fig. 17], was as sensational in its way as the art itself.

Among the most dramatic of Miró's paintings seen in
New York during the war was the *Seated Woman II.* A
startling, grotesque image, *Seated Woman II* was a
hybridized half-length of a woman with the head of a
prehistoric monster, a Ubangi-like neck more distended
than that of Parmigianino's *Madonna del Collo Lungo,*
tiny paw-like hands, a jeweled necklace with a
dangling, hairy, vulva-like fetish, and unequal,
pendulous striped breasts pointing, like cannon, in
opposite directions. It was an obscene image,
threatening and sinister in its allusion to death and
deformity in the skeletal head and flipper-like
appendages. No image of pain or violence could have
expressed as powerfully the sinister menace threatening
Europe. In its garish colors, half-length pose, and
physical malformation, the *Seated Woman II* is the
sister of the angry *Reaper,* Miró's lost mural for the
Spanish Pavilion in the 1937 Paris World's Fair.

Both Miró and Picasso had accepted commissions
from the embattled Republican government to decorate
the Spanish Pavilion. Picasso's choice of a group scene
commemorating a specific historic moment, the
bombing of the Basque town of Guernica, was typically
melodramatic. Miró's creation of a symbol of the
collective popular spirit in a single allegorical figure —
an allusion to the Biblical "grim reaper" — is
connected to the deep, continuous themes in his art of
personal revolt and the heroism of the Catalan peasant.
Miró's interpretation of historical events in religious
terms universalizes suffering and links man to his past
in the way American artists wished to be connected
with a moral purpose and collective spirit. An allusion
to the Biblical parable that evildoers shall reap what
they sow seems obvious in the menacing gesture of the
enraged figure wearing the curled Phrygian-type cap,
which identifies him as the archetypal Catalan peasant,
the figure who reappears many times in Miró's works.
The upraised arm, the classic gesture of rebellion, is an
ominous warning of the Reaper's future revenge
against the exploiting oppressors.

Guernica was shipped from the 1937 Paris Exposition
directly to New York where it remained until its recent
return to the Spanish people, but Miró's *Reaper*
survived only in photographs. A related work, a tryptich
on celotex, was made out of the material left over
from the single horrifying figure of the *Reaper.* In
contrast with Picasso's choice of the anguish of the
passive victims of the bombing of *Guernica,* Miró's

Fig. 17. Frederick Keisler installation, Art of This Century, 1942.

portrayal of the active and heroic resistance of the
brutalized peasant stirred to revolt is the more
genuinely revolutionary image. Miró's identification with
the cause of the Spanish Civil War, for which he made
fund-raising posters depicting the image of the Catalan
peasant in revolt, brought him admiration from the
New York School, whose sympathies were entirely with
the Republican government. His capacity to translate
political content into universal symbols of tyranny and
repression without using an illustrational style was
especially respected in America where artists were
increasingly suspicious of the use of art as
propaganda.[27]

A culminating work in Miró's distressed and distorted
peinture sauvage style, *Seated Woman II* had an
immense impact on the American artists who flocked
to Art of This Century. This influence is particularly
visible in the work of Hans Hofmann, who had his first
one-man show over the objections of the Surrealists,
who considered Hofmann a Germanic, academic,
retardataire Cubist — in short, the enemy itself.

Miss Guggenheim was persuaded to show Hofmann,
whose work did not particularly impress her either, by
her secretary, Howard Putzel, who was, as we have
seen, a major supporter of Miró. Putzel had been
introduced to Hofmann's work by Lee Krasner and
Jackson Pollock. Putzel, Krasner, and Pollock instigated
the show for Hofmann in 1944. The Surrealists who
filled Miss Guggenheim's salon were furious, Krasner
recalls, and tried to have the show cancelled.[28]

It may have been to ingratiate himself with the
powerful Surrealists-in-Exile, as Breton's expatriate

coterie was known in New York, that Hofmann adopted the *personnage* format of Miró's *Seated Woman II* in his painting, also titled *Seated Woman* [fig. 18]. In any event, a number of Hofmann's paintings, such as *Bacchanale, Delight, Ecstasy, Liberation,* and *The Flight* of 1946-52, reflect Miró's direct influence in their use of automatic drawing to delineate a fantasy figure. They are unique in Hofmann's oeuvre and seem forced in their grotesque deformity. Despite his adoption of the *Seated Woman* format, Hofmann's color remained essentially Fauve and his space, distinctly Cubist.

Apparently, Hofmann was influenced more fundamentally by Miró's use of accident as a point of departure, as shown in paintings like *Birth of Taurus* and *Palimpsest, Cataclysm* and *The Fish and the Bird.* In these works, paint is rubbed in rather than painted over the surface, creating a sense of an indefinite and atmospheric space; and accident is cultivated as an essential component of a non-composed look. Essentially, these were Miró's ideas, which Hofmann borrowed.

Hofmann was not alone in being inspired by Miró's reliance on an accidental mark or stain as a point of departure for provoking free-form images. In a work like *Night Sounds* [fig. 19], Pollock followed Miró's example of elaborating a shape from a splotch. This use of the accident as a point of departure is not to be confused with automatic drawing. Miró was careful to make the distinction and to clarify his debt to the Dada artists, who were the first to incorporate the accidental into art as a conscious program for creating new forms.

> Never, never do I set to work on a canvas in the state it comes in from the shop. I provoke accidents — a form, a splotch of color. Any accident is good enough. I let the *matière* decide. Then I prepare a ground by, for example, wiping my brushes on the canvas. Letting fall some drops of turpentine on it would do just as well . . . The painter works like the poet: first the word, then the thought. I attach much importance to the initial shock.[29]

The use of accident in art was a primary Dada contribution. Picabia's ink blot, a black spatter he titled *La Sainte Vierge (The Holy Virgin),* is one of a series of early experiments with chance that Duchamp turned into intellectual exercises and Arp refined to a procedure for composition. Miró was keenly aware of these Dada experiments with chance. However, he broadened the meaning by searching for images suggested by random formations. Miró's experiments with materials went beyond anything the Dadaists could imagine. For pigment, he used everything from

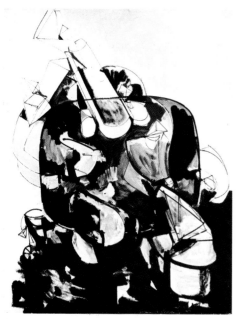

Fig. 18. Hans Hofmann. *Seated Woman,* 1944.

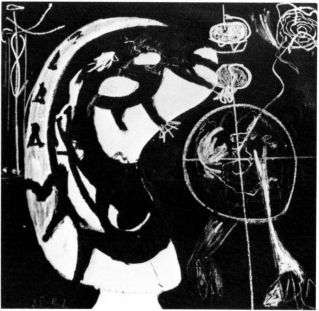

Fig. 19. Jackson Pollock. *Night Sounds,* ca. 1944.

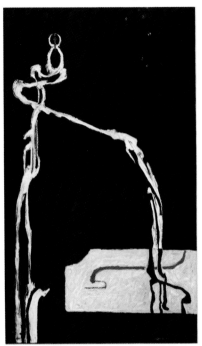

Fig. 20. Clyfford Still. Untitled, 1945.

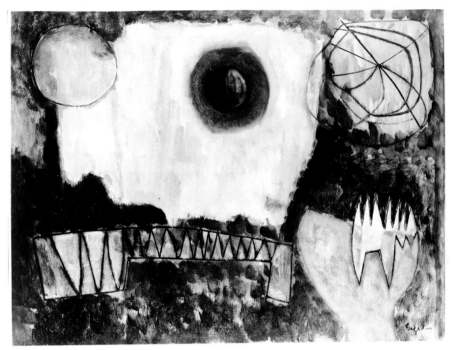

Fig. 21. William Baziotes. *Moon Forms*, 1947.

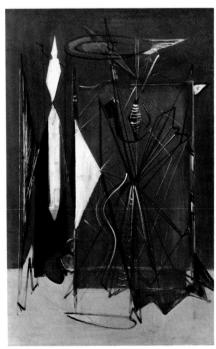

Fig. 22. Mark Rothko. *Phalanx of the Mind*, 1944.

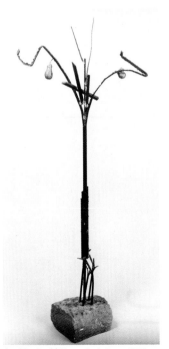

Fig. 23. David Hare. *Fruit Tree*, 1956.

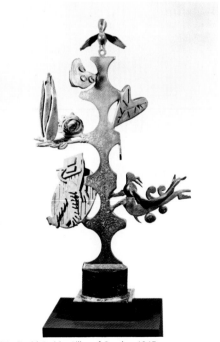

Fig. 24. David Smith. *Pillar of Sunday*, 1945.

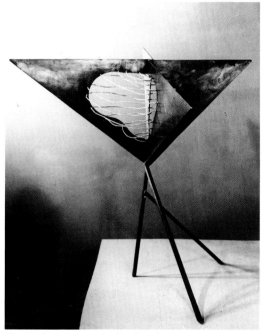

Fig. 25. Ibram Lassaw. *Conjunctive Triangles*, n. d.

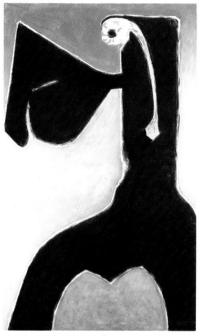

Fig. 26. David Hare. *Standing Figure*, 1980.

jam to excrement. His attitude toward the mutability of the support was even more radical, and its consequences with regard to the future of painting are still being assimilated.

V. SYMBOLIC MONSTERS

- If the models we've used are the apparitions seen in a dream, or the recollection of our prehistoric past, is this less a part of nature or realism than a cow in a field? I think not.

 Adolph Gottlieb, "The Ides of Art,"
 Tiger's Eye, II, December 1947.

Hofmann's hybrid *personnage* paintings were among many such figures inspired by Miró. Still [fig. 20], Baziotes [fig. 21], Rothko [fig. 22], Pollock, Stamos, and others painted *personnage*. Sculptors David Hare [fig. 23], David Smith [fig. 24], Ibram Lassaw [fig. 25], Seymour Lipton, and Herbert Ferber were equally inspired by Miró. In the seventies, Hare revived the ominous *personnage* in a series of large paintings [fig. 26].

Among Miró's best-known *personnages* figures was *The Potato*, which appeared on the cover of the 1941

Museum of Modern Art catalogue. With its lumpy brow and grizzled ear, *The Potato* is one of Miró's most powerful doubled body-landscape images. On one side of the motley, androgynous *personnage* is the flaming heart, symbolizing divine love.[30] On the other side is the ladder of ascension from earth to heaven. In place of the heart is the Catalan flag. One hand is raised in the gesture of benediction. Both the gesture and the silhouette of the head against a blue ground recall the image of Christ as Salvator Mundi from the Catalan Romanesque church of San Clemente de Tahull [fig. 27]. The initial "M" in the palm of the blessing hand suggests that the artist is depicting himself as the Savior and, in the form of a potato, the food of poor people. The benign *Potato*, symbolizing the artist as provider, is the negation of *The Reaper*.[31]

The Potato, which was widely reproduced, significantly influenced Arshile Gorky, for whom the Miró exhibition was a revelation. Gorky shared with Miró a medieval heritage; he loved the medieval manuscript illumination and fresco paintings of his native province of Van in Armenia. Miró's delicate filigreed line and spiritual poetry apparently put Gorky back in touch with his own roots. From 1940 to 1943, Gorky transformed his imagery, basing his metamorphic forms directly on images taken from Miró's paintings of

1928-30. Inspired by Miró's elaborately twirling and looping line, which was, coincidently, reminiscent of the ornate, curvilinear tracery of Armenian manuscripts, Gorky freed himself from Picasso and took Miró as a new master.

Although Miró's images were often grotesque and sometimes apocalyptic, they did not suggest the sado-masochistic wounding and tearing of flesh and exposing of the anatomy that Gorky's tragic imagery did. Indeed, one of the major differences between Miró's figurative style and that of the Abstract Expressionists is that his *personnages* have distinct contours: their bodies are bounded, their "guts" contained. However, in the paintings of the Abstract Expressionists, beginning with Gorky, fleshly contours are opened and pain is openly, even violently expressed. This is particularly true of the tragic series of *personnages* Lee Krasner painted in the months following Pollock's death.

At the height of his powers, Gorky's technical mastery was unsurpassable. However, he was essentially conventional in his attitude toward materials and media and, in that sense, closer to the Surrealists-in-Exile than to Miró, who attacked (in a literal sense) his canvases with all the vehemence and hostility of the Dadaist. Gorky was undoubtedly a finer and more gifted draftsman than Miró, again in the conventional sense [fig. 28]. His drawing became increasingly intricate after he began to use line as an autonomous element and thin his paint to transparent waterfalls of running color.

Of all the New York School painters, Gorky imitated Miró most directly. (Miró once nearly mistook a painting of his own for a Gorky.)[32] However, as Sidney Tillim pointed out, there was none of Miró's wit and irony in Gorky or, for that matter, in the art of any of the Abstract Expressionists.[33] Also absent from Gorky's art was the element of the grotesque that dominates Miró's imagery and is part of his lifelong homage to Catalonia, where a strong tradition of the grotesque persists.

Indeed, the presence of the grotesque is so strong in Barcelona that it nearly overpowered German art critic, Julius Meier-Graefe. An early champion of Impressionism, Meier-Graefe kept a diary of his trip to Spain in 1907. For Meier-Graefe, Barcelona was, on the one hand, "a sort of little Paris," with a sophisticated cultural life. Physically, however, he did not care for it at all. He complained, "Barcelona is a mixture of sublime and grotesquely ugly ornaments."[34] Describing an excursion to Gaudí's Güell Park, arranged by the writer Utrillo, Meier-Graefe warned, "Park sounds innocent and peaceful . . . you must abandon such ideas when you go to the Güell Park." He described his astonishment on seeing "a kind of temple or a gigantic roundabout which however did not move. This edifice was supported by pillars which resembled monstrous elephants' tusks . . . Moreover we hadn't time to think about it because in the twinkling of an eye we were confronted by another buiding of unintelligible form, half Indian Palace, half dog-kennel, made out of pottery or glass or soap bubbles. Horta and Guimard, Endell and Obrist . . . struck me as peaceful classicists by the side of the invention of this monster in Barcelona." The monster, of course, was Miró's revered mentor Antonio

Fig. 27. Maestro de San Clemente de Tahull. *Pantocrator,* n. d.

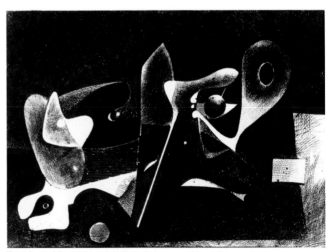

Fig. 28. Arshile Gorky. *Nighttime, Enigma, and Nostalgia,* ca. 1929.

Gaudí. The Luna Park atmosphere that drove Meier-Graefe to distraction was the environment in which Miró grew up, and which marked him for the rest of his life.[35] As Meier-Graefe correctly observed, Gaudí's fantasy and metamorphic forms went far beyond the stylized organic ornament of *art nouveau* in terms of fantasy and the grotesque.

The Byzantine richness of the combinations of materials Gaudí used, many of which were light reflective, affected Miró deeply and helped form the unconventional attitude toward materials that is one of the most original features of his art and one of its greatest influences on American art. His love of the richly decorative and the ornamental was particularly appreciated by Gorky, Pollock, Krasner, and Pousette-Dart. Critics attribute the elaborate arabesques of Miró's work to the influence of *art nouveau.* However, his ornate filigreed tendrils and minaret forms are as likely a relic of the Mozarabic heritage of Catalonia, a reflection of the Islamic decorative impulse which filtered into Spanish art at all levels and is expressed in Gaudí's minaret-like turrets. This Near Eastern influence, felt in Miró's twisting, intricate line, is surely one of the aspects of his style that made it so attractive to the Armenian Gorky.

Miró's attraction to the monstrous is entirely explicable in relationship to the Spanish tradition. In addition to the grotesque elements of medieval art, there were the paintings by Bosch and Bruegel collected by Phillip II in the sixteenth century and later housed in the Prado. These images are so familiar to Spanish artists that they may be considered part of the national patrimony. Closer to the modern period is the example of Goya's *pinturas negras,* the dark visions he painted toward the end of his life. Goya's inscription for the frontispiece of *Los Caprichos,* "el sueno de la razon produce monstruos," "the sleep of reason produces monsters," could have been the Surrealist motto. Thus, there are many antecedents for Surrealist imagery in the earlier history of Spanish art that were certainly familiar to Miró.

The element of the monstrous, which dominates Miró's art, is alien to American artists. The exception is Pollock, who appears to have felt his own attraction to the grotesque vindicated by Miró's diabolical troupe. There is also a connection between Miró's *femmes* and de Kooning's leering women, the theme for which he is best known. However, Miró's general view of women was as maternal fertility goddesses, whose deformations were no stranger than the exaggerations of

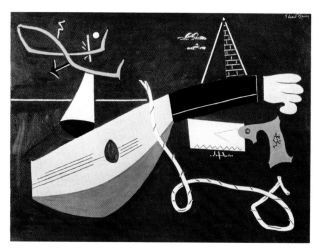

Fig. 29. Stuart Davis. *Mandolin and Saw,* 1930.

paleolithic cult figures. De Kooning, on the other hand, isolates the grimacing female figure, exaggerating dangerous teeth and fingernails, and further identifying woman as fatal rather than fecund.

Like Miró, the Dutch-born de Kooning had a natural affinity for the landscape as did Pollock and Gorky. Indeed, all three left Manhattan in the forties to live and work in the country. For these artists, Miró's landscape and seascape imagery was especially provocative. Pollock used motifs from Miró's fantasy seascapes of the late twenties in such works as *Moby Dick,* a scene of struggle and tempest. Kandinsky called Miró a "volcanic" artist, and certainly Miró frequently painted spontaneous eruptions, especially in his later works when the accidental was more violently provoked. However, in contrast with Pollock's heaving and lurching seas, Miró's Catalan coastline has a Mediterranean tranquility. As attracted as he was to Goethe, Wagner, and German romanticism, Miró could not know the depths of brooding melancholia of which American painters were capable.

Some of Miró's paintings, like *Horse by the Sea,* were filled with incident and fantasy, inspiring even as hard-headed a Cubist-Realist as Stuart Davis to emulate their whimsy. Davis, like Miró, had a sense of absurdity, which he expressed in *Mandolin and Saw* [fig. 29]. Although no fantasist, Davis could appreciate Miró's fantasy as it delighted in changing the normal scale relations of objects, dislocating them out of context in that space which de Kooning referred to as the existential "no environment." Davis, of course, never

accepted biomorphism, automatism, or any material from the subconscious in his works. In his fidelity to the reality of a concrete, fixed orientation and bounded, hard-edged shapes, Davis isolated himself from his comrades, de Kooning and Gorky, who were prepared to fantasize along with Miró.

In the late twenties, Miró gradually gave up the use of the horizon line in his paintings, which seem to be all blue sky. Bright and cloudless as summer days, like beach scenes without the beach, cleared of sand, rocks, and people, these paintings became edge to edge fields of transparent color. They have the tranquil silence and meditative quality Miró has spoken of as a kind of mystical quietism like that preached by St. John of the Cross. Sky and sea mate, merging in blue haziness that simultaneously suggests both air and water. These transparent, reductive paintings influenced a number of New York painters, particularly Rothko, Gottlieb, and Baziotes. Later, Motherwell remembered them and enlarged their fields to monumental scale.

VI. COLOR AND FIELD

Miró's conception of metaphysical transcendence and visionary spirituality remains, for all its spatial ambiguity, essentially earthy. This earthiness is reflected in Miró's preoccupation with materials. "Never has there been painting which stayed more strictly within the two dimensions, yet created so much variety and excitement of surface," Clement Greenberg wrote in 1944, "Picasso piles pigment on the surface; Miró sinks it in." This insight had great significance for the theory of post-painterly abstraction Greenberg later formulated. At the time, it was simply an observation no one else was keen enough to make. Later, it supplied Greenberg with a rationale to launch a school of "stain" painters notable for sinking pigment into canvas.

Miró's dematerialized space is protean and amorphous, a volume of changing, shifting, transparent, or translucent color that only the mind can measure. After 1940, Miró definitively gives up the horizon line, and figures float, ungrounded, in an extraterrestrial atmosphere. This amorphous space lacks the referents to representational art that remain as a residue in the planimetric spatial organization of Cubist painting, with its opposition of foreground and background, its advancing and receding planes, and its overlapping and reversible shapes. The influence of Miró's new conception of space as an indeterminate

environment where fragments of anatomy and landscape hybridize is reflected in a statement made by de Kooning in 1949. It echoes the sentiment of the New York School regarding the analogy between their efforts to renew creation and Biblical Creation.

> In Genesis, it is said that in the beginning was the void and God acted upon it. For an artist that is clear enough. It is so mysterious that it takes away all doubt. One is utterly lost in space forever. You can float in it, fly in it, suspend in it and today, it seems, to tremble in it may be the best . . .[36]

In the thirties, de Kooning had begun experimenting with biomorphism and had done drawings using biomorphic motifs [fig. 30]. However, it was not until after the 1941 Miró retrospective that de Kooning began opening the contours of his figures, allowing planes to slip into one another, and using drawing as an active element in slicing back into space behind the plane. Although there is always a residue of Cubist closure and grid structure in de Kooning's freest "action paintings," in the forties, Miró's conception of a fluid, mutable space in which forms could float, collide, and unite was an important element in the evolution of his style. Miró's example permitted de Kooning, as it permitted Gorky, Pollock, and Baziotes, to retain figurative elements necessary to the content of his art, without renouncing his allegiance to the most advanced principles of modernism.

Fig. 30. Willem de Kooning. Untitled, ca. 1939.

In the mid-forties Gorky's imagery, which was never gay, began taking on a darker, more sinister, strained quality when he came under the spell of Matta, a partisan of "psychic automatism," which Miró, who preached the controlled accident, not the uncontrollable psychic outpouring, was not [fig. 31]. In a review of Gorky's 1945 show, Clement Greenberg chastised Gorky for exchanging the inspiration of Miró for the influence of Matta, "that comic-stripper."[37] It was a cruel but perhaps just criticism of the most naturally gifted, poetic, and refined of the major Abstract Expressionists, who was perhaps the most derivative as well.

Possibly Gorky imitated other artists because he could, whereas the other New York School artists, except de Kooning, who could draw like Ingres, were forced to be original and unconventional if they were to be anything at all. In proving that an artist could be truly great without being phenomenally gifted in an academic sense, Miró set an example for New York artists. Like Pollock, who agonized about his lack of natural ability, Miró lamented his own limitations, rating himself most gifted as a colorist.[38] Ironically, Marcel Duchamp and Clement Greenberg, the most important taste-makers in America, who probably agreed on little other than Miró's greatness, concurred with him.[39]

It was Miró's gifts as a colorist that were the last to be recognized, but they contributed greatly to the development of color-field painting and what Greenberg has termed "post-painterly abstraction." The origin of the large-scale color-field paintings that Rothko and Newman began painting around 1950 is in great measure the zoned landscapes and seascapes Miró painted in 1927, in which large areas of luminous color are simply divided by a horizon line. These reductive landscape images inspired Newman to simply divide the canvas into zones of color in his painting *Horizon Light* [fig. 32].

In the early forties, as he freed himself from the influence of Milton Avery, Rothko painted many fragile, poetic watercolors. According to Robert Rosenblum, Rothko's Surrealist watercolors were inspired by Walt Disney's film *Fantasia,* made in 1940. For Rosenblum, *Fantasia* "seems to herald almost every primeval image attained so anxiously by Rothko, Still, Newman or Pollock."[40] Since these artists were known for their disdain for the mass media, this seems highly unlikely. On the other hand, the animated landscapes of *Fantasia,* produced in Hollywood where Miró exhibited

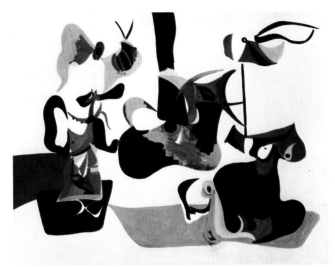

Fig. 31. Arshile Gorky. *Garden in Sochi,* 1940-41.

Fig. 32. Barnett Newman. *Horizon Light,* 1949.

in the late thirties, were certainly influenced by Miró. The movie reduced his organic, pulsating imagery, shuffled anatomy, and ambiguous sea-sky-earth backgrounds to kitsch imagery, easily assimilated by the popular culture. The vulgar biomorphic shapes and garish color of *Fantasia* did affect American artists unable or unwilling to distinguish kitsch from high art.

Initially, the cartoonish quality of Miró's art attracted American viewers who saw his *personnages* in fantasy landscapes as relatives of Krazy Kat. In his youth, Miró had certainly been exposed to the satiric caricature that flourished in Barcelona. However, the tradition to which his distorted creatures belong is that of the Gothic grotesque which produced the cathedral gargoyles and the grimacing incarnations of the devil of the Beatus manuscripts, not that of debased modern pop culture.

However, Rosenblum is correct in stating that Miró's 1924 *The Family,* exhibited in February 1941 in Putzel's New School show and the subsequent Museum of Modern Art retrospective, was an important inspiration

for Rothko's series of Surrealizing watercolors and oils of the early forties [fig. 33]. The aqueous viscosity of these works is related to Baziotes' marine imagery of the forties, as well as to Newman's early drawings, which seem to refer to early life forms and the biological substrata of evolution.

Their focus on marine imagery and the earliest forms of life is linked with Miró's preoccupation with the basic pre-historical themes of creation and evolution. This involvement with early life resulted from the belief that the technology invented by "civilization" had become identified with both the destruction of the race and destruction of the creative process. "Subject matter" had to be found in the antedeluvian world before species had evolved their separate ways and man was cut off from the plants and beasts from which he sprang.

Once they felt secure in their art, American artists dropped the marine theme. The "wateriness" of much of the imagery of the New York School during the war years conveys a drowning anxiety that disappears in the late forties, when the atmospheric, airy quality in Rothko, Newman, Pollock, and even Gorky predominates. For Miró, however, the question of evolution remains central to his iconography throughout his life. It is most obvious in his consistent emphasis on *hair*, a secondary sexual characteristic and the most obvious link between *homo sapiens* and the hairy species from which he evolved. Robert Motherwell noted Miró's obsession with hair in his article prompted by Miró's second Museum of Modern Art retrospective in 1959.[41]

The distinct strand of hair — the few wavy lines designating eyelashes, beard, moustache, head and body hair in all its varieties — appears in one way or another in Miró's works even as recently as the flaming orange bush in *Hair Chased by Two Planets* of 1968. The single strands of hair are the isolated remnant of the profusion of individual details in Miró's early Cubist paintings. As he purified and emptied out his canvases, reducing signs to a minimum, hair was the last anatomical detail to go, perhaps because hair is the concrete symbol that man remains part animal, rooted in nature and tied to the history of the species. Hair connects man to nature the way the oversized foot roots the peasant in the earth. The balance struck between this world and the otherworldly is a unique characteristic of Miró's art and part of its greatness.

Miró's attitude toward the role of the artist as a shaman evoking spirits and phantoms, with the power to effect a collective catharsis, was close to the conception of the New York School. This redefinition of the role of the artist as a magician, capable of transforming matter into spirit, is summed up in a statement Huidobro made about Miró in the special issue of *Cahiers d'Art* on Miró published by Zervos in 1934.

> Joan Miró means the dematerialization of the material in order to convert it into new material. And no one has painted with greater economy of means. There is his strength and his wealth. The strength of not wanting to be strong, the wealth of not wanting to be rich. If there were a painter capable of giving emotion to a dot, that painter would be Joan Miró . . .

Leaving prints of his own hands, as paleolithic man left his trace on cave walls, Miró anticipated the direct bodily involvement of American artists like Pollock and Johns, who have left imprints of their own hands in their paintings. With such ideas, Miró contributed largely to the New York School ideal of "direct" painting, improvisational abstraction often involving an unconventional means of applying paint. "I work in a state of passion and trance," Miró has said. "When I begin a painting, I obey a physical impulse in order to get started; it is like a physical discharge."[42] This trance-like involvement is close to the way Pollock described his methods, his sense of being *in* the painting.[43] Miró's intense mental concentration, coupled

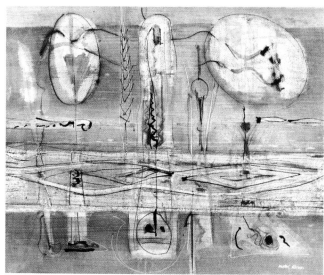

Fig. 33. Mark Rothko. *Entombment I*, 1946.

with direct physical involvement, was an example of total commitment many American artists attempted to emulate in the forties and fifties.

Miró was the first artist to observe that a change in the character of the support resulted in a change in the character of pictorial space. Throughout the twenties and thirties, he painted on any kind of surface that appealed to him. (His *peintures sauvages* on copper are the first important paintings on copper since the sixteenth century.) At one point he countered Duchamp's argument that Rembrandt's paintings should be used as ironing boards by literally painting on ironing boards.

Both Sweeney and Carl Holty, whose studio Miró rented in New York, commented on his unorthodox treatment of the canvas. (See their descriptions of Miró's technique in the appendix.)

Miró used his alterations of the support to provoke images from the blotting, staining, rubbing, and buffing. Once again the agricultural metaphor is invoked by the painter-as-farmer. In answer to a question posed by Georges Raillard (in the interviews published as *Ceci est la Couleur de mes Rêves*), Miró insisted:

> Paintings must be fertile. They must cause a world to be born. It matters little if one sees flowers, people, horses, as long as a universe, something living, is revealed.

Counter to the belief that Pollock was influenced by Ernst's automatic and uncontrolled painting processes (frottage, grattage), Pollock was actually searching, as Miró did, for images to suggest themselves during his process of manipulating materials. Pollock's emphasis on *control* in his use of the accidental is first underlined by Miró in his description of his critical evaluation of the accident, which Sweeney published in the 1948 *Partisan Review* interview. (See appendix). This description is echoed in a later statement by Pollock.

During his most creative periods, Miró has attacked the canvas with a combination of Dada aggression and a picador's sense of mission. He has punched it, scratched it, crumpled it, burned it, stained it, sewed it, patched it, wrapped it, beat it, nailed it — in short, manipulated the support, stretching it to its absolute limits. By attacking the canvas, Miró makes literal yet another metaphor. He attacks matter itself, thus literally dematerializing physical substance. He is also, in another sense, using the support as a punching bag —

the phantom opponent the feisty Miró boxes, as he once boxed Hemingway, among others. Since he is rarely observed working, not enough commentary on Miró's experimental methods exists. However, it seems safe to say that a large part of recent experiments with canvas "off the stretcher" and attempts to emphasize the support as a physical entity were predicted by Miró. Moreover, it was Miró, who, with increasing emphasis, left areas of the support bare, thus prefiguring the essential element in stained color-field painting.

Indeed, Miró believes the support is no more sacred than any other element in painting. He has probably used more different supports for his paintings than any artist alive: masonite, wood, copper, burlap, cardboard, paper. Ultimately, he began weaving his own canvas in the *sobreteixims*, which are part of his collaboration with artisans.

VII. ROPE AND PEOPLE

> • Anonymity permits me to renounce myself, but in renouncing myself I affirm myself even more. In the same way, silence is the refusal of noise, but the result is that in silence the slightest noise becomes enormous.
>
> Joan Miró, interview with Georges Raillard, *Ceci est la Couleur de mes Rêves,* 1977

Because Miró's life has never given rise to any scandal, the idea that his work is specifically autobiographical is not frequently raised. However, the expression of immediate feeling that he has constantly sought makes it likely that there is a great deal of content in his works tied to specific moments in his life. For example, two of Miró's most technically radical works, *Rope and People I* and *Rope and People II,* probably record an actual event. Oil on cardboard, they have thick, twisted rope projected from them, not in the refined manner of collage, as an element integrated into the painting surface, but in the raw, brute form typical of the found objects Rauschenberg projects forward in his "combine" paintings.

Although Rauschenberg and other assemblage artists may not have been directly influenced by Miró, his Dada-inspired collages and objects of the thirties are echoed in their works. For example, Miró's stuffed bird in his 1936 Dada construction, often on view in The Museum of Modern Art, is an ancestor of Rauschenberg's stuffed goat in *Monogram*. Miró's imagery evidently inspired Joseph Cornell's series

with parrots [fig. 34]. Miró's collages with postcards and photographic reproductions influenced Cornell, as well as the pop artists fascinated by such nostalgic materials. Like Miró, they frequently drew from everyday experience, transforming autobiography into iconography.

The source of the imagery in *Rope and People I* and *Rope and People II* relates to Man Ray's account of a visit to Miró in the late twenties in his Rue Tourlaque studio. What he saw revealed Miró's stoic resistance and silent courage at a traumatic moment. Two Surrealist poets (elsewhere identified as Breton and Eluard) had started what seemed like a harmless Surrealist game, according to Man Ray, ''with Miró as the stake.'' Man Ray describes the gruesome joke as follows:

> While one pinioned his arms behind him, the other tried to adjust a noose around his neck, Miró fought furiously, as if in earnest, but the expression on his face was one of fear . . .[44]

Man Ray noted, ''Miró has since used a lot of rope in his compositions, enough rope to hang all his adverse critics, although they would be the last to recognize that it was intended for them.''

The childlike revenge of including in the painting enough rope for critics to hang themselves is reminiscent of the literalism of Jasper Johns' response upon hearing a critic remark that his painting had ''no balls.'' He retaliated by painting a series that included small wooden balls. There is an infantile, primitive level of thinking involved in such a Dada gesture, which at the same time permits the artist to express his aggression creatively by transforming anger into a response in art. This conversion of anger into content, in this case, autobiographical content, is typical of both Johns and Miró, artists whom one would not normally associate with one another. Nevertheless, both have invented a secret language which is part of the enigmatic content of their work. Both have painted subjects dealing with primitive, instinctual responses like fear, anxiety, and anger, acted out directly against the painting itself, which the artist attacks, punctures, lacerates.

In the thirties, Miró regularly incorporated string, twine, and cord into painting-objects. Nowhere does the rope seem such an explicitly autobiographical element, however, as in the two paintings, *Rope and People I* and *Rope and People II*, both painted in

Fig. 34. Joseph Cornell. *The Caliph of Bagdad,* ca. 1950.

March 1935. The shocking image of two menacing, androgynous *personnages* flanking a tiny figure with dangling legs, around whose throat the rope is wrapped, evokes the image of the mock hanging of Miró staged by Eluard and Breton. Another interpretation is offered by William Rubin's catalogue note on the painting.[45] Rubin identifies the figures as a man, a young girl, and a woman. Painted on the eve of the Spanish Civil War, a direct threat to himself, his wife, and their young daughter, the work may be a compression of feelings of fear evoked by two instances in which the artist felt extremely threatened. The attachment of an emotion of the present to a memory of a similar emotion experienced in the past is in keeping with Miró's free-flowing unconscious imagery and commitment to the authentic expression of lived reality. Unlike the Surrealists, Miró never illustrated literary or mythological subjects. His themes were his subjective experiences, which he had the power to transform into universal symbols of emotional states.

Reading Miró's art as a kind of autobiography, elements of his iconography fit together into coherent patterns. Miró's personal crises can be seen as the catalysts which caused him to change his art. Such a reading of his oeuvre reveals, moreover, that Miró's

political and artistic crises often corresponded to similar crises among American artists and provided the link between his work and theirs. This coincidence alone insured him a major role in the development of American art.

Political reality touched Miró early. Sidra Stich has done an excellent reading of the autobiographical character of Miró's art.[46] Recently, Miró has become more explicit regarding the iconography of his art. In an interview with Georges Raillard, he explained that the triptych *L'Espoir du Condamné à Mort (The Hope of the Condemned to Death)* was inspired by the execution of a young Catalan nationalist.[47] It is not exaggerated to say that Miró intends his art to have political content, at least in the sense that Dürer's woodcuts of the Apocalypse, or Bosch's *Haywain,* or Bruegel's *Dulle Griet* have political content. At times, he paints images like the *Reaper,* the *Seated Woman,* or the *Still Life with Old Shoe* that express existential terror and universal pestilence.

Still Life with Old Shoe, painted at the height of the Spanish Civil War, is, like many of Miró's fantastic paintings, a laminated image. This time two genres, landscape and still life, are merged. The result is an eerie and ominous mood. The difference between the mood of the still life and the humble dignity of early kitchen pieces like *The Carbide Lamp* is immediately discernable. The palette of the early works is earthy and restful; objects are outlined with the distinctness and crispness characteristic of the "detailist" style. They are as solid and stable as architecture. In contrast, the unworldly phosphorescent colors of *Still Life with Old Shoe* suggest conflagrations and cataclysm.

The theme of the Apocalypse is suggested by many of the *peintures sauvages* of the late thirties. Lost and stranded *personnages* wander aimlessly in a landscape that suggests mud or quicksand, a shifting ground under a blackened night sky. The use of black as the color of the sky in Miró's works of the late thirties indicates the dark pessimism of the period [fig. 35].

His switch to a lighter ground and the adoption of a new set of motifs beginning in 1940 in the *Constellations,* small gouaches he began to paint in Varengeville in 1940, are evidence that he survived a second "dark night of the soul" and emerged with renewed faith in man's role in the cosmic order. In interviews, Miró has described the anguish of the period during which the *Constellations* were painted, which began when he realized he would have to leave Varengeville, France.

I felt a deep desire to escape. I closed within myself purposely. The night, music and stars began to play a major role in suggesting my paintings. Music had always appealed to me, and now music in this period began to take the role poetry had played in the early twenties . . . especially Bach and Mozart, when I went back to Majorca upon the fall of France.[48]

Miró had already painted ten of the series of twenty-three when he left for Spain. He had arranged for his wife to take their daughter and for him to travel separately, carrying only the first of the *Constellations.* The paintings, finished in Palma and Montroig during the war, while Miró lived in complete isolation and anonymity, are among the most lyrical and poetic of Miró's works, an affirmation of faith and order — the contrapuntal classical order of Bach and Mozart — at the moment of darkest despair.

The exhibition of Miró's *Constellations,* which had been smuggled out of Europe by diplomatic pouch, at Pierre Matisse's Gallery in 1945 caused great excitement in New York. All twenty-two of the gouaches exhibited were sold, and the show was an immense success, especially among artists. Miró's cosmic symbols immediately entered the vocabulary of the New York School and were as likely to turn up in Pollock's works as Gottlieb's.

The *Constellations* presented a radical new interpretation of all-over painting, which was really only fully understood by Pollock. Indeed, it provided Pollock with the key to exploding his own cosmic vision. In the

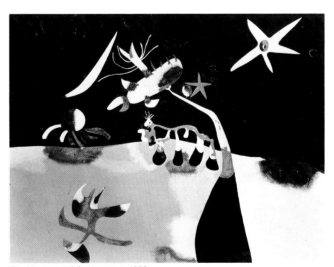

Fig. 35. Joan Miró. *Nocturne,* 1938.

Constellations, Miró's network of lines was intersected by blots of color and suspended in space, floating on a transparent ground. In many respects, including the vastness of the space, indicated by the washes of color, the Constellations helped free Pollock from an image oriented with regard to a fixed viewpoint.

The all-over composition of the Constellations differs from post-Impressionist all-overness in which equal strokes of equal pressure and intensity create a dense surface from edge to edge. The source of Miró's all-overness is not post-Impressionism but his own early "detailist" paintings. Their exaggeration and proliferation of line and equalization of detail create an all-over patterning that Miró recreates in an abstract sense in the Constellations. The variabilility of the linear tracery connecting cosmic symbols and the variable saturation of the background undermine the literal all-overness of post-Impressionism. The Constellations offer a new interpretation of compositional order that inspired Pollock in his "all-over" dripped paintings, which are no more literally "all-over," of course, than Miró's Constellations.

The Constellations symbolize Miró's rebirth of faith after the "dark night" — the black skies and black suns — of the peintures sauvages style of the thirties. The first of the series of twenty-three gouaches, The Ladder for Escape, was painted in 1940 at Varengeville, shortly before Miró left for Spain, where he finished the series.

In the Catalan Notebooks, Miró describes painting the series.

> I remember when I was working on the Constellations in Palma in 1940. In the morning about ten I used to go to the cathedral to listen to the organ. At that time of morning nobody was around, except the organist practicing, and I used to linger a long while. There was the organ music, occasionally singing, and the sunlight reflected through the stained glass windows (fabulous, those windows), and the canons with their red vestments in the dim light.

> Several paintings, including Dancer Listening to the Organ in a Gothic Cathedral and Woman Listening to Music were inspired by these experiences with music and light filtered through stained glass.

As William Rubin has pointed out, the Constellations constitute a specific series related in imagery (sun, stars, birds, lovers), medium (oil and gouache on paper), and size (all 23 are 18 x 15 inches).[49] Prior to the exhibition of the Constellations, no American painter had conceived a set of related works as a series. By 1950, a number of artists, including Rothko, Newman, Motherwell, Still, and Reinhardt were painting serially. By 1960, serial imagery was the standard practice in American art.

VIII. THE DREAM OF THE LARGE STUDIO

- If one is to continue to paint or write as the political trap seems to close upon him he must perhaps have the extremest faith in sheer possibility.

 In his extremism he shows that he has recognized how drastic the political presence is.

 Robert Motherwell and Harold Rosenberg, Possibilities, no. 1, winter 1947-48

- In negating negation, I affirm.

 Joan Miró, interview with George Raillard, Ceci est la Couleur de mes, Rêves, 1977

The war was not yet over when Miró's Constellations arrived, but soon it was, and Miró made the long-awaited trip to New York in 1947. It was a critical year for the New York School. Miró's presence apparently helped catalyze the rapid development toward symbolic abstraction and away from the more literary concerns of the Surrealists-in-exile, who returned to Europe the same year Miró arrived in New York.

Miró and his wife were greeted by Miró's life-long friend, sculptor Alexander Calder, wearing a Catalan beretinna in honor of Miró. The two had enjoyed a warm friendship since Calder first visited Miró's studio in Paris in 1928. The visit changed the course of Calder's art. Almost immediately he began using Miró's abstract biomorphic shapes, abandoning the wire sculpture of his miniature circus. Indeed, Calder's mobiles look like moving Mirós. (At one point Calder owned five of Miró's paintings.) Later when Calder began doing his monumental stabiles, the forms look as if they were cut out of Miró's paintings. The success of these stabiles as public art may have encouraged Miró to work on this gargantuan scale in sculpture.

In 1947-48 when the Mirós were in New York, they frequently visited the Calders in Roxbury, Connecticut. "Sandy and I are like brothers," Miró has said, recalling with affection their long friendship. During Miró's stay in New York, Calder drove him around with Tanguy in a bizarre car. "We created a sensation on Fifth Avenue," Miró recalls.

Pierre Matisse had secured a commission for Miró to paint a 38 1/2-foot-long mural for Cincinnati's Terrace

Plaza Hotel. It was Miró's first big commission, the
realization of his lifelong desire to make public art.
Matisse had rented Carl Holty's garage studio in the
East Nineties for Miró to paint in. Alice Trumbull Mason
had the next-door studio, and her work was certainly
influenced by proximity to Miró. Baziotes met Miró at
this time. He recalled Miró "unveiling the mural in his
studio, watching for the reaction of the onlookers,
walking rapidly and excitedly all over the place, upset
and very nervous."

Miró commuted back and forth on the subway
between the noisy industrial neighborhood uptown and
Stanley William Hayter's Atelier 17 print shop in East
Eighth Street in Greenwich Village. There, Miró
produced three etchings for Brunidor Editions. The
director of the press, John Bernard Myers, an editor of
the New York Surrealist magazine *View*, recalls that
Miró was very consistent and business-like in his attire
and work habits, which surprised American artists who
came in contact with him.[50]

The artist whose work was most affected by Miró's
presence at Atelier 17 was Anne Ryan [fig. 36], who in
1948 began making delicate collages reflecting Miró's
concepts of space and design. Anne Ryan spoke
Spanish and could converse with Miró. This was not
true of Jackson Pollock, whom Miró also met at
Hayter's workshop. In 1942, Pollock had worked
steadily for some months learning intaglio printing
processes from Hayter, and he apparently continued to
drop in from time to time. "We could not do much
more than smile at each other," Miró recalls, "since we
had no common language."[51] Later, Miró was
impressed by Pollock's 1951 exhibition of black and
white paintings in Paris.

The artist Miró saw most frequently in New York was
Duchamp, with whom he lunched regularly at the
Lafayette Restaurant, a mediocre French bistro near
Hayter's workshop. Sometimes they were joined by the
Surrealist poet, Nicolas Calas.[52] Miró had a warm
personal relationship with Duchamp. Artistically,
however, Miró was constantly answering Duchamp's
aesthetic questions positively and humanistically,
whereas Duchamp remained the negative pessimist. In
Paris, Miró had expressed his fighting spirit by boxing
with Hemingway. In New York, he shadow-boxed with
Duchamp, countering with a new way of painting that
was alive every time Duchamp proclaimed painting
dead.

This ongoing dialogue with Duchamp can be traced
back to Paris in the twenties when Miró responded to

Fig. 36. Anne Ryan. *#245*, ca. 1948-54.

the modern progressive idea of Duchamp's *"eau et gaz
à tous les stages,"* (plumbing and light on all floors,) by
putting a railroad sign in his studio announcing *"train
passant sans arrêt,"* (train passing without stopping.)
Electricity and plumbing, the gadgetry of modern life,
so impressed Duchamp that he reacted by rejecting
painting as old-fashioned. Modern life held no mystery
for Miró, who was involved with a sense of continuity
rooted in the medieval past that took the longest view
of history possible, identifying art with the magical
practices of cavemen instead of with the mechanical
reproductions of the modern age.

One has the sense that Duchamp was no more
genuinely impressed with the idea of progress than
Miró, but as an urban intellectual, he was its victim.
Miró, on the other hand, managed to keep himself
intact by maintaining his roots in Montroig, where
nothing changed. "Montroig is my religion," he has
said recently. This religion constantly fed Miró's
imagination.

Duchamp was certainly on Miró's mind in the mid-
thirties when he began using found objects in his art,
incorporating photographs in constructions and
collages. However, in all of Miró's works, the element
of transformation trancends the objectness of the
found item or image, which is but the point of
departure of the artist's fantasy.

Miró's transformation of all kinds of visual
information into his own personal imagery was

extended to machinery as well. Like the other artists of his generation, he was fascinated by the advertisements for machinery that appeared in mail-order catalogues. However, instead of glorifying the machine, he transformed and humanized it, as Oldenburg later turned the world into soft machines. According to Zervos, newspaper advertisements which he collaged together provided the inspiration for the forms in the large *Compositions* of 1933. Earlier, he had turned a machine called the *Queen Louise of Prussia* into a *personnage* with the same name, whose voluptuous curves look anything but mechanical.

The original collages inspiring the 1933 *Compositions* were published by Sweeney in his catalogue; so we know that they were the original provocation. The resulting imagery, however, has predominately horned shapes that suggest associations with the *corrida* or Minoan altars, rather than with machines. One sees an echo of these primitive horned shapes in the work of geometric artist Myron Stout. The biomorphism of the large 1933 paintings is particularly clear. Shapes are distinctly silhouetted, although the penetration of figure by ground when a solid shape suddenly is presented as transparent, creates a different spatial effect from that of Matisse's cut-outs. Matisse is a more direct inspiration for Ellsworth Kelly's hard-edge abstraction than Miró; however, one cannot rule out the impression Miró's biomorphism and, more important, his sense of large scale, had on Kelly.

In Miró's large-scale works like the 1933 *Compositions,* the idea of the decorative undergoes a transformation that had repercussions for American art. Both Miró and Matisse were fascinated with Islamic and Romanesque art. However, for Miró, these traditions were indigenous; consequently, his art was closer to the original spirit. Miró's daily contact with Mozarabic architectural decoration, in which pattern is three-dimensional and sculptural, not flat like ceramic decoration, inspired his twirling and winding forms, which do not give in to the inevitable flatness and graphic quality of the decorative styles, but remain distinct and vibrant. The use of pattern in Catalan retables, which contrast differing brocades and draperies against one another, is another source for a decorative style based not on the overall repetition of pattern, but on the clash and contrast of pattern, which is often embossed in relief. Because his sources of decorative imagery are in relief, Miró's mural art rarely flattens out in the manner of abstract pattern derived from graphic sources.

Matisse's sources of Islamic art are Persian miniatures and ceramics, whereas Miró's source is the Arabic fantasy element in Catalan medieval art. It is fascinating, however, that both Miró and Matisse were inspired to paint some of their most radical early works, in both cases the earliest color-field paintings, by the same source: the Apocalypse manuscripts transcribed by the Spanish monk, Beatus of Liebena, and illustrated by a number of different illuminators. Because of the primitiveness of Romanesque drawing, its flattened spatial conventions are close to those of modern painting. As in modern painting, the figure is inserted into the background rather than standing out in front of it. Both Miró and Matisse were interested in the directness of the outline drawing in Romanesque paintings, as well as the way in which color was zoned into abstract bands that divided the surface without the creation of receding planes. In his interpretation of the Beatus manuscripts, Matisse kept the zoned format and imitated the simplified drawing style, but employed a palette of colors found in nature. Miró, on the other hand, responded to the literal eschatological content of the vision of the Apocalypse, fragments of which constantly reappear in his work.

Zoned color is used by Miró throughout the twenties. We have seen that in watercolors and drawings of the early forties, both Rothko and Newman had begun to zone color. Miró's radically reduced paintings of the late twenties are perhaps an even more important source for the use of two or three contrasting colors in large areas than Matisse's paintings, popularly considered the source of color-field painting. Miró's paintings divide the landscape into three zones of sky, land, and sea, which are sometimes compressed into the more condensed duality of heaven and earth. Miró's earthy palette is closer to the deep, resonant palette adopted by Rothko, Newman, Gottlieb, and Still in their color-field paintings of the fifties.

More to the point, perhaps, is the indeterminacy of space Miró created by changing the saturation of paint into canvas and sometimes changing the color of the ground itself, modulating tone into tone. The curious radiance Miró produced by technical procedures — varying the pressure of the brush, rubbing colors in with rags, painting wet into wet, and mixing media — caused his fields to tremble and vibrate with luminous variation. By contrast, the relative flatness and finite compression of Matisse's space remain essentially Cubist. The atmospheric and ambiguous space Miró creates alludes to an immeasureable infinity ultimately

more relevant to the Transcendental aspirations of American artists. His contribution to the development of large-scale color-field painting in America can hardly be overestimated.

The inclusion in the 1941 Museum of Modern Art retrospective of four of Miró's large 1933 *Compositions,* including one over six feet wide, helped persuade American avant-garde artists to pursue monumental art.

Prior to the exhibition of Miró's large paintings of 1933, the art of the Mexican mural painters and Picasso's *Guernica* had been the models of the "big picture." However, both Picasso and the Mexicans were involved with propagandistic statements which the New York avant-garde disdained. As early as the Artists Union meetings, discussions were already centering on the idea of art as timeless and universal, free of any specific or topical historical reference that would limit its capacity to transcend the anecdotal or sentimental.

Miró's text, "I Dream of a Large Studio," was first published in English in 1938. However, the fact that in 1947 Miró worked in New York on an immense wall-size painting in an industrial space must have contributed to the urge of New York painters to work in big commercial spaces rather than in conventional studios.

All of the idealist modern movements from Russian Constructivism to de Stijl to Purism to the Bauhaus have dreamed of a reintegration of the arts within a social context, as they were last integrated in the anonymous craft guilds of the Middle Ages. This Utopian dream, now surely never to be realized in our time, was revived in America during the thirties when the W.P.A. supported crafts and commissioned wall paintings as public art. For the advanced modernist artists on the W.P.A., or more precisely those who became modernists when they matured, the idea of wall painting, public murals, was still alive, as was the idea that painting and sculpture and architecture could once more be united. The fight against cultural fragmentation was one of the main battles Miró fought in associating himself with craftsmen and working in craft media. Many of the Abstract Expressionists were interested in collaborating with architects: Pollock discussed a "museum without walls" to house his paintings with Peter Blake, Newman designed a synagogue, Reinhardt left designs for a meditation museum for his black paintings, and Rothko actually was commissioned to decorate the chapel designed by Philip Johnson for Mr. and Mrs. John de Menil.

The year 1947, when Miró arrived in New York, was a turning point for the New York School. It is difficult to say how much Miró's presence contributed to the adoption of a rationale for defining "subject matter" as a limited number of hermetic symbols related to ideograms and pictographs. Miró's views on the limitations of easel painting as a bourgeois commodity fetish must have lent additional impetus to the evolution of the "big picture" developed in the late forties by Pollock, Still, Newman, and Rothko.

For American artists, Miró had become the symbol of the resistance of the Spanish Republic against Fascism. Writing in *Partisan Review* in 1938, George L. K. Morris observed that Miró was better able to express the Spanish cause than Picasso because his feelings were more authentic and less calloused as an individual. Clement Greenberg later came to the same conclusion.[53]

In Miró's synthesis of form with psychological content, American artists found the model for the resolution of their own dilemma of dealing with "subject matter," i.e., psychological and symbolic content, in the context of a non-objective art. Miró's technical experiments with media and materials provided them with an example of risk-taking they could emulate. Miró's determination to go beyond easel painting, his mediation between accident and control, and his insistence on "direct" painting and the personal, even bodily, involvement of the artist with his art, coinciding with the total existential *engagement* to which they themselves were committed, seemed exemplary to American artists seeking a way out of the Cubist *cul-de-sac.*

Gorky denounced social realism as "poor art for poor people" and painted a series of abstract murals for the W.P.A. at the Newark airport. The public and the press were not ready for Gorky's transformation of airplane parts into humanoid forms with soft bulging contours, and there was a great deal of outrage regarding the murals. Although Gorky was indebted to Léger for the basic conception and theme of aviation, the metamorphic quality of the imagery and the idea of "the evolution of forms in aerodynamics," which was Gorky's title for the whole series, reveal a debt to Miró and his transformation of object into free-form image.

Pollock, too, was struggling to reconcile his sense of morality with his sense of artistic integrity. He painted some American Scene genre pictures while working on the W.P.A., but at the same time he experimented with a Picassoid style, especially in his drawings, which free-

associated images taken from different cultures in an attempt to synthesize a universal statement. Miró's influence on Pollock in 1941-44 and again in 1947-48 was brief but liberating: it helped him achieve his goal of integrating a volatile angry spirit of protest and revolt with a disciplined attitude toward control and accident.

Miró's example of converting political protest into a public art, which presumably addressed itself directly to the people, gave great impetus to the evolution of the "big picture" containing concealed symbolic motifs of protest and rebellion, as Miró so frequently camouflaged the tiny Catalan flags in his works. His unwillingness to permit himself to be used as a front for political agitators demanding a "Surrealism in the service of the Revolution," which he publicly refused to join, combined with his position as a man of the Left impressed the New York avant-garde, already vigorously anti-Stalinist in the thirties.

Comparing Picasso's "morass of mannerism" with Miró's spirituality, Morris concluded that Miró "has been able to put on canvas in a much more satisfying way his reactions to the war. This might have been foreseen, for his is less the intellectual constructor, more the commentator upon his inward vision. Above all, his interpretations are unmannered. There is none of the aggressive showmanship with which Picasso is accustomed to startle and insult his audiences, before subduing them with an unapproachable grandeur of style."

For Motherwell, the cause of the Spanish Republic symbolized the tragedy of democracy overthrown by dictatorship. From the beginning of his series of *Elegies to the Spanish Republic,* Miró's inspiration is felt, especially in his use of black and the use of controlled accident. Motherwell's enthusiasm for Miró has never waned [fig. 37]. Indeed, it has recently begun to reassert itself. Throughout his career, from his collages of the early forties to his current monumental color-field paintings, one feels Motherwell's debt to Miró, which the artist himself has been the first to admit.

Greenberg was suspicious of Miró's ambition to go beyond easel painting. Miró had written that the aim of easel painting was "a paltry one," and that he intended "to come closer by means of my painting to the mass of men, about whom I have never stopped thinking."[54] For Greenberg, "to go beyond easel painting — especially in order to come to the masses . . . means to go toward the mural. And not to arrive at the mural means to fall between two stools, a

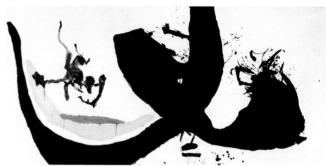

Fig. 37. Robert Motherwell. *Black on White,* 1961.

situation whose appropriate genre is the decorative panel."[55]

While Greenberg lamented "the crisis of the easel picture" that mural-size canvases announced, the artists of the New York School saw in Miró's ideas about public art a means of communicating directly with the masses the solution to their own problems of conscience. Disenchanted with the Left, but horrified by the hysterical anti-Communism of the Right, the New York School was left with no tenable political position. At the same time, moral commitment demanded some social statement. That statement became the "big picture," the mural-scale painting intended for collective public viewing. In arriving at this solution, New York artists drew heavily on Miró's experience.

During Miró's stay in New York, Clement Greenberg met him. He described the encounter in his book on Miró.

> Those who had the opportunity to meet Miró while he was here saw a short, compact, rather dapper man in a dark blue business suit. He has a neat round head with closely trimmed dark hair, pale skin, small, regular features, quick eyes and movements. He is slightly nervous and at the same time impersonal in the company of strangers, and his conversation and manner are non-committal to an extreme. One asked oneself what could have brought this bourgeois to modern painting, the Left Bank and Surrealism.[56]

Greenberg apparently became interested in writing a monograph on Miró as a result of Pollock's enthusiasm for the Catalan painter. While Greenberg was out in East Hampton visiting them, Lee Krasner and Jackson Pollock took him to see Miró's paintings in the collection of Jesse Helms, who lived nearby. (The paintings are reproduced in Greenberg's monograph.) By this time, Krasner had become less involved with

Mondrian and more enthusiastic about Miró, and Pollock's admiration had, if anything, increased.

IX. MIRÓ RETURNS TO NEW YORK

In 1959, Miró returned to America for his second retrospective at The Museum of Modern Art. Eighteen years had passed since his last big New York show, and much had changed, including the aesthetic of the New York School. The success of the "big picture" had given Americans their own heroes. Nevertheless, they continued to look at Miró's art and to learn from it.

There is good reason to think that Miró's 1959 retrospective initiated the first phase of "post-painterly abstraction" — commonly referred to as "stain painting" on the part of artists like Frankenthaler, Noland, Olitski, Dzubas. Frankenthaler [fig. 38], the *chef d' école,* had been looking at Miró's paintings since 1951, when she began painting abstract landscapes, staining color directly into the unprimed canvas. Her initial inspiration was Pollock's black and white paintings. However, the spurting images, the hands, and ladders in her works of the late fifties recall Miró. A painting of the seventies recalls the outlines of Miró's *Portrait of Mistress Mills in 1750.* Frankenthaler's

reaction to hard-edge painting was similar to Miró's reaction to Cubism: she humanized the form, making it organic and natural.

The official rationale for stained painting was that it reconciled illusionism with flatness by emphasizing the literal, i.e., woven cloth, character of the support by merging color with surface. Miró had called attention to the literal physical character of the support source in the field paintings of the late twenties, in which he rubbed color so thoroughly into the canvas that the weave showed through in spots. The variegation of the texture and color of the ground created more spatial effects.

In 1959, Miró apparently began to look at the impact of his work on American art and to be fed back in return, gaining confidence to return to his most radically minimal monochrome field paintings and to enlarge a single ideogram to fill a whole field, as Kline and Motherwell did. The turning of Motherwell and Liberman in their most recent work to Miró for inspiration indicates what a rich source of technical and formal ideas Miró remains.

On his second trip to New York Miró stated that the pressing cultural problem was the preservation of artisanship. He saw the disappearance of craft in

Fig. 38. Helen Frankenthaler. *Blue Rail,* 1969.

Fig. 39. Richard Hennessy. *Korea,* 1981.

Fig. 40. Dan Christensen. *Sha Sha Stomp,* 1981.

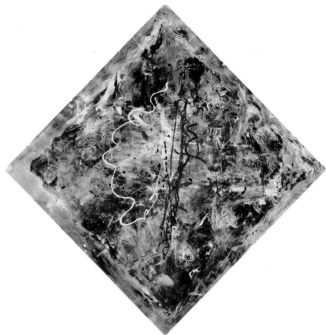

Fig. 41. Darryl Hughto. *Knots,* 1974.

America as disheartening. He might be pleased to see the ceramic Renaissance in California inspired by his own ceramic sculptures and the return to the handmade in all areas of art. Miró's life and art are a critique of false progress as much as they are a symbol of the continuity of *homo faber* and his works with a collective past, which Miró has never ceased believing will be the future as well. Indeed, one of the most positive factors in contemporary American culture is the number of American artists, including Richard Hennessy [fig. 39], Ron Davis, Peter Alexander, Dan Christensen [fig. 40], Darryl Hughto [fig. 41], Pat Adams [fig. 42], and Ray Parker, who are looking at Miró's art for inspiration.

Margit Rowell first noted that Miró's field paintings of the sixties and seventies represent his reaction to the American interpretation of his own "magnetic field" paintings of the twenties. Since Barnett Newman's large horizontal, color-field paintings were on view at French & Co. in 1959, Miró probably saw the show, which was reviewed at the same time as his own retrospective.

There is, however, a considerable difference between Miró's interpretation of the field and that of American color-field painters. Miró always includes scale elements and some kind of metaphorical allusion. He never

changed his mind regarding the necessity of "subject matter," whereas by 1960, most important American art was thoroughly non-allusive and abstract. Miró found this an alarming development. In an interview with Edouard Roditi in *Arts,* October 1958, Miró complained:

> Art has closed and sealed too many doors in recent years. Now nobody has the courage to open any of them again. Most artists are afraid, if they should ever revert to figurative work, for instance, of being accused of having become reactionaries. Modern art progresses along an increasingly narrow path.

As for Miró, he was ready to broaden the path in sculpture, ceramics, tapestries, and public works.

X. TRAIN PASSING WITHOUT STOPPING

* What counts is not one's work, but the trajectory of the mind over the whole of one's life, not what a man has done in the course of his life, but what it gives an inkling of and what it will enable others to do at some more or less distant time to come.

 Joan Miró, *Catalan Notebooks*

In the sixties, Miró's influence as a metaphysical artist waned, as did that of all symbolic or metaphysical art. Miró's characteristic imagery was caricatured by Oldenburg and Lichtenstein, who like Miró, homogenized all objects in their own styles. In the early sixties, a few artists like Larry Poons, whose "dot" paintings are related to both Mondrian's plus and minus series and Miró's field paintings and *Constellations,* and Jules Olitski maintained an interest in luminous, atmospheric color volumes; but by the end of the decade, they, too, had become so involved with the material aspect of the work of art that surface, not space, became the primary concern. Of the younger New York School artists, only Dzubas and Frankenthaler remained involved with allusion, fanciful imagery, and light as metaphors of transcendental illumination. For many American artists in the sixties, the artificial light of neon and dazzle replaced the natural light of the sun and sky. Today, that tendency is reversing itself as Miró's paintings are once more being experienced as a way out of a *cul-de-sac.*

Like Spaniards, Americans frequently manifest a taste for an extremely literal realism. Miró has commented on the link between Gaudí, who cast real objects as part of his architecture, and George Segal's plaster casts. The popularity in America of *trompe l'oeil* painting around the turn of the century, Magic Realism in the thirties, and Photo Realism in the seventies is an expression of this taste. Miró's hyper-realism of the detailist period, however, is neither based on photography, like the various *trompe l'oeil* styles, nor involved with bizarre juxtapositions. Unlike the other Surrealists, who were influenced by film editing, Miró does not create strangeness by juxtaposing unlikely images, with the exception of his few Dada constructions of the thirties. Instead of collaging fragments in imitation of cinematic montage, he creates an entire world that is unreal but within its own context, entirely consistent.

The two other artists who have fashioned similar parallel universes are Dubuffet and Oldenburg, who were both influenced by Miró's capacity to homogenize landscape, figure, still life, and architecture into a single physical consistency. In all three artists, there is a certain element of caricature, but it is caricature in the grand manner, a kind of medieval carnival of masked and costumed actors. Coincidentally, Miró, Dubuffet, and Oldenburg considered themselves as public artists, and all three were involved with the popular spectacle of theater.

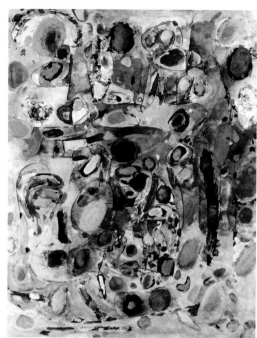

Fig. 42. Pat Adams. *Sequence to Illogic,* 1955.

Beginning with the decor of *Romeo and Juliet* in 1928, which he designed with Max Ernst, Miró has done a number of sets and costumes for ballet. In the work of Dubuffet and Oldenburg, the theatrical element is obvious. Theatricality plays an equal role in Miró's art at certain points, particularly in the *peintures sauvages* and *personnage* paintings. In the persistant reuse of stock characters — *femme, oiseau, personnage,* etc. — in stock situations — love, conflict, or isolation — he draws on the popular tradition of the zarzuela, provincial Spanish operettas which are like the commedia dell'arte or guignol in their use of stock characters, such as the village idiot and the village gossip. Whenever one of Miró's toothless crones or hybridized misfits appears, there is the pleasure of familiarity one has in recognizing Punch and Judy.

Miró's deliberate limitation of his cast of symbolic characters lends continuity and coherence to his work that Picasso's rapid shifts from moment to moment lack. In other words, the continuity in Picasso's oeuvre is Picasso's ego; the continuity in Miró's art is his pantheistic, anti-industrial, anti-urban world view, which meshed with a strong tendency among American artists to view progress pessimistically.

Both sides of Miró's character are expressed in his work. The avant-garde aspect led him in the direction

of Dada objects, collages, constructions, mixed media, and ballet decor; his modernism, on the other hand, kept him securely anchored to the physical properties of the craft of painting. Both sides of Miró were appreciated by American artists, although not necessarily by the same artists. However, versatility and willingness to experiment help to explain the breadth of Miró's appeal in the United States.

When Georges Raillard visited Miró's studio to tape the interviews published in 1977 under the title *Ceci est la Couleur de mes Rêves,* he found two books in Miró's studio. One was on Van Gogh and the other on Duchamp. When he queried Miró on why they were there, Miró answered it was a matter of chance. The longer one studies Miró's works, the more convinced one is that very little in the life of Joan Miró is a matter of chance. It is more likely that the evolution of his art has taken place between these two poles of modernism: Van Gogh's humane expressionist color painting and Duchamp's ascetic, dry intellectual irony.

Miró permitted, even encouraged, critics to cast him as a primitive painter. That is because he wished to be free to pursue complex philosophical problems on his own.

Most of the ideas held about Miró's intentions and the significance of his art were wrong; one has a sense that for many years Miró was amused by how wrong. Now, it seems he is more anxious to set the record straight, providing information regarding the iconography of key works and granting interviews as detailed as Raillard's recorded conversations, as well as publishing his own notes and drawings in the *Catalan Notebooks.* Moreover, he has given to the Fundació Miró, which he established not as a personal museum, but as a center for living art, all his notes and preliminary drawings so that scholars may reconstruct his thought processes. They are, it turns out, extremely complicated and hardly the work of an anti-intellectual. They show Miró engaged in a constant process of self-criticism, symbolized in the minute auto-investigation completed in his x-ray-like *Self-Portrait,* the extended analysis of his conscience completed just before beginning the cathartic *Constellations.*

Two recent exhibition catalogues have brought us closer to the actual quality of Miró's mind: *Magnetic Fields* by Rosalind E. Krauss and Margit Rowell and *Joan Miró: The Development of a Sign Language* by Sidra Stich. Both are convincing cases for the deliberate, systematic manner in which Miró created an art that had the look of the primitive but was essentially as sophisticated as the highest level of thinking and writing of his time. The symbolic language

Fig. 43. Joan Miró. Sketch: *Personnage avec un oiseau,* 1944.

Fig. 44. Joan Miró. Sketch for *Personnage et Oiseaux,* n. d.

Miró developed to express poetic content and a world view based on the superiority of archaic agricultural societies is a complete syntax of imagery based originally, like all pictographic writing, on real objects. The transformation of object into sign is among the major intellectual feats of twentieth-century art history and one of the few successful attempts by an artist to keep pace with developments in philosophy. The relationship of consciousness to self-consciousness in Miró's art thus becomes critical.

Miró does not make preparatory drawings for paintings. Neither does he "doodle" on his paintings. He saves memories, notes, clippings, photographs, which are ultimately amalgamated into a single synthetic image, rich in meaning and dense with associations. In Barcelona, at the Fundació Miró, a beautiful, light-filled building designed by Miró's friend, José Luis Sert, I found many drawings of the *Personnage et Oiseaux* [fig. 43, 44, 45] that are assimilated into the culminating incarnation of the image in the towering public sculpture unveiled in Houston on Miró's eighty-ninth birthday on April 20, 1982.

The continuity of Miró's life and thought are symbolized by the Fundació, where Miró's art, symbolically embraced by the works of his two lifelong friends, the Catalan-American architect Sert and the American sculptor Calder, remains as his gift to future generations. Unlike Picasso, who left his heirs to squabble over his legacy, Miró has already given his entire personal collection and archives to the Fundació.

One cannot imagine what Miró's influence will be on the art of Catalonia and Spain, where modern art was suppressed for so many years by Franco. Today King Juan Carlos frequently visits Miró in Palma and has awarded him the highest honor Spain has for its artists. Miró considers Juan Carlos a friend, but, he emphasizes, "we remain Republicans of course."[57]

Throughout his life Miró has remained true to his roots. In many respects *La Sagrada Familia,* Gaudí's unfinished fantasy cathedral, symbolizes the continuity of Catalan culture, which Miró has never wanted to exchange for anything more contemporary. Indeed Miró's salvation was his refusal to become a modern person. Like Medieval man, Miró has experienced the collective work of a single cathedral, still unfinished, continuing to be built despite the ravages of time and history throughout his entire lifetime. The paradox of his deep conservatism and extreme artistic radicalism contributes to the richness and tension of Miró's art. At

Fig. 45. Joan Miró. Sketch for *Personnage et Oiseaux*, n. d.

eighty-nine Miró continues to fight for the same cause he has devoted his life to, that of Catalan nationalism. Unlike American artists, who can attach themselves to no political or cultural ideal, Miró has seen his own country liberated from dictatorship and the Catalan language and literature restored to legitimacy. The serenity of his late works reflects a life of idealistic purpose fulfilled.

If one senses in Miró a stubbornness that at times appears excessively single-minded, a closed system of images within a well-defined set of parameters, one may attribute the intensity of his focus on a limited number of themes to his sense of mission as a carrier of an ancient but besieged culture. Free of the usual artist's narcissism, there is, nevertheless, a sense of the messianic about Miró and his art. He shared this messianic complex with the artists of the New York School, who felt responsible, as survivors of a holocaust that decimated European culture, to revive the art of the West after the war.

It is already obvious that Miró's contribution to American art has been far greater than the wealth of phantasmagoric imagery he created.[58] His cast of mocking, puppet-like *personnages* caused many to interpret his art as humorous, although he himself has said he believes it is fundamentally tragic. We understand Miró's world view better if we see it in the context of a certain Spanish pessimism, which the philosopher Miguel de Unamuno described as the *sentimiento tragico de la vida,* "the tragic sense of life," with which the Spanish people are burdened.

In his stoic treatment of dark themes as facts of life to be accepted along with the sunlight and joy, Miró's

art has a completeness that is rare. In our fragmented time Miró's courage, his universality, his active combat, not only with totalitarian attempts to quell freedom of expression, but also with the debasement and demoralization of art in any form, has been and continues to be a shining example of the battle still being fought of faith against despair, belief against nihilism. Miró's opposition to all that would make the function of art less than it has been in culturally integrated societies continues to inspire a new generation of American artists, who work with renewed conviction in the redemptive role of art and continue to look to Miró as an example of an artist who has maintained the original spirit of protest which once defined the ethos of modernism.

NOTES

1. Melvin P. Lader, "Howard Putzel: Proponent of Surrealism and Early Abstract Expressionism in America," *Arts Magazine* 56 (March 1982): 85-96.
2. Ibid., p. 94.
3. James Johnson Sweeney, *Joan Miró* (New York: The Museum of Modern Art, 1941), p. 28.
4. *Miró/Calder* (Basel: Galerie Beyeler, 1972), p. [37]
5. See Leo Marx, *The Machine in the Garden, Technology and the Pastoral Ideal in America* (New York: Oxford University Press, 1964) for a discussion of anti-industrial sentiment in American culture.
6. Both Miró and O'Keeffe have insisted they paint what they see. Since both are visionary artists as well as literalists, "seeing" takes on, at times, a hallucinatory dimension. Miró has claimed, "I have done nothing else than elaborate what I saw day after day in my environment. . . Since this environment has remained the same ever since my youth, nothing much has changed in my pictures." (Walter Erben, *Joan Miró* [New York: Braziller, 1959], p. 51). Throughout his life, Miró has collected objects with special significance for him: pieces of Balearic folk art or natural objects. (Coincidentally, both O'Keeffe and Miró have collected boxes and stones.)
7. Pierre Schneider, "At the Louvre with Miró," *Encounter* 24 (March 1965): 44.
8. David M. Guss, ed., *The Selected Poetry of Vicente Huidobro* (New York: New Directions, 1981), p. 4.
9. Ibid., p. xviii.
10. *Miró/Calder*, p. [35]
11. Miró, "I Dream of a Large Studio," in *Miró* (New York: Pierre Matisse Gallery, 1938).
12. "Miró, Leader of Surrealists, Has Exhibit," *Art Digest* 9 (February 1, 1935): 11.
13. William A. Camfield, *Francis Picabia: His Art, Life, and Times* (Princeton: Princeton University Press, 1979), p. 113.
14. Joan Miró, *Ceci est la Couleur de mes Rêves*, interview with Georges Raillard (Paris: Seuil, 1977), p. 68.
15. Joan Miró, "Un Grand Prince de l'Esprit," *Vingtième Siècle*, no. 27 (1966), pp. 89-90.
16. Miró, *Ceci*, p. 65.
17. Ibid., p. 23.
18. Vicente Huidobro, "Joan Miró," *Cahiers d'Art* 9 (1934): 42.
19. Leo Steinberg, *Other Criteria: Confrontations with Twentieth-Century Art (New York: Oxford University Press, 1972), p. 85.*
20. *Miró/Calder*, p. [1]
21. Sidra Stich, *Joan Miró: The Development of a Sign Language* (St. Louis: Washington University Gallery of Art, 1980) is an exceptionally lucid and coherent explication of Miró's iconography, stressing the importance of prehistoric sources for his art.
22. Barnett Newman, "Jackson Pollock: An Artists' Symposium, Part 1," *Art News* 66 (April 1967): 29.
23. Sweeney, op. cit., p. 14.
24. Krasner to the author.
25. Bolotowsky to the author, February 1981.
26. Motherwell to the author.
27. The anti-Stalinist position of the New York avant-garde in the thirties is clearly articulated in interviews contained in the film *Art/Work/USA: American Art in the Thirties* (documentary film by the author).
28. Krasner to the author.
29.
30. The flaming heart is a central symbol in the poetry of St. John of the Cross, which Miró read and admired. St. John of the Cross (San Juan de la Cruz) was the first monk to join a barefoot order. In Miró's art, the bare foot alludes to the peasant's rootedness in the earth.
31. Dürer was the first artist known to have painted a portrait of himself as Christ. Many examples of artists portraying themselves in messianic roles have been recorded.
32. Miró, *Ceci*, p. 148.
33. Sidney Tillim, "Miró: 'Let anonymity. . . claim the man,'" *Progressive Architecture* 41 (January 1960): 180.
34. Julius Meier-Graefe, *The Spanish Journey*, translated by J. Holroyd-Reece (New York: Harcourt, Brace, 1927), pp. 298-301.
35. Meier-Graefe speaks of the frightening, nightmarish effect the grotesques of Güell Park might have upon children.
36. Thomas B. Hess, *Willem de Kooning* (New York: The Museum of Modern Art, 1968), p. 15.
37. Clement Greenberg, "Art," *The Nation* 160 (March 24, 1945): 343.
38. Miró, *Ceci*, p. 121. In a handwritten note in the archives of the Fundació Miró, Miró has written, "Am a colorist, but hopeless at form. I can't tell a curve from a straight line. I only achieve a real sense of form by drawing from the sensation of touching something with my eyes shut."
39. Marcel Duchamp, "Joan Miró," in *Collection of the Société Anonyme: Museum of Modern Art, 1920* (New Haven: Yale University Art Gallery, 1950), p. 108; Clement Greenberg, *Joan Miró* (New York: Quadrangle Books, 1948), p. 35.
40. Robert Rosenblum, *Rothko's Surrealist Years* (New York: Pace Gallery, 1981), p. 7.
41. Robert Motherwell, "The Significance of Miró," *Art News* 58 (May 1959): 65.
42. *Miró/Calder*, p. [3]
43. Francis V. O'Connor and Eugene V. Thaw, eds., *Jackson Pollock: A Catalogue Raisonné of Paintings, Drawings, and Other Works* (New Haven: Yale University Press, 1978), v. 4, p. 262.

44. Man Ray, "Juan Gris, Joan Miró, Pablo Picasso," in *Picasso, Gris, Miró: The Spanish Masters of Twentieth Century Painting* (San Francisco: San Francisco Museum of Art, 1948), p. 44.

45. William Rubin, *Miró in the Collection of The Museum of Modern Art* (New York: The Museum of Modern Art, 1973), p. 68.

46. Stich, op. cit.

47. Miró, *Ceci,* p. 45.

48. *The Ladder of Escape* (1939) preceded the *Constellations* and announces its iconography: the ascension from worldly sorrow to the musical harmony of cosmic consciousness.

49. Rubin, op. cit., p. 81.

50. John Bernard Myers to the author. Miró made four etchings in 1947 at Atelier 17 in New York.

51. Miró to the author, Barcelona, June 1981.

52. John Bernard Myers to the author.

53. Clement Greenberg, "Art," *The Nation* 158 (May 20, 1944): 604.

54. Miró, "I Dream of a Large Studio."

55. Greenberg, *Miró,* p. 44.

56. Ibid., p. 38.

57. Miró to the author.

58. Of the New York School artists, only Pousette-Dart and Reinhardt seem to have been entirely untouched by Miró's influence. Pousette-Dart developed a metaphysical style based on pointillism which created a compact space and encrusted surface at odds with color-field painting. Reinhardt, on the other hand, was against any kind of figuration or symbolic art because he saw such elements as diluting the purity of art. As far as the others were concerned, however, the presence of Miró in America was decisive for the future of their art.

Previous page: Joan Miró in New York.

Overleaf: Joan Miró in his studio.

MIRÓ SEEN BY HIS AMERICAN CRITICS

Joan Miró's art has been the subject of American review and criticism since the second decade of this century. From the first, his work was widely discussed and almost consistently well-received, at least by the cognoscenti. The changing perceptions of Miró's work reflect the complexity and richness of his oeuvre, which Hilton Kramer has described as both, "a vision which places itself beyond the reach of a criticism which can deal with art only in terms of its formal structure," and an art that, "challenges contemporary notions in the role of 'literature' in painting."[1] A survey of the written response to Miró's work reveals the shifting concerns and emphases in the American aesthetic consciousness.

As early as 1926, Miró's work appeared in the New York based *Little Review,* one of the few magazines which discussed both American and European avant-garde art. Both of the works reproduced in the article were important pictures which later joined American collections: *The Hunter* (1925-26) [fig. 46] and *The Tilled Field.*[2] The *Little Review* text by Miró's friend, poet-ethnologist Michel Leiris, while vividly imparting the Surrealist and poetic qualities intrinsic to Miró's work, must have left its readers more baffled than edified.

A finger, an eyelash, a sexual organ shaped like a spider, a sinuous line or the echo of a glance, the flax of thought, the warm savannas of a damp-contoured

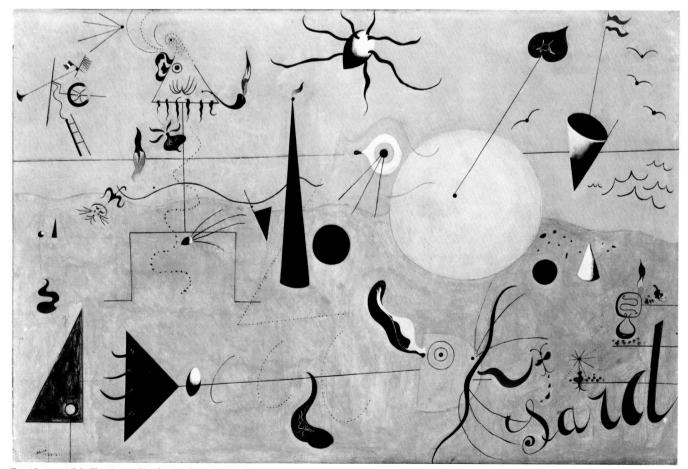

Fig. 46. Joan Miró. *The Hunter (Catalan Landscape),* 1923-24.

mouth, animals or vegetables at nurse, composite monsters with newspapers for limbs, trees which bear eyes, crevices in the stone where insects swarm, bark, eaten with mildew in an infinite variety of patterns and colors, numbers and letters from a copybook, persons reduced to a moustache, the sharp point of a breast, a pipe's glow or perhaps the ashes of a cigar: in this country of surprising candor the horns of the moon are a snail's horns and extravagant tubercules sprout in the meteoric sky.[3]

The first American critic to really appreciate and enthusiastically champion Miró's work was Henry McBride (1867-1962). One of the most widely read and highly esteemed art journalists of his time, McBride wrote for The New York Sun, the monthly social and political magazine The Dial (1920-29), served as editor of Creative Art (1930-32), and later contributed regularly to Art News (1950-55). McBride, a consistent supporter of modernism, championed Miró's work before it was widely seen in this country.

In December 1928, the critic recounted how by winter 1927, word about Miró's work had reached America with such "insistence" that McBride made a special trip to Paris during the summer of 1928 to see the artist's work. McBride was immediately struck by the Miró paintings he saw at The Galerie Pierre in Paris. He prophetically singled out Dog Barking at the Moon [fig. 47], one of the first Miró paintings to be seen widely by the American public and to capture its attention. McBride tried to convey to his readers the emblematic power of Miró's uncomplicated forms, whose simplicity he compared to "stylized toy animals," stating that Miró's symbols had "the power of something genuinely imagined" and were "painted as though to the order of Don Quixote himself."[4]

In his December 8, 1928, column in The New York Sun, McBride identified Miró as a Surrealist, "probably the most outstanding of the present group of rebels in Paris,"[5] and alluded to Miró's use of automatism, the technique used by Surrealists to uncover the oneiric and primordial imagery rooted in the subconscious.

He gives full sway to his pencil and carte blanche to his soul. He must sometimes, when he has recovered from the trances in which he paints, be vastly surprised himself at what he has achieved.[6]

McBride described Dog Barking at the Moon as having a "powerful effect comparable to that that would envelop scientists who had just received a message from Mars,"[7] emphasizing the otherworldly quality of Miró's work. In the same article, he

anticipated the difficulty the American public would have in understanding Miró's work, while making a case for its importance.

It is really difficult. It will be mentally accessible, I fear, only to those who lean readily toward the mystical. It is cabalistic. It looks, at first glance, like the writings upon a cobalt canvas of a particularly lazy Indian. But the laziest Indian never paints a picture without putting himself in communication with the unseen powers, and so it is with Miró. There is more to be discerned in his work upon acquaintance; and it is fortunate to be able to make this acquaintance in the first flush of the artist's contact with the world.[8]

Miró's paintings were the first Surrealist work to capture the attention of an American art public for whom contemporary painting in the twenties and thirties consisted mainly of Cubist-based Precisionism, whose mechanistic and industrial imagery glorified the modern age, and American Scene and Regionalist painting, whose anecdotal vignettes of American life glorified traditional values. Critics less enlightened than Henry McBride seemed unsure what to make of Miró's work.

In the fall of 1929, painter and scholar Albert E. Gallatin loaned twenty-eight paintings from his Gallery of Living Art, usually housed at New York University, to an exhibition at the Brummer Gallery on 57th Street. Miró's Dog Barking at the Moon, which Gallatin had bought just a few months earlier, was included and was, "from a news standpoint, the feature of the show."[9] The painting was reproduced in the December 1929, Art Digest accompanying a satirical article entitled "Miró's Dog Barks While McBride Bites." While acknowledging Miró as the "reputed leader" of the Surrealist school, the reviewer did not understand the Surrealist content in Miró's work.

An impossible dog looks up idiotically at a sick moon set in a sky which has the purple depth of infinity. There is a ladder reaching upward toward a tiny patch of light in that terrible and depressing sky, and no one can tell whether the rift is receding and vanishing or coming forward and spreading. And somehow one feels very, very small in front of this ladder, which may lead to futility, in the presence of an idiot dog barking at he knows not what.[10]

In October-November of 1930, Miró's first one-man show in the United States was held at the Valentine Gallery in New York. A reviewer in Art News articulated the problem facing an American art public trying to comprehend Miró without a knowledge of Surrealism.

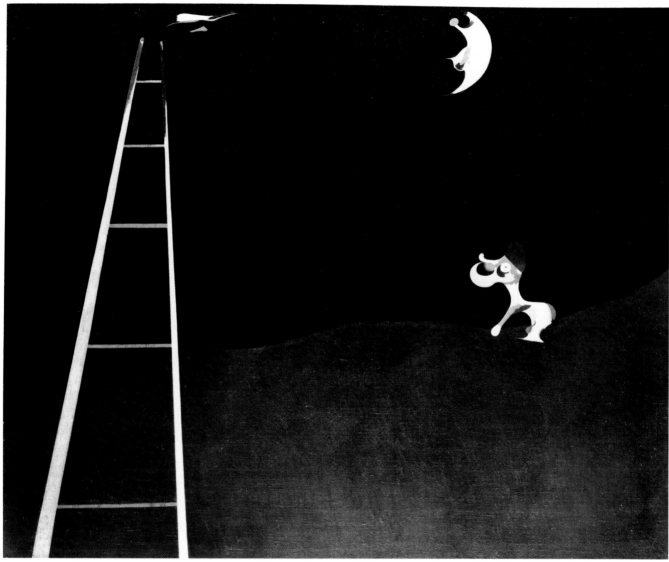

Fig. 47. Joan Miró. *Dog Barking at the Moon*, 1926.

. . . for the average gallery-goer the Miró canvases must stand on their painting merits pure and simple, since their more cabalistic side is apt to remain wrapped in deepest obscurity until some further illuminating text is provided.[11]

Three decades later, the Abstract Expressionist painter Robert Motherwell wrote, "Miró's method is profoundly and essentially surrealist, and not to understand this is to misunderstand what he is doing, and how he came upon it . . . "[12]. This, then, was the initial obstacle to an understanding of Miró in America.

Even Lloyd Goodrich, later the Director of the Whitney Museum of American Art (1958-68) and author of monographs on many American artists, among them Albert Pinkham Ryder, Winslow Homer, Raphael Soyer, and Reginald Marsh, discussed Miró's show at the Valentine Gallery in a manner which typified American oversimplification and misunderstanding of Surrealism.

The surrealists, as is well-known, profess to rely for

inspiration largely upon the subconscious mind; but the latter is certainly a more weighty affair than it is pictured by M. Miró, and considerably less amusing. Any person who has taken the trouble to examine the thoughts which rise unbidden from the depths of his own mind and appear before his inner eye, has probably found many strange, and uncomprehensible images, but nothing quite so like a Halloween party as M. Miró's inventions.[13]

In 1932 Miró became associated with the Pierre Matisse Gallery in New York where he began to have frequent shows. Although many critics remained bewildered by his work, with one reviewer in *The New York Times* writing, "The titles are plain as the nose on your face, but if you can find relationship between them and the designs to which they are appended, you may consider yourself warmly congratulated by this department,"[14] the exhibitions at the Matisse Gallery introduced the Catalan artist to an increasingly appreciative public. Miró's paintings were bought by private collectors and during the thirties were added to the collections of major museums, among them the Wadsworth Atheneum and The Museum of Modern Art. Even Edward Alden Jewell, critic for *The New York Times* and generally a bastion against the avant-garde, could not deny the veracity and power of Miró's work. When Miró exhibited at the Matisse Gallery in 1932, Jewell commented:

> Of course, you cannot expect to be able to walk in upon such things and understand them without a struggle. Some of us, after prolonged and honest effort, are still struggling, while perhaps a few of us have given up all hope of ever becoming initiates. The things by Miró are, in a sense, the most difficult, since this artist never, or very, very seldom, coats his bitterish psychological pills with the honey of beguiling loveliness. There are sometimes strange and haunting beauties in Max Ernst's paint surfaces. Miró simply will not compromise.[15]

However, in a *New York Times* review of Miró's 1933 Matisse Gallery show, Jewell reverted to the trivializing descriptions of Miró's art which appeared with regularity on the pages of the conservative *Times*. Jewell wrote patronizingly of Miró's "Compositions" from 1933 [fig. 48]:

> . . . they are nice bright, little pieces of decoration, and very meticulously painted . . . For the eye and mind not attuned to these artistic profundities even very long titles, such as "Jeune fille faisant de la culture physique" don't help. It is terrible to confess

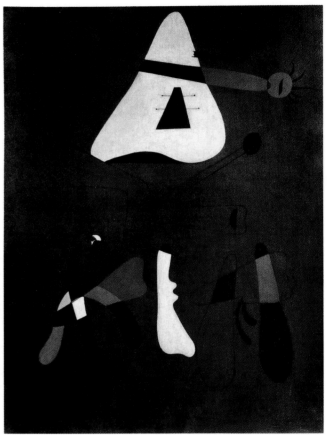

Fig. 48. Joan Miró. *Composition,* 1933.

> it but the reviewer could see no really helpful difference between this young lady doing her setting up exercises and the lady sitting down or *en repose* . . .[16]

Jewell dismissed Miró's work as "charmingly and disarmingly silly,"[17] and in a statement which must go down in the annals of critical misjudgement pronounced, "If ever Joan Miró gets into the movies, Walt Disney will have to look to his laurels."[18]

Although Miró was still best known as the painter of the ubiquitous *Dog Barking at the Moon,* by this time his shows at the Pierre Matisse Gallery were annual events. The exhibition from December 29, 1933 through January 18, 1934, included the lady *"en repose"* mentioned by Jewell in the previously quoted review, several paintings on wood from 1932, and larger compositions from 1933 inspired by his work with collage. As his work was shown with more

regularity in New York, a wider comprehension of his art began to develop.

> In previous exhibitions of Miró's work in New York the public stood aloof, skeptical, evidently fearing that something was being put over on it. This was a very irritating attitude for our cognoscenti to take — I felt at the time like beating our cognoscenti up — but the Miró exhibitions were too infrequent and there was no chance to do much about it. For my part, the Miró sincerity was unmistakable. He was as honest as Blake, as Beardsley, as Felicien Rops, and the fact that he was occasionally as erratic as they were in no degree affected his honesty. He was as honest as death. I mean he was a born artist.[19]

In the 1935 show at the Matisse Gallery, Miró's paintings and collages from 1933 and 1934 were shown, along with *The Farm* [fig. 49], 1922 (owned by Ernest Hemingway). Again, Jewell mentioned Miró in his column in *The Times* with condescension and disdain, ignoring visual and critical issues.

> The two drawings on colored paper are interesting exploits in calligraphy and one or two of the drawings on sandpaper are very agreeably decorative. For the most part, one approaches Miró's art in a mood of pronounced skepticism, to say the least.[20]

The first American critic to deal fully with Miró's work was James Johnson Sweeney. A graduate of Georgetown University in Washington, D. C., Sweeney began his career as a poet. After Georgetown he went to Cambridge, England and during a visit to Dublin, met Edward Alden Jewell, who was visiting a mutual friend. Jewell was at that time a critic for the *Christian Science Monitor* in Boston; three years later, after becoming art critic for *The New York Times,* he offered Sweeney a job. In 1934 Sweeney published a small volume entitled *Plastic Redirections in Twentieth Century Painting,* which essentially founded his career and his reputation as an insightful critic. By 1946, when he was appointed Director of the Painting and Sculpture Department at The Museum of Modern Art, he was known throughout the art world as a scholar with a perceptive eye and keen critical insight. He eventually served as Director of the Solomon R. Guggenheim Museum in New York and as Director of The Museum of Fine Arts, Houston.[21]

Surrealism began as a literary movement. Miró has always had an affinity for poetry and poets. He has been quoted as saying, "For a thousand men of letters, give me one poet!"[22] and is an avid reader of poetry. Thus it was appropriate that Sweeney, who started his

career as a poet, published the first piece of critical writing which dealt with Miró's oeuvre as a whole and attempted to define and analyze his own personal brand of Surrealism. Sweeney opened his article in the *New Republic,* entitled "Miró and Dali," by defining what he saw as the difficulty the American public had in perceiving Miró's work.

> Joan Miró is a painter who has never hesitated, through fear of compromising his chances of popular success, to give free rein to the vagaries of his personal stylistic evolution. Popular success in painting depends on the public's familiarity with the painter's idiom.
>
> And because Miró has a fertility of invention that he has not confined to bait favor, the public, in great part unacquainted with any representative cross-section of his work, has frequently been mystified by the seeming non-sequiturs in his development from season to season.[23]

Sweeney emphasized the influence of Miró's heritage, the impact of the peasant folk imagery, and the colors of his native Catalonian countryside on his ideography and his palette. The critic elucidated Miró's art within the context of Surrealism, drawing an important distinction between Miró's use of the unconscious as a source of poetic and spontaneous imagery which he then integrated into his overall plastic concerns, and the more literary Surrealists' use

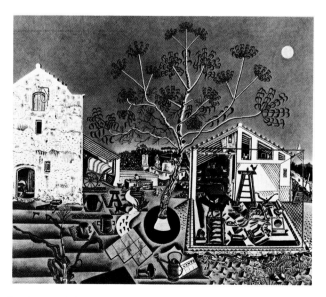

Fig. 49. Joan Miró. *The Farm,* 1921-22.

of the unconscious as a fount of images to be illustrated.

> The result is that while the Superrealist paintings of Dali and of his less interesting colleagues are presentations, arresting merely for illustrational qualities, of old forms in hackneyed formal organizations, Miró's work constantly provides plastic inventions that have a genuine Superrealist quality of spontaneity and freedom.[24]

Miró's work was widely seen in the United States during 1936. Five of his works were included in the encyclopedic exhibition *Cubism and Abstract Art* organized by Alfred Barr at The Museum of Modern Art in March-April of that year. Sweeney had drawn distinctions between Miró and other Surrealists. Alfred Barr, in his catalogue accompanying the exhibition, did so as well.

> Miró's drawing is at times almost meditative, wandering, like a river over a flat plain; his color possesses an extraordinary freshness; and his forms have the convincing gusto of primitive cave paintings or children's watercolors. Of all the Surrealists Miró has the most plastic humor but at times he can drop his clowning and paint imposing compositions, unsurpassed among recent paintings in line and color.[25]

During the thirties the emerging American avant-garde was still primarily influenced by the strict geometric abstraction of the European Neoplasticist and Constructivist movements. However, as more was written about Surrealism, Miró began to be seen as a part of an important and influential group. In "Miró and the Surrealists," published in *Parnassus,* October 1936, John Frey delineated the two types of Surrealists: the "poet-painter," who illustrated a "newsreel record of the subconscious," and the "painter-poet," whose automatism led to a creative flow of imagination which resulted in "the organic growth of a plastic conception." Frey analyzed Miró's career as an evolution from "poet-painter" to "painter-poet."[26]

Later that year, at the beginning of December, the Matisse Gallery held a retrospective of Miró's work done between 1922 and 1936. Six years after his first one-man show at the Valentine Gallery, reviewers, once baffled by his work and reluctant to take it seriously, readily acknowledged its importance. Critics wrote about him within the context of Surrealism, but growing comprehension of the complexities of the movement enabled them to identify the Surrealist characteristics of his art as well as those which set it apart from other Surrealist painting.

> He [Dali] is first of all the thinker, then the painter of thoughts. Miró's expression is the opposite. With nothing *a priori,* Miró paints under the capricious direction of his imaginative subconscious life as one might absently pluck at the banjo. There is no improvisation, but because there is direction, even though irrational, there is unity and, because he is first of all a painter, there is painterliness.[27]

In an insightful reveiw of Miró's 1936 show at the Matisse Gallery, Martha Davidson again tried to define Miró's special kind of Surrealism, drawing the by-now-usual comparison with Dali's literary visions.

> While Miró's is a pictographic language of the subconscious, Dali's is representational. Miró translates this superreal existence into a perceptual form which at the same time affords reiteration and emphasis. He, like Klee, avoids dependence on literary transcription and refers to the objective world sparingly, merely for the infinite suggestive force which lies in a familiar form.[28]

Davidson not only articulated and probed the iconography of Miró's paintings, but also analyzed the canvases in more formal terms than had been done heretofore.

> *Landscape by the Sea* (1920)[29] [Fig. 50] and the renowned *Dog Baying at the Moon*＊ (1926) at first amusing soon become a haunting embodiment of Miró's dual consciousness. In the latter, the ladder, far more than a material object, becomes a bridge between two worlds, the conscious and the unconscious, with the dog identified with the conscious world and the man with a less fathomable sphere. Simply represented in large divisions of brown and black, garnished sparingly with color, this painting is the foremost illustration of the romantic, poetic disposition which probes the apparent, the "real" for the "unreal," the infinite mysteries which lie hauntingly beneath the seen . . . [30]

By 1936, Miró's paintings could be presented within a context which was unavailable when they were first seen in this country. Writers and critics had a more sophisticated knowledge of Surrealism which enabled them to see more in Miró's work than an "impossible dog" and a "sick moon."[31]A growing familiarity with Miró's vocabulary of biomorphic signs and symbols made it possible for them to deal with the content of Miró's work. A broader knowledge of the range of

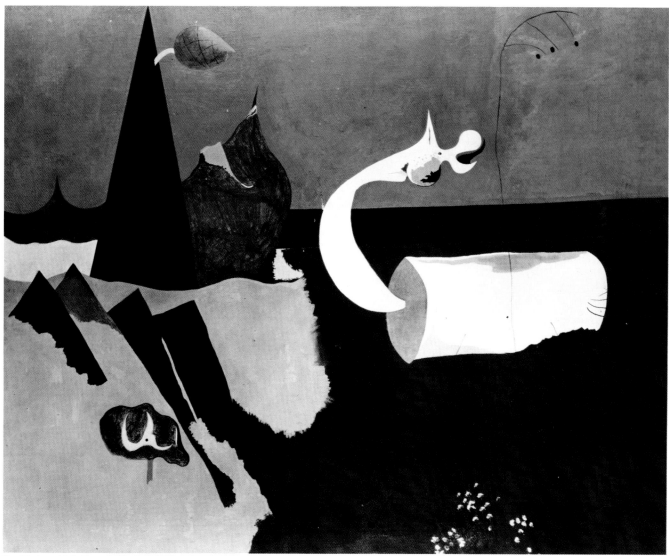

Fig. 50. Joan Miró. *Horse by the Sea,* 1926.

Surrealism led them to draw distinctions between Miró, whose images sprang from automatism, and the more literary Surrealists, such as Dali, who actually painted concrete illustrations of dream imagery.

In December 1936, Alfred Barr organized another watershed exhibition at The Museum of Modern Art called *Fantastic Art, Dada, and Surrealism.* Fifteen works by Miró were included in the show, among them a gouache (1933-36) owned by the critic/abstract artist George L. K. Morris and two paintings already in the Museum's permanent collection: *Statue* (1926) and *Rope and People I* (1935).

In the February 1938 issue of *Partisan Review,* George L. K. Morris, a staunch supporter of the American abstract avant-garde, published an article entitled "Miró and the Spanish Civil War." In his discussion of the Civil War and its effect on Miró, as well as on Picasso and Gris, "the other famous Spaniards," Morris stressed the universality of Miró's art.

Miró, on the other hand, has been able to put on canvas in a much more satisfying way his reactions to the war. This might have been foreseen, for he is less the intellectual constructor, more the commentator upon his inward vision."[32]

Noting the influences which he felt had shaped Miró's art, Morris described its unique amalgam of capriciousness and sobriety.

Miró's development has been the logical result of the influences which have crowded upon him. He commenced with that dry sharpness of vision which must haunt the air of Northern Spain, which produced Zurburan, Juan Gris, and the anonymous Catalonian frescoes. Later, as he came in contact with Arp and the Dadaists, who opened up the field of tactile sensations, he alone of their disciples never grew mannered. Here already was the familiar Miró, the world half heavy with gloom, half buoyant with fantasy, alive through tiny linear rhythms that tickle the canvas and create a dance.[33]

In Miró's April 1938 exhibition at the Matisse Gallery, only paintings from 1937 were shown. Critics as disparate as Edward Alden Jewell and Henry McBride noted the changes Miró's work had undergone during the Spanish Civil War. Predictably, their perceptions were quite different. Jewell focused on the cosmetic rather than the cosmic aspects of Miró's work and could not resist the hackneyed mention of the Miró painting best known, and most often mistitled, by the public.

It is a far cry now from the famous *Dog Baying the Moon* and from subsequent abstract designs in which color shapes, however undecipherable they might for some of us prove, were nonetheless contrived with extreme bright neatness. What Miró might be doing at the moment I do not know. But last year, it is plain to be seen, he was splashing about with glee that seems close to abandon.[34]

The May 1938 *Art Digest* published Henry McBride's reaction to the same exhibition.

"If you don't like it," writes McBride, "you are condemned as insensitive to some of the finest qualities of modern art." He [McBride] calls the new batch of Miró's "the most difficult to date," but urges those of his readers who do not "get" Miró to visit this show and to see the paintings for themselves . . . The critic [McBride] then lists what he sees in Miró's pictures: imaginative and very rare color; a subtle touch; unfailing wit; a strange instinct for the uses of the pigment and perfect balance in the

compositions.[35]

In the April 1939 *Art Digest,* Paul Bird alluded to some of the ambiguities which, it had become apparent, inevitably accompanied any attempt to label or define the parameters of Miró's art.

Miró disowns the title Surrealist, preferring non-conformism in his art, and he believes that the garden variety of Surrealism is a literary movement anyway, unrelated to the problems of painting.

In comparison with his works of last year, Miró has intensified his color and given more drama to his forms, if pure forms may be said to be dramatic. The pictures are non-representational, non-literal. . . . All painting to Miró is lines, area and interceptions, and on these three instruments he plays a pictorial recital in color that has its unquestioned poignancy. The sensitive and undulating lines of *Flight of Bird over Plain* traverse the dull orange area of the canvas in a manner symbolic of flight, while the rhythmically elongated form of the wing is graceful as the pinion of a soaring spirit. Miró's is an art of symbolism, a refined, subtle, sensitive blazonry.[36]

In 1941, as guest curator at The Museum of Modern Art, James Johnson Sweeney organized Miró's first major museum retrospective. Seen in New York from November 18, 1941 through January 11, 1942, the show included fifty-one paintings, a series of seventeen etchings, five drawings, two tapestries, and one rug. The works spanned Miró's career from 1917 through 1939. Sweeney's text for the accompanying exhibition catalogue was the first monograph on the Catalan painter to appear in English. Fully illustrated, with a chronology and bibliography, the book was by far the most informative and insightful presentation of the artist and his work which had yet been made to the American public.

Sweeney proposed that, unlike most of the Surrealist painters who turned their backs on the Cubists' emphasis on "formal fundamentals,"[37] Miró's commitment to painting and plastic values enabled him to "meet the problem of his own generation with an equal or even greater effectiveness than his contemporaries."[38] Sweeney emphasized the duality of poetry and painterliness which characterized Miró's art and lent it such uniqueness.

Because of his fundamental devotion to painting, Miró has been unable to recognize the value of the lessons learned by those generations immediately preceding his who sternly emphasized the formal bases of painting. Because he was a poet, he saw the

weakness of a pictorial expression which discouraged any enrichment by means of extra-pictorial suggestion. Through the combination of these two sides of his talent, he has been able to bring a new tonic element into contemporary painting, without compromising an essential pictorial approach. And the record of Miró's development to date is a history of the constant single-minded affair he has made toward combining and perfecting these abilities.[39]

Quoting Miró's own denial that he was an abstract artist, Sweeney stressed that content was always present in Miró's work. Even in the most ostensibly abstract works, the forms on Miró's canvases were those of an ideography directly related to poetic images in Miró's mind, which in the artist's own words, "belong essentially to the world of reality."[40] In discussing Miró's "Compositions," a series of large oils from 1933, Sweeney attributed their convincing pictorial integrity to the fact that the unfamiliar symbols were "signs transcribed on the canvas at the moment when they correspond to a 'concrete reality' in Miró's mind."[41]

Throughout his essay, Sweeney emphasized what he saw as the uniquely Catalonian character of Miró's art, contributing to both its fantastic and earthy aspects. When, as a Surrealist, Miró turned to the subconscious, poetry, and dreams, it was not an artificial device but a natural part of his heritage.

> In his work Miró is essentially a Catalan—that type of fantasist visionary which, in the Middle Ages, produced the manuscript illuminations of Beatus' commentaries on the Apocalypse . . .[42]
>
> [Miró's painting] is the record of a persistent constructive effort to achieve a sound balance of the spiritual with the material in painting, an aesthetic paradigm for a fuller, richer life in other fields . . . A pictorial poetry in which oriental and occidental traditions fused was an essential part of his Catalan heritage . . . A loyalty to the traditional folk expressions of his native land has kept his feet solidly on the ground.[43]

Sweeney's exhibition subsequently traveled to Smith College, Vassar College, the Portland Art Museum and the San Francisco Museum of Art.

In 1945 Miró had two consecutive shows at the Matisse Gallery: the first from January 9 to February 3 and the second from February 5 to February 25. Included in the January show were ceramic vases decorated by Miró and executed by his friend, the well-known ceramicist Artigas, and a series of some twenty

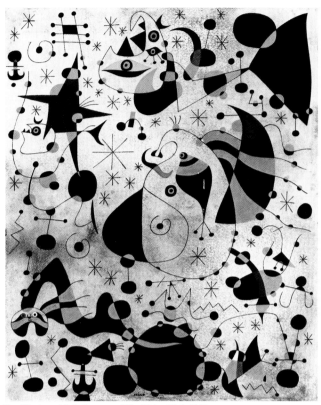

Fig. 51. Joan Miró. *Passage of the Divine Bird,* 1941.

gouaches done by Miró between January 1940 and September 1941. This was the first time that the "Constellations" [fig. 51], as they came to be called, were seen in the United States. Critics and reviewers immediately recognized a new direction in Miró's work, commenting on the gouaches' characteristic all-over composition, which was so crucial to the course of post-World War II painting in America.

> . . . Miró has spun on the surface plane all-over patterns of his incisive, brilliant symbols: the familiar stars, the crescent moons, the gyroscopic balls, triangles, beads, the sperm-like shapes, the little clusters which look like the chemist's atomic structure diagrams, all these are woven together in taut relationship and tied by thin electric lines.[44]

One reviewer wrote about the "Constellations" in prophetic terms, suggesting that the gouaches "might well stand as a series to be numbered,"[45] and perspicaciously noting their all-over imagery which presented "a separate emotion of wholeness by viewing it at six paces."[46]

In his 1973 catalogue *Miró in the Collection of The Museum of Modern Art,* William Rubin incisively summed up, in retrospect, the impact of Miró's "Constellations" on American art.

> They were the first works by a major European artist that were seen in New York after World War II (except, of course, for those by artists who had fled to America). When they were shown at the Pierre Matisse Gallery in 1945, just two years before Pollock "broke the ice" for American painters with his own version of the all-over configuration, the Constellations aroused tremendous enthusiasm, especially among avant-garde artists.[47]

In 1947 Miró made his first visit to the United States to paint, in American abstract artist Carl Holty's New York studio, a mural commissioned for the roof-garden restaurant of the Terrace Plaza Hotel in Cincinnati. Miró stayed in the United States from February through October. The completed mural was displayed at The Museum of Modern Art in New York before it was actually installed in Cincinnati. By then, Miró was recognized as having a "long-held position in the forefront of contemporary art expression,"[48] and his presence in New York evoked great interest. He was interviewed by several American writers during his stay.

> A man of extreme modesty and simplicity, Miró refuses to talk about his work and avoids making the slightest comment on its significance. . . Miró refused to offer any interpretation of his work except to proclaim his non-submission to any canon whatever.[49]
>
> And as a last question, Monsieur Miró, what advice would you give to a young painter? A: Work hard—and then say, nuts.[50]

Not surprisingly, the most enlightening interview with Miró was by James Johnson Sweeney. In his "Comment" preceding the interview published in the February 1948, *Partisan Review,* Sweeney emphasized, as he had in his 1941 monograph, the concrete, earth-bound quality of Miró's work. Sweeney stated that the directness and intensity of Miró's art stemmed from its "primitivism": not a primitivism having to do with lack of skill, but instead rooted in a "single-minded attempt to effect primary appeals with an intensity of focus that never allows him to deviate from his objective."[51]

> The true approach, therefore, to Miró's art is not to something esoteric, but to something in our age naive—as simply pictorial and lyrical—as Rousseau's was in his time. The only difference (a necessary one in the case of two true artists) is that Miró paints his

lyrics in the idiom of the twentieth century while Rousseau painted his in that of the nineteenth century. The same respect for craft is there, the same single-mindedness, peasant practicality, and realism. . .[52]

This original perception on Sweeney's part helped to clarify that quality in Miró's work which had been referred to as "whimsy," and its relation to the Surrealist character of the artist's work which had been the subject of so much confusion. Sweeney provoked enlightening comment from the usually taciturn artist, so much so that most of the American writing about Miró which followed (including two monographs, one by Clement Greenberg in late 1948 and one by James Thrall Soby in 1959) assimilated many of Sweeney's ideas and used direct quotations from his interview with Miró. Sweeney ended his interview with Miró's own description of his work method. The artist elaborated on his use of the unconscious and discipline, suggestion and control, and stressed how intrinsic he believed his Catalonian heritage was to his work.

> Even a few casual wipes of my brush in cleaning it may suggest the beginning of a picture. The second stage, however, is carefully calculated. The first stage is free, unconscious; but after that the picture is controlled throughout, in keeping with that desire for discipline I have felt from the beginning. The Catalan character is not like that of Malaga or other parts of Spain. It is very much down-to-earth. We Catalans believe you must always plant your feet firmly on the ground if you want to be able to jump up in the air. The fact that I come down to earth from time to time makes it possible for me to jump all the higher.[53]

In late 1948 Clement Greenberg published *Miró,* the only monograph he has ever written. At the time of its publication, he was, in the words of one reviewer, "the only American critic regularly, seriously, and ambitiously engaged in evaluating contemporary painting."[54] In analyzing Miró's work, Greenberg repeatedly used the formalist vocabulary and values which have become part of the critical language of Abstract Expressionism and much subsequent abstract painting. Speaking of Miró's work and its relation to the School of Paris, Greenberg stated:

> Literalness is the premise of their [Miró, Picasso, Gris] respective styles at their respective best—as it is, ultimately, the premise of all truly contemporary painting, a literalness which understands painting as something that begins and ends, no matter what happens in between, with a pigment applied to a flat

surface and depends for its essential effect on the sensations received from a pigmented triangle.[55]

Greenberg, a partisan of the emergent American avant-garde, shared with most of the members of the American Abstract Artists, a group formed in 1936, an orientation toward Cubist-based geometric abstraction rather than Surrealist biomorphism. In writing about Miró, he acknowledged but minimized Surrealism, emphasizing, again in a formalist vocabulary, the artist's relationship to Cubism.

> Miró was for awhile an enrolled Surrealist and gradually parted company with them only during the thirties. He was never, anymore than Masson, who had likewise joined the movement, attracted to Surrealism's academic side and he made no contact with the literary and illustrative tendencies expounded by Dali, Ernst, Magritte, and Tanguy. And only for a while was he misled by the Surrealist revival of the anti-art, pseudo-abstract "irrationalities" of Marcel Duchamp, Francis Picabia, and *Dada*. His grasp of painting as an art and his sense of what it had to do in his time were too secure. Impressionable as Miró may be at moments, he has let nothing interfere with the conception he got from Cubism of painting as an irrevocably two-dimensional medium, and he has seldom wavered in the conviction that modern painting can make effective statements only in accordance with this conception. Surrealism's advocacy of the "strange" was for him, ultimately the sanction to go as far as he desired in the direction of the flat, abstract picture. . .[56]

Greenberg also presented the first discussion of Miró as a color painter. The critic's perceptive insights into the Catalan artist's use of color indicated the shift of emphasis, in Greenberg's writing, to Miró's formal rather than literary values.

> Miró had early discovered black as a *color* and had begun using it even before 1924, with an effect no other painter of our time except Matisse has approached. Black becomes his touchstone as white is for Picasso. It is the vehememce and opacity of black and the precision with which it defines a plane that he tries to equal in his other deep colors. And he succeeds in doing this fully by 1930, achieving a brilliant density in his ultramarines, vermilions, viridians, and browns, while the oranges, yellows and even light blues and pinks take on, by contrast, some of the clarity and luminosity of white. . . In the end his ability to use color structurally—that is, to build the picture on the oppositions of pure hue as apart from those of dark and light—surpasses Picasso's and perhaps any other painter's of his time

except, again Matisse's.[57]

Greenberg also discussed Miró's "Constellation Series," which was, as already noted, crucial to the "all-over" imagery of Abstract Expressionism. Greenberg's perception of the "Constellations" in terms of Cubism was unique at that time.

> The most important thing he did as far as the extending of his style is concerned is a series of twenty-two gouaches, rather thin but also rather happy in effect, that was begun in Varengeville and finished in Spain. These pictures, "based on reflections in water" and characterized by small, evenly distributed spots of paint connected with each other by networks of thin black lines, are significant in that they mark Miró's closest approach to the compositional methods of late analytical cubism. Gertrude Stein once wrote: ". . . the composition was not a composition in which there was one man in the center surrounded by a lot of other men but a composition that had neither a beginning nor an end, a composition of which one corner was as important as another corner, in fact the composition of cubism." Miró had in the past, notably in "The Farm" and also, perhaps, in "The Tilled Field," done compositions without a controlling, central idea, but only because he had relied—not altogether with success—on the rhythm and equilibrium of a number of small different ideas. In these "water reflections" gouaches, however, more or less the same idea is repeated with minor variations over the whole picture surface. The spots still float in free space, but the background begins to assume a more prominent role and is considerably less indeterminate than before. This is indeed the "composition of cubism."[58]

Greenberg emphasized Miró's universality and his stature as a major artist of the twentieth century stating," . . . he has created a style that answers to our contemporary world's sense of itself and which is so incorporated by now in its visual sensibility that no one who paints ambitiously can afford to be unaware of it." Greenberg defined Miró as a brilliant and original synthesizer of disparate past trends in twentieth century painting, and as a saviour of painting of the future.

> And not only did Miró show that it was possible to build a unified style on the collective achievements of the age of Cubism, joining Klee's and Kandinsky's more explicit "poetry" to Picasso's and Matisse's "engineering" and not only is he the sole new master of international importance to have appeared in painting anywhere in the twenty years between the two wars (Klee and Mondrian were already definitely

on the scene by 1920)—he has also acted as a test case to decide the viability of post-Cubist painting as a *school.*[59]

Without Miró the prospects of painting beyond Picasso, Matisse and Klee might have appeared restricted to the alternatives of Surrealist academicism as practiced by Dali, Ernst, and Tanguy, and the "pure abstraction" of Mondrian. This later alternative does not mean quite the impoverishment of art that so many people fear as its consequence, but for the time being post-Cubist painting still has variant possibilities open to it, and this is what Miró has shown us.[60]

In 1954, on the occasion of Miró's 60th birthday, *Art News Annual* celebrated him as "the most creative painter of the post-Picasso generation." The magazine published a major piece on Miró by James Johnson Sweeney. The essay was profusely illustrated with reproductions of works spanning Miró's career, among them *Landscape with Donkey* (1918), *The Farmer's Wife* (1922-23), *Portrait of a Lady* (1929), *Self Portrait* (1938) [fig. 52], *Women, Birds, and Stars* (1943), and *The Red Stem Pushes Towards the Moon* (1953). In addition to a summation of the biographical material in Sweeney's 1941 monograph, it offered new information about Miró's latest work methods and insights into the relationship between changes in his technique and the resultant works. Sweeney, in his article, recalled a conversation with Miró.

> "Nowadays," he has said, "I rarely start a picture from hallucinations as I did in the twenties, or as later, about 1935, from forms suggested by collages. What is more interesting to me today is the materials I am working with. They very frequently supply the shock which suggests my forms much as the cracks in the wall suggested form to Leonardo."[61]

Sweeney quoted Miró's description of the stages of his work. The words were similar to those the artist used in Sweeney's 1948 "Comment and Interview".

> "I start a canvas, or a drawing, without a thought of what it may eventually become. I put it aside after the first fire has abated. I may not look at it again for months. Then I take it out and work at it coldly like an artisan, guided strictly by rules of composition after the first shock of suggestion has cooled."[62]

Sweeney concluded that Miró had modified his earlier techniques so that instead of "a mere liberation from a naturalist convention," he sought now to refine "in the light of traditional expression," the "evocation of his painting from pictorial means." Sweeney summarized Miró's position in the fifties.

Fig. 52. Joan Miró. *Self-Portrait, I,* 1937-38.

> The enthusiast of the Surrealist day has come back, but with a difference: the difference being what Miró has learned in the interim in the way of self-discipline and of freedom which is eventually controlled.
>
> . . . today a new freedom—a new joy in painting—is evident in every canvas of his recent production; and a sound freedom of expression which, to the second glance, is clearly based on his lessons from tradition, his insistence on a forceful self-liberation and, finally, a scrupulous self-criticism.[63]

During 1957, Miró worked on two ceramic murals commissioned for the UNESCO Building in Paris. For the walls, completed in 1958, he was awarded the 1958 Guggenheim International Award.

In November 1958, the Pierre Matisse Gallery held an

exhibition of Miró's paintings from the 1930's, and the illustrated catalogue contained a brilliant essay, "On the 'peintures sauvages' of Joan Miró," by James Fitzsimmons. Fitzsimmons, a former photographer and self-taught painter, went on in the sixties to become editor and publisher of the important periodical, *Art International.* In direct contrast to the formalist approach taken by Greenberg in his 1948 monograph,

Fitzsimmons prefaced his essay by stating that he was more concerned with what Miró's work might "signify at the level of feeling," as "highly nuanced communications of states of being," than with formal values because, "the modern artist is concerned with making images of delight, horror and consummation, images of being, and with formal values only when the precise notation of his precepts requires it."[64]

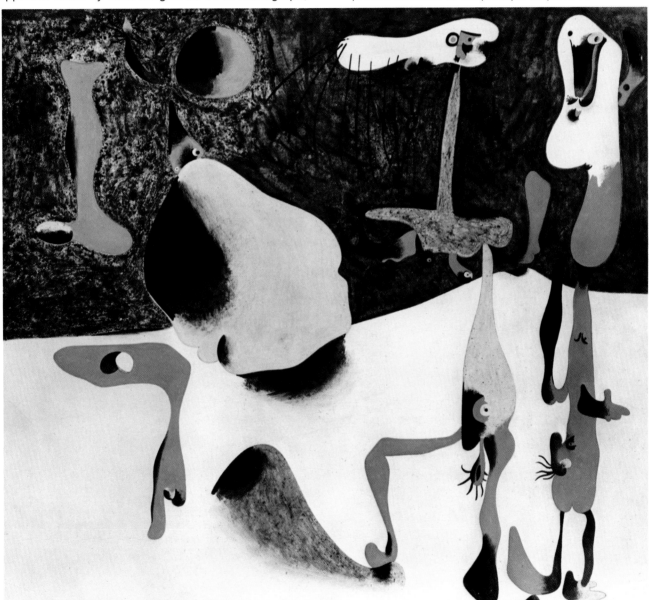

Fig. 53. Joan Miró. *Personages in the Presence of a Metamorphosis,* 1936.

Fitzsimmons also wrote about Miró's painting within the context of poetry [fig. 53]. Unlike previous writers who stressed his affinity with Surrealist poetry in both its imagery and its technique of automatism, Fitzsimmons compared Miró's painting to modern poetry in its representation of the all-over emotional content of everyday life.

> The formal relations we find in Miró's paintings are also like those of "metaphysical" and modern poetry. Indeed, Miró's mind seems to work very much as a poet's does, for it is "constantly amalgamating disparate experience," as Eliot put it in contrasting the poet with the ordinary man, who does not see the connections that may exist between (I paraphrase) falling in love, reading Spinoza, the noise of a typewriter and the smell of cooking but which the poet recognizes as parts of a meaningful whole. Miró's painting is like modern poetry then, in that it seeks to do justice to the complexity of experience— which also explains his juxtaposition of images belonging to different orders of phenomena, and the almost systematic use of incongruity.[65]

In March through May 1959, The Museum of Modern Art in New York held a second Miró retrospective, which included over one hundred paintings, prints, and ceramics. The exhibition was accompanied by a lavishly illustrated monograph written by James Thrall Soby, a longtime friend of Miró and a curator at The Museum of Modern Art. Soby's monograph was basically a panegyrical biography, more useful in its compilation of previously published data and interviews, than for its critical insights.[66]

The Museum of Modern Art retrospective prompted written response from Robert Motherwell, one of the most literate and articulate of the Abstract Expressionist painters and probably the best-versed in the Surrealist antecedents of that group. Motherwell's article, "The Significance of Miró," included a description of Miró's most recent work, "a rhythmically animated colored surface-plane that is invariably expressive. . . ,"[67] evocative of the large fields of subtly modulated color of Abstract Expressionists Rothko and Newman. In his article Motherwell referred to Miró as "a direct link and forerunner in his automatism with the most vital painting of today." Motherwell defined "automatism" in art as a kind of free-association "most easily and immediately recognized by calling the method 'doodling' "; he related Miró's automatism specifically to Abstract Expressionism.

> When Miró has a satisfactory ground, he "doodles"

on it with his incomparable grace and sureness, and then the picture finds its own identity and meaning in the actual act of being made, which I think is what Harold Rosenberg meant by "Action-Painting."[68]

Hilton Kramer's positive review of the 1959 retrospective stated that "one would have to go through the roster of mandarins in the New York School with a magnifying glass to discover a single post-war painter of importance who has not at one time or another submitted to Miró's spell."[69] Kramer also pointed out that Miró's position in contemporary painting at the brink of the sixties was "extremely ambiguous," stating:

> . . . Miró's art remains aloof from the whole temper of post-war aesthetics, with its relentless drive to empty its pockets of negotiable imagery.[70]

At the very time when American reviewers and critics were writing about Miró's work within the context of Abstract Expressionism (as earlier generations had used the referential framework of Surrealism), younger American artists were beginning to react against what they saw as the "excesses" of Abstract Expressionism by championing rigorous formalist values. This conflict led to a tendency on the part of critics to equivocate when writing about Miró's work of the sixties.

In his review of a late December 1960 show at the Matisse Gallery, artist and writer Sidney Tillim posed the question, "Has Miró really become an action painter?"[71] After describing the works which prompted the question, "canvases in which black paint had been flung upon a surface," and a work with "a soft point in dead center surrounded by a few random scrawls of color." Tillim singled out three mural-sized works. The paintings, *Blue I, Blue II and Blue III* [fig. 54], had "either twinkling or hard black spots, a thin line unraveling across the plane and sudden radiant eruptions of red."[72] Tillim proposed that the blue paintings in particular were a response by Miró to his own work, more than an assimilation on his part of Abstract Expressionism.

> If the blue paintings can be traced to certain respectable prototypes of Miró's earlier years, the "action" group suggests an inevitable reaction to the meticulousness and systematization that had claimed his spontaneity — or had begun to — as far back as twenty years ago.[73]

Writing about Miró's 1964 retrospective at the Tate Gallery in London, American critic Gene Baro placed Miró's recent, more abstract work within the context of

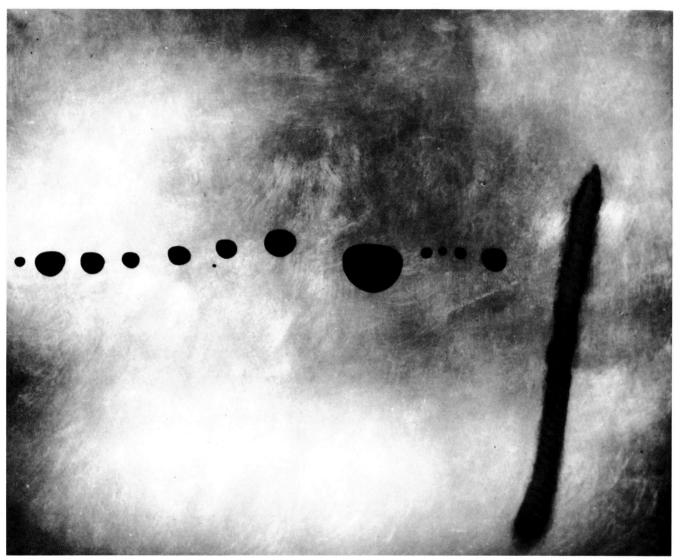

Fig. 54. Joan Miró. *Blue II,* 1961.

the rest of his oeuvre. He discussed Miró's sensitivity to freedom and formality, qualities whose "proper proportions in a work of art is a concern so fundamental that no vital art can avoid it."[74] Despite this helpful context provided by Baro, American writing continued to reflect a certain disdain towards Miró's work of the sixties.

Minimal artist Don Judd exemplified the ambivalence of formalists to Miró's work in his 1965 review of a joint Calder/Miró show at the Perls Gallery stating, "Neither Miró nor Calder has flagged: Neither has changed much either."[75]

Charles Giuliano's disparaging review of Miró's 1967 show at the Matisse Gallery typified the way Miró's current work was downgraded at the height of the sixties' formalism.

> Long identified with a childlike whimsey, Miró, now tends strongly to the puerile. His present works are executed with such casual abandon that they are entirely innocent. They make no effort toward statement or form. This may seem a very endearing freedom to some, yet it saddens me.[76]

With the opening of the decade of the seventies, a broader perspective appeared in the writing about Miró's work. In her 1971 monograph on the Catalan artist, Margit Rowell dealt with Miró's paintings of the sixties from an art historical viewpoint rather than a contemporary bias. After documenting his exposure to and enthusiasm for the work of American artists such as Pollock, Motherwell, Rothko, Gorky, and Kline, which Miró saw not only during his 1947 and 1959 visits to the United States but in Europe during the interim, Rowell suggested that the options offered by Abstract Expressionism acted as a catalyst for Miró.

> The notions of action, total commitment, and total risk, as well as the openness of space and form, represented not only a radical extension of Cubist pictorial space and structure, but a transgression of the traditional definition of painting. This complete reappraisal of the function and meaning of art had only been suggested in Europe. Moreover, the emphasis on the physical, the impulsive, and the immediate and on the authority of the subconscious, not to mention that of the painted surface itself, indicated a radical recovery of the purely spontaneous creative act that was infinitely meaningful to Miró. [77]

The cornerstone of our current perception of Miró and his importance was the 1972 exhibition and catalogue of the same name, *Joan Miró, Magnetic Fields,* which was organized by Margit Rowell, then Associate Curator at the Guggenheim Museum and Rosalind Krauss, at that time Assistant Professor at M.I.T. This exhibition, which opened in October 1972 at the Guggenheim Museum in New York, analyzed the relationship between paintings from two phases of Miró's career: the years between 1925 and 1927 and the decade of the sixties. The works from both of these periods are marked by their spare abstract character, in contrast to the lush imagery usually associated with Miró.

In her text, "Magnetic Fields: The Structure," Krauss advanced her thesis that the Surrealist poets' concern to create an uninterrupted field of language paralleled the concern of Miró in the mid-twenties to make paintings from an "uninterrupted field of color."[78] She suggested two poetic sources for the pictorial quality of Miró's paintings of this period: *"ecriture* — a descriptive line pushed toward the abstract disembodiment of the written sign," and the actual shapes of letters and words used in the poems.[79]

After elaborating the sources of the forms in Miró's paintings of the mid-twenties, Krauss related those works to the large canvases of the sixties.

> . . . in the early 1950's he saw and was moved by work of the American abstract-expressionist generation, particularly the paintings of Jackson Pollock. With the impetus of these painters behind him, Miró returned to the scale he had achieved in his great *Circus Horse* painting of 1927 and to the structure by means of pure color of his 1925 *Painting.* Reconnecting with the sign language of *Head of a Catalan Peasant* and with the symbol systems of the great works of 1927, he began work on the huge mural cycles which have preoccupied much of his thought during the past decade and at which he is still at work.[80]

Margit Rowell's text, "Magnetic Fields: The Poetics," analyzed Miró's specific involvement with Surrealist poetry and the various ways in which it influenced his imagery. Rowell defined, and then illustrated in detail, the manner in which Miró's work was affected conceptually and visually by poetry.

Harold Rosenberg (1906-78), doyen of American critics and a longtime champion of Abstract Expressionism, reviewed the exhibition. Predictably, given his Abstract Expressionist bias, Rosenberg criticized the show for its "formalist scholasticism"[81] in dealing separately with the issues of form and content in Miró's work. He accused the show's organizers of trying "to contrive an American scale color-field painter out of two segments of their hijacked Surrealist."[82]

Despite Rosenberg's criticism, the exhibition *Magnetic Fields* and its accompanying texts were crucial in contributing to a more sophisticated level of thinking about Miró.

Scholar Kermit Champa expressed some of the valuable new insights that the show's art historical perspective revealed.

> For the first time, at least for this writer, Miró's work can be seen to be capable of probing for unique pictorial substance over an extended period rather than to be, as it often appears, so highly idiosyncratic and abrupt in its successive maneuvers as to feel more self-indulgent than serious. The surprise brought about by this recognition of unique substance is brought about most forcefully by the works from the '20's. Those from the '60's present themselves in generally familiar American terms of scale and incident, so their qualities are somewhat less unexpected in type, if not in character.[83]

Thomas Hess (1920-1978), writer, critic and, at the time of his death in 1978, Curator of 20th Century Art

at the Metropolitan Museum of Art, also wrote about the *Magnetic Fields* exhibition. Hess noted that the Guggenheim Museum presented Miró, for the first time, as an "intellectual" artist, a "literate, highly sophisticated master."[84] Hess briefly outlined the different turns taken by American criticism about Miró, noting that "formalist prejudice has dominated much of the writing on his art, or he was discussed in pseudo-poetics. His subject matter was ignored." Hess pointed out that even the most acute writers about Miró had been "involved in placing Miró in history, in securing him a niche."[85] Hess underscored the new perception of Miró as presented by the *Magnetic Fields,* exhibition, the perception which has remained unaltered during the past decade.

> Krauss and Rowell, on the other hand, are younger, they take Miró's art (i.e., his greatness) for granted. They treat him as an OLD MASTER, settled in history as a monument to be explored.[86]

And it is Miró's greatness, "settled in history," that we celebrate today.

NOTES

1. Hilton Kramer, "Month in Review," *Arts Magazine* 33 (May 1959): 48.
2. *The Hunter,* 1923-24, was purchased by The Museum of Modern Art, New York, in 1936. *The Tilled Field,* 1925, was in private collections in America, 1940-1972, and was purchased by The Solomon R. Guggenheim Museum, New York, in 1972.
3. Michel Leiris, "Joan Miró," *Little Review,* Spring-Summer 1926, pp. 8-9.
4. Henry McBride, "Modern Art," *Dial* 85 (December 1928): 526-528.
5. Daniel Catton Rich, *The Flow of Art: Essays and Criticisms of Henry McBride* (New York: Atheneum, 1975), p. 243.
6. Ibid., p. 243.
7. Ibid., p. 243.
8. Ibid., p. 243.
9. "Miró's Dog Barks While McBride Bites," *Art Digest* 4, no. 6 (December 15, 1929): 5,10.
10. Ibid., pp. 5, 10.
11. "Miró Exhibition: Valentine Gallery," *Art News* 29 (October 25, 1930): 11.
12. Robert Motherwell, "The Significance of Miró," *Art News* 59 (May 1959): 66.
13. Lloyd Goodrich, "November Exhibitions," *Arts Magazine* 17 (November 1930): 119.
14. "Art Roster: Comment on Recent Openings," *New York Times,* November 6, 1932, p. 4.
15. Edward Alden Jewell, "Works of Two Surrealists Offer Opportunity to Understand Them With a Struggle," *New York Times,* November 5, 1932.
16. Edward Alden Jewell, "Adroit Art Marks Large Miró Show," *New York Times,* December 30, 1933, p. 11.
17. Ibid., p. 11.
18. Ibid., p. 11.
19. "The Sincerity of Miró," *Art Digest* 8 (January 15, 1934): 13.
20. Edward Alden Jewell, *New York Times,* January 20, 1935.
21. Russell Lynes, *The Good Old Modern* (New York: Atheneum, 1973), p. 272.
22. James Johnson Sweeney, *Joan Miró* (New York: The Museum of Modern Art, 1941), p. 13.
23. James Johnson Sweeney, "Miró and Dali," *The New Republic* 81 (February 6, 1935): 360.
24. Ibid., p. 360.
25. Alfred Barr, *Cubism and Abstract Art* (New York: The Museum of Modern Art, 1936), p. 182.
26. John G. Frey, "Miró and the Surrealists," *Parnassus* 8 (October 1936): 13-15.
27. "Retrospective of Introspective Miró, Whose Dog Barked at the Moon," *Art Digest* 11 (December 1, 1936): 13.
28. Martha Davidson, "Subconscious Pictography By Joan Miró," *Art News* 35 (December 5, 1936): 25.
29. *Landscape by the Sea,* 1926 was misdated in the Davidson article.
30. Ibid., p. 25.
31. "Miró's Dog Barks While McBride Bites," p. 25.
32. George L. K. Morris, "Miró and the Spanish Civil War." *Partisan Review* 4, no. 3 (February 1938): 32-33.
33. Ibid., pp. 32-33.
34. Edward Alden Jewell, "Art Shows Given By Lie and Miró," *New York Times,* April 19, 1938.
35. "Do You Get It?" *Art Digest* 12 (May 1, 1938): 21.
36. "The Fortnight in New York," *Art Digest* 13 (April 15, 1939): 18.
37. Sweeney, *Joan Miró,* 1941, p. 13.
38. Ibid., p. 14.
39. Ibid., p. 14.
40. Ibid., p. 13.
41. Ibid., p. 53.
42. Ibid., p. 14.
43. Ibid., p. 79.
44. *Art News* 43 (January 15, 1945): 27.
45. "New Temperas and Ceramics by Miró," *Art Digest* 19 (January 1, 1945): 13.
46. Ibid., p. 13.
47. William Rubin, *Miró in the Collection of The Museum of Modern Art* (New York: The Museum of Modern Art, 1973), pp. 81-82.
48. Ben Wolf, "Miró Show, Delayed in Transit, Opens in New York," *Art Digest* 21 (June 1947): 10.
49. José Gomez Sicre, "Joan Miró in New York," *Right Angle* 1, no. 10 (January 1948): 5-6.
50. Francis Lee, "Interview with Miró," *Possibilities* no. 1, (Winter 1947-48): 66-67.
51. James Johnson Sweeney, "Joan Miró: Comment and Interview," *Partisan Review* 15, no. 24 (February 1948): 206-212.
52. Ibid., pp. 206-212.
53. Ibid., pp. 206-212.
54. "Miró and Modern Art," *Partisan Review* 16 (March 1949): 324-326.
55. Clement Greenberg, *Joan Miró* (New York: Quadrangle Press, 1948), pp. 8-9
56. Ibid., p. 26.

57. Ibid., p. 31.
58. Ibid., p. 37.
59. Ibid., pp. 40-41.
60. Ibid., p. 41.
61. James Johnson Sweeney, "Miró" *Art News Annual* 23 (1954): 187.
62. Ibid., p. 187.
63. Ibid., pp. 187-188.
64. James Fitzsimmons, "On the 'Peinture Sauvages' of Joan Miró," (New York: Pierre Matisse Gallery, 1958).
65. Ibid.
66. James Thrall Soby, *Joan Miró* (New York: The Museum of Modern Art, 1959).
67. Motherwell, op. cit., p. 65.
68. Ibid., p. 66.
69. Kramer, op. cit., p. 48.
70. Ibid., p. 48.
71. S[idney] T[illim] "New York Exhibitions: In the Galleries," *Arts Magazine* 36 (January 1962): 34.
72. Ibid., p. 35.
73. Ibid., p. 35.
74. Gene Baro, "Miró: A Leap in the Air," *Arts Magazine* 39 (October 1964): 38-43.
75. D[on] J[udd], "In the Galleries," *Arts Magazine* 40 (April 1966): 50.
76. C[harles] G[iulliano], "Miró, Fowl of Venus," *Arts Magazine* 42 (December 1967): 59.
77. Margit Rowell, *Miró* (New York: Abrams, 1971), p. 19.
78. Rosalind Krauss and Margit Rowell, *Joan Miró: Magnetic Fields* (New York: The Solomon R. Guggenheim Museum, 1972), p. 12.
79. Ibid., p. 11.
80. Ibid., p. 37.
81. Harold Rosenberg, "Miró's Fertile Fields," *Art International* 17 (Summer 1973): 19.
82. Ibid., p. 9.
83. Kermit Champa, "Miró" *Artforum* 11:61.
84. Thomas Hess, *New York Magazine* (January 1973): p. 66.
85. Ibid., p. 67.
86. Ibid., p. 67.

COLOR PLATES

1. THE ROSE. 1916. Oil on board, 30¼ x 29 in. (77 x 74 cm). Private collection, Geneva, Switzerland

2. STANDING NUDE
1921. Oil on canvas,
51⅛ x 37¾ in. (130 x 96 cm)
Altsdorf Foundation, Chicago

3. THE HUNTER (CATALAN LANDSCAPE). 1923-24. Oil on canvas, 25½ x 39½ in. (65 x 100 cm). The Museum of Modern Art, New York, Purchase

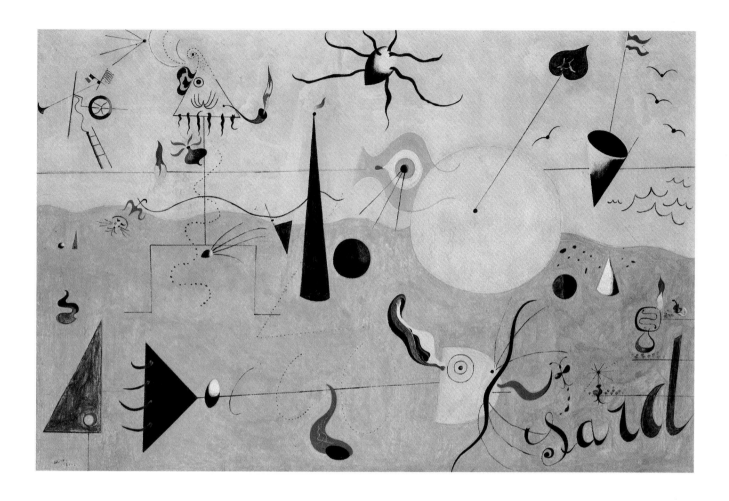

4. THE UPSET
1924. Oil, pencil, charcoal and
tempera on canvas,
36 x 28½ in. (91 x 72 cm)
Yale University Art Gallery,
gift of Collection Société Anonyme

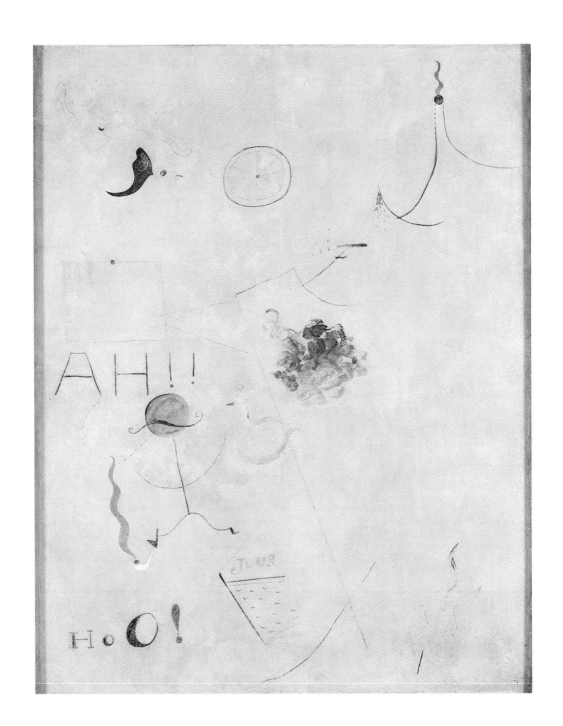

5. HEAD OF A CATALAN PEASANT
1925. Oil on canvas,
35⅞ x 28¾ in. (91 x 73 cm)
National Gallery, Washington, D.C.

6. THE RED SPOT
1925. Oil on canvas,
57½ x 44½ in. (146 x 113 cm)
Davlyn Gallery, New York

7. PHOTO: "THIS IS THE COLOR OF MY DREAMS." 1925. Oil on canvas, 38 x 51 in. (96.5 x 129.5 cm). Private collection

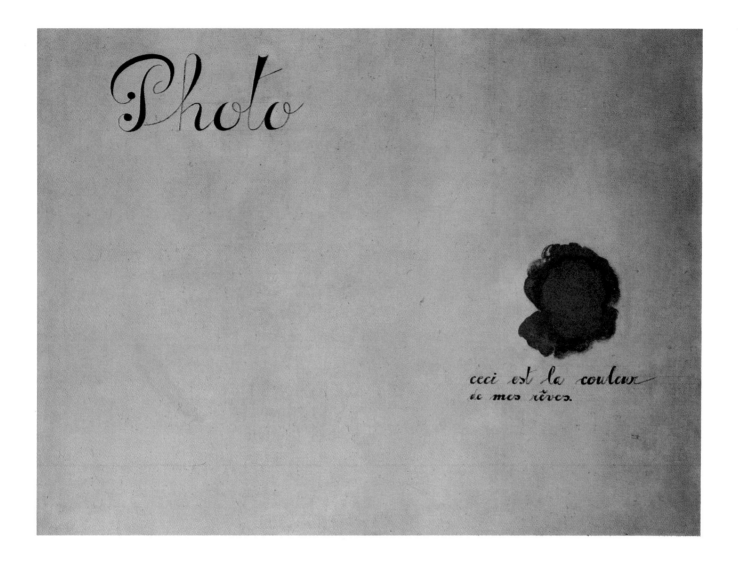

8. COMPOSITION. 1925. Oil on canvas, 39½ x 51¾ in. (100 x 130 cm). Harcourts Gallery, San Francisco

9. DOG BARKING AT THE MOON. 1926. Oil on canvas, 28¾ x 36¼ in. (73 x 94 cm). Philadelphia Museum of Art, The A. E. Gallatin Collection

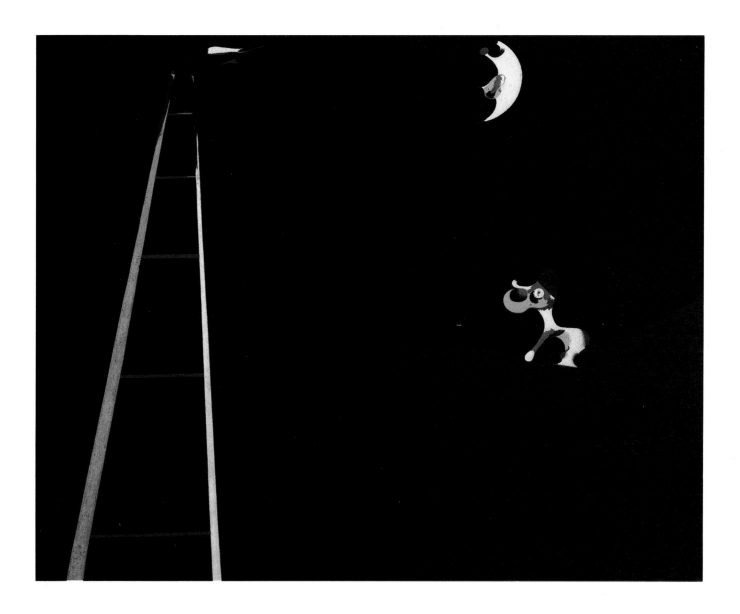

10. HORSE AT SEASHORE (or LANDSCAPE BY THE SEA). 1926. Oil on canvas, 26 x 36⅝ in. (66 x 93 cm). William R. Acquavella, New York

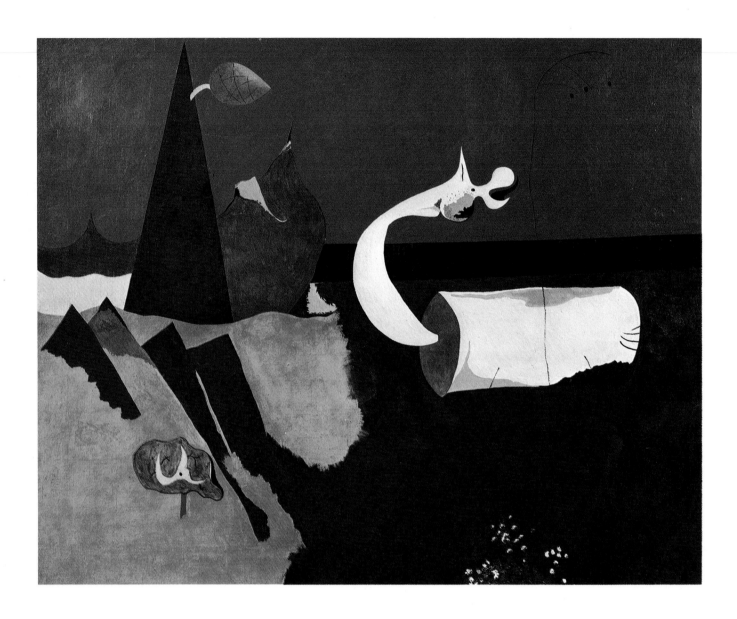

**11. PORTRAIT OF
MISTRESS MILLS IN 1750**
1929. Oil on canvas,
46 x 35¼ in. (117 x 90 cm)
The Museum of Modern Art,
New York,
James Thrall Soby Bequest

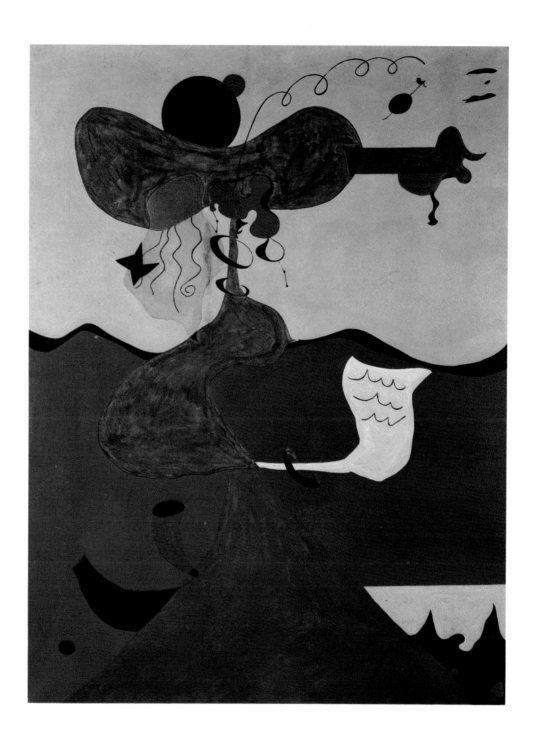

12. QUEEN LOUISE OF PRUSSIA. 1929. Oil on canvas, 31¾ x 39¼ in. (80.6 x 99.7 cm). Meadows Museum, Southern Methodist University, Dallas

13. PAINTING. 1930. Oil on canvas, 59 x 88⅝ in.(150 x 225 cm). Private collection, United States

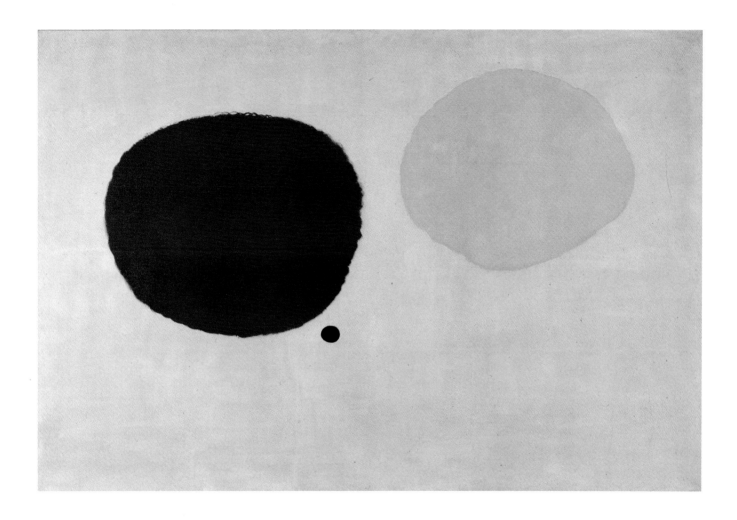

14. COMPOSITION
1933. Oil on canvas,
57½ x 44⅞ in. (146 x 114 cm)
Perls Galleries, New York

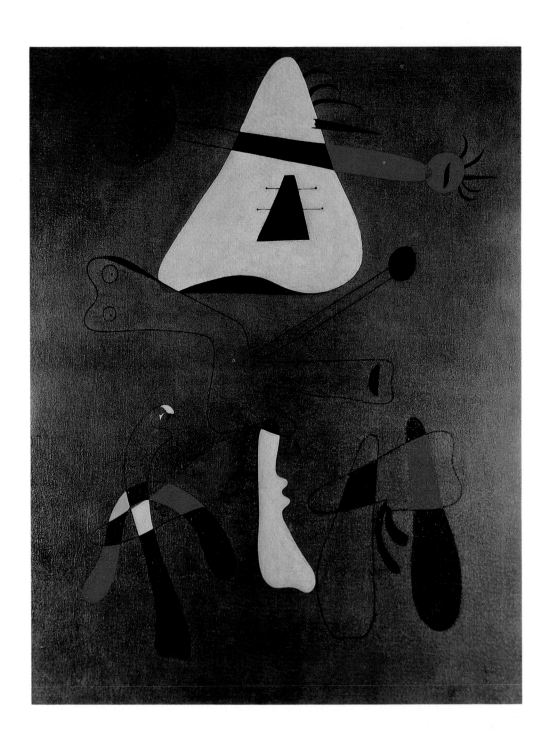

15. THREE PERSONAGES AND HEAD
1934. Ink and pastel,
18½ x 24¾ in. (47 x 62.6 cm)
Harcourts Gallery, San Francisco

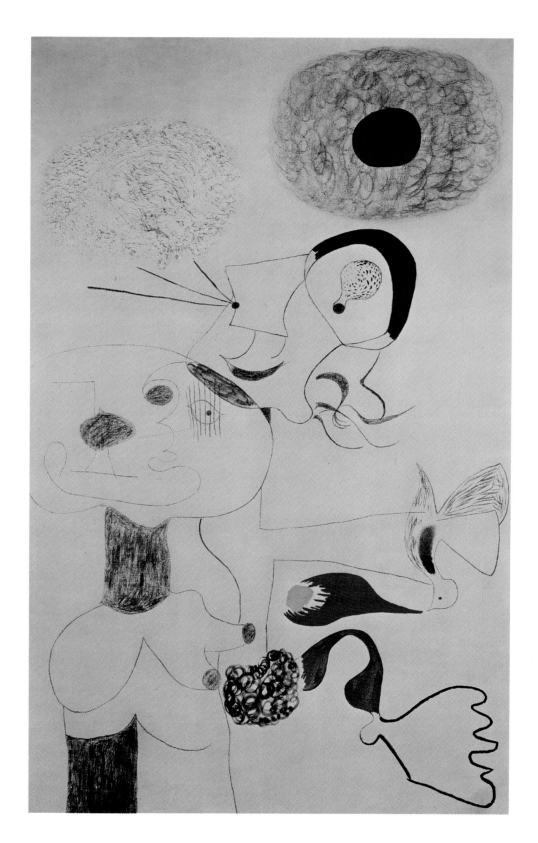

16. THREE WOMEN
1935. Oil on cardboard,
41¾ x 29½ in. (106 x 75 cm)
Acquavella Galleries, Inc., New York

17. PERSONAGES AND MOUNTAINS
1936. Egg tempera on masonite,
11⅞ x 9⅞ in. (30 x 26 cm)
William R. Acquavella, New York

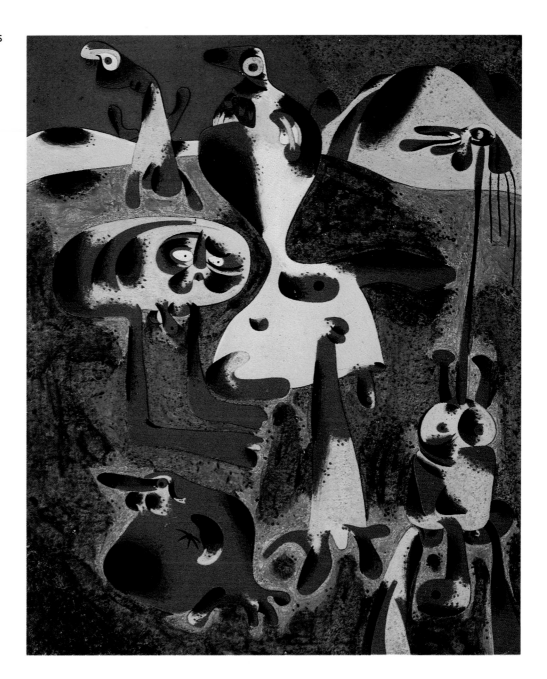

18. PAINTING ON MASONITE. 1936. Oil, casein, tar, and sand on masonite, 30¾ x 42½ in. (78 x 108 cm).
Collection of Mr. and Mrs. George Heard Hamilton, New Haven

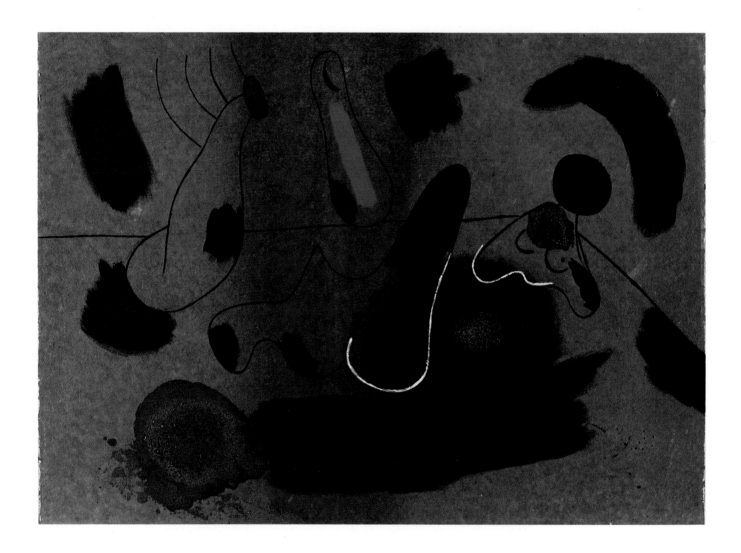

19. STILL LIFE WITH OLD SHOE. 1937. Oil on canvas, 32 x 46 in. (81 x 117 cm).
Collection, The Museum of Modern Art, New York, fractional gift of James Thrall Soby

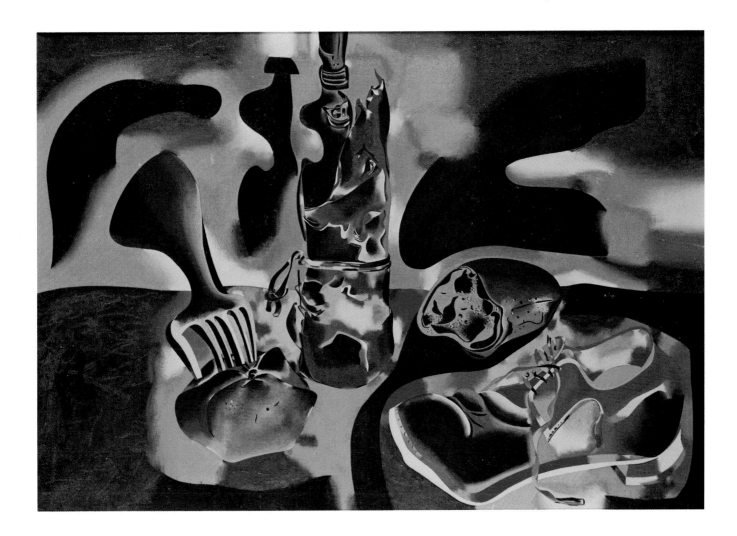

20. A STAR CARESSES THE BREAST OF A BLACKWOMAN. 1938. Oil on canvas, 51⅛ x 77⅛ in. (129.9 x 195.9 cm). Pierre Matisse Gallery, New York

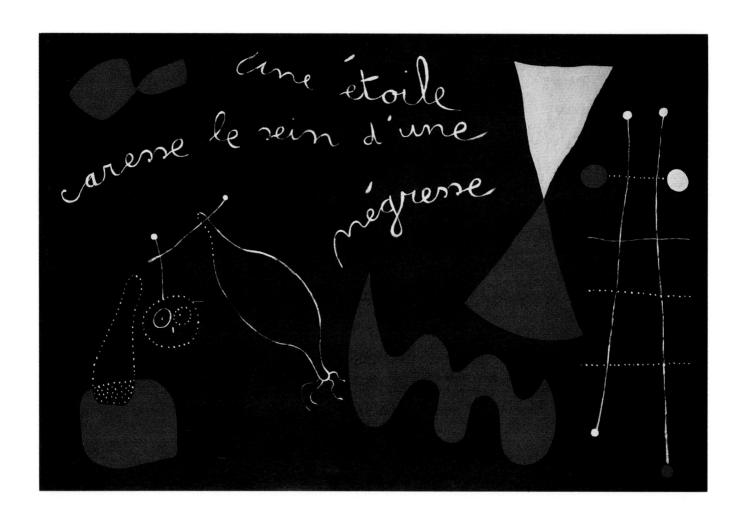

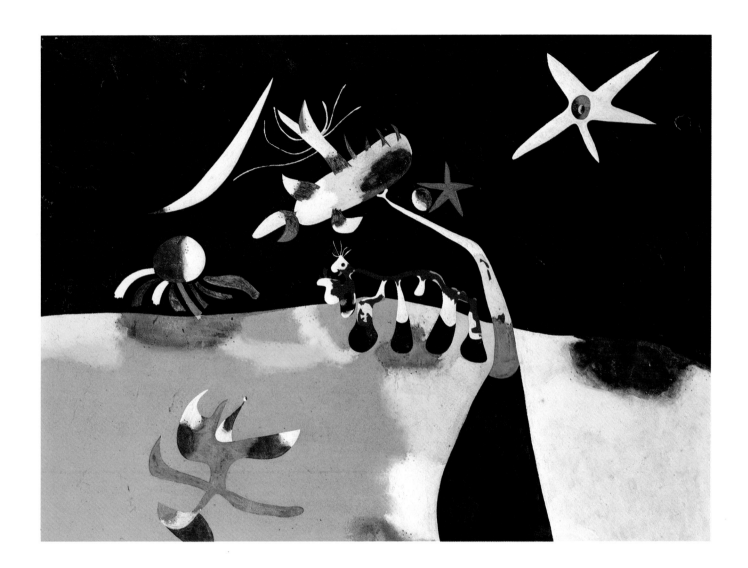

22. THE NIGHTINGALE'S SONG AT MIDNIGHT AND MORNING RAIN. 1940. Gouache and oil wash on paper, 15 x 18⅛ in. (38 x 46 cm). Perls Galleries, New York

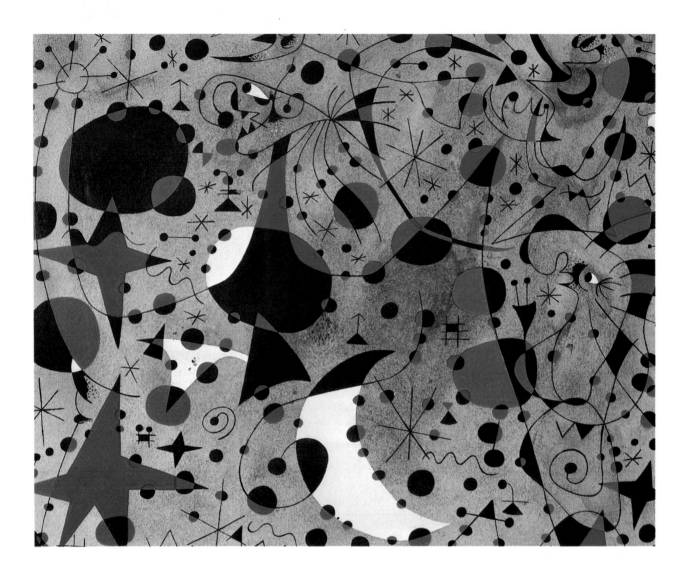

23. THE PASSAGE OF THE DIVINE BIRD
1941. Gouache and oil wash on paper,
18 x 14⅝⁄₁₆ in. (45.7 x 37.9 cm)
Private collection, United States

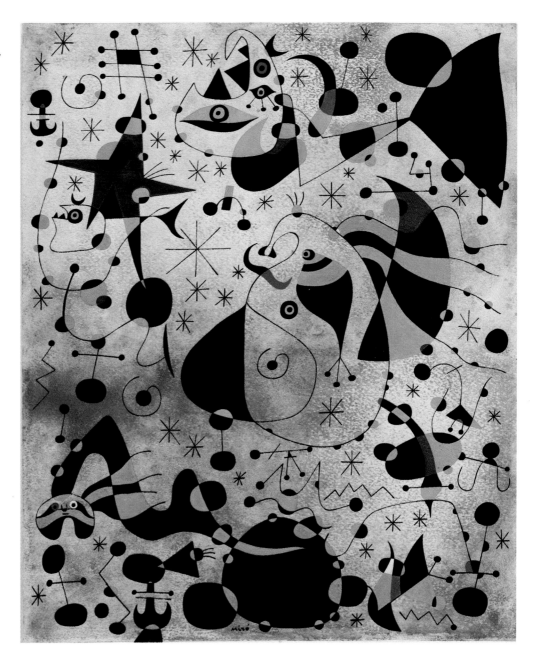

24. WOMAN, BIRD. 1944. Oil and watercolor on canvas, 14⅛ x 14⅝ in. (36 x 37 cm). Jeffrey H. Loria Collection, New York

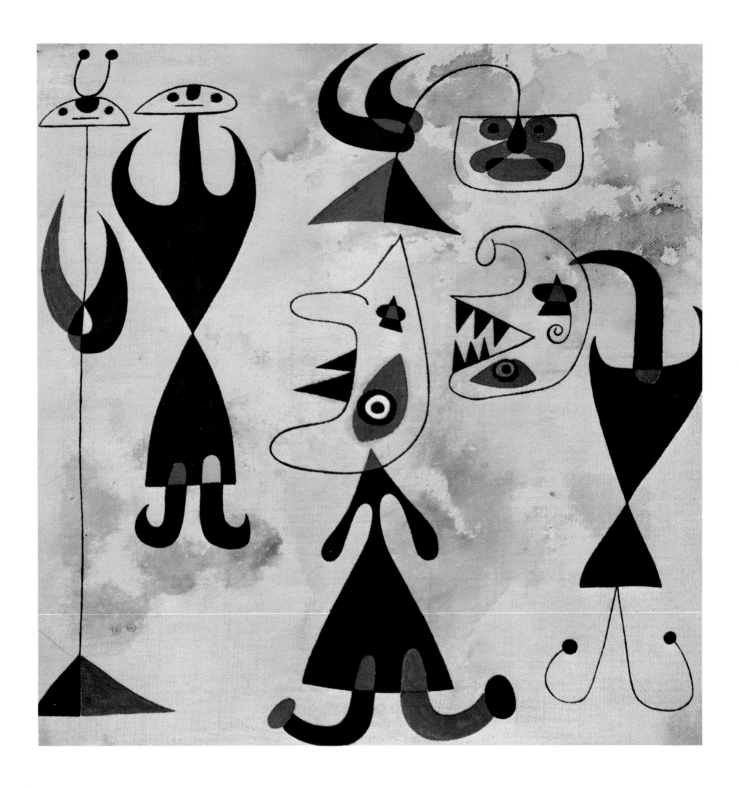

25. WOMEN IN THE NIGHT
1946. Oil on canvas,
14 x 12 in. (35.56 x 30.5 cm)
Jeffrey H. Loria Collection, New York

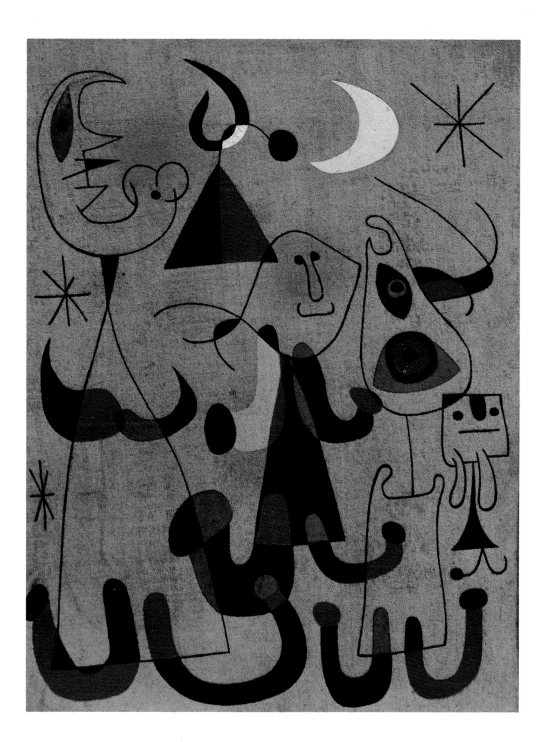

26. NIGHT. 1946. Oil on canvas, 23⅝ x 28¾ in. (60 x 73 cm). Collection of LeRoy Makepeace, Washington, D.C.

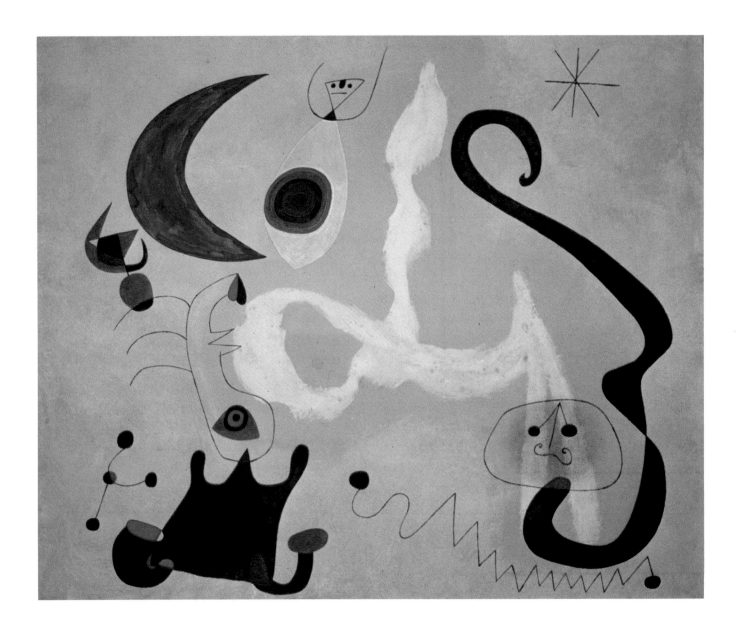

27. AT THE BOTTOM OF A SHELL. 1948. Oil on canvas, 29⅞ x 37¾ in. (76 x 96 cm). Private collection, Sara and Moshe Mayer, Geneva, Switzerland

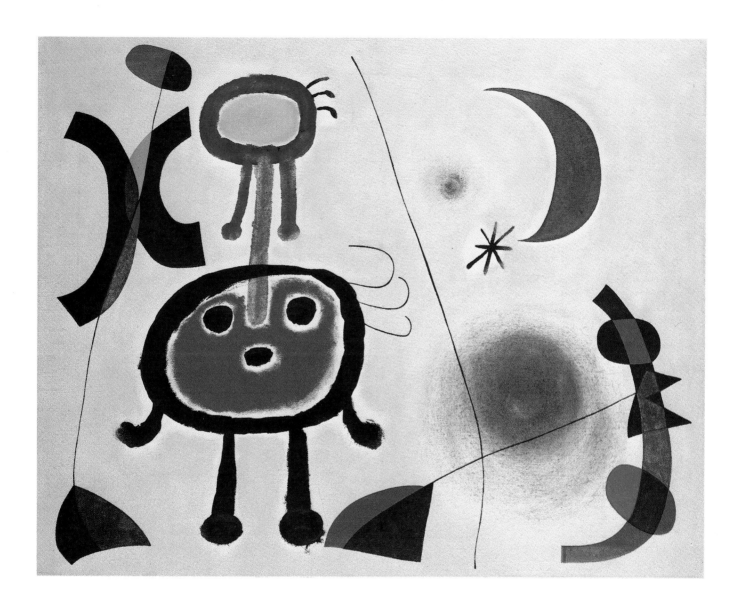

28. PAINTING. 1950. Oil on canvas, 32 x 39½ in. (81 x 100 cm). Collection of Mr. and Mrs. Gordon Bunshaft, New York

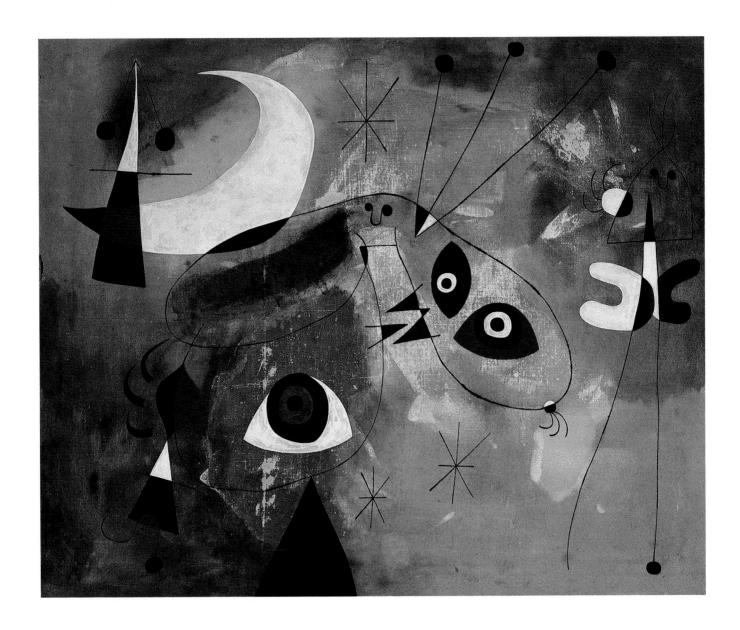

29. THE HALF-OPEN SKY GIVES US HOPE. 1954. Oil on canvas, 51⅛ x 76¾ in. (130 x 195 cm). Pierre Matisse Gallery, New York

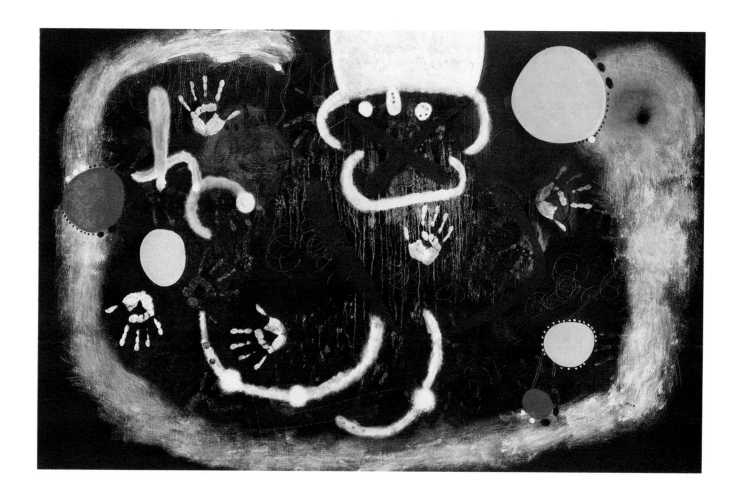

30. BLUE III. 1961. Oil on canvas, 106¼ x 139¾ in. (270 x 355 cm). Pierre Matisse Gallery, New York

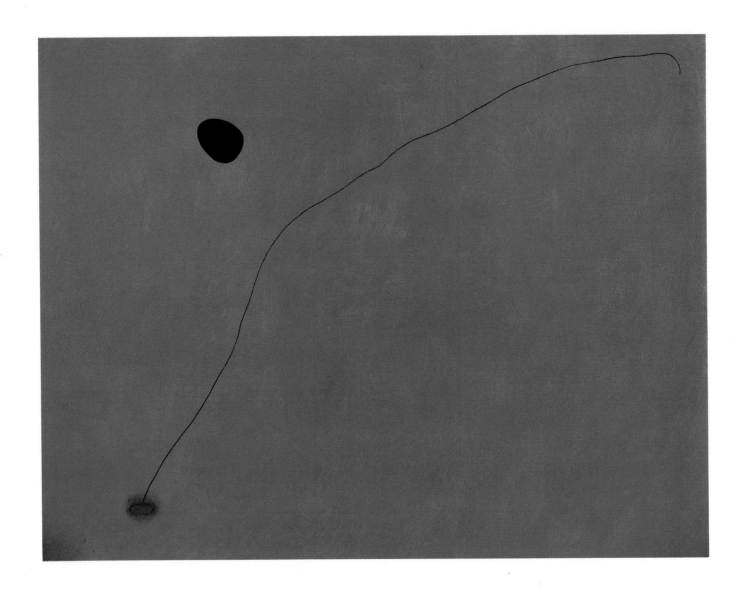

**31. HAIR PURSUED BY
TWO PLANETS**
1968. Oil on canvas,
76⅞ x 51¼ in. (195 x 130 cm)
Pierre Matisse Gallery, New York

32. BIRD, INSECT, CONSTELLATION
1974. Oil on canvas,
51 x 30 in. (129.5 x 96.5 cm)
Pierre Matisse Gallery, New York

MIRÓ'S PUBLIC ART

Excerpt from Macmillan's ''Miró's Public Art,'' 1982.

In 1929 and 1930, Joan Miró produced a series of assemblages which were exhibited in the 1930 group exhibition *La Peinture en Défi (Painting Challenged.)* The artistic descendants of these assemblages include two of Miró's latest pieces of public art: *Miss Chicago* and *Personnage et Oiseaux,* both sculptures. Miró's rejection of painting, symbolized by the assemblages, was not unique. In the introduction to the catalogue, Louis Aragon raised for the first time the cry that has frequently been heard since, ''Painting is dead.'' Aragon was proposing a new kind of art freed from all the implications of its status as property. During the next few years, André Breton developed the idea of a collective art for a new society, an art ''that would find again the natural, true and primitive originality.''[1] By the time Breton wrote that remark, Miró had embarked on his career as a public artist.

In the late twenties Miró became friends with the architect José Luis Sert, a fellow Catalan.[2] He and Miró talked endlessly about grand schemes for combining art and architecture. Their first collaboration was modest, however, or at least Miró's contribution to it was. Miró painted a small, irregularly shaped asbestos panel that was set into the wall of a domestic interior designed by Sert for an exhibition of the architectural group, Gatepec, in Barcelona in 1934. The painting was set in the surface of the wall in such a way that the painting was continuous with the wall. According to Sert, the intention was that the painting should look like a fresco. Then, as now, Miró profoundly admired the fresco paintings of the Catalan Middle Ages. In the *Catalan Notebooks* of 1940-41, he constantly ruminated

Fig. 55. Joan Miró. Cincinnati mural, 1947.

on technical methods that might approximate the effect of fresco in large projects, but here the "fresco" appeared in the context of a very ordinary dwelling. Sert's interior was not intended to be grand but was an example of the improvement in ordinary life that the proper use of an architect's skills could produce. The use of a "fresco" in such a context was a gesture in the true spirit of the Arts and Crafts tradition.

This small endeavor was followed three years later by Miró's first public work, the mural painting for the Pavilion of the Spanish Republic that Sert designed for the Paris World's Fair of 1937. In the same pavilion were Gonzalez' iron sculpture *Montserrat*, Calder's *Quicksilver Fountain*, and Picasso's *Guernica*.

Miró did not find a new opportunity for large scale painting until 1947 with the commission for the Cincinnati mural [fig. 55]. The Cincinnati commission arose from the desire of Jack Emery of Cincinnati to build a truly modern hotel, not, he admitted, out of any deep conviction of the essential value of the modern style, but out of a sound commercial feeling that in spite of his lack of sympathy with it, a hotel of the forties should be in the style of the forties.[3] To this end he retained as architects Skidmore, Owings and Merrill, who had never built a hotel before.

From the beginning the design included proposals for commissioning art. Emery and the architects favored American artists. The credit for suggesting Miró goes to Philip Adams, then curator of the Cincinnati Art Museum where Jack Emery was Chairman.[4] Adams asked Emery, "Why employ the imitators when you could get hold of the originals?" He suggested Miró, Braque, or Dufy. After considerable discussion, not least about price, Miró was chosen. The two other artists commissioned were Americans, Steinberg and Calder. An elaborate contract was drawn up between Miró and his dealer Pierre Matisse and Jack Emery's firm, Thos. Emery's Sons Ltd. It was signed on April 15, 1947. Miró was required to visit Cincinnati and submit a sketch by May 22. According to Philip Adams, when Jack Emery first saw Miró's sketch, his comment was, "My God, Phil, how do you tell a good Miró from a bad one?"

Though originally planning to paint in Cincinnati, Miró eventually decided to work in New York. There he shared the studio of Carl Holty.

Departing from the usual austerity of his color, Miró included the whole of the rainbow in his picture: red, yellow, orange, green, blue, violet. Painting his picture for the rooftop of a skyscraper, he started with the cerulean blue of the sky itself, and then what else is suggested by the arc of a circle in the sky, but a rainbow? An *arc-en-ciel*.

After completion on September 1, the mural was displayed at The Museum of Modern Art in New York before its installation in the Cincinnati hotel's rooftop Gourmêt Restaurant in early 1948. The painting occupied one quarter of the sharply curved wall of the circular restaurant. The other three quarters were glass, open to the sky. When it was in position, the right end of the picture was somewhat obstructed by a large pillar, bigger than was originally intended. When Miró visited the painting in Cincinnati in June 1952, he was noncommittal. The picture suffered considerably from being part of a busy restaurant, but although it was destined for the museum from an early date (certainly by 1959), it remained in place when the hotel changed hands in 1959 to become the Hilton Terrace Plaza Hotel. When undertaking alterations to the restaurant in 1965, the new owners transferred the painting to the museum.[5] The mural is now displayed in the museum on a shallower curve than at the restaurant.

Miró's next major public commission was the painting for the Harkness Law School dining room at Harvard University [fig. 56]. Walter Gropius, the architect for the project, supported by Alfred Barr, proposed Miró. The picture was painted in Barcelona and shipped to America. Once again Miró had a casual audience whose primary purpose was not to look at his picture, but who, nonetheless, might give it their attention at leisure. As at Cincinnati, it was an opportunity for a subtle and complex painting designed to intrigue and involve the spectator, not to persuade him by rhetoric. From Miró's point of view, the Harvard site had an added attraction. "The mural will enable me to establish close contact with the student, the young men of tomorrow. It is better to influence the young generation than try to convert stubborn old men."[6]

The dining room site, for all its advantages, proved an unfortunate one for the picture, as it had done at Cincinnati. When Miró saw the painting in 1959, he was very distressed by its condition.[7] After considerable discussion, it was agreed that he would replace the painting with a ceramic mural. The original picture was returned to Pierre Matisse and, in due course, sold to The Museum of Modern Art.

As previously, Miró prepared a careful sketch to scale. Sent to Harvard on March 15, 1950, the sketch bears quite a close relationship to the finished work, consisting of four separate figures against a softly modulated ground of gray paper. The picture reached

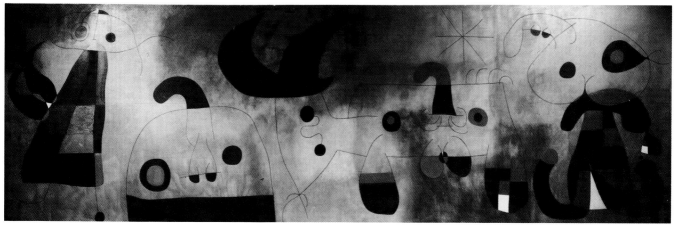

Fig. 56. Joan Miró. *Mural Painting,* 1950-51.

Harvard in July 1951.

The canvas was prepared with a scumbled ground color, modulating between green, blue, brown, ochre, and gray. We know that he considered carefully the site for his works. In this case, the finished picture was to hang near a long window overlooking a lawn, trees, and buildings. These ground colors may have been suggested by this immediate context.

The subject has been convincingly identified as a bullfight.[8] The figures, reading left to right, are the banderillero, the picador's horse, the bull, and the matador. If the picture does in fact represent a bullfight, then it is related to the painting *Bullfight* of 1945. In a gesture that suggests the significance of the painting to him, Miró presented *Bullfight* to the Musée National d'Art Moderne in Paris the same year that he painted it.

Connecting the Harvard painting to the *Bullfight* of 1945 links it to his discussion of this theme in the *Catalan Notebooks.* In *Notebook 6* he writes, "Let the banderillero be like an insect, the handkerchiefs like pigeons' wings, the horses' wounds like huge eyes." Again he writes, "Let these canvases be full of humor and full of poetry, like Jarry's writings."[9] In *Notebook 1,* which is devoted to the subject of the bullfight, he writes, "A hail of rectangular pieces of multi-colored paper heralding some event, unfolding like a flight of birds as they float into the arena."[10]

In all these points (except the pigeon's wing which seems not to appear in either picture), the Harvard picture is closer than the 1945 painting to the original notes in which Miró first explored the bullfight theme. The banderillero is notably insect-like, particularly in the sketch. The horse's wounds become wounded eyes,

gazing out reproachfully. The multi-colored rectangles do not appear as pieces of paper but have coalesced into the matador's cape and the bull's hind leg, which in turn suggest the checkered pattern of the costumes of the matador and banderillero. Again, this rectangular patterning is particularly noticeable in the sketch. Finally, the picture puts one far more in mind of Jarry than the earlier version of the theme. Both the lugubrious horse and the inflated pride of the matador are reminiscent of the characters in Jarry's *Ubu Roi.*

If this connection is established, it has further consequences. Running through the *Catalan Notebooks* is a preoccupation with large compositions, and at one point Miró refers specifically to *Guernica.* In the *Daphnis and Chloe Notebook* he wrote, "Do a large canvas embodying memories of the wars I have lived through . . . This canvas should have nothing of the theatrical side of *Guernica.* Only the impact of the tragedy."[11] He says that this picture should be a very big one, and then mentions *Guernica* again twice. After describing a working process identical to that which he adopted in painting the Cincinnati picture, he concludes, "This is a procedure quite different from Picasso's, for he started from reality and I will start from the spirit and white surface of the canvas."[12]

The link between the bullfight theme and *Guernica* is confirmed by analogies between some of the early drawings and Picasso's composition, analogies which are continued in the 1945 painting. The figure of the bull with head erect and horns raised high appears in Picasso's picture and both of Miró's. In Miró's *Bullfight,* the horse with its head thrown back, mouth open, and teeth showing relates to the screaming woman to the left and beneath the bull in *Guernica.* Again in Miró's

picture, the matador's turned-back head and arrow hand echo the shape and attitude of the woman on the right in *Guernica*. In the Harvard painting, by giving prominence to the horse and to the relationship of the horse and bull, Miró comes once more close to Picasso's composition.

It may have been with this relationship in mind that Miró remarked cryptically about his painting at Harvard that it was "of muralistic and poetic significance."[13] He also said that the picture was "a capital work [which] summed up all my research." As he had already reflected so deeply on *Guernica* and on the theme of the horse and bull, it was to be expected that in turning to this theme again, on a monumental scale to match Picasso's painting, that he should still have Picasso in mind. But the most striking relation between his picture of 1951 and his reflections on *Guernica* of 1940-41 is not in any of these detailed connections. It is in the mood of the whole composition. His main criticism of *Guernica* was its theatricality; his own canvas is extraordinarily still. Only the banderillero seems to be moving. Everything else is static.

Only once since 1951 has Miró used a painting for a permanent location. That was in 1975 for the auditorium of the Fundació Miró. It is on the sounding board above the rostrum. In its imagery, the painting is closely comparable to the later ceramic walls, but it has an additional delightful element. Miró painted the ceiling picture on the ground and walked all over it with his bare feet. There on the ceiling in the auditorium are his black footmarks, his self-portrait, or at least his signature.

On other occasions, he used painting as a deliberately impermanent medium. For exhibitions in Barcelona in 1969 and Osaka in 1970, he painted pictures which were destroyed at the end of the exhibitions. In Barcelona, the occasion was of special importance. Held at the College of Architecture, the exhibition was called *Miró-Otro (The Other Miró)* and was counter to an official exhibition. Miró painted on the windows of the building over a ground of paintings done by the young organizers of the exhibition. This was, therefore, a cooperative picture. It was also a gesture of solidarity with the young.

In the two great paintings of 1947 and 1951, Miró's mistrust of the medium of painting as a means of expression is not apparent. Their stunning beauty is obvious. That, however, was not enough. In turning to ceramics, Miró could create his marvelous imagery out of the earth itself. Ceramics also gave him an opportunity to realize his ambition of a cooperative art, working first with Llorens Artigas, then with Llorens and his son, Joan Gardy Artigas, and, after Llorens' death, with Joan Gardy.

Throughout the Iberian Peninsula, the ceramic tradition has always been strong. In their informality, Catalan ceramics are remote from the life-denying perfection of the classic European porcelains of the eighteenth and nineteenth centuries. In Catalonia, the ceramic tradition was never wholly distinct from the still vigorous folk tradition that Miró has frequently acknowledged.

In turning to ceramics as a monumental idiom, Miró was conscious of the precedent of Gaudí, who used broken pieces from the ceramic workshops of Barcelona to create a style of architectural decoration that Miró has used several times. He paid homage to Gaudí in his account of the creation of his first great ceramic walls.

Invited to contribute to the decoration of the new UNESCO building in Paris, Miró suggested ceramic walls and was given the commission in 1955. Peter Bellew, coordinator of art at UNESCO, said in conversation that there had been nothing quite like Miró's ceramic walls since Persepolis. Although pictorial ceramic decoration is common enough, particularly in Spain, it is difficult to find a precedent for the stunning ceramic walls created by Miró and Artigas in their first joint monumental project.

Miró put a great deal of thought into the UNESCO walls.[14] He has described how he studied the building and talked with the architects and workmen. He was determined to make his work fit its environment. The immense concrete walls suggested to him his two images: the great red sun and the blue moon. Actually, the sun may have been suggested initially by the fact that UNESCO architect Marcel Breuer had planned his building on an arc following the sun. It would have been uncharacteristic, however, if Miró had not seen the sun as a symbol of a hoped-for new worldwide order of social and cultural harmony.

The walls are built of stone glazed bricks or tiles. The ground color was fired onto the tiles before Miró started work. Separate firings followed for each color: black, red, green, blue, and yellow. The red was a particularly remarkable achievement of Artigas' technical skill, though of course the effects of the colors could not be seen until all the firings were complete. The disc of the sun and the crescent of the moon are actually cut into the surface of the wall, thus

increasing their definition and impact.

Miró has always approached public art with a profoundly considered sense of purpose and with careful reflection upon the particular place and occasion for which his work is intended. He constantly stresses his involvement in *la matire,* the substance of his art. This he sees as a natural consequence of automatism.[15] His involvement in *la matière,* "the material," corresponds to his belief in the significance of the metaphors of technique, following his collaboration with various craftsmen.

There is not space here to discuss in detail all the ceramic walls that Miró has designed in the years since 1960, though together they constitute one of the most remarkable achievements of any artist of the twentieth century. He himself has given an account of his working method.

> Clearly, I work directly on ceramic floor tiles. I begin by making a maquette, which puts me into a spiritual frame of mind. But the finished product may have no resemblance to the maquette. I do it to put me into the mood and to explain to Joanet Artigas how I wish him to prepare the tiles. It requires, first, a preparatory coat on which I will draw. I draw, flatly. But first, I reflect a great deal. When my maquette is ready, I inform Joanet; I tell him in which spirit I wish him to prepare the ground; we discuss it; we agree. When he has prepared the tiles, I go to Gallifa; I look

all afternoon; then I go to bed. During the night, I think about it, and the next day, early, I attack! We do not lunch until the first stage is finished. If it is four hours, so much the worse! Then we lunch; I take a short siesta, and I look over what I did that morning. I reflect. And the morning of the next day, if it is necessary, I rearrange some things. I stop myself to make the construction of the design, and I indicate the colors with small samples, which I spread out on the ground — because in ceramics one does not see the colors; before firing, black is a little maroon, green is straw-colored . . . One works like a composer who composes a movement of music. It is like lithography, too, where you only work with black.[16]

The walls can be divided into two categories: those on which Miró worked directly in the manner that he has described and those which, because of their size, had to be executed from maquettes.

Within the first group, two walls use writing as part of the decoration. For the Business School at St. Gall, Switzerland, in 1964, Miró created a long, narrow frieze of mystic writing. It recalls the role of writing in his earlier work and the inspiration of the *Calligrammes,* which led to his exploration of the relationship between writing and drawing. The manner of execution suggests the inspiration of Japanese and Chinese calligraphy in which the graphic dynamism of the characters conveys a message even without our

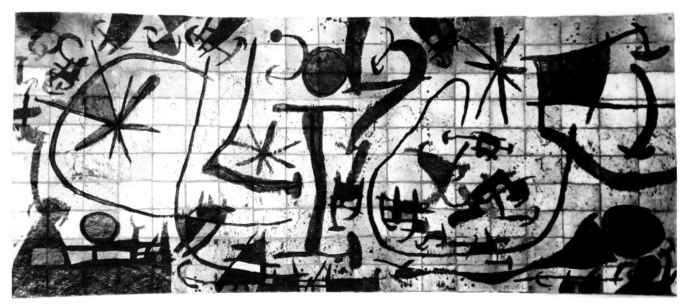

Fig. 57. Joan Miró. *Alicia,* 1967.

knowing the specific meaning of each character.

In 1967 Miró turned again to writing for his imagery to create a wall in the Guggenheim Museum in memory of Solomon Guggenheim's wife, Alice [fig. 57]. The wall that he produced is a visual elegy on the letters of her name, Alicia. Around the main letters are strange, floating, secondary shapes that suggest cuneiform writing, the oldest writing in the world. Of the use of writing in his later works, Miró said it was the plastic function of the word, rather than its meaning, that interested him. Here, the name retains its meaning but not as an isolated statement. It is like a page of an illuminated manuscript. Properly realized, the text and the decoration cannot be separated, for the illumination is richer in meaning as a single creation than the sum of its separate elements. The whole structure of this work is reminiscent of the design tradition to which Miró owed so much.

The other relatively small walls are located in Vence, France (1968), Osaka (1970) [fig. 58], Zurich (1971-72), Barcelona (1976), and Vitoria, Spain (1972). Their freedom is dramatic. The black is applied with a brush, a watering can, and even a bucket to achieve the desired dynamic fluidity. Through the shifting net that this creates, the imagery evolves and disappears.

In Osaka and Zurich, eyes suggest living presences in a tangle of experience. Miró has said the eyes in Romanesque frescoes suggest that the whole world is looking at you. "For me, the whole world is living."[17] The eyes suggest this omnipresent life. In Osaka, the tangle becomes a labyrinth. In Zurich, the eyes suggest birds' and peacocks' tails.

In the wall of the Fondation Maeght at Vence, a female figure is seen in a tangle of creatures. In the I.B.M. Building wall in Barcelona [fig. 59], these creatures struggle into being, indifferent to human presence. They rise above a long, horizontal black line that cuts across the picture field. This line was dictated by the position of the receptionist's desk, which stands in front of the wall and becomes, in the image, the flat level of a primeval swamp.

Three very large ceramic walls are at the Hack Museum in Ludwigshafen, Germany, the Barcelona Airport (1970), and the Palace of Congresses and Exhibitions in Madrid (1980) [fig. 60]. In each case Miró prepared a large maquette as a guide for himself and his colleagues. The sheer vastness of the projects restrained his usual spontaneity and forced him to work closely to the maquette. Measuring 10 x 50 meters and including nearly 5,000 separate pieces, the Barcelona

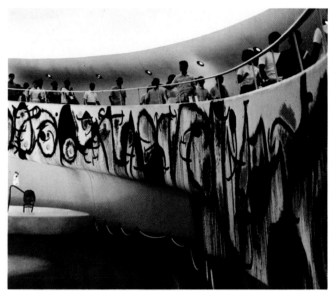

Fig. 58. Joan Miró. Osaka mural, 1970.

Airport mural consists of great curving lines which enclose solid areas of color. The shapes and colors are reminiscent of the picture, *Catalan Peasant by Moonlight,* which was painted about the same time as the maquette, suggesting that the powerful swinging shapes beneath the single star represent peasant and landscape. The Madrid mosaic is similar in execution to the Barcelona Airport mural, but more open in design. Of the three, the most remarkable is the Ludwigshafen wall. This is an extremely complex image, and, considering its scale, it is executed with great freedom. It suggests a vast world of creatures struggling into realization, a great arching panorama of animation.

The remaining work to be discussed in the context of Miró's ceramics does not fall strictly into that category. The Ramblas pavement in Barcelona [fig. 61] is made of vitrified bricks. The street where the citizens of Barcelona stroll up and down in the evening, the Ramblas is the main artery of the city's social life. Nothing could be more remote from the deep-freeze of museums. Miró's art has become a part of the people's environment that neither asks nor needs separate appreciation. Nor does it need to be read. Sert said the obscure imagery in a Gothic cathedral has meaning as part of the ensemble, even when it is not understood intellectually.[18] In keeping with his idea, Miró has created a condensed pictogram. In the fourteenth century, Ambrogio Lorenzetti used a chain of dancing figures as the focus and symbolic image in his fresco,

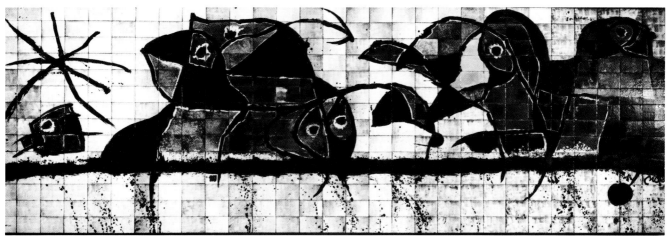

Fig. 59. Joan Miró. I.B.M. ceramic wall, Barcelona, 1976.

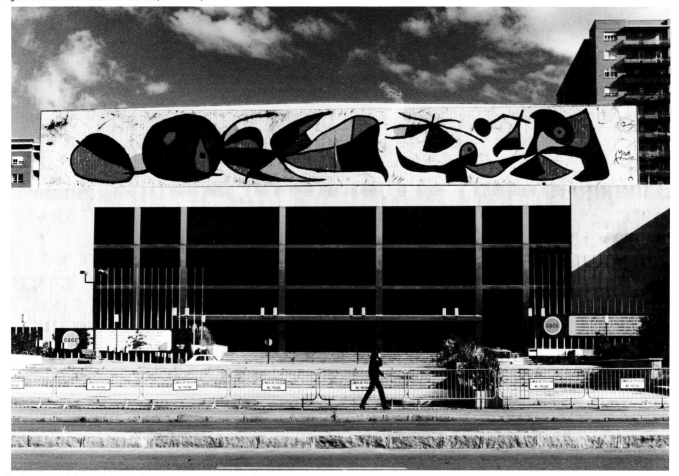

Fig. 60. Joan Miró. Mural for the Palace of Congresses and Exhibitions, Madrid, 1980.

Good Government, in the Palazzo Pubblico in Siena. It is difficult to imagine any more telling actualization of this figurative image than the Catalan national dance, the sardana. It transcends governments, good or bad, as a metaphoric enactment of social harmony and unity. The outer edge of Miró's pavement is the circle of the sardana. It has the size and the small irregularities of form and rhythm of a circle of thirty or forty dancers. Within this circle of the greater community are four smaller circles, and the whole composition is cut across by a tense, curving arrow. Either by coincidence or direct reference, Miró has used an image of Paul Klee. In Klee's *The Thinking Eye,* the circle and arrow are described as an image of the "developed cosmos."[19] Klee frequently uses the image of the arrow, as Miró has used it here, to suggest evolving energy.

Before considering Miró's sculpture, there is another branch of two-dimensional art to consider: stained glass windows. The two windows at the Fondation Maeght in Vence are Miró's only productions in this medium so far, but he is currently working on a suite of eighteen windows for the Church of St. Flambourg near Paris. Stained glass is a medium to which he might have been expected to turn earlier for several reasons: his frequent use of color outlined in black, his acknowledgment of the inspiration of stained glass in the *Catalan Notebooks,* and the importance of stained glass in medieval art. Also, Gaudí created beautiful stained glass windows that were probably an inspiration to Miró. His first two stained glass windows are very lovely, and when the current suite is completed, stained glass will surely take its proper place among his public works.

The best way to approach Miró's sculpture is to consider it in the context of his other work. Never is this seen more clearly than in the Labyrinth at the Fondation Maeght. For all the variety of work that the Labyrinth contains, it can be called a single work, and it is one of the most complex and delightful of all his public works. It is like entering one of his paintings. Largely created between 1963 and 1968 for Aimé Maeght on a hillside above Vence, the Labyrinth was, characteristically, a cooperative effort. Miró worked with Sert, his constant collaborator in such projects; the Artigases, father and son; and a whole series of artisans, ranging from bronze casters to a family of Algerian refugee wallbuilders.

High above the Labyrinth on a tower of the main building is a strange, three-footed bird turning its head

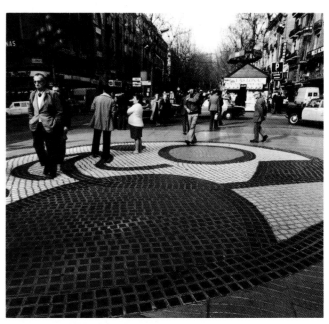

Fig. 61. Joan Miró. Ramblas, Barcelona, 1976.

to the sky. This bird was created out of sheet metal from a small terra cotta in 1968. At either end of the Labyrinth are two of his most monumental creatures. The *Oiseau Lunaire* in white marble guards the entrance; at the further end is a great concrete *Arch-Personnage.* Just outside the Labyrinth, as though it were flying in to land, the *Oiseau Solaire,* also in marble, stands on a high pedestal where the land drops away outside the garden. This gives the effect of its being in free space, but at eye level.

These last three images are of special importance to Miró, and they exist in numerous variants. The *Oiseau Lunaire* stands in the garden of the Rue Blomet to commemorate his early days in Paris, and he is currently working on a variation of the *Arch* to be the *Gateway to Catalonia* at la Jonquera, a project in cooperation with Sert. The *Oiseau Solaire* appears in several sizes and media. All three of these creations began as small clay models during his first period of making ceramics. They represent a different response to the possibilities of that medium, the transformation of earth, not through fire, but through the water that makes clay malleable.

In the *Catalan Notebooks,* looking at new possibilities, Miró wrote:

> Starting to do some sculptures at Montroig, I have regained contact with the earth, and that will give

me, in the deeper sense of the word, a more human and direct awareness of things — sculpture done in the country in these circumstances will not be tainted with superficiality or artifice, as it might well be in town, deprived of direct elements, with the danger of its being the work of a sculptor who cannot get beyond that one art form, like a specialist in engraving who cannot get beyond engraving.[20]

The creatures that are among Miró's earliest sculptures follow this ideal. They are, therefore, truly telluric, as they have been described by Jacques Dupin. They are of the earth, and they have heavy solid feet to retain their contact with it, yet as bird or arch, they reach above it. All three are bull-like, vaguely threatening creatures with crescent horns. The *Arch*, which is a giant personage with a face, is very close indeed to the bull figure in the Harvard mural, while the *Oiseau Lunaire* is clearly related to the Minotaur and is aggressively sexual. These are the creatures of the subconscious in which all levels of experience are united. Fierce and strange though they are, meeting them in the Labyrinth we can perhaps come to recognize our kinship with them.

The other images in the Labyrinth include a wonderful series of gargoyles, a lizard that could have stepped out of a Catalan fresco, a strange sausage-shaped male/female object that floats in space, a great *Egg*, and a marble *Fish*, each adorning a pool. The dominant imagery of the series of more than a dozen sculptures in the Labyrinth arises from the imagery of the clay objects Miró produced from 1944 to 1956. These sculptures are a group of earth-related images, even though, like the *Fish* or the *Oiseau Solaire*, they may be separate from it.

Two among the most notable images are different. Completely earthbound, the *Dèese, or Mother Goddess*, is a large bronze, a variant on a theme that goes back to 1949 and appears variously as *Femme, Maternity* and *Dèese*. In each case the image is a squat, limpet-like figure, usually conical and placed on a broad base that hugs the earth. The figure is dominated by a gigantic female sexual organ, in the case of *La Dèese*, doubly marked for fertility by a leaf. Her buttocks and breasts are short, stumpy protuberances, while her head and arms are male sex organs reduced by her potency to drooping appendages. She is an extraordinary creation, binding femininity to the earth and Miró's art to the earliest imagery of man in his remotest origins.

The other exceptional image is radically different from the *Dèese*. Standing against the sky where the screen

of trees parts to give a breath-taking view over the valley to the southwest is *La Fourche (The Pitchfork)*, a wooden peasant's fork cast in bronze and held in triumph on a quadrant which is pierced with a circle and mounted on a slender tapering iron column. Of all Miró's monumental works, this is the most formal and austere, and yet the pitchfork itself is one of the most specific and least ambiguous objects in his sculpture. Though raised against the sky, it still cannot be anything but a humdrum object of physical labor in the fields. The extraordinary effect of this sculpture is that the pitchfork remains concrete and yet is elevated into something transcendental like an object in a Van Gogh still life. Each point of contact between the pillar and ground, the quadrant and pillar, and the pitchfork and quadrant is as slight as possible, and all three parts of the sculpture point towards the sky. The shaft of the pillar has unformed lumps of iron sticking to it, as though they were traces of the earth that it is leaving behind. The whole image is scarcely anthropomorphic, but seen against the descending sun, the quadrant becomes a majestic eye of unbending gaze, and the pitchfork with its five prongs resembles a hand.

The pitchfork is an important symbol for Miró. He used it directly in several sculptures, and, in a modified form, it became the crowning element in *Miss Chicago*. As seen at Vence, the pitchfork is one of the noblest statements of an idea that is essential to understanding his art, namely, the elevation of the ordinary, the transformation of the base into the transcendental.

The three very large sculptures for which Miró has been responsible are, in chronological order, the work at La Défense, *Miss Chicago*, and the Houston *Personnage et Oiseaux*. Each belongs very roughly to one of the three groups identified in the Vence Labyrinth. The work at La Défense, whose full title is *Couple d'amoureux aux jeux de fleurs d'amandier (Lovers by the blossoming almond tree)*, belongs to the telluric or earth-based, upwards aspiring creatures like the *Oiseau Lunaire*. Like the works in that group, it was made originally in clay. Even polychromed and standing nearly forty feet high, the work retains the twist and pinch of the artist's thumb. One of the two figures still has the horns of the bull-bird, but there the similarity ends. These two extraordinary creatures have burst through the concrete. They are something primeval from the earth, pursuing their own strange, amorous dance, defying the inhumanity of the barren rectangular world of La Défense like the flower of the almond tree in February, bringing back astonishing life

and color to the barren landscape of winter. Nowhere can one see more clearly how Miró conceives his monumental art, not as simply framed by an appropriate setting, but actively participating in the creation of a humane environment.

Miss Chicago [fig. 62] is first cousin to *The Pitchfork*. Both images stem from a combination of fabrication and found object. More importantly, both share an emphatic verticality which associates them with a small group of works known from the start as *Studies for a Monument*. But again the differences are profound. *The Pitchfork* is distinctive in its specific, concrete imagery. *Miss Chicago*, on the other hand, is hieratic, mysterious, and remote. She relates directly to the small group of found object assemblages of 1954, the projects for a monument. In fact, she still has the inverted hook for a nose and eyes that appears in several of these, and her concrete base, decorated with ceramic, derives from their painted stone and ceramic bases.

Miró created *Miss Chicago* for a 1967 commission from Skidmore, Owings and Merrill in Chicago. Miró visited the site and was excited by the proposition, but then the project fell through. For a number of years he tried to find a site for his sculpture in Barcelona. During that time the studies were known as projects for a monument for the city of Barcelona, and in the end he did place a twelve-foot-high version at the Fundació Miró. Like *The Pitchfork* at Vence, it stands against an open vista, silhouetted against the sky. Eventually, however, the Chicago project was revived, and the full scale sculpture was installed there in 1981.

Miss Chicago is guardian of a mystery, a priestess figure strongly suggestive of the hieratic priestess figures of the ancient Mediterranean and their descendants among the Majorcan xiulets, painted terra-cotta figures of Majorcan folk art. Yet she is also just Miss Chicago, the beauty queen, an ordinary girl transformed for a day or two by the lottery of a beauty contest. By elevating a little clay and some pieces of junk to the monumental, Miró has given us the transcendental in the ordinary.

Miró's original collage/assemblages defied the power of good taste to classify things into worthy or unworthy of attention, into good or bad. In *Miss Chicago* he has extended this transformation of the object into a demonstration of human significance.

The same idea gave rise to the extraordinary sequence of bronzes begun in 1967 to which the original model for the Houston *Personnage et Oiseaux*

belongs. Miró was in his mid-seventies when he began these bronzes, and in a few years he produced a body of work which many artists would be more than happy to see as a lifetime's achievement.

Like the projects for a monument which gave rise to *Miss Chicago*, these bronzes can trace their origins to the assemblages of 1929 and 1930. At first sight it seems inconsistent, even exploitative, to turn into bronze, the supreme academic metal, assemblages whose origins lay in the rejection of good taste. However, the antiquity of bronze is such that it pre-dates all canons of good taste. Moreover, the metaphor of process explains Miró's intention. Heat works on bronze like the artistic imagination on inert matter. Transformed into a fluid, bronze fuses disparate objects and creates in them a new unity and new life. Bronze is a metaphor for the discovery of life in the object that the artist touches.

Jacques Dupin did more than brilliantly focus the difference between Miró and Picasso when he wrote of

Fig. 62. Joan Miró. *Miss Chicago*, 1981.

their ways of using found objects.

> Any object that makes Miró stop and admire it is unique. He contemplates it with devotion. It possesses, in his eyes, magic virtues of its own; it becomes sacred. This attitude towards the object is the very opposite of Picasso's. The latter plays with objects he picks up only to assert his own demi-urgic powers over them, his virtuosity, his talents as a prestidigitator. He at once subjugates, denatures or transfigures whatever he touches. Miró, on the other hand, wants the piece of iron to remain a piece of iron, the root to remain a root — he wants to keep their natural magic powers intact. Like a primitive man, he marvels at the evocative — more accurately, the mediating — power of the thing in its natural state . . . Miró's relation to objects is one of secret communication with the world of nature.[21]

In his 1930 introduction to *La Peinture en Défi,* Louis Aragon identified the metamorphic property of assemblage with Ovid's interpretation of the role of metamorphosis in primitive society: the discovery of the marvelous in the ordinary. In Miró's hands, assemblage continues to have just this capacity, only enhanced by the second transformation of assemblage into bronze.

From these transformed objects, Miró produces *personnages,* women, birds, and combinations of all three. These new creations are invested with the mysterious animation of the artist's touch and yet retain an unbreakable link with the ordinary. They become a metaphor for the infinite variety and absolute particularity of human individuality. It may seem a remote comparison, but the artist to whom Miró comes closest in this is Peter Bruegel, founder of the anti-ideal tradition. Passionately rejecting all idealization, he puts human nature in the real world, while declaring that individuality is unique and irreducible. This comparison sets Miró in a perspective that includes the whole of western art, not just the events of the last eighty years. It is in this perspective that his achievement must be seen. On another count, Bruegel is relevant. In the extraordinary painting, *The Blind Leading the Blind*, he first stated categorically that the artist's vision of reality is inseparable from moral vision and so carries with it inescapable responsibilities.

The word *personnage,* which comes into the title of so many of these sculptures, including the Houston sculpture, is almost untranslatable into English. It seems lame to resort to the scarcely current equivalent, personage, though that word does mean '''a person of eminence,'' which is at least part of the meaning

Fig. 63. Joan Miró. *Personage and Birds,* 1970.

contained in the French word. But *personnage* can also mean, in French, a character in a play. Thus the word stresses individuality as both distinct and important. *Femme* carries something of the same connotation for Miró because of his sense of the importance and yet apartness of women from his experience as a man. The *oiseaux,* however, belong to another level of experience. Constant companions to both the women and personages, birds are of the earth and yet rise above it. They represent the spiritual or imaginative dimension.

The Houston sculpture, *Personnage et Oiseaux (Personage and Birds)* [fig. 63], was proposed by the architect I. M. Pei as part of the new building Texas Commerce Bank in United Energy Plaza. The seventy-five story tower was set off-center in its block to create a small square to be enlivened with trees, water, and a monumental sculpture. Miró was selected as the artist at an early stage. The first work chosen for the site,

Girl with her Hair in Disorder (1968), was rejected in favor of the present work. To suit the site, the sculpture has been scaled up to between ten and eleven times its original size. The original bronze was not colored. Miró painted a small wooden maquette as a guide for the final coloring of the sculpture.

Fabrication of the sculpture has proved a complex engineering problem. The base, which in the original assemblage was a piece of cheap carpentry, is made from solid steel sections bolted together. The appendages for the lower part and the whole of the upper part of the sculpture are bronze. Seventy-five separate castings were involved. The whole of the upper part is supported on a stainless steel armature bolted to a steel plate at the apex of the base triangle. The final structure will stand fifty-five feet high, and the base measures thirty-five feet across.

The elements of the Houston sculpture are a triangular base with three appendages, two small globes behind for buttocks and an ambiguous sex organ in front. At the apex of the triangle, a flat element represents shoulders and arms. To that is attached a half spherical piece of redundant plumbing, or some similar object, with two holes with projecting rims for eyes. A small element is placed between these for a nose. Two chair legs joined by the remains of a cross piece are attached to the head at an angle. At the top of each of the legs and at the open end of the second cross piece of this structure are three constructed elements. Two turn up like wings, while the third element faces forward and down and has a rough face drawn on it.

The simplest reading of the figure is that the half sphere is a head with eyes and nose. A single bird is flying around the head. The triangular base identifies the figure as a woman. With the rudimentary protuberances of sexual definition, she is connected to the iconographic group of the *Dèese (Goddess)*. A prehistoric sign for a woman, the triangular form is an image that Miró has frequently used. This image is of equal antiquity with the mother goddess that inspired the conical shape of the *Dèese*.

Both *Miss Chicago* and *Personage and Birds,* like all Miró's public art, are monumentally individual. They reach us not by an appeal to abstraction but because we can identify with them. The comical peculiarities of Miró's personages and the inalienable dignity of the grotesque are essential characteristics of human nature. Miró's images are human images.

In place, the *Personage and Birds* will bring color to downtown Houston, fulfilling the architect's design of enlivening a civic space, while providing a focus for several streets. But it will do more than that. Miró's art is monumental not only in size but also in the importance of its message. *The Personage and Birds* enshrines a whole set of values. As an earth figure aspiring to the sky, upwards and outwards through its attendant bird, the personage is a metaphor for the aspiration and freedom of the human imagination. In the elevation of the mundane and the rejected, the found objects out of which the original sculpture was composed, into a monumental and transcendental image, the figure stands for the life and dignity of all creation. Fused together these objects are transformed into a unique personality and so stand for the concept of individuality. Individuality is in its essence mysterious, and the process by which these objects are transformed is a mystery. It is the artist's mystery — not his own peculiar possession but something of which he is the custodian for us all. By seeing his art placed in the center of our communities, he is only fulfilling the responsibility inherent in that custodianship.

NOTES

1. André Breton, *Position Politique de l'Art d'Aujourd'hui* (1935), reprinted in *Manifestes du Surréalisme* (Paris: Jean-Jacques Pauvert, 1962), p. 271.
2. I am indebted to Mr. Sert for the following information about his early collaboration with Miró.
3. Philip Adams to the author.
4. E. F. Ireland to Jack Emery, August 2, 1946, Cincinnati Art Museum files.
5. Cincinnati Art Museum files.
6. "Boiling Internally," *Time* 56 (July 10, 1950): 45.
7. Fogg Art Museum files.
8. By Margit Rowell. William Rubin, *Miró in the Collection of The Museum of Modern Art* (New York: The Museum of Modern Art, 1973), p. 132.
9. Gaëtan Picon, ed., *Joan Miró: The Catalan Notebooks* (New York: Rizzoli, 1977), p. 129.
10. Ibid., p. 106.
11. Ibid., p. 120.
12. loc. cit.
13. Rubin, op. cit., p. 87.
14. Joan Miró, "Ma Dernière Oeuvre, c'est un Mur," *Derrière le Miroir* no. 107-109 (1958), pp. 24-29.
15. Joan Miró, *Ceci est la Couleur de mes Rêves,* interview with Georges Raillard (Paris: Seuil, 1977), pp. 97, 153.
16. Ibid., pp. 95-96.
17. Ibid., p. 61.
18. José Luis Sert, "Peintures pour de Grands Espaces," *Derrière le Miroir* no. 128 (1961), p. 3.
19. Jürg Spiller, ed., *Paul Klee: The Thinking Eye* (New York: Wittenborn, 1961), p. 2.
20. Picon, op. cit., p. 136.
21. Jacques Dupin, *Joan Miró: Life and Work* (New York: Abrams, 1962), p. 464.

APPENDIX

Joan Miró:

I DREAM OF A LARGE STUDIO

From Joan Miró: Exhibition of Early Painting, 1940

On my arrival in Paris in March 1919, I stopped at the Hotel de la Victoire, rue Notre des Victoires. I stayed in Paris all the winter. That summer I went back to Spain, to the country. The next winter I am back again in Paris. I stopped at another hotel, number 32 Boulevard Pasteur. It is there that I had a visit from Paul Rosenberg. Picasso and Maurice Raynal had spoken to him about me. Sometime later Pablo Gargallo, who was spending the winter in Barcelona teaching sculpture at the Beaux Arts School, turned his studio over to me. It was at 45 rue Blomet, next door to the Bal Nègre, still unknown to Parisians at that time as it had not yet been discovered by Robert Desnos. André Masson had the studio alongside. Only a partition separated us. In the rue Blomet I began to work. I painted the "Tête d'une Danseuse Espagnole" which now belongs to Picasso, the "Table au Gant," etc. Those were pretty hard times: the panes of the window were broken, my heater that cost me forty-five francs in the flea market would not work. However, the studio was very clean. I used to tidy it up myself. Since I was very poor I could not afford more than one lunch a week: the other days I had to be contented with dried figs and I chewed gum.

The next year it is not possible to get Gargallo's studio. I go first to a small hotel on the Boulevard Raspail where I finish the "Fermière," "l'Epi de Blé" and some other pictures. I give up the hotel for a boarding house on the rue Berthollet. "La Lampe à Carbure." Summer in the country. Return to Paris to the studio in the rue Blomet. I finish "La Ferme" which I began in Montroig and carried on in Barcelona. Léonce Rosenberg, Keinwheiler [sic], Jacques Doucet, all the Surrealists, Pierre Loeb, Viot, the American writer Hemingway, dropped in to see me. Hemingway buys "La Ferme." In rue Blomet I paint the "Carnival d'Arlequin" and the "Danseuse Espagnole" now in the Gaffé collection. In spite of these first sales times were still hard enough. For the "Carnival d'Arlequin" I made many drawings into which I put the hallucinations provoked by my hunger. In the evening I would come home without having eaten and put down my sensations on paper. I went about quite a bit that year with poets because I felt that it was necessary to go a step beyond the strictly plastic and bring some poetry into painting.

A few months later Jacques Viot arranged my first exhibition at the Galerie Pierre. After that I had a contract with Jacques Viot which helped me to stick it out. I rented a studio, rue Tourlac, Villa des Fusains, where Toulouse-Lautrec and André Derain had lived and where Pierre Bonnard still has his studio. At that time Paul Eluard, Max Ernst, a Belgian dealer from the rue de Seine, Goemans, René Magritte, Arp were also living there. On my door I put up a sign I had found in a junk shop: TRAIN PASSANT SANS ARRÊT. Things were now going better but it was still hard enough. One day with Arp, I lunched on radishes and butter. As soon as it was possible I took a larger studio in the same house, on the ground floor, but I did not keep it long.

Back to Spain. Am married. Return to Paris with my wife and leave the Villa des Fusains where I had painted my whole series of the blue canvases for an apartment on the rue François Mouthon. Worked a great deal. Spent most of the year in Spain where I could concentrate better on my work. In Barcelona I used to paint in the room where I was born.

In Spain, where I went very often, I never had a real studio. In the beginning I used to work in such tiny cubby-holes I could hardly squeeze in. When I was dissatisfied with my work I used to bang my head against the wall. My dream, when I am able to settle down somewhere, is to have a very large studio, not for the light — north light, etc. — that does not matter to me, — but to have room and lots of canvases, for the more I work the more I want to work. I would like to try sculpture, pottery, engraving, and have a printing press. To try to go further than easel painting which in my opinion, sets itself a narrow aim — to try to go as far as possible and through painting, to get closer to the people who are never out of my mind.

Now I am on Boulevard Blanqui in the house of the architect Nelson. It was in this house that Mrs. Hemingway kept "La Ferme" before taking it away to America.

Once I felt like taking another look at the studio of the rue Blomet. In the court there was a very beautiful lilac bush. The house was being pulled down. A big dog jumped at me.

Francis Lee:

INTERVIEW WITH MIRÓ

From Possibilities, 1947-48

F.L. Do you like to read, Monsieur Miró?
J.M. Yes, but only for short periods — 15 or 30 minutes at a time, rarely more. My favorites? The poets — the pure poets — Rimbaud, Jarry, Blake and the mystics.
F.L. Do you ever read novels or stories?
J.M. Very seldom. But when I do it's crime stories. Georges Simenon, Fantonas, etc.
F.L. When you don't feel like painting, what do you usually do?

J.M. But I always feel like painting! If I don't paint, I worry, I become very depressed, I fret and become gloomy and get 'black ideas' and I don't know what to do with myself.

F.L. *Generally speaking, what is your daily schedule of painting?*

J.M. Well, here in New York I cannot lead the life I want to. There are too many appointments, too many people to see, and with so much going on I become too tired to paint. But when I am leading the life I like to in Paris, and even more in Spain, my daily schedule is very severe and strict and simple. At 6 A.M. I get up and have my breakfast — a few pieces of bread and some coffee — and by seven I am at work. I paint straight through from 7 A.M. until noon. At 12 I take physical exercise for half an hour. Something violent, like running or boxing. Then lunch; food, well prepared, but in small quantities. After that a cup of coffee and three cigarettes; no more, no less. Then a siesta of exactly five minutes, never more. By this time it is 2 P.M. and that is the hour when I take a walk or meet friends or attend to business, etc., etc. By 3 I am at work again and paint without interruption until 8 P.M., at which time I have dinner. After dinner I like to listen to music or sometimes I read.

F.L. *What music do you like?*

J.M. The classics and swing music both. The classics — Bach, Mozart, Beethoven, and the modernists — De Falla, Stravinsky, Ravel, etc. And I adore your swing music.

F.L. *Do you paint also on Sundays?*

J.M. No, Sunday for me is a day of repose. I spend most of my time eating and sleeping and after dinner a liqueur and a small cigarillo.

F.L. *Can you paint better in Paris, Spain or New York?*

J.M. Spain. I can concentrate more in my place in the country where I am never disturbed. Secondly, in Paris; but even in Paris there are distractions. In New York, my life is not the same. There are so many appointments and so many people to see. I have finally solved the problem and at present I am working hard.

F.L. *Do you miss the stimulation of Paris?*

J.M. Yes, I must go there.

F.L. *When in Paris, do you have much of a social life? Openings, parties, etc.?*

J.M. Merde! I absolutely detest openings and nearly all parties! They are commercial, 'political' and everyone talks so much. They give me the "willies." No, when I am in Paris, I lead a more or less isolated life.

F.L. *When you started in Paris, in the early days, did Picasso help you out?*

J.M. Yes, very much. He encouraged me, and we are the best of friends.

F.L. *It is said that you once refused to take part in an exhibition of abstract painting in Paris. (The "Abstraction-Creation" group.)*

J.M. Yes, that is true. It was because their aims were too limited.

F.L. *I suppose you have been to the Metropolitan Museum of Art in New York. I have often wondered who your favorite old masters or schools of painting are?*

J.M. My favorite schools of painting are as far back as possible: the cave painters — the primitives. To me the Renaissance does not have the same interest. But I have a great respect for the Renaissance. In the work of Leonardo da Vinci I think of the 'esprit' of painting. And in the work of Paolo Ucello, it is the plasticity and structure which interest me. This I think happens often in painting. Some painters are better for the spirit and the force they represent. And other painters one likes because they are better as painters. With me, I find that I like Odilon Redon, Paul Klee and Kandinsky for their 'esprit.' As pure painting — from the point of view of plasticity — I like Picasso or Matisse. But both points of view are important.

F.L. *Today there are many kinds of painting. In the older epochs, the Egyptian, the Greek, the Renaissance, there was more or less one kind of painting in each period. Why is that?*

J.M. There are always different kinds of painting in an epoch. What we see in the museums today is only the résumé of what has come through all the others. In a period of transition (like the present), where there are many different efforts and views, one finds many trends in art. It is for this reason that I isolate myself from others in order to see clearly. I regard the past and I work with the future in mind as well.

F.L. *What do you think is the direction that painting ought to take?*

J.M. To rediscover the sources of human feeling.

F.L. *Why is painting so esoteric today?*

J.M. We live in a period of transition. It is necesary to make a revision of everything that has been done. Il faut faire un revision de tous qu'il passé.

F.L. *How do you like the painting in America? I mean the younger, forward looking painters.*

J.M. Yes, I understand. I admire very much the energy and vitality of America [sic] painters. I especially like their enthusiasm and freshness. This I find inspiring. They would do well to free themselves from Europe's influence.

F.L. *Do you think America will influence you?*

J.M. Yes, very much so. Especially as force and vitality. To me the real skyscrapers express force as do the pyramids in Egypt.

F.L. *Are there any things here that have especially impressed you or that you like?*

J.M. Yes — the sports! I have a passion for baseball. Especially the night games. I go to them as often as I can. Equally with baseball, I am mad about hockey — ice hockey. I went to all the games I could this year.

F.L. *In our present society, what do you think is the place of art?*

J.M. To liberate society from its prejudices — so that feeling and sentiments may be freshened.

F.L. *And as a last question, Monsieur Miró, what advice would you give to a young painter?*

J.M. Work hard — and then say, nuts.

30 June 1947

José Gomez Sicre:
JOAN MIRÓ IN NEW YORK

From *Right Angle,* 1940

The art of Catalonia has maintained, down through the ages, a borderland flavor which gives it a very special place in Spanish art. From the 14th century to the present it has played the role of mediator between the Spanish hinterland and nearby France. Thus the Catalans have created a culture, a manner of expression of their own, drawing on the characteristic elements of the two lands. They have blended that passion for realism which makes the Spaniard bring heaven and its angels down to earth for analysis under a terrestrial light with the orderly, gently idealistic, lyrical fantasy of the French soul.

In the history of Spanish art we are at once struck by the unbridled spirit of independence of the Catalans, whose culture has roots in remote Iberian antiquity. Castile with its dark brown tones and its precise, implacable realism has been the center of Spain in painting. But in Catalonia, from the earliest times, bold fantasy and prodigal imagination have abounded. The nearness of France cast on the region the shadow of a world of less austere spirituality and more profound lyricism.

After Goya Spanish painting was sullied by Sorolla and his pseudo-impressionism, and one was forced to conclude that no salvation was possible for the Spanish interior, which continues, today as always, endlessly repeating the same insubstantial formulas. While the court and the rest of the provinces have submerged themselves in the persistent blindness and deafness of an external, descriptive art, losing the vitality of the good realism of their predecessors, Catalonia has distinguished itself by seeking out a world of less vulgar expression. (Remember that Picasso had to take refuge in Barcelona, fleeing from Malaga and Madrid's Royal Academy of San Fernando. It was in the Catalonian capital that he began to find himself.)

Catalonia has had schools which have taught the profession with unusual beauty. Salvador Dali, despite the errors of his commercialized schizophrenia, is excellent proof of the Catalonian school's rigor in drawing. But another Catalan of the School of Paris, Joan Miró, with a style which is the reverse of Dali's spectacularness, ranks as one of the leading personalities of modern painting.

Miró was born in Montroig, near Barcelona, in 1893. At 14 he entered the School of Fine Arts of Barcelona, leaving it soon afterwards at the insistence of his family, which for twelve years tried to make a clerk of him. After this period of enforced absence, he returned to his studies at the Galí Academy, also in Barcelona. Three years later, already master of his profession, he began painting on his own, without any scholastic conventions, a typically Catalonian rebel. He had his first one-man show at the Dalmau Gallery in Barcelona in 1918, and the following year paid his first visit to Paris. He installed himself in the French capital in 1920, and it was there that he gave form to his profoundly Catalonian vision.

But Joan Miró did not follow the spectacular, fame-seeking path of Dali. Ever since his Barcelona days he has been preoccupied with finding his own idiom, after thorough study of the contemporary movements in France. As early as his first show at the Dalmau Gallery one could note his interest in Van Gogh and Cezanne. In France he was impressed by cubism and momentarily dazzled by the dadaist explosion. The Surrealists tried to claim his work for their school, but he remains free of any dogma, not a partisan of any movement or foreign frenzy. Now, when his art has grown surprisingly, it is more difficult than ever to classify him within any certain school or tendency. In his most recent exhibition at the Pierre Matisse Gallery in New York, his work revealed an undeniable maturity, which makes him loom as one of the greatest independent artists of the world's painting today.

Miró was recently in the United States. Through the feverish contagion of the tempo of New York he passed with the same calm, sure rhythm with which he formed his personality as an artist and gained enormous prestige. I first met him in the workshop of the engraver William Hayter, cutting in copper his delightful, evasive figures, like uncapturable beings from some invented planet. A few days later I visited him in the studio where he was working on a large mural canvas to decorate a hotel in Cincinnati.

A man of extreme modesty and simplicity, Miró refuses to talk about his work and avoids making the slightest comment on its significance. Our conversation touched on New York, but the artist showed no surprise at this example of so brutally industrial an America. He observes Manhattan with curiosity, he assured me, but he hates the subway because it keeps him from seeing people in the light of day. Later we walked through the overpopulated streets of the city, which he prefers to the elegant little salons where the "select" spirits gather in search of the definitive phrases and devastating poses of cocktail parties.

This attitude of the man which gives his present work precision and neatness was also apparent in the beauty and honesty which struck me when I first saw his famous painting "La Granja" in Ernest Hemingway's house in Havana. In that

work of 1921, he began to organize the world of memories and the world of reality with an unusually poetic flavor. In that calm, splendidly arranged canvas, which marked the point of departure for his present work, we see the same tranquil, sure Miró whom I met in New York, free of flattery, devoid of presumption, meditating on his art and emotions. "La Granja" displays composition of exquisite brilliance, worthy of its illustrous [sic] 14th and 15th century predecessors, the Catalonian painters Martorell and Ferrer-Bassa.

For Miró, this tormented era in which we live has not brought polemic disputes or definitive declarations. He has not let himself be seduced by the profitability of making spectacles to *epater le bourgeois* which has led some of his colleagues to sell their souls to the devil.

In intent and achievement we can only compare Joan Miró with the great Paul Klee, who died prematurely in 1940. But between the two lies the distance which separates Latin from Saxon sensibility. Starting from the same principle of primary values and achieving results of similar quality, Klee tries to systematize his findings, while Miró does not even pretend to explain his or much less submit them to method. Passion, though measured as well as powerful, cannot be reconciled with reasoning. While Klee — free, intense, purposeful — busied himself with the preparation of his "Pedagogical Sketchbook," Miró refused to offer any interpretation of his work except to proclaim his non-submission to any canon whatever. Both arrived by different routes at a plastic expression in which fantasy and dreams yield painting full of surprise and miracles, revealing a world bare of stuffing or affectation.

Miró, with his taste for the essential, works out his designs on crude, rough materials.On burlap, sandpaper, or fiber board he unwinds his rhythmical forms, drawn with a brutal line which varies its dimensions with unexpected fluidity. The color, of exemplary beauty, shines in flat zones which he encloses with firm, always undulating and certain drawing.

To the layman, Miró's art may appear capricious, inexplicable, even comic, but it could never be called insincere, prostituted or frivolous, for what the artist does is to deposit in his work his healthful temperament and the best experiences which he extracts, without literariness or artifice, from the human world which surrounds him. At least, that is the impression which I got from my visit with Joan Miró.

Translated by George C. Compton

James Johnson Sweeney:
JOAN MIRÓ: COMMENT AND INTERVIEW

From *Partisan Review,* 1948

Fernand Léger, the French Cubist, tells of meeting Henri Rousseau, *le douanier,* at the *vernissage* of an official Salon in Paris a year or so before the older man's death. They happened to be in a room with a group of pictures by the academician Bouguereau. Léger was uninterested; Rousseau was enthusiastic — "But, Monsieur, look at the wonderful technique. See the little highlights on the fingernails!"

It was the virtuosity of the academician that impressed Rousseau. He was a sensitive and careful technician himself. His essential naïveté lay in his failure to realize the futility of academic ostentation in comparison with his own gifts. Actually he was painting in their manner, more than they could ever appreciate — more than would ever appear from a superficial comparison of the work of both. For the academician had set out to seek exactly what Rousseau was finding. The academician's premises were sound: a scrupulous compositional structure, an integrity of line, and a cleanness of workmanship. It was a weakness for ostentation, for exhibitionism, that spoiled the product. Rousseau's personal simplicity and directness were his strength. His intensity of focus on his objective, the picture, would not permit him to be led aside by alien interests — display, easy effects, or worldly success. He could not see beyond the picture itself any more than a Piet Mondrian could. He lived in his painting and for his painting. He put all his ability and sensibility into his work to that end. This was his naïveté.

But since the recognition accorded Rousseau as an artist, a plague of "naive" painting has spread over Europe and America. Every country, district — almost every art gallery has its own so-called "primitive": his work justified by a proclaimed resemblance to that of Rousseau. The basis for the claim is either a total misunderstanding of Rousseau's art, or a willing blindness to the difference between it and the other. Such "primitives" are usually "Sunday painters" as Rousseau was forced to be. "In view of the lack of fortune on the part of his parents," he explained in a biographical paragraph which he composed for a directory of painters and sculptors, "he was obliged at first to follow another career than that to which his artistic tastes called him." But in most cases, the paintings of these "naives," unlike those of Rousseau, fail through their limited technical competence to express the artists' innate sensitivity. Their work, therefore, is closer to children's than to Rousseau's. It may be superficially amusing, or delightful for the moment, but it has no durable quality.

A picture of Rousseau, on the other hand, suffers no more from a lack of technical competence in expression than a painting of the School of Avignon, or an African Negro sculpture. Its primitivism lies rather in the primary character of its appeal — its unadorned immediacy — its appeal to the *primitif visuel,* or the child in the grown-up. And in this sense the terms "primitivism" and "naïveté" meet. For naïveté in art is directness and simplicity in contrast to the sophistication of pretending to do one thing while doing another. Incompetence has no place.

And in the light of these two principle characteristics of Rousseau's work, it is not the so-called "primitives," or "Sunday painters" who are his equivalents in our period. It is

more properly Joan Miró. For in Miró, both personally and in his work, we find a "primitivism" similar to that of Rousseau, quite apart from any lack of competence — a single-minded attempt to effect primary appeals with an intensity of focus that never allows him to deviate from his objective. We also recognize a naïveté in the fact that he is carried away by the striking effects achieved by the literary and sophisticated approach of the surrealists, so often basically plastic; but Miró, again like Rousseau, makes use only of what is pictorially valuable beneath the sophistication which attracts him and is never misled into fields of exhibitionism, or distracted from the picture itself.

The true approach, therefore, to Miró's art is not to something esoteric, but to something in our age as naive — as simply pictorial and lyrical — as Rousseau's was in his time. The only difference (a necessary one in the case of two true artists) is that Miró paints his lyrics in the idiom of the twentieth century while Rousseau painted his in that of the nineteenth century. The same respect for craft is there, the same love of artisanry, the same single-mindedness, peasant practicality, and realism (Rousseau described himself in his biographical note as *"un de nos meilleurs peintres realistes"*), and the same absence of a sense of humor regarding his own work (despite its gaiety throughout): all this marked by the deep impression made upon him in the early twenties by the surrealist devices to produce, out of the unconscious, their "little highlights on the fingernails."

[The following remarks do not pretend to be verbatim, but are based on several formal and informal discussions with the artist.]

Miró:

"For me a form is never something abstract; it is always a sign of something. It is always a man, a bird, or something else. For me painting is never form for form's sake.

"In my early years I was an extreme realist. I worked constantly at realistic painting up to 'The Farm.' Even that painting which I made in Paris to keep me in touch with Montroig was so dependent on reality I used to go out to the Bois de Boulogne to pick twigs and leaves to use as models for the plants and foliage in the foreground. The picture represents all that was closest to me at home, even the footprints on the path by the house. It was Montroig in Paris. I am very much attached to the landscape of my country. That picture made it live for me.

"Besides this, 'The Farm' is a synthesis of much that went before. I had always admired the primitive Catalan church-paintings and the gothic retables. An essential factor in my work has always been my need of self-discipline. A picture had to be right to a millimeter — had to be in balance to a millimeter. For example in painting 'The Farmer's Wife,' I found that I had made the cat too large: it threw the picture out of balance. This is the reason for the double circles and the two angular lines in the foreground. They look symbolic,

esoteric: but they are not fantasy. They were put in to bring the picture into equilibrium. And as was this same need that had forced me the year before to sacrifice reality to some degree in 'The Farm': the smooth wall had to have the cracks to balance the wire of the chicken coop on the other side of the picture. It was this need for discipline which forced me to simplify in painting things from nature just as the Catalan primitives did.

"Then there was the discipline of cubism. I learned the structure of a picture from cubism . . .

"And there was the influence of two early teachers: Urgell and Pasco. Urgell's was very important. Even today I recognize forms constantly apearing in my work that originally impressed me in his painting, though it is true Urgell was a romantic follower of Bocklin and saw things in a sad light while these forms in my work always take a gay character.

"I remember two paintings of Urgell in particular, both characterized by long, straight, twilit horizons which cut the pictures in halves: one a painting of a moon above a cypress tree, another with a crescent moon low in the sky. Three forms which have become obsessions with me represent the imprint of Urgell: a red circle, the moon, and a star. They keep coming back each time slightly different. But for me it is always a story of recovering: one does not discover in life . . .

"Another recurrent form in my work is the ladder. In the first years it was a plastic form frequently appearing because it was so close to me — a familiar shape in 'The Farm'. In later years, particularly during the war, while I was on Majorca, it came to symbolize 'escape': essentially form at first — it became poetic later. Or plastic, first; then nostalgic at the time of painting 'The Farm'; finally, symbolic.

"Pasco was the other teacher whose influence I still feel. He was extremely liberal and encouraged me to take every liberty in my work. Color was easy for me. But with form I had great difficulty. Pasco taught me to draw from the sense of touch by giving me objects which I was not allowed to look at, but which I was afterwards made to draw. Even today, thirty years after, the effect of this touch-drawing experience returns in my interest in sculpture: the need to mold with my hands — to pick up a ball of wet clay like a child and squeeze it. From this I get a physical satisfaction that I cannot get from drawing or painting . . .

"At the time I was painting 'The Farm,' my first year in Paris, I had Gargallo's studio. Masson was in the studio next door. Masson was always a great reader and full of ideas. Among his friends were practically all the young poets of the day. Through Masson I met them. Through them I heard poetry discussed. The poets Masson introduced me to interested me more than the painters I had met in Paris. I was carried away by the new ideas they brought and especially the poetry they discussed. I gorged myself on it all night long — poetry principally in the tradition of Jarry's *Surmâle* . . .

"As a result of this reading I began gradually to work away from the realism I had practiced up to 'The Farm,' until, in

1925, I was drawing almost entirely from hallucinations. At the time I was living on a few figs a day. I was too proud to ask my colleagues for help. Hunger was a great source of these hallucinations. I would sit for long periods looking at the bare walls of my studio trying to capture these shapes on paper or burlap.

"Little by little I turned from dependence on hallucinations to forms suggested by physical elements, but still quite apart from realism. In 1933, for example, I used to tear newspapers into rough shapes and paste them on cardboards. Day after day I would accumulate the shapes. After the collages were finished they served me as points of departure for paintings. I did not copy the collages. I merely let them suggest shapes to me . . .

"Between the years 1938 and 1940 I once again became interested in realism. Perhaps the interest began as early as 1937 in 'Still Life With Old Shoe.' Perhaps the events of the day, particularly the drama of the war in Spain, made me feel that I ought to soak myself in reality. I used to go every day to the Grande Chaumiere to work from a model. At the time I felt a need to control things by reality.

"This realistic discipline gave me the strength to take a new stride — much as the discipline of cubism had given me the courage earlier . . .

"At Varengeville-sur-Mer, in 1939, began a new stage in my work which had its source in music and nature. It was about the time that the war broke out. I felt a deep desire to escape. I closed myself within myself purposely. The night, music, and the stars began to play a major role in suggesting my paintings. Music had always appealed to me, and now music in this period began to take the role poetry had played in the early twenties — especially Bach and Mozart when I went back to Majorca upon the fall of France.

"Also the material of my painting began to take a new importance. In water colors I would roughen the surface of the paper by rubbing. Painting over this roughened surface produced curious chance shapes. Perhaps my self-imposed isolation from my colleagues led me to turn for suggestions to the materials of my art. First to the rough surfaces of the heavy burlap series of 1939; then to ceramics . . .

"Nowadays I rarely start a picture from an hallucination as I did in the twenties, or, as later, from collages. What is most interesting to me today is the material I am working with. It supplies the shape which suggests the form just as cracks in a wall suggested shapes to Leonardo.

"For this reason I always work on several canvases at once. I start a canvas without a thought of what it may eventually become. I put it aside after the first fire has abated. I may not look at it again for months. Then I take it out and work at it coldly like an artisan, guided strictly by rules of composition after the first shock of suggestion has ended.

"— Then after the heavy burlap series of 1939 I began a group of gouaches which were shown here in New York at the Pierre Matisse Gallery just after the war — an entirely new conception of things. I did about five or six of them

before I left Varengeville for Spain and Majorca at the fall of France. There were twenty-two in all in the series. They were based on reflections in water. Not naturalistically — or objectively — to be sure. But forms suggested by such reflections. In them my main aim was to achieve a compositional balance. It was a very long and extremely arduous work. I would set out with no preconceived idea. A few forms suggested here would call for other forms elsewhere to balance them. These in turn demanded others. It seemed interminable. It took a month at least to produce each water color, as I would take it up day after day to paint in other tiny spots, stars, washes, infinitesimal dots of color in order finally to achieve a full and complex equilibrium.

"As I lived on the outskirts of Palma I used to spend hours looking at the sea. Poetry and music both were now all-important to me in my isolation. After lunch each day I would go to the cathedral to listen to the organ rehearsal. I would sit there in that empty gothic interior daydreaming, conjuring up forms. The light poured into the gloom through the stained-glass windows in an orange flame. The cathedral seemed always empty at those hours. The organ music and the light filtering through the stained-glass windows to the interior gloom suggested forms to me. I saw practically no one all those months. But I was enormously enriched during this period of solitude. I read all the time: St. John of the Cross, St. Teresa, and poetry — Mallarmé, Rimbaud. It was an ascetic existence: only work.

"After having finished this series of paintings in Palma, I moved to Barcelona. And as these Palma paintings had been so exacting both technically and physically I now felt the need to work more freely, more gaily — to 'proliferate.'

"I produced a great deal at this time, working very quickly. And just as I worked very carefully in the Palma series which had immediately preceded these, 'controlling' everything, now I worked with the least control possible — at any rate in the first phase, the drawing. Gouaches: in pastel colors, with very violent contrasts. Even here, however, only the broad outlines were unconsciously done. The rest was carefully calculated. The broad initial drawing, generally in grease crayon, served as a point of departure. I even used some spilled blackberry jam in one case as a beginning; I drew carefully around the stains and made them the center of the composition. The slightest thing served me as a jumping off place in this period.

"And in the various paintings I have done since my return from Palma to Barcelona there have always been these three stages — first, the suggestion, usually from the material; second, the conscious origination of these forms; and third, the compositional enrichment.

"Forms take reality for me as I work. In other words, rather than setting out to paint something, I begin painting and as I paint the picture begins to assert itself, or suggest itself under my brush. The form becomes a sign for a woman or a bird as I work.

"Even a few casual wipes of my brush in cleaning it may

suggest the beginning of a picture. The second stage, however, is carefully calculated. The first stage is free, unconscious; but after that the picture is controlled throughout, in keeping with that desire for discipline which I have felt from the beginning. The Catalan character is not like that of Malaga or other parts of Spain. It is very much down-to-earth. We Catalans believe you must always plant your feet firmly on the ground if you want to be able to jump up in the air. The fact that I come down to earth from time to time makes it possible for me to jump all the higher."

Barbara Rose:
INTERVIEW WITH MIRÓ

(This interview took place in French without a tape recorder and was transcribed by hand.)

Barcelona, June 30, 1981.

I have come to Barcelona to interview Joan Miró. At first, I am told that no one can see Miró. I explain I am organizing an exhibition, *Miró in America,* and that, in fact, I have had an appointment for several months. I have taken care to stay at the same comfortable middle-class hotel as Miró (just in case, by chance, we should find each other in the same elevator). I know that Miró now only comes to Barcelona from Majorca, where he lives and paints in seclusion, once a year to take care of his affairs, to work on prints, and to see the occasional foreigner fortunate enough to cross the barrier set up between him and the world.

Miró says, "History gives me a headache." It is often said that his art is childlike, but he himself seems singularly lacking the cruelty and irresponsibility of children I have so often seen. This man, so influenced by primitive art, seems to have made a conscious moral decision to behave always in the most civilized fashion. I wonder how he strikes the balance between spontaneity and control that is part of the greatness of his art, but I am sure this is a question he could not or would not answer so I never ask it. Miró's close friend and biographer, the poet Jacques Dupin (most of his friends are poets) has said there has never been any scandal and gossip surrounding Miró. Certainly no one has ever heard about Miró the kind of monstrous stories told about Picasso. But Picasso, after all, was a Malagueño — a man of the South — whereas Miró is the essence of Catalan dignity and civility.

When I arrive at the gallery, which is in the dark medieval caverns of the Barrio Gotico, near the Cathedral and down the street from the Picasso Museum, I once again have to explain M. Miró has invited me. He is working, I am told, and cannot be disturbed. I sit down, ready for a long siege. One of the gallery directors appears; his expression is quizzical. He

tells me I may come up while the master is working. (He looks as if he cannot understand why I am being given such preferential treatment.) I slip into the studio upstairs behind him, taking pains not to disturb Miró, who has changed from his normal uniform of dark business suit into a white lab coat. He looks more like a surgeon or perhaps a priest than an artist. His instruments are neatly arranged — the spatula gleaming like a scalpel. Miró is entirely involved with the print he is making, seemingly oblivious to all else. He works quickly, but stops to look and think after a mark has been set down. The most surprising thing, however, which explains a great deal to me about his work that I have never understood, is that he is working directly with his hands, smearing the dark *tusche* around on the metal plate with his fingers as a child might make mudpies or finger-paint.

When Miró is satisfied with a proof of the print, he washes up, removes his coat — like a surgeon after an operation — and invites me to lunch. With his wife and Sr. Fereras, director of the Gallery Maeght, we go to an unpretentious fish restaurant where, it appears, Miró eats every day when he is in Barcelona. The clientele is working class mainly; no one appears to notice that one of the greatest painters of the twentieth century is having lunch there. I explain that my idea for the exhibition *Miró in America* is to show his work in the context of the American artists he influenced. He seems delighted by the idea. I am encouraged to begin my questioning:

B.R. *Why didn't you go to America during World War II like so many other European artists?*
J.M. Well, you see, we were able to return to Spain so there was no real danger. During the war, no one was interested in me. No one could find me, even though we were in Barcelona. A friend came looking for me and was told that there was no news of me.
B.R. *Why did you go to America after the war in 1947?*
J.M. It was the idea of my dealer, Pierre Matisse. I was very happy to go to America because that is where I was successful. In fact, the Americans made my career. Nobody really liked my paintings in Paris. I remember when Breton and Eluard saw my *Farm* — the painting that Hemingway bought — they stared at it a long time and said nothing.
B.R. *Recently, your friend, the Surrealist painter, André Masson, said in an interview that you were never really a Surrealist. Is that true?*
J.M. It's true. I was not a Surrealist, really. A Spaniard does not need to be a Surrealist — he is already irrational. I was interested in the idea of *peinture-poésie* — painting as visual poetry — but the narrative side of Surrealism, the little stories, was nothing I cared about.
B.R. *I always feel a great freedom in your paintings, a lack of inhibition. Is that because you were encouraged to*

be an artist as a child?

J.M. Quite the contrary. I was forbidden to make art and stuck in an office. I was supposed to be something like an accountant. Can you imagine? It was awful. Freedom is not something given — you must fight to be free all the time. The harder you fight, the greater the obstacle, the freer and the stronger you become in overcoming it. The struggle to be free, to be spontaneous, is the lifelong battle. Creativity is normal, but liberty is a fight.

B.R. *Have you faced many obstacles in your life?*

J.M. Yes, of course. For one thing, I am not very big and not naturally strong. All my life I have worked to be physically strong. At my farm in Montroig, I used to run every day back and forth to the beach. On rainy days, to keep in shape, I jogged up and down the stairs. I still run up and down the stairs a lot, and of course I work all the time. Right now I am painting, making prints and drawings, and designing costumes and decor for a new ballet conceived by my friend, the poet Jacques Dupin. It's for the Teatro la Fencie in Venice. I have always enjoyed designing for the theater. I did my first ballet decor in 1932 for Massine. But my biggest project now is a sculpture park for the city of Barcelona. There will be real pine trees and a forest of my sculptures — lots of things made with cement — things to sit on and play with — a kind of playground. It will be an artist's park, like Gaudí's Güell Park, with all the objects in it designed by me.

I believe that the politics of the artist is what he can give as a gift to all the people — to the public in general. I am tired of my paintings being used as international bank notes. My art is for the people — it is for everybody. That is why, I suppose, my main interest recently has been the monumental sculptures, the public art.

B.R. *Your latest public sculpture is the* Personnage et Oiseaux *for Houston. The image of a figure with birds occurs again and again in your work. What does it signify?*

J.M. A human being is like a tree, planted in the ground. Birds fly into space — they can carry us away, off the ground into higher things, into the world of fantasy and imagination that is not earthbound.

B.R. *I have just seen the pornographic drawings in the Picasso Museum here in Barcelona. Why have you never done such drawings, even when you were young?*

J.M. I have often drawn and painted couples making love. But pornography is a low, base thing. Eros is sacred. If I represent sex, it is in the religious sense — like the Hindus. Love is for the gods, pornography is for the pigs.

B.R. *When I began work on the exhibition* Miró in

America, *it was suggested that I should do a show of "Miró's Mirós." I said that knowing the spirit of your work, I doubted that you had kept your own art. Yesterday, I visited the Fundació Miró. I found that I was right — you had given your art away — and that the purpose of the Fundació was not to show your work, but to support and exhibit young artists.*

J.M. I am not interested in a mausoleum. The Miró Foundation is not a tomb; I don't want to be buried there. Art is a *living* thing — it goes on.

B.R. *Did you know that many young American artists continue to be influenced by your work?*

J.M. Now that makes me *very* happy!

B.R. *Do you have any memories of your trips to America?*

J.M. I loved America — it gave me a terrific sense of energy and expansiveness. I wanted to do very large works. Pierre Matisse found me a giant studio that belonged to Carl Holty. That's where I painted the Cincinnati mural. When I arrived in New York in 1944, Sandy Calder met me. He was wearing a little Catalan hat. Everyone stared at us when we walked down Fifth Avenue — at him, not at me, of course. We had a great time together. We loved each other immediately. He was a wonderful friend. There is a big Calder in front of the Fundació Miró; you must have seen it. Sandy took me dancing in Harlem. There was a giant black girl who was a terrific dancer. She wanted to dance with me. Sandy wouldn't leave me alone until I got up and danced with her. We were an absolutely ridiculous couple.

B.R. *Did you know many American artists in New York?*

J.M. I knew Stuart Davis and George L. K. Morris in Paris. And I met Jackson Pollock at Hayter's Atelier 17 where I was making prints. I knew American writers much better — Hemingway and Henry Miller. We were all working in an atmosphere of camaraderie. Pollock and I would greet each other, but we could not have a conversation because he only spoke English and my English is very poor. I did not really know his work until I saw the black and white show at Fachetti in Paris in 1951. It was stunning — really bold and impressive.

B.R. *What are you looking forward to most now?*

J.M. First, my park in Barcelona. The new mayor is young and dynamic. He is really behind the project, and it is my dream to give it to the people of Barcelona. Then, of course, I would love to go to Houston. (Turning to Mme. Miró) What do you think, Pilar? Mme. Miró: I think you should stop smoking. Men are really weak sometimes.

B.R. *Artists often have many mistresses, especially the Surrealists. Yet you have only had one wife, isn't that true?*

J.M. (Winking at Pilar Miró, whom he married in 1929): Well, for the time being.

George L. K. Morris:
MIRÓ AND THE SPANISH CIVIL WAR

From Partisan Review, 1938

Last year, for the first time, it appeared that there may be some relation between liberalism in politics and what might be termed "radicalism" in the plastic arts. Early in 1937 the liberal-radical governments of Spain and France gave official recognition — and support in more tangible ways as well — to such aesthetic revolutionaries as Picasso, Miró, and Léger. The advent of the Blum ministry caused an extraordinary change in the temper of French art commissions, those traditional enemies of all that is living in art. And the Spanish government in the midst of its fight for life, has given important commissions to such artists — hitherto unknown in their native land — as Gonzales, Picasso, and Miró.

Picasso and Gonzales have lived for many years in the vicinity of Paris, but Miró has always remained in contact with his countrymen. He has done most of his best work in Catalonia. The selection of Miró, therefore, to execute commissions for the Spanish government is the most appropriate choice of all, and is likely to prove the most fruitful. The war in Spain, especially since it involves also a bitter class struggle, has had disturbing repercussions on Miró's development — at once stimulating and confusing. The shocks* have been accentuated because Miró lacks the sophistication of the other famous Spaniards. The recent work of Picasso, for example, suggests that perhaps his sensibility has been calloused by the many reversals, the swift and acrobatic changes of style which have marked his career in painting. His sincerity in publicizing the cause of Loyalist Spain cannot be questioned, but neither can it be said that he has been able to give mordant or convincing expression to his feelings. In his recent paintings on Civil War themes, the aesthetic impact seems to be bogged in a morass of mannerisms.

Miró, on the other hand, has been able to put on canvas in a much more satisfying way his reactions to the war. This might have been foreseen, for he is less the intellectual constructor, more the commentator upon his inward vision. Above all, his interpretations are unmannered. There is none of the aggressive showmanship with which Picasso is accustomed to startle and insult his audiences, before subduing them with an unapproachable grandeur of style.

Miró's development has been the logical result of the influences which have crowded upon him. He commmenced with that dry sharpness of vision which must haunt the air of Northern Spain, which produced Zurbaran, Juan Gris, and the anonymous Catalonian frescoes. Later, as he came in contact with Arp and the Dadaists, who opened up the field of tactile sensations, he alone of their disciples never grew mannered. Here already was the familiar Miró, the world half heavy with gloom, half buoyant with fantasy, alive through tiny linear rhythms that tickle the canvas and create a dance. With the beginning of the present decade the technique was ready to

loosen and the forms floated free from the background; the picture opened with an ordered smoothness unknown to Western painting since the days of Simone Martini and the Lorenzetti. He reached his summit with the large mural canvases of 1933; the outcome of the war will determine for the future whether this spacious series is destined to remain the most important achievement of Miró.

No one knows toward what end this development might have led, since the Civil War has obliterated the old creative approaches. For several months Miró endeavored to follow the path he had been opening, but the break in his progression is at once apparent. The suave lyricism dries up before the new staccato rhythms, the color withers into black and grey, the brush can no longer titillate, and caress the canvas. The works of these months are confused episodes in a welter of unabsorbed sense-impressions; he must leave Spain for a long contemplation in tranquility and gather up the meaning of the social upheavals that begin to make themselves felt.

It is now eight months since Miró recommenced his work in Paris; he began again with the interminable drawings, broken only by the large mural for the Spanish Government Pavilion at the Exposition; an area so vast must have been a trial to one whose poise and style were still on the verge of rising from such recent ruins. He fills other commissions for his government, and the resulting attempt at remaining impersonal becomes a strain upon him. He must return to his natural beginnings if he is to stand securely, and so rearranges into still-lives the household objects that dominated his first dry period. He is back in the visual world and interprets it once more in the old tight style native to Catalonia, but this time more tortured and mature. For four months he works over a painting of his shoes, but he has not yet found the plastic expression to hold the change of viewpoint. His next painting is to be a self-portrait.

"Doubtless individuality is a sign of decadence," he said recently. "In the great epochs individual and community go along together; but today what do we have?" Perhaps if the nation with which he has so closely identified himself can win its fight for survival, his talent will move forward with its old decisiveness, and "individual and community may go along together," enriching his work with a fulness beyond even the murals of 1933.

* Since this writing, we have learned that Miró's brother-in-law has been shot by a fascist firing-squad.

Robert Motherwell
THE SIGNIFICANCE OF MIRÓ

Excerpt from Art News, 1959

How Miró makes a painting is interesting. As Renaissance painters did, he proceeds by separate steps (though his process has nothing else in common with Renaissance

painting, any more than does his image of reality). The whole process is pervaded throughout by an exquisite "purity," that is, by a concrete and sensitive love for his medium that never distorts the essential nature of the medium, but respects its every nuance of being, as one respects someone one loves. The nature of the medium can be distorted by a brutal or insensitive artist, just as a person's nature can be distorted by another human being. The painting medium is essentially a rhythmically animated, colored surface-plane that is invariably expressive, mainly of feelings — or their absence . . . The expression is the result of emphasis, is constituted by what is emphasized, and, more indirectly, by what is simply assumed or ignored.

In "bad" painting, the emphases are essentially meaning-less, i.e., not really felt, but counterfeited or aped . . . There are not many painters as sensitive to the ground of the picture at the beginning of the painting-process as Miró — Klee, the Cubist collage, Cézanne watercolors, Rothko come to mind, and the Orient, with which he otherwise has no affinity. When Miró has made a beautiful, suggestive ground for himself, emotionally the picture is half-done (technically a third-done), whether he chooses a beautiful piece of paper (sand or rag) and just leaves it as the ground, or whether he scrubs it with color, color-patches, or a single color all-over, or color-patches and a main color both. Indeed, there is a picture in the present exhibition at The Museum of Modern Art that is simply a blue-brushed color plane, punctured in the upper left corner by a hole the roundness of a pencil, and in the lower right corner his tiny signature and the year. The picture stands. Brancusi polished his statues with the same love. Matisse did it the other way round. He made his revisions on working canvases, and then made the final version as clean and pure as Miró's paintings, but with an infinitely more subtle and varied brush — but then Matisse's brush is the most subtle since Cézanne's, the most complicated and invariably right in its specific series of emphases. What a miracle it is! It is as though the brush could feel, breathe and sweat and touch and move about, as though sheer being contacted sheer being and fused. After the artist who did it is dead and gone, we can still see that intense moment captured on the canvas. That is the miracle for the audience. Miró's miracle is not in his brushing, but in that his surface does not end up heavy and material, like cement or tar or mayonnaise, but airy, light, clean, radiant, like the Mediterranean itself. There is air for his creatures to breathe and move about in. No wonder he loves Mozart.

To speak of Miró's second step is to be forced to introduce two words that are perhaps the most misunderstood critical terms in America, "Surrealist automatism." Miró's method is profoundly and essentially Surrealist, and not to understand this is to misunderstand what he is doing, and how he came upon it, and usually derives from a mistaken image of Surrealism itself — which was a movement of ideas, had its greatest expression of all in literature, in French, and which produced the greatest painters and sculptors of the post-Picasso generation in Europe — Jean Arp, Max Ernst, Alberto Giacometti and Joan Miró, as well as a masterpiece of art literature, *The Secret Life of Salvador Dali*. Painting is a secondary line in Surrealism and the dream images of Dali-Tanguy-Magritte-Delvaux, on which popular image is based, are a secondary line of its painting, which appears in a major way in the early de Chirico.

Surrealist ideas pervade some of the most alive literature in Europe today. I for my part, though this is not my subject, believe that Surrealism is the mother, as certain philosophers are the father, of a major part of the attitudes in contemporary Existentialist literature in art. I believe, too, that the fact of the Parisian Surrealists being here in New York in the early forties had a deep effect on the rise of what is now called Abstract-Expressionism; for example, Surrealist automatism was discussed often with Jackson Pollock in the winter of 1941-42, before his first show; he made Surrealist automatic poems in collaboration with others that same winter — which is to take nothing from his personal force and genius. All this is a long and complicated story: but one can't help remarking how fantastic are the lies that have been built up about those days during the last nineteen years, by people who were not around then, and even worse, by some who were — in the interests of chauvinism, of originality, of being first, of, as Harold Rosenberg quotes, everyone wanting to get into the act, an act that started so simply and straight.

Miró is not merely a great artist in his own right; he is a direct link and forerunner in his automatism with the most vital painting of today. The resistance to the word "automatism" seems to come from interpreting its meaning as "unconscious," in the sense of being stone-drunk or asleep, not knowing what one is doing.

The truth is that the unconscious is inaccessible to the will by definition; that which is reached is the fluid and free "fringes of the mind" called the "pre-conscious," and consciousness constantly intervenes in the process. What is essential is not that there need not be consciousness, but that there be "no moral or aesthetic *a priori*" prejudices, (to quote André Breton's official definition of Surrealism) for obvious reasons for anyone who wants to dive into the depths of being. There are countless methods of automatism possible in literature and art — which are all generically forms of free-association: James Joyce is a master of automatism — but the plastic version that dominates Miró's art (as it did Klee's, Masson's in his best moment, Pollock's and many of ours now, even if the original automatic lines are hidden under broad colored areas) is most easily and immediately recognized by calling the method "doodling," if one understands at once that "doodling" in the hands of a Miró has no more to do with just anyone doodling on a telephone pad than the "representations" of a Dürer or a Leonardo have to do with the "representations" in a Sears catalogue.

When Miró has a satisfactory ground, he "doodles" on it with his incomparable grace and sureness, and then the

picture finds its own identity and meaning in the actual act of being made, which I think is what Harold Rosenberg meant by "Action-Painting." Once the labyrinth of "doodling" is made, one supresses what one doesn't want, adds and interprets as one likes, and "finishes" the picture according to one's aesthetic and ethic — Klee, Miró, Pollock and Tanguy for example, all drew by "doodling," but it is difficult to name four artists more different in final weight and effect.

The third, last stage of interpretation and self-judgment is conscious. A dozen years ago Miró explained to J. J. Sweeney: "What is most interesting to me today is the material I am working with. It supplies the shock which suggests the form just as the cracks in the wall suggest the shapes to Leonardo. For this reason I always work on several canvases at once. I start a canvas without a thought of what it may become. I put it aside after the first fire has abated. I may not look at it again for months. Then I take it out and work at it coldly like an artisan, guided strictly by rules of composition after the first shock of suggestion has cooled . . . first the suggestion, usually from the material; second, the conscious organization of these forms; and third, the compositional enrichment."

Carl Holty:
ARTISTIC CREATIVITY

Excerpt from *Bulletin of the Atomic Scientists*, 1959

A little over ten years ago the Catalan painter Joan Miró came to the United States to do a large mural painting for a modern hotel in Cincinnati. Miró chose to execute the painting in New York where there was more to entertain him and his family during their short visit to this country. As an acquaintance, I had the opportunity of seeing that picture in all the stages of its development.

It was interesting to watch Miró combine and fuse a craftsman's method with an artist's adventure; and observing the gradual evolution of the work was revealing, technically enlightening, and at times confusing.

Miró had a small water color sketch (to scale) but it was not really a sketch, just a plan of four separate form complexes, a general layout committing the artist to nothing in particular.

The first step taken on the huge canvas itself was when Miró painted the entire surface a rich cerulean blue. He wore an ordinary house painter's brush down to its handle because he rubbed and scuffed the paint into the cloth. The resulting effect was that of an enormous uneven and exciting blue vista turbulent in its texture. All that fire and liveliness was to be gradually diminished; the blue became background, space and foil to the positive shapes in solid colors — black, red, green, yellow, and white.

There was no doubt that Miró had created in his blue surface a variant of Leonardo's mildewed walls "upon which the artist can see all manner of shapes and objects" so that

he, Miró, could find the exact place and size of the forms he was to create.

This "underpainting" was considered thoroughly dry after two weeks had passed and then on successive days Miró "tried out" three compositional versions of what he had in mind. These he drew lightly in charcoal on the shaggy blue canvas. He drew each of these compositions in one day's time and dusted off the rejected first two late in the afternoon or early the following morning. He used a large bandanna handkerchief, always dusting never rubbing, so that when he finished cleaning the surface it was unsmudged and pristine. Miró is a tiny man and his charcoal was affixed to a long light wand. He moved easily, almost like a ballet dancer, before the huge canvas. He often drew above his head with long sweeping movements of his arm and without directly looking at what he was doing. He told me that he liked "not to think," but he never sketched, he always knew exactly what he was doing. He never faltered, and he changed his mind only when he went over to an entirely new version of his conception.

The third "cast" appeared to satisfy him. He told me earlier that he wanted to compose his picture in long monumental lines (*avec des grandes lignes monumentales*). Now he seemed to have attained their balance, and he went on to what he called the "definitive" and final drawing. I was curious to see what this would be and I was rather disappointed to find that he was just making the lines already drawn somewhat darker and in a few instances straightening out what was a bit wobbly. After that he painted in all the large areas that were to be black solidly to "equilibrate" the composition.

When the painting was almost complete and we were looking at it late one afternoon (after darkness made working impossible, for Miró was very orderly and punctilious about the working day), I pointed out certain accidental images of the mind that are bound to emerge uninvited in all complex fields of vision. Miró was not interested in these, nor moved to study the changes brought about in the painting by the waning daylight when the blues become lighter, the reds and yellows darker, and a painting often resembles a photographic negative of itself. I was surprised that all this meant nothing to him, the more so since he told me that after his Cubist period he had tried out every manner of producing visual effects. But the real shock of the day came when I pointed to a large white form in the left part of the picture and asked, "That is a fish, isn't it?" — and he answered somewhat irritably, "For me it's a woman." How was it possible that two painters, both of whom had painted nonrepresentational pictures for more than twenty years (and I had once been much influenced by Miró's work), could be so far apart on such an important point? And how could we chide the layman for being so obtuse?

When I hedged a bit on my obvious misinterpretation by suggesting that perhaps he was more interested in the ornamental or decorative use of his "private" language, he

denied this, saying he was not the least interested in decoration or ornament but only in the image. What image then? He was not rigid about composition. While he did not change anything, he certaintly added new elements.

One afternoon, after watching some children fly kites on the roof of our studio building, Miró was so inspired by the waving, undulating movements of the kite's tail that he drew those long rhythmic lines into his picture already ''equilibrated'' and partially painted and right away without much deliberating. Since the canvas was so much wider than it was high, he drew the lines in horizontally in the lower right hand corner of his painting, the only place where there was any room left. Surely, wavy lines running from left to right are not an exact interpretation of the vertical movement of those same lines leaping and soaring against the sky.

Perhaps the answer to what seemed so mysterious was given by another artist who came to look at the painting when it was finished. This visitor, who might have had some prejudices about Miró's work, in the presence of this painting was moved to say, with considerable emotion, ''It isn't true that he is a decorator. He is not at all decorative, he creates out of a spirit of visual wealth and imaginative opulence.'' This seemed to establish the important image Miró created. It was an image of all that is rich and plentiful, singing color, fantasy, and poise. The rest, fish or woman, was perhaps a private matter.

In a published interview Miró once stated that he, who like most young artists of his generation had been a Cubist, decided to abandon the quest for the ''plastic'' to listen instead to the voice of poetry.

CHRONOLOGY AND DOCUMENTARY PHOTOGRAPHS

1893 Joan Miró born on April 20 to Michel Miró Adzerias, a goldsmith, and Dolores Ferra, at 4 Basaje del Credito, Barcelona.

1900 Student in Barcelona. Takes drawing lessons with Civil.

1901 Earliest extant drawings.

1905 Visits grandparents in Tarragona and Palma de Majorca. Makes many nature drawings.

1907 Briefly studies business in Barcelona. Attends Escuela Oficial de Bellas Artes de la Lonja, Barcelona and is influenced by his teachers, Modesto Urgell and José Pascó.

1910 Takes job as a business clerk and temporarily abandons art studies. Contracts typhoid fever and recovers at parents' home in Montroig. Dedicates himself to painting.

1912 Becomes student at Galí's Escola d'Art in Barcelona. Meets the painter E. C. Ricart and the ceramist Josep Llorens Artigas. Makes first oil paintings. Sees Impressionist, Fauve, and Cubist paintings at Galerie Dalmau, Barcelona.

1915 Participates in the Sant Lluch circle and shares first studio with Ricart. Makes nude drawings and paints in a fauvist manner.

1916 Paints first self-portrait, still lifes, and landscapes. Sees Vollard's exhibition of French art in Barcelona. Reads avant-garde magazines and poetry by Mallarmé, Apollinaire, and Reverdy.

1917 Meets Francis Picabia. Produces portraits and Montroig landscapes.

1918 First solo show at the Galerie Dalmau of sixty-four canvases and drawings made from 1914 to 1917. Joins Agrupació Courbet, a group of artists associated with Artigas.

1919 Takes first trip to Paris and visits the Louvre. Meets Pablo Picasso and Maurice Raynal. From 1919 until 1933, spends winters in Paris and summers in Montroig.

1920 Meets Max Jacob, Tristan Tzara, and Reverdy in Paris. Participates in Dada Festival at the Salle Gaveau. Has studio at 45, rue Blomet.

1921 First solo show at the Galerie La Licorne organized by Dalmau with catalogue preface by Raynal. Exhibition considered a failure. Paints *The Farm*.

1922 Begins friendship with André Masson, also with Leiris, Limbour, Artaud, Salacrou, and Tual. Completes a small group of realistic still lifes.

Fig. 64. Joan Miró with his parents and sister.

Fig. 65. Miró in his first communion suit.

1923 Develops friendships with Jacques Prévert, Ernest Hemingway and Henry Miller. Begins *The Tilled Field.* Exhibits at the Salon d'Automne in Paris with other Catalan painters.

1924 Paints *Harlequin's Carnival* in new fantastic manner. Joins Surrealist group. Sees Kandinsky's work in Paris.

1925 Makes ''painting-poems'' and ''dream paintings.'' Solo show at Galerie Pierre, Paris (considered a *succés de scandale*). Included in his first Surrealist group show at Galerie Pierre. (Catalogue preface written by Benjamin Peret.)

1926 First public showing of his work in America at the *International Exhibition of Modern Art* at the Brooklyn Museum, organized by Marcel Duchamp and Katherine S. Dreier's Société Anonyme.

1927 Moves studio to Montmartre. Lives near Magritte, Arp, Ernst, and Eluard.

1928 Visits Holland and paints after Dutch masters. Makes *papiers collés.* Meets Alexander Calder.

1929 Solo show in Brussels. Marries Pilar Juncosa in Palma.

1930 Included in exhibition at Galerie Pierre with Braque, Picasso, Ernst, Arp, and Picabia. First solo exhibition in America at the Valentine Gallery, New York. Included in The Museum of Modern Art's *Painting in Paris* exhibition.

1931 Has show of paintings at the Arts Club of Chicago. Daughter Dolores born.

1932 First solo show at the Pierre Matisse Gallery in New York. Creates sets and costumes for the Ballet Russe de Monte-Carlo. Exhibits with the Surrealists at the Salon des Surindependants. Returns to Barcelona.

1933 Paints large canvases after collages. First solo London show at the Mayor Gallery.

1934 Makes paintings on sandpaper and large pastels during new ''savage'' period. Produces tapestry cartoons.

1935 Makes many gouaches and watercolors until 1938. Included in Surrealist exhibition at Tenerife, Canary Islands. Included in The Museum of Modern Art's *Modern Works of Art: Fifth Anniversary Exhibition* in New York.

1936 Included in *Fantastic Art, Dada, Surrealism* and *Cubism and Abstract Art* at The Museum of Modern Art. Makes paintings in tempera and on copper and masonite. First phase of the Civil War, leaves Spain and returns to Paris.

1937 Paints *Still Life with Old Shoe.* Attends classes at the Grande Chaumière. Paints *The Reaper* for the Spanish

Fig. 66. Miró in New York. Copyright © Arnold Newman

Fig. 67. Miró with José Artigas in a Barcelona café.

Pavilion at the Paris World's Fair. Makes poster for the Spanish loyalists.

1938　Spends the summer in Normandy. Paints in a calmer, more austere manner. Writes "Je rêve d'un grand atelier."

1939　Paints on burlap. Inspired by music.

1940　Begins *Constellations* series. Settles in Palma.

1941　Has major retrospective at The Museum of Modern Art with first monograph on Miró written by James Johnson Sweeney.

1942　Makes works on paper of women, stars, and birds. Returns to Barcelona.

1944　Miró's mother dies. Makes ceramics with Artigas.

1945　Exhibition at Pierre Matisse Gallery of *Constellations* and ceramics.

1946　Series of women and birds in the night.

1947　First trip to America to paint a mural for the Terrace Plaza Hotel in Cincinnati. Illustrates Tristan Tzara's *L'Antitête.* Meets Adolph Gottlieb. Represented at Surrealist Exhibition at the Galerie Maeght.

1948　Returns to Paris, has solo show at the Galerie Maeght. The Museum of Modern Art exhibits the Cincinnati mural.

Fig. 68. Miró in a passageway in Barcelona.

Fig. 69. Miró and Artigas in front of the Barcelona airport mural.

Fig. 70. Miró working on the Barcelona airport mural.

Fig. 71. Miró in his studio.

Fig. 72. Miró sculpting.

1949 Exhibition in Barcelona. Retrospectives at the Kunsthalle, Bern and the Kunsthalle, Basel.

1950 Paints mural for Harvard University. Sees exhibition by Jackson Pollock in Paris.

1952 Paints pictures in freer, more brutal style. Visits Cincinnati to see mural *in situ*.

1954 Travelling exhibition to German museums. Awarded the Grand Prix International for graphic work at the Venice Biennale. Stops painting until 1959.

1955 Completes second stage of work in ceramics with Artigas.

1956 Exhibition of ceramics at the Galerie Maeght. Works in studio in Palma designed by José Luis Sert.

1957 Graphic work exhibited in German museums. Begins ceramic murals, *Day* and *Night,* for UNESCO building in Paris.

Fig. 73. Miró and Alexander Calder in Paris, 1974.

1958 Wins Guggenheim International Award for UNESCO walls. Included in exhibition, *Fifty Years of Modern Art,* at the World's Fair in Brussels. Introduces a new style with his print entitled *The Giants.*

1959 Second trip to America for retrospective at The Museum of Modern Art. Presentation from President Eisenhower for Guggenheim Award.

1960 Mural for Harvard (done with Artigas) exhibited in Barcelona, Paris, and New York.

1961 Makes mural paintings *Blue I, II,* and *III.* Again visits New York.

1962 Makes series of paintings on cardboard. Large retrospective at the Musée National d'Art Moderne, Paris.

1963 Makes ceramic sculptures with Artigas. Retrospective at the Tate Gallery in London.

Fig. 74. Miró making a lithograph.

1964 Makes large sculptures and ceramics for the Fondation Maeght in Saint-Paul-de-Vence.

1965 Visits New York and Chicago.

1966 Paints mural for Osaka, Japan. Retrospective of graphic work at the Philadelphia Museum of Art. Begins ceramic mural *Alicia* for the Guggenheim Museum.

1967 Awarded Carnegie Institute prize for painting.

1968 Receives honorary Doctor of Arts from Harvard University. "Miró Year" celebrated in Barcelona.

1969 Major retrospective in Munich.

1970 Makes ceramic mural for Barcelona Airport with Artigas. *Impromptu*, his largest mural, exhibited at Expo '70 in Osaka.

1971 Sculpture exhibition in Minneapolis at The Walker Art Center. Tours to Cleveland Museum of Art, Art Institute of Chicago, and Museum of Fine Arts, Boston.

1972 Designs tapestry for the National Gallery of Arts' East Wing in Washington, D.C. Exhibition at the Guggenheim Museum of *Joan Miró: Magnetic Fields*.

1973 Exhibition of Miró's work in the collection of The Museum of Modern Art.

1974 Exhibitions in Paris at the Grand Palais and the Musée d'Art Moderne of paintings, sculpture, ceramics, and graphic work.

1975 Fundació Joan Miró, Centre d'Estudis d'Art Contemporani opens in Barcelona.

1976 Exhibition of drawings from 1901 to 1975 at the Inauguration of the Fundació Miró.

1978 Retrospective of paintings at the Museo Español de Arte Contemporanea, Madrid.

1979 Retrospective at the Fondation Maeght in honor of his eighty-sixth birthday. Installation of his stained glass windows in the Fundació Joan Miró.

1980 Retrospective at the Museo d'Arte Moderno, Mexico City. Major painting exhibition at the Hirshhorn Museum, Washington, D.C. Travelling exhibition of paintings and drawings in Japan. Inauguration of monumental ceramic sculpture at the Palacio de Expositiones, Madrid.

1981 Inauguration of the monumental sculpture, *Miss Chicago* (in collaboration with Joan Artigas), in Chicago. Retrospective *Miró Milano*, Italy.

1982 *Miró in America* at The Museum of Fine Arts, Houston.

Fig. 75. Miró

Fig. 76. Miró with Gerald Hines, I. M. Pei, Ben Love, Hugh Roff, and others in Majorca.

BIBLIOGRAPHY

STATEMENTS BY MIRÓ

Ashton, Dore. "Miró — Artigas." *Crafts Horizons* 17 (February 1957): 16-20.

Bouchard, Thomas, producer. *Joan Miró Makes a Colorprint.* Film, 2 reels; 16 mm.; sound; color. New York: Bouchard Productions, 1951.

_____. *Around and About Miró.* Directed by Thomas Bouchard. Film; 16 mm.; sound; color. New York: Bouchard Productions, 1956.

Fifield, W. "Miró: an Interview in Mallorca." *Arts Magazine* 43 (November 1968): 17.

Katzenbach and Warren, Inc. "Mural Scrolls." Introduction by James T. Soby. Katzenbach & Warren, 1949.

Lee, Francis. "Interview with Miró." *Possibilities* no. 1 (Winter 1947-1948): 66-67.

Miró, Joan. *Ceci est la Couleur de mes Rêves.* Entretiens avec Georges Raillard. Paris: Sevil, 1977.

Miró, Joan. "I Dream of a Large Studio" in *Joan Miró: Exhibition of Early Paintings.* New York: Pierre Matisse Gallery, 1940.

Picon, Gaëtan, ed. Joan Miró: *The Catalan Notebooks.* New York: Rizzoli, 1977.

Roditi, Edouard. "Interview with Joan Miró." *Arts Magazine* 33 (October 1958): 38-43.

Saarinen, Aline B. "A Talk with Miró about his Art." *New York Times,* May 24, 1959, p. 17.

Sweeney, James Johnson. "Joan Miró: Comment and Interview." *Partisan Review* 15 (February 1948): 206-212.

BOOKS

Art Since 1945. New York: Abrams, 1958.

Barr, Alfred H., ed. *Masters of Modern Art.* New York: The Museum of Modern Art, 1954.

_____. *Painting and Sculpture in The Museum of Modern Art.* New York: The Museum of Modern Art, 1948.

_____. *What is Modern Painting?* New York: The Museum of Modern Art, 1943.

Bazin, Germain. *History of Modern Painting.* New York: Hyperion, 1951.

Bulliet, Clarence J. *The Significant Moderns.* New York: Covici-Friede, 1936.

Dreier, Katherine S. *Modern Art.* New York: Société Anonyme-Museum of Modern Art, 1926.

Dupin, Jacques. *Joan Miró: Life and Work.* New York: Abrams, 1962.

_____. *Miró.* Paris: Flammarion, 1961.

Edwards, Hugh. *Surrealism and its Affinities; the Mary Reynolds Collection, a Bibliography.* Chicago: Art Institute of Chicago, 1956.

Gomis, Joaquim and Prats-Valles, Joan. *The Miró Atmosphere.* Preface by James Johnson Sweeney. New York: Wittenborn, 1959.

Greenberg, Clement. *Art and Culture: Critical Essays.* Boston: Beacon Press, 1961.

_____. *Joan Miró.* New York: Quadrangle Press, 1949.

Guggenheim, Peggy, ed. *Art of This Century . . . 1910 to 1940.* New York: Art of this Century, 1942.

Hunter, Sam. *Joan Miró: His Graphic Work.* New York: Abrams, 1958.

Krauss, Rosalind and Rowell, Margit. *Miró, Magnetic Fields.* New York: The Solomon R. Guggenheim Museum, 1972.

Leiris, Michel. *The Prints of Joan Miró.* New York: Curt Valentin, 1947.

Levy, Julien. *Surrealism.* New York: Black Sun Press, 1936.

Lynes, Russell. *The Good Old Modern.* New York: Atheneum, 1973.

Mourlot, Fernand. *Art in Posters. The Complete Original Posters of Braque, Chagall, Dufy, Léger, Matisse, Miró, Picasso.* New York: Braziller, 1959.

The Museum of Modern Art Library. Scrapbook on Joan Miró (1939-current).

Raynal, Maurice (& Others). *History of Modern Painting,* vol. 3: *From Picasso to Surrealism.* Geneva: Skira, 1950.

Read, Herbert. *Art Now.* New York: Harcourt, Brace, 1934.

_____. *A Concise History of Modern Painting.* New York: Praeger, 1959.

Rowell, Margit. *Joan Miró, Painter-poet.* Paris: Editions de la

Différence, 1976.

_____. *Miró.* New York: Abrams, 1971.

Rubin, William S. *Miró in the Collection of The Museum of Modern Art.* New York: The Museum of Modern Art, 1973.

Sachs, Maurice. *The Decade of Illusion; Paris 1918-1928.* New York: Knopf, 1933.

Soby, James Thrall. *After Picasso.* New York: Dodd, Mead, 1935.

_____. *Contemporary Painters.* New York: The Museum of Modern Art, 1948.

_____. *Joan Miró.* New York: The Museum of Modern Art, 1959.

_____. *Modern Art and the New Past.* Norman: University of Oklahoma Press, 1957.

Sweeney, James Johnson. *Joan Miró.* New York: The Museum of Modern Art, 1941.

_____. *Plastic Redirections in 20th Century Painting.* Chicago: University of Chicago Press, 1934.

PERIODICALS

"Acquavella Gallery, New York: Exhibition." *Art in America* 60 (September 1972): 119.

"Acquavella Gallery, New York: Exhibition." *Arts Magazine* 47 (November 1972): 85.

Alloway, L. "Art: Exhibitions at the Guggenheim and Several New York Galleries." *Nation* 215 (November 1972): 508-510.

Alvard, Julien. "What Does Miró Do with What He Sees?" *Art News* 66 (November 1967): 32-33.

"Another Catalonian." *Art Digest* 13 (April 15, 1939): 18.

Armstrong, L. D. "Exhibition in Los Angeles." *Art News* 67 (December 1968): 18.

"Art Galleries: Exhibition at Pierre Matisse." *The New Yorker* 37 (November 1961): 216.

"Art Roster: Comment on Recent Openings." *New York Times,* November 6, 1932, p. 4.

Ashbery, J. "Miró's Bronze Age." *Art News* 69 (May 1970): 34-36.

Baro, G. "Miró: A Leap in the Air." *Arts Magazine* 39 (October 1964): 38-43.

"Boiling Internally." *Time* 56 (July 10, 1950): 45.

Brenson, M. "Miró Sculptures." *Art in America* 67 (March 1979): 44-45.

Brown, Milton. "Review of Pierre Matisse Show of Miró." *Parnassus* 13 (April 1941): 154-155.

Calas, N. "Miró Without Mirror." *Arts Magazine* 47 (December 1972): 69.

Canaday, J. "Miró Barks Merrily at his Critics." *New York Times Magazine,* March 15, 1959, pp. 22-23.

Champa, Kermit. "Miró." *Artforum* 11 (February 1973): 57-61.

Church, R. M. "Spanish Masters of 20th Century Painting." *Architect and Engineer* (San Francisco) 174 (September 1948): 10-12.

Coates, R. M. "Art Galleries: Exhibition at Matisse Gallery of Objects in Terra Cotta in Collaboration with Joan Artigas." *The New Yorker* 32 (December 1956): 130-131.

_____. "Art Galleries: Retrospective Exhibit at the Museum of Modern Art." *The New Yorker* 35 (April 1959): 144-146.

_____. "New Mirós." *The New Yorker* 23 (May 1947): 72.

Connolly, Cyril. "Surrealism." *Art News* 50 (November 1951): 130-162.

"Dain Gallery, New York: Exhibition." *Arts Magazine* 47 (December 1972): 80.

Davidson, M. "Subconscious Pictography by Joan Miró." *Art News* 35 (December 1936): 11.

"Do You Get It?" *Art Digest* 12 (May 1, 1938): 21.

"Double Image of Surrealism." *Art News* 40 (January 1942): 21.

Duthuit, Georges. "Fantasy in Catalonia." *Magazine of Art* 30 (July 1937): 440-443.

"Exhibition at Matisse Gallery." *Art News* 60 (December 1961): 10.

"Exhibition at Pierre Matisse Gallery." *Arts Magazine* 40 (December 1965): 46.

"Exhibition at Pierre Matisse Gallery." *Arts Magazine* 42 (December 1967): 59.

"Exhibitions at Weintraub and Dain Galleries." *Art News* 69 (Summer 1970): 65.

"Exhibition from Private Collections in Saint Louis." *St. Louis Museum Bulletin,* September 1965, p. 8.

"Femmes et Oiseau dans la Nuit." *Detroit Institute Bulletin* 40 (1960-61): 66-67.

"The Fortnight in New York." *Art Digest* 13 (April 15, 1929): 18.

Frey, John G. "Miró and the Surrealists." *Parnassus* 8 (October 1936): 13-15.

Getlein, F. "Art Exhibition at The Museum of Modern Art." *New Republic* 140 (May 1959): 22.

Gibson, M. "When I see a tree . . . I can feel that tree talking to me." *Art News* 79 (January 1980): 52-56.

Giuliano, Charles. "Miró, Fowl of Venus." *Arts Magazine* 42 (December 1967): 59.

Gomez Sicre, José. "Joan Miró in New York." *Right Angle* 1 (January 1948): 5-6.

Goodrich, Lloyd. "November Exhibitions." *Arts Magazine* 17 (November 1930): 119.

Greenberg, Clement. "Art." *The Nation* 152 (April 19, 1941): 481-482.

_____. "Art." *The Nation* 158 (May 20, 1944): 604.

_____. "Art." *The Nation* 160 (June 9, 1945): 657-659.

_____. "Art." *The Nation* 164 (June 7, 1947): 692-694.

Groser, M. "Art: Exhibition at The Museum of Modern Art." *The Nation* 188 (April 1959): 322-323.

"Had Any Good Dreams Lately? Exhibition of the Works of Joan Miró and Salvador Dali." *The New Yorker* 17 (November 1941): 58.

Henning, E. B. "Joan Miró: Woman with Blond Armpit Combing her Hair by the Light of the Stars." *Cleveland Museum Bulletin* 55 (March 1968): 71-77.

_____. "Painting by Joan Miró." *Cleveland Museum Bulletin* 66 (September 1979): 235-240.

Hugnet, Georges. "In the Light of Surrealism." *Bulletin of The Museum of Modern Art* 4 (November-December 1936): 19-32.

Jewell, Edward Alden. "Adroit Art Marks Large Miró Show." *New York Times,* December 30, 1933, p. 11.

_____. "Works of Two Surrealists Offer Opportunity to Understand Them with a Struggle." *New York Times,* November 5, 1932.

"Joan Miró: Magnetic Fields: Guggenheim Museum, New York, Exhibition." *Art International* 17 (February 1973): 46.

"Joan Miró: Magnetic Fields. Miró at Acquavella Galleries (New York)." *Connoisseur* 182 (February 1973): 187.

Kaufman, B. "Miró Year." *Commonweal* 70 (May 1959): 134-135.

Kramer, Hilton. "Eye of the Beholder." *Reporter* 20 (May 1959): 38.

_____. "Month in Review." *Arts Magazine* 33 (May 1959): 48-51.

Langsner, J. "Exhibition of Drawings in Los Angeles." *Art News* 61 (December 1962): 22.

Leiris, Michel. "Joan Miró." *Little Review,* Spring-Summer 1926, pp. 8-9.

Lieberman, William S. "Modern French Tapestries." *Bulletin of the Metropolitan Museum of Art* 6 (1947): 142-148.

"Los Angeles County Museum of Art: Exhibition." *Art News* 74 (December 1975): 84.

Mauny, Jacques. "New York Letter." *Formes* 7 (July 1930): 21-23.

Messer, T. A. "Miró Twice Removed." *Detroit Institute Bulletin* 51 (1972): 105-111.

McBride, Henry. "Modern Art." *Dial* 85 (December 1928): 526-528.

McGavick, A. "Weird Worlds." *Commonweal* 27 (April 1938): 630.

"Miró and Modern Art." *Partisan Review* 16 (March 1949): 324-326.

"Miró at Pierre Matisse Gallery." *Arts Magazine* 44 (May 1970): 25.

"Miró Exhibition: Valentine Gallery." *Art News* 29 (October 25, 1930): 11.

"Miró, Leader of Surrealists, Has Exhibit." *Art Digest* 9 (February 1, 1935): 11.

"Miró, Painter of Reality." *Art Digest* 26 (December 1, 1951): 16.

"Miró's Barcelona Suite." *Art Journal* 32 (Summer 1973): 44.

"Miró's Dog Barks While McBride Bites." *Art Digest* 4 (December 15, 1929): 5, 10.

Moratz, F. "Mending a Miró." *Art in America* 50 (Fall 1962): 29.

Morris, George L. K. "Art Chronicle: Sweeney, Soby and Surrealism." *Partisan Review* 9 (March-April 1942): 125-127.

_____. "Miró and the Spanish Civil War." *Partisan Review* 4 (February 1938): 32-33.

Motherwell, Robert. "Significance of Miró." *Art News* 58 (May 1959): 32-33.

"Mural for Cincinnati's Terrace Plaza Hotel." *Architectural Forum* 88 (April 1948): 148.

"Mural for Terrace Plaza Hotel, Cincinnati." *Art Digest* 21 (May 1947): 16.

"New Temperas and Ceramics by Miró." *Art Digest* 19 (January 1, 1945): 13.

Nordland, G. "Report from Los Angeles." *Arts Magazine* 37 (December 1962): 55.

"Pace Gallery, New York: Exhibition." *Arts Magazine* 49 (February 1975): 16.

"Pierre Matisse Gallery, New York: Exhibit." *Art News* 72 (Summer 1973): 97.

"Pierre Matisse Gallery, New York: Exhibit." *Art International* 17 (October 1973): 53-54.

"Pierre Matisse Gallery, New York: Exhibit." *Arts Magazine* 48 (December 1973): 72.

"Pierre Matisse Gallery, New York: Exhibit." *Art News* 73 (January 1974): 93.

"Pierre Matisse Gallery, New York: Exhibit." *Art International* 19 (June 1975): 71.

"Pierre Matisse Gallery, New York: Exhibit." *Arts Magazine* 49 (June 1975): 26.

"Pierre Matisse Gallery, New York: Exhibit." *Arts Magazine* 50 (June 1976): 20.

"Pierre Matisse Gallery, New York: Exhibit." *Arts Magazine* 51 (February 1977): 26.

"Pierre Matisse Gallery, New York: Exhibit." *Art International* 22 (March 1979): 42-43.

"Pierre Matisse Gallery, New York: Exhibit." *Art News* 78 (February 1979): 174.

"President (Eisenhower) Presents Award to Miró, Spanish Artist." *New York Times,* May 19, 1959.

Pucinelli, Dorothy. "Miró Exhibition at the San Francisco Museum." *California Arts & Architecture* 59 (July 1942): 10.

Read, H. "Two Masters of Modern Art." *Reporter* 28 (June 1963): 38-40.

"Recent Paintings and Ceramics at New York's Pierre Matisse Gallery." *Progressive Architecture* 42 (December 1961): 71.

"Retrospective of Introspective Miró, Whose Dog Barked at the Moon." *Art Digest* 11 (December 1, 1936): 13.

Roditi, E. "Galerie Maeght's Exhibition of Ceramics by Miró and Artigas." *Arts Magazine* 38 (October 1963): 35.

Rose, Barbara. "Joan Miró." *Vogue* 160 (December 1972): 156-158.

Rosenberg, H. "Avant-garde Masterpieces: Exhibition at The Museum of Modern Art." *The New Yorker* 49 (November 1973): 120.

_____. "Fertile Fields." *The New Yorker* 48 (December 1972): 61-64.

_____. "Miró's Fertile Fields." *Art International* 17 (Summer 1973): 16-19.

"Round Table on Modern Art." *Life* 25 (October 11, 1948): 56-79.

Rowell, M. "Miró in the Collection of The Museum of Modern Art." *Art News* 73 (January 1974): 94-96.

Rubin, William. "Miró in Retrospect." *Art International* 3 (1959): 34-41.

Schneider, Pierre. "At the Louvre with Miró." *Encounter* 24 (March 1965): 44.

_____. "Exhibition at the Galerie Maeght." *Art News* 62 (October 1963): 66.

_____. "Miró." *Horizon* 4 (March 1959): 70-81.

_____. "Retrospective at the Musée d'Art Moderne." *Art News* 61 (October 1962): 48.

"Studio for Joan Miró, Mallorca — J. L. Sert, Architect." *Architectural Record* 123 (January 15, 1958): 138-140.

"The Sincerity of Miró." *Art Digest* 8 (January 15, 1934): 13.

"Solomon R. Guggenheim Museum, New York: Exhibition." *Art Journal* 32 (Winter 1972-73): 214.

"Surrealism in Art (Knoedler Gallery, New York: Exhibition)." *Art News* 74 (April 1975): 91.

Sweeney, James J. "A Note on Super-Realist Painting." *The Arts* 16 (May 1930): 611-613.

_____. "Miró." *Theatre Arts* 33 (March 1949): 38-41.

_____. "Miró." *Art News* 52 (November 1953): 58-81, 185-188.

_____. "Miró and Dali." *New Republic* 81 (February 1935): 360.

_____. "Miró's Mirror Magic." *Town & Country* April 1945, pp. 93, 126-127.

Tillim, Sidney. "Miró: 'Let anonymity. . . claim the man.'" *Progressive Architecture* 41 January 1960): 180.

_____. "New York Exhibition: In the Galleries." *Arts Magazine* 36 (January 1962): 34.

Todd, Ruthven. "Miró in New York: A Reminiscence." *The Malahat Review* 1 (January 1967): 80-81.

Trucco, T. "Art Market: Expressionist Explosion." *Art News* 79 (March 1980): 140.

Tuchman, M. "European Painting in the Seventies." *Art and Artists* 10 (November 1975): 45-46.

Weiss, Hugh. "Miró-Magic with Rocks." *Art News* 55 (Summer 1956): 48-49, 56-58.

Wolf, Ben. "Miró Show, Delayed in Transit, Opens in New York." *Art Digest* 21 (June 1947): 10.

Young, J. E. "Pasadena Art Museum: Exhibition." *Art International* 15 (April 1971): 46.

EXHIBITION CATALOGUES

Alexander Calder — Joan Miró. New York: Perls Galleries, 1961.

Art in Our Time. New York: The Museum of Modern Art, 1939.

Art in Progress. New York: The Museum of Modern Art, 1944.

The Artist and the Book, 1860-1960, in Western Europe and the United States. Boston: The Museum of Fine Arts, 1961.

Barr, Alfred H., *Cubism and Abstract Art.* New York: The Museum of Modern Art, 1937.

_____. *Fantastic Art, Dada, Surrealism.* New York: The Museum of Modern Art, 1937.

_____. *Modern Works of Art.* New York: The Museum of Modern Art, 1935.

_____. *Painting and Sculpture in The Museum of Modern Art.* New York: The Museum of Modern Art, 1942.

_____. *Painting in Paris from American Collections.* New York: The Museum of Modern Art, 1930.

Castleman, Rive. *Joan Miró: Fifty Recent Prints.* New York: The Museum of Modern Art, 1970.

Chrysler, Walter P., *The Collection of Walter P. Chrysler, Jr.* Richmond: The Virginia Museum of Fine Arts, 1941.

Contemporary Movements in European Painting. Toledo: Toledo Museum of Art, 1938.

Cooper, Douglas. *Joan Miró.* New York: Acquavella Galleries, 1972.

De Cezanne à Miró. New York: The Museum of Modern Art, 1968.

Drawings by Joan Miró. Beverly Hills: Paul Kanter Gallery, 1962.

The Early Paintings of Joan Miró. New York: Pierre Matisse Gallery, 1951.

First Showing of Paintings, Gouache, Pastels and Drawings by Joan Miró. New York: Pierre Matisse Gallery, 1952.

Four Spaniards: Dali, Gris, Miró, Picasso. Boston: Institute of Contemporary Art, 1946.

Franc, Helen M. *An Invitation to See.* New York: The Museum of Modern Art, 1973.

A. E. Gallatin Collection. New York: Gallery of Living Art, New York University, 1930.

Gershinowitz, Mary. *Joan Miró.* Houston: Contemporary Arts Association, 1951.

Goldwater, Robert and d'Harnoncourt, René. *Modern Art in Your Life.* New York: The Museum of Modern Art, 1949.

d'Harnoncourt, René. *Modern Art, Old and New.* New York: The Museum of Modern Art, 1950.

International Exhibition of Modern Art. New York: The Brooklyn Musuem, 1927.

Joan Miró. Detroit: Donald Morris Gallery, 1965.

Joan Miró. New York: Valentine Gallery, 1930.

Levin, Gail and Hobbs, Robert. *Abstract Expressionism: The Formative Years.* Ithaca: Herbert F. Johnson Museum of Art, Cornell University, 1978.

Louise and Walter Arensberg Collection. Philadelphia: Museum of Art, 1954.

Lieberman, William S. *Joan Miró.* New York: The Museum of Modern Art. 1959.

Miró. New York: Pierre Matisse Gallery, 1932.

Miró. New York: Pierre Matisse Gallery, 1934.

Miró. New York: Pierre Matisse Gallery, 1935.

Miró. New York: Pierre Matisse Gallery, 1936.

Miró. New York: Pierre Matisse Gallery, 1938.

Miró. New York: Pierre Matisse Gallery, 1939.

Miró. New York: Pierre Matisse Gallery, 1940.

Miró. New York: Pierre Matisse Gallery, 1941.

Miró. New York: Pierre Matisse Gallery, 1942.

Miró. New York: Pierre Matisse Gallery, 1944.

Miró. New York: Pierre Matisse Gallery, 1945.

Miró. New York: Pierre Matisse Gallery, 1947.

Miró. New York: Pierre Matisse Gallery, 1948.

Miró. New York: Pierre Matisse Gallery, 1949.

Miró. New York: Pierre Matisse Gallery, 1951.

Miró. New York: Pierre Matisse Gallery, 1953.

Miró. New York: Pierre Matisse Gallery, 1956.

Miró. New York: Pierre Matisse Gallery, 1957.

Miró. New York: Pierre Matisse Gallery, 1958.

Miró. New York: Pierre Matisse Gallery, 1961.

Miró. New York: Pierre Matisse Gallery, 1963.

Miró. New York: Pierre Matisse Gallery, 1965.

Miró. New York: Pierre Matisse Gallery, 1967.

Miró. New York: Pierre Matisse Gallery, 1970.

Miró. New York: Pierre Matisse Gallery, 1972.

Miró. New York: Pierre Matisse Gallery, 1973.

Miró. New York: Pierre Matisse Gallery. 1973.

Miró. New York: Pierre Matisse Gallery. 1975.

Miró. New York: Pierre Matisse Gallery, 1976.

Miró. New York: Pierre Matisse Gallery, 1978.

Miró. New York: Pierre Matisse Gallery, 1980.

Modern Masters from European and American Collections. New York: The Museum of Modern Art, 1940.

Paintings by Joan Miró. Chicago: The Arts Club of Chicago, 1931.

Paintings and Sculpture from the Collection of Mr. and Mrs. David Lloyd Krieger. Washington, D.C.: Corcoran Gallery of Art, 1965.

Paintings from Private Collections. New York: The Museum of Modern Art, 1955.

Picasso, Gris, Miró: The Spanish Masters of Twentieth Century Painting. San Francisco: Museum of Art, 1948.

Rubin, William S. *Dada, Surrealism, and Their Heritage.* New York: The Museum of Modern Art, 1968.

The School of Paris. New York: The Museum of Modern Art, 1966.

Seitz, William C. *The Art of Assemblage.* New York: The Museum of Modern Art, 1961.

Sert, José Luis. *Miró Sculpture.* New York: Pierre Matisse Gallery, April 1976.

Soby, James Thrall. *The James Thrall Soby Collection of Works of Art Pledged or Given to The Museum of Modern Art.* New York: Knoedler and Company, 1961.

Stich, Sidra. *Joan Miró: The Development of a Sign Language.* St. Louis: Washington University Gallery of Art, 1980.

Sweeney, James Johnson. "The Atmosphere Miró" in *Joan Miró: Constellations.* New York: Pierre Matisse Gallery, 1959.

_____. *Joan Miró.* New York: The Museum of Modern Art, 1942.

Twentieth Century Art from the Nelson Aldrich Rockefeller Collection. New York: The Museum of Modern Art, 1969.

Wechsler, Jeffrey. *Surrealism and American Art, 1931-1947.* New Brunswick: Rutgers University Art Gallery, 1977.

Wheeler, Monroe, ed. *Modern Drawings.* New York: The Museum of Modern Art, 1944.

_____. *Twentieth Century Portraits.* New York: The Museum of Modern Art, 1943.

Works of Art Given or Promised. New York: The Museum of Modern Art, 1958.

MIRÓ EXHIBITIONS IN AMERICA

NOTE: Only the works shown in New York have been individually identified, as these are the works that American artists would most likely have seen.

1926 New York. Brooklyn Museum, *International Exhibition of Modern Art.* November 19-January 1.

1930 New York. The Museum of Modern Art, *Painting in Paris.* January 19-February 16.

1930 New York. Gallery of Living Art, New York University, *A. E. Gallatin Collection.*

Dog Barking at the Moon, 1926

1930 New York. The Valentine Gallery. October 20-November 8.

Paysage au Bord de la Mer, 1926.
Grand Paysage, 1927.
Grand Paysage, 1927.
Nu, 1926.
Portrait de la Reine Louise, 1929.
Portrait de la Fornarina, 1929.
Portrait d'une Dame en 1820, 1929.
Interieur Hollandais, 1929.
Interieur Hollandais, 1928.
Pommes de Terres, 1928.
Nature Morte, 1928.
Portrait de Mrs. Mils., 1929.

1931 Chicago. The Arts Club of Chicago, *Paintings By Joan Miró.* January 27-February 17.

1931 New York. The Valentine Gallery. December 28, 1931-January 16, 1932.

1932 New York. Pierre Matisse Gallery. November 1-25.
Paintings on Paper:

Le Guitariste.
Tête d'homme.
Homme et femme.
Femme se promenant.
Tête de femme.
Femme mangeant une pomme.
Femme se promenant.
Homme et femme.
Femme avec ses enfants.
Tête de femme.

Drawings:
Femme assise.
L'Etoile.
Femme à bouche ouverte.
Madame X. . .
Le chapeau à plume.
Femme accroupie.

1933 New York. Pierre Matisse Gallery. December 29, 1933-January 18, 1934.
Paintings on Wood:

Femme Nue.
Les Amoureux.
Femme en Extase.
Figure.
Baigneuse.
Femme Assise.
Tête d'homme.
Jeune fille Faisant de la Culture Physique.
Une Femme.
Paintings on Canvas:
Composition, 5-6-33.
Composition, 10-6-33.
Composition, 4-4-33.
Composition, 8-5-33.
Composition, 4-3-33.
Composition, 31-3-33.
Composition, 12-4-33.
Composition, 8-3-33.
Composition, 3-3-33.
Composition, 12-5-33.

1934 Chicago. The Arts Club of Chicago. March 16-30.

1934 San Francisco. East-West Gallery. June. Organized by Howard Putzel.

1935 New York. Pierre Matisse Gallery, *Paintings-Tempera-Pastels.* January 10-February 9.

The Farm.
The Singer.
Two Figures.
The Blue Star.
Man Smoking a Pipe.
Woman on a Green Background.
Gouache on Black Paper.
Gouache on Black Paper.
Five paintings on sand paper.
Six gouache-drawings.
Five pastels.
Two drawings on colored paper.
Two paintings on paper.
Figure.
Drawing on Sand Paper.

1935 San Francisco. San Francisco Museum of Art. June 30-August 12, and December 1-15.

1935 Los Angeles. Stendahl Gallery. September.

1935 Hollywood. Stanley Rose Gallery. October 14-November 2. Organized by Howard Putzel.

1935 New York. The Museum of Modern Art, *Modern*

Works of Art: 5th Anniversary Exhibition. November 20, 1934-January 20, 1935.

1936 Hollywood. Stanley Rose Gallery, April, Organized by Howard Putzel.

1936 New York. Pierre Matisse Gallery. November 30-December 26.

Man with a Derby, ca. 1918.
Portrait of a Girl, ca. 1920.
The Farmer's Wife, ca. 1920.
Still Life with Glove, 1921.
Flowers and Butterfly, 1922-23.
The Gentlemen, 1924.
Dog Barking at the Moon, 1926.
Landscape by the Sea, 1926.
The Fratellini, 1927.
The Potato, 1928.
Women Resting, 1932.
Seated Woman, 1932.
Painting, 1933.
Painting, 1934.
Three Women, 1935.
Dancers, 1935.
Head of a Man, 1935.
Figures in the presence of a Metamorphosis, 1936.
Figures and Mountains, 1936.
Figures Attracted by the Shape of a Mountain, 1936.
Catalonian Peasant Resting, 1936.
The Two Philosophers, 1936.
Figure, Bird and Sun, 1936.
Figure, 1936.
Man, 1936.
The Rivals, 1936.
Painting, 1936.
Harlequin, 7-24-35. Gouache.
Harlequin, 7-29-35. Gouache.
Music, 7-30-35. Gouache.
Bird and Snake, 9-13-35. Gouache.
Seated Woman, 8-12-35. Gouache.
Shooting Star and Heads, 8-14-35. Gouache.
Apparitions, 8-29-35. Gouache.
Girl Skipping Rope, 9-9-35. Gouache.
Figure and Animal Head, 9-11-35. Gouache.
Woman in the Presence of a Snake, 9-13-35. Gouache.
Bird, Moon, Fish and Landscape, 9-27-35. Gouache.
Watercolor, 1936.

1936 New York. The Museum of Modern Art, *Cubisim and Abstract Art.* March 2-April 19.

Relief Construction, 1930. Wood. 35⅞ x 27⅝.
Head of a Man, 1932. Oil on wood. 13¾ x 10¾.
Composition, 1933. Painting on sandpaper. 14¼ x 9¼.
Composition, 1933. Oil on canvas. 68½ x 77¼.
Composition, 1934. Watercolor. 25 x 18½.

1936 New York. The Museum of Modern Art, *Fantastic Art, Dada, Surrealism.* December 7, 1936-January 17, 1937.

Catalan Landscape (The Hunter), 1923-24. Oil on canvas.

25½ x 39½.
Person Throwing a Stone at a Bird, 1926. Oil on canvas. 29 x 36¼.
Dutch Interior, 1928. Oil on canvas. 36⅛ x 28¾.
Relief Construction, 1930. Wood and metal. 35⅞ x 27⅝.
Composition, 1933. Oil on canvas. 57⅝ x 45⅛.
Rope and Personnages, 1935. Oil on cardboard with coil of rope. 41¼ x 29⅜.
Object, 1936. Wood, stuffed parrot, etc. 33¼ high.

1937 New York. The Museum of Modern Art, *Twelve Modern Paintings.* April 28-May 30.

1937 Hollywood. Stegel Antheil Gallery. March.

1937 Hollywood. Putzel Gallery. March.

1937 Honolulu. Honolulu Academy of Arts. Summer.

1938 New York. Pierre Matisse Gallery. April 18-May 7.

Still life with an old shoe, 1937. Oil.
Smoke, 1937. Oil.
Circus, 1937. Oil.
Abstraction, 1937. Oil.
Personage in meditation, 1937. Pastel.
Space, 1937. Gouache.
Standing Woman, 1937. Oil.
Collage, 1937. Gouache.
Personages, 1937. Gouache.
Woman with chignon, 1937. Oil.
Arrival of the good luck bird, 1937. Gouache.
Personage, 1937. Oil.
Painting on paper, 1937. Oil.
Painting on paper, 1937. Oil.
Women surrounded by birds, 1937. Pastel.
Abstraction, 1937. Oil.
Two personages, 1937. Oil.
Two women, 1937. Gouache.
Head and personage, 1937.
Painting, 1937. Oil.

1938. Hollywood. Putzel Gallery. April.

1938 Chicago. Katherine Kuh Galleries. November 1-30.

1938 Toledo. Toledo Museum of Art, *Contemporary Movements in European Painting.*

1939 New York. Pierre Matisse Gallery. April 10-May 6.

Auto-portrait I, 1938. Painting.
Auto-portrait II, 1938. Painting.
Portrait IV, 1938. Painting.
Woman Seated I, 1938. Painting.
Woman Seated II, 1938. Painting.
The flight of the bird, 1938. Painting.
Figure in front of the sea, 1938. Painting.
The flight of the bird over the plain, 1938. Painting.
Group of personages, 1938. Painting.
Head of a woman, 1938. Painting.
Group of Women, 1938. Painting.
Woman seated, 1938. Painting.

Personages in front of the moon, 1938. Painting.
Group of Women, 1938. Painting.
The Black Sun, 1938. Pastel.
The woman with a necklace, 1938. Watercolor.
Woman reclining, 1938. Watercolor.
"La toilette de violette," 1938. Gouache.
Four personages, 1938. Gouache.
Sunrise, 1938. Gouache.
Figure on the Beach, 1938. Colored crayon.

1939 New York. The Museum of Modern Art, *Art in Our Time: 10th Anniversary Exhibition.* May 10-September 30.

1940 New York. Pierre Matisse Gallery. March 12-31.

Early Paintings, 1918-1925:

Portrait du Chauffeur, 1918.
Vue de la Ferme, 1918.
Portrait d'un Orfèvre, 1918.
Paysage aux Oliviers, 1919.
Nu au Miroir, 1919.
Nature Morte au Cheval, 1920.
Les Cartes Espagnoles, 1920.
La Table au Gant, 1921.
La Fermière, 1922-23.
La Lamp à Carbure, 1922-23.
L'Epi de Blé, 1922-23.
La Terre Labourée, 1923-24.
Carnaval d'Arlequin, 1924-25.
Pastorale, 1924-25.

1940 New York. Gallery of Living Art, New York University.

1940 New York. The Museum of Modern Art, *Modern Masters from European and American Collections.* January 26-March 24.

1941 Richmond. Virginia Museum of Fine Arts, *The Collection of Walter P. Chrysler, Jr.* January 16-March 4.

1941 New York. The New School for Social Research. February. *The Family Maternity.*

1941 New York. Pierre Matisse Gallery. March 4-29.

Paintings:

Animated Landscape.
Painting (deep blue).
Painting (light blue).
Smoke.
The flight of the bird over the plain II.
Women and bird in the night.
Woman combing her hair.
Women greeting the crescent of the moon.
Woman and butterfly.
Figures and bird in front of the sun.
Woman and horn-beetle among the constellations.
Personages magnetized by the stars.
Women and birds in the night.
A drop of dew falling from the wing of a bird.

awakens Rosalie asleep in the shade of the cobweb. Decorative panel.

Gouaches and Drawings:

Summer.
Drawing on red paper.
The little village.
Personage in a landscape.
Woman at a mirror.
The funambulist.
Head.
Woman.
The witch.
Four figures.

1941 New York. The Museum of Modern Art. November 18, 1941-January 11, 1942.

Landscape with Donkey, 1918. Oil on canvas.
Nude, 1917. Pencil. 7¼ x 5⅞.
Nude, 1917. Pencil. 7⅜ x 5⅝.
Landscape with Olive Trees, 1919. Oil on canvas. 28½ x 35½.
Nude with Mirror, 1919. Oil on canvas. 44 x 40.
Flowers and Butterfly, 1922-23. Tempera on wood. 31¼ x 25½.
The Ear of Grain, 1922-23. Oil on canvas. 14⅞ x 18⅛.
The Farmer's Wife, 1922-23. Oil on canvas. 31¾ x 25½.
The Tilled Field, 1923-24. Oil on canvas. 26 x 37.
Catalan Landscape (The Hunter), 1923-24. Oil on canvas. 25½ x 39½.
In Reverse (The Renversement), 1924. Oil, pencil, charcoal, tempera on canvas. 36¼ x 28⅝.
Pastoral, 1923-24. Oil drawing on canvas. 23½ x 36.
The Harlequin's Carnival, 1924-25. Oil on canvas. 26 x 36⅝.
Glove with Face, 1925. Tempera and oil on canvas. 45¾ x 35.
Nude, 1926. Oil on canvas. 36 x 28¾.
Dog Barking at the Moon, 1926. Oil on canvas. 28¾ x 36¼.
Person Throwing a Stone at a Bird, 1926. Oil on canvas. 29 x 36¼.
Portrait, 1927. Oil on canvas. 57½ x 45.
Landscape by the Sea, 1926. Oil on canvas. 29 x 36⅝.
Statue, 1926. Charcoal. 24½ x 18⅜.
Composition, 1927. Oil on canvas. 13 x 9½.
The Fratellini, 1927. Oil on canvas. 51 x 38.
The Horse, 1927. Oil on canvas. 51⅜ x 38¼.
Dutch Interior, 1928. Oil on canvas. 36 x 28½.
Portrait of Mrs. Mills in 1750, 1929. Oil on canvas. 45½ x 35.
Relief Construction, 1930. Wood and metal. 35⅞ x 27⅝.
Seated Woman, 1932. Oil on wood. 18¼ x 15.
Composition, 1933. Oil on canvas. 68½ x 77¼.
Composition, 1933. Oil on canvas. 58 x 45¼.
Painting, 1933. Oil on canvas. 51½ x 64.
Composition, 1933. Oil on canvas. 51¼ x 64.
Drawing-collage, 1933. Chalk and pasted postcards. 24½ x 18½.
The Blue Star, 1934. Gouache and pencil on red paper. 19½ x 25½.

The Lovers, 1934. Pastel. 41½ x 27½.
Figure, 1934. Pastel. 41¾ x 27⅞.
Composition, 1935. Oil on sandpaper. 14⅜ x 9¼.
Rope and Persons, 1935. Oil on cardboard with coil of
 rope. 41½ x 29½.
Dancer, 1935. Oil and duco on cardboard. 41½ x 29¾.
Tapestry, designed by Miró before 1937. 77 x 70.
Person in the Presence of Nature, 1935. Gouache on
 cardboard. 29 x 41.
The Gardener, 1936. Watercolor. 12 x 14½.
Women Bathing, 1937. Oil on canvas. 5½ x 7⅛.
*Nursery decoration "Pour Jackey, Peter et Pauley
 Matisse,"* 1938. Oil on canvas. 31⅝ x 10'4".
Still Life with Old Shoe, 1937. Oil on canvas. 32¼ x 46¼.
Self-portrait, 1938. Pencil and oil on canvas. 57½ x 38¼.
Portrait I, 1938. Oil on canvas. 64¼ x 51¼.
Painting-poem, 1938. Oil on canvas. 51 x 76.
Nocturne, 1938. Oil on compoboard. 22 x 29.
*Persons magnetized by the stars walking on the music of a
 Furrowed Landscape,* 1939. Oil on canvas. 18 x 13⅛.
Women and Kite among the constellations, 1939. Oil on
 burlap. 31⅞ x 23⅝.
Glove and Newspaper, 1921. Oil on canvas. 46 x 35.
The Carbide Lamp, 1922-23. Oil on canvas. 15 x 18.
Composition, 1924. Oil and pencil on wood. 7⅜ x 10¾.
Circus, 1927. Oil on canvas. 45¾ x 35¼.
The Sun, 1927. Oil on burlap. 14⅞ x 18.
Dutch Interior, 1928. Oil on canvas. 50¾ x 38.
Composition, 1931. Watercolor. 25 x 18½.
Object, 1932. Painted stone, shell, wood and mirror.
 22 wide.
Composition, 1933. Oil on canvas. 45 x 57½.
Drawing-collage, 1933. Chalk and pasted postcards.
 24½ x 18½.
Persons, 1934. Pastel and ink. 24¾ x 18½.
Two figures on green paper, 1934. Ink. 27½ x 19½.
Drawing on sandpaper with collage, 1934. 14½ x 9⅛.
Persons Attracted by the Form of the Mountain, 1936.
 Tempera on board. 13 x 19¾.
Persons, 1936. Watercolor and oil. 15⅞ x 12½.
Summer, 1938. Gouache. 14 x 10½.
Mongoose, Rug designed by Miró, 1938. 62 x 80.
Rug designed by Miró, 1938. 6' x 4', and original
 design for the rug, 14¾ x 9⅞.
Woman, Flower and Star, Tapestry designed by Miró. Series
 of 17 etchings, 1939.

1942 New York. Art of This Century, *Objects-Drawings-
Photographs-Paintings-Sculpture-Collages, 1910-1942.*

Two Personnages and a flame, 1925. Oil. 56 x 44½.
Dutch Interior. 1928. Oil. 28½ x 35½.
The seated woman, 1938-39. Oil. 51 x 63½.

1942 New York. 451 Madison Avenue, *First Papers of
Surrealism.* October 14-November 7.

1942 New York. Pierre Matisse Gallery. December 8-31.

Paintings:

Painting, 1933.
Painting-Collage, 1934.

Painting-Collage, 1934.
Painting, 1936.
Painting, 1936.
Painting, 1936.
Circus, 1937.
Swan on a lake, sun rainbow, 1937.
Woman and bird in the night, 1939.
Head of a woman, 1939.
Two Women, 1939.

Drawings:

Drawing-Collage, 1933.
Bathers, 1939.

Gouaches:

Two women, 1937.
Personage and signs, 1937.
Woman arranging her hair, 1939.
Sleepers awakened by a bird, 1939.
Romantic singer, 1939.

Pastels:

Pastel, 1934.
Pastel, 1934.
Pastel, 1934.
Pastel, 1934.
Two personages in meditation, 1937.

Watercolors:

Metamorphosis, 1936.
Metamorphosis, 1936.
Group of personages, 1939.

1942 New York. The Museum of Modern Art, *Twentieth
Century Portraits.* December 9-January 24, 1943.

1943 Chicago. Arts Club of Chicago. March 24-April 7.

1944 New York. The Museum of Modern Art, *Modern
Drawings.* February 16-May 10.

1944 New York. The Museum of Modern Art, *Art in
Progress: 15th Anniversary Exhibition.* May 24-October
15.

1944 New York. Pierre Matisse Gallery. May 3-June 3.

Man reading a newspaper, 1927. Oil.
Composition on sand paper, 1934. Oil.
Painting-collage on sand paper, 1934. Oil.
Gouache-drawing, 1934.
Gouache-drawing, 1934.
Man and woman, 1935. Oil.
The farmer's meal, 1935. Oil.
Portrait of a young girl, 1935. Oil.
Still life with a butterfly, 1935. Gouache.
Woman, 1935. Gouache.
Bird, moon, fish and landscape, 1935. Gouache.
Woman, 1935. Gouache.
Woman with chignon, 1937. Oil on celotex.
Smoke, 1937. Oil on celotex.

Composition, 1937. Oil on celotex .
Romantic landscape, 1937. Oil and pastel.
Two personages in meditation, 1937. Pastel.
Woman Seated, 1939. Oil.
Group of personages, 1939. Watercolor.
Tight rope walker, 1939. Gouache.

1945 New York. Gallery 67, *A problem for critics*. Organized by Howard Putzel.

1945 New York. Pierre Matisse Gallery. January 9-February 3.

Tempera paintings: (constellations)

Le Léver du soleil, 1-21-1940.
L'échelle de l'évasion, 1-31-1940.
Personnages dans la nuit guidés par les traces phosphorescentes de escargots, 2-12-1940.
Femmes sur la plage, 2-15-1940.
Femmes à la blonde aisselle coiffant sa chevelure à la lueur des étoiles, 3-5-1940.
Personnage blessé, 3-27-1940.
Femme et oiseaux, 4-13-1940.
Femme dans la nuit, 4-27-1940.
Danseuses acrobates, 5-14-1940.
Le chant du rossignol à minuit et la pluie matinale, 9-4-1940.
Le 13 l'échelle à frôlé le firmament, 10-14-1940.
Nocturne, 11-2-1940.
La Poétesse, 12-31-1940.
Le réveil au petit jour, 1-27-1941.
Vers l'arc-en-ciel, 3-11-1941.
Femmes encerclées par le vol d'un oiseau, 4-26-1941.
Femmes au bord du lac à la surface irisée par le passage d'un cygne, 5-14-1941.
L'oiseau migrateur, 5-26-1941.
Chiffres et constellations amoureux d'une femme, 6-12-1941.
Le bel oiseau déchiffrant l'inconnu au couple d'amoureux, 7-23-1941.
Le crépuscule rose caresse les femmes et les oiseaux, 8-14-1941.
Le passage de l'oiseau divin, 9-12-1941.

1945 New York. Pierre Matisse Gallery. February 5-25.

Lithographs, 1944.

1946 Boston. Institute of Contemporary Art, *Four Spaniards: Dali, Gris, Miró, Picasso*. January 24-March 3.

1947 New York. Pierre Matisse Gallery. May 13-June 7.

Personage, Bird, Star, 1942. Gouache. 42 x 28.
Women and Birds Before the Sun, 1942. Pastel. 43 x 31.
Woman and Bird Before the Sun, 1942. Pastel. 42½ x 28¼.
Women, Bird, Stars, 1942. Pastel. 42½ x 28¼.
Woman in the Night, 1944. Oil on canvas. 61 x 19⅜.
Woman and Bird Before the Moon, 1944. Oil on canvas. 8⅝ x 6¼.
Woman in the Night, 1944. Gouache. 25 x 18½.
Woman, Bird, Star, 1944. 8⅝ x 6¼.
Woman, Stars, Ladder of Escape, 1944. Oil on paper. 8⅝ x 6¼.
Woman in the Night, 1944. Oil on canvas. 19½ x 15.

Women and Bird Before the Sun, 1944. Oil. 17¾ x 14.
Women and Bird in the Night, 1944. Oil. 9¼ x 16½.
Woman, Birds, Stars, 1944. Oil on canvas. 18¼ x 7½.
Woman and Bird in the Night, 1944. Oil on canvas. 6 x 19¼.
Woman and Bird in the Night, 1944. Oil. 8¼ x 5¼.
Woman Before the Moon, 1944. Oil. 7 x 9¼.
Woman and Bird Before the Moon, 1944. Oil. 7¼ x 4¼.
Woman and Bird in the Night, 1944. Oil. 11½ x 19½.
Women and Birds, 1945. Oil on canvas. 15⅞ x 49⅛.
The Port, 1945. Oil on canvas. 63½ x 51.
Dancer Hearing Organ Music Played in a Cathedral, 1945. Oil on canvas. 77 x 51¼.
Woman Dreaming of Evasion, 1945. Oil on canvas. 57½ x 45.
Women in the Night, 1946. Oil on canvas. 21⅝ x 15.
Women and Birds in the Night, 1946. Oil on canvas. 18 x 13.
Women at Sunrise, 1946. Oil, pastel, gouache on canvas. 24 x 15.
Night, 1946. Oil on canvas. 23⅝ x 28¾.
Woman and Bird at Sunrise, 1946. Oil on canvas. 24¼ x 25¼.
Bird, 1946. Bronze. Height 5''.
Bird, 1946. Bronze. Height 7½''.

1948 New York. The Museum of Modern Art. March 3-April 4.

(Mural for Terrace Plaza Hotel, Cincinnati.)

1948 New York. Pierre Matisse Gallery. March 16-April 10.

Pastoral, 1923-24. Oil on canvas. 23 x 36.
Animated Landscape, 1927. Oil on canvas. 51 x 76.
Woman in Repose, 1932. Oil on wood panel. 9⅜ x 13.
Painting, 1933. Oil on canvas. 38 x 51.
Man with a Pipe, 1934. Pastel. 41¾ x 27¾.
Animated forms, 1935. Oil on canvas. 68 x 77.
Figures in Front of a Metamorphosis, 1936. Tempera on panel. 17 x 22¼.
Head of a Woman, 1938. Oil on canvas. 18 x 21¾.
A drop of dew falling from the wing of a bird awakens Rosalie asleep in the shade of a cobweb, 1939. Oil on canvas. 25½ x 36½.
Figures and Bird in Front of the Sun, 1939. Oil on canvas. 7⅝ x 10¾.
Woman and Bird Before the Sun, 1942. Pastel. 42 x 28.
Personages and Bird, 1942. Gouache. 20 x 25¾.
Woman, Star, 1942. Gouache. 20 x 25½.
Woman, Bird, Star, 1944. Oil on canvas. 13½ x 10⅜.
Women, Stars, 1944. Oil on canvas. 13⅝ x 10½.
Woman in front of the Sun, 1944. Oil on canvas. 13 x 9½.
Woman and Bird in Front of the Sun, 1944. Oil on canvas. 13½ x 10⅜.
Woman and Bird in Front of the Moon, 1944. Oil on canvas. 8⅝ x 6⅜.
Women in the Night, 1944. Oil on canvas. 8⅝ x 6⅜.
Woman and Birds in Front of the Moon, 1944. Oil on canvas. 8⅝ x 6⅜.
Woman and Bird in the Night, 1944. Oil on canvas. 8⅝ x 6⅜.
Woman, Bird, Star, 1944. Oil on canvas. 8⅝ x 6⅜.
Woman, Bird, 1944. Oil on canvas. 8⅝ x 6¾.

Woman and Bird in the Night, 1944. Oil on canvas.
 22½ x 17.
Personages, Bird, Stars, 1944. Oil on canvas. 6 x 36⅜.
Personages, Bird, Stars, 1944. Oil on canvas. 5¾ x 29.
Women and Birds in the Night, 1946. Oil on canvas.
 32⅛ x 13¼.
Personages and Star, 1946. Oil on canvas. 21½ x 15.
Women at Sunrise, 1946. Oil on canvas. 15 x 24.
Women and Bird in the Night, 1946. Oil on canvas.
 13¾ x 9¼.

1948 San Francisco. San Francisco Museum of Art, *Picasso, Gris, Miró: the Spanish Masters of 20th Century Painting.* September 14-October 17.

1948 Portland, Oregon. Portland Art Museum. October 26-November 28.

1949 New York. Pierre Matisse Gallery. April 19-May 14.

Pastorale, 1923-24. Oil.
Catalan Landscape, 1923-24. Oil.
Portrait Mme. B . . ., 1924. Oil.
L'Addition, 1925. Oil.
L'Etreinte, 1925. Oil.
Dame se promenant sur la rambla de Barcelone, 1925. Oil.
Le Cheval, 1927. Oil.
Painting, 1927. Oil.
Landscape, 1927. Oil.
Painting, 1927. Oil.
L'Etoile, 1927. Oil.
Still Life, 1927. Oil.

1949 New York. Perspectives Gallery. October.

1949 Chicago. The Art Institute of Chicago. October 20-December 18.

1949 New York. Buchholz Gallery, *Leger-Matisse-Miró-Moore: Panels and Sculpture.*

1949 New York. Pierre Matisse Gallery. December 6-31.

Drawing-collage, August 10, 1933.
Drawing-collage, September 6, 1933.
Pastel (untitled), February 17, 1934.
Pastel (untitled), March 26, 1934.
Pastel (untitled), March 5, 1934.
Gouache-drawing (untitled), August 1934.
Collage painting (untitled), September 1934.
Collage painting (untitled), September 1934.
Man smoking a pipe, October 1934. Pastel.
Signs and Figurations, December 21, 1934. Watercolor.
Figure, February 3, 1936. Watercolor.
Gouache (untitled), May 29, 1936.
Montroig, September 22, 1937. Gouache pastel.
Circus, November 2, 1938. Gouache.
Personage and Bird, November 16, 1938. Gouache.
Woman, Bird, Stars, January 4, 1942.
Woman, Bird, Stars, April 1942.
Woman and Bird in front of the sun, April 15, 1942.
Woman, Bird, Stars, May 16, 1942.
Young girl skipping rope, bird, stars, May 30, 1942.
Women, Bird, Stars, June 2, 1942.

Women dreaming of escape, September 4, 1942.
Nocturne by a lake, September 8, 1942.
Women in the Night, October 9, 1942. Watercolor pastel.
Personage and Birds in front of the sun, October 20, 1942.
 Gouache.
Personages, Bird, October 23, 1942. Gouache.
Personage in front of the sun, October 28, 1942.
Woman, Bird, Star, October 31, 1942.
Nocturne, December 18, 1942.
Towards the ladder of escape, January 6, 1943.
 Gouache pastel.
Personage and bird in front of the sun, January 15, 1943.
Women, Bird, Stars, January 16, 1943. Watercolor pastel.

1951 New York. Pierre Matisse Gallery. March 6-31.

Woman and Girl, 1946. Oil on canvas. 64 x 51.
The serpent with poppies, 1947. Oil on board. 41½ x 29½.
Personages, star and blue moon, 1947. Oil on canvas.
 25¾ x 32.
Woman, bird and stars, 1948-49. Oil on canvas. 25½ x 36.
Red Sun, 1948-49. Oil on canvas. 35½ x 27.
Dark figure and sun, 1948-49. Oil on canvas. 51½ x 38.
Personages and star, 1948-49. Oil on canvas. 24 x 16.
Personages and constellation, 1948-49. Oil on canvas.
 28½ x 35¾.
Figure under the moon, 1948-49. Oil on canvas. 17⅝ x 13.
Constellation with figures, 1949. Oil on canvas. 51 x 77.
Personages and moon, 1949-50. Oil on canvas. 39 x 28¾.
Woman, bird, and sun, 1949-50. Oil on masonite. 21 x 42½.
Woman, moon and stars, 1949-50. Oil on canvas. 32 x 39½.
Personages in the night, 1949-50. Oil on canvas. 45 x 35.
Figure, 1950. Oil on board. 17¼ x 25.
Bird and moon, 1950. Oil and pastel on board. 23 x 17.
Red sun and personages, 1950. Oil on board. 41 x 29½.
Personages and star, 1950. Oil on canvas. 31 x 39.
Head, 1950. Bronze.
Composition, 1950. Bronze.
Figure, 1950. Bronze.
Bell, 1950. Bronze.

1951 Houston. Contemporary Arts Association, *Exhibition of Painting and Sculpture: Calder-Miró.* October 14-November 4.

1951 New York. Pierre Matisse Gallery, *The Early Paintings of Joan Miró.* November 20-December 15.

Olive Grove (Montroig), 1916. Oil on board.
Olive Trees (Montroig), 1916. Pastel. 19⅜ x 22⅛.
Portrait of J. F. Rafols, 1917. Oil on board. 29⅛ x 20¼.
Still Life with bird (Nord-Sud), 1917. Oil on canvas.
 24⅜ x 27⅜.
Self portrait, 1917. Oil on canvas. 24½ x 19½.
View of Montroig, 1917. Oil on canvas. 25½ x 28½.
The Farm Girl, 1917. Oil on canvas. 31 x 25.
Portrait of the Engraver E. C. Ricart, 1917. Oil on canvas.
 32 x 25½.
Still life with coffee grinder, 1917. Oil on canvas. 24⅜ x 28.
Flowers, 1918. Oil on canvas. 28⅜ x 26.
The Chauffeur, 1918. Oil on canvas. 27½ x 24½.
The Olive Grove (Montroig), 1919. Oil on canvas.
 28½ x 35½.

Nude with Mirror, 1919. Oil on canvas. 44 x 40.
The Spanish Playing Cards, 1920. Oil on canvas. 25¼ x 27¾.
Still life with a horse. Oil on canvas. 29½ x 32½.
The Carbide Lamp, 1922-23. Oil on canvas.
 14⅝ x 18⅛.

1952 New York. Kootz Gallery. January 28-February 16.

1952 New York. Pierre Matisse Gallery. April 15-May 17.

Painting, 1933. Oil. 98 x 78.
Gouache-dessin, 1934. 41½ x 28.
La spirale du rossignol au temps des moissons, 1939.
 Watercolor. 16 x 13.
Femmes, oiseau, étoiles, 1942. Oil. 40½ x 29½.
Fillettes sautant à la corde, oiseaux, étoiles, 1942. Oil.
 43 x 30½.
La naissance du jour, 1942. Gouache. 31 x 42½.
Femmes, oiseau, étoiles, 1942. Pastel. 42 x 48.
Femmes, oiseau, étoiles, 1942. Pastel. 42 x 28.
Femme devant le soleil, 1942. Gouache. 12¼ x 9.
Femmes, Étoiles, 1942. Gouache. 9½ x 12¼.
Femmes et oiseau devant le soleil, 1942. Gouache.
 12¼ x 16½.
Femmes, oiseau, étoiles, 1942. Gouache. 22¾ x 17½.
Femmes devant l'horizon, 1942. Gouache. 18¾ x 26½.
Personnage devant le soleil, 1942. Gouache, india ink, pastel.
 25 x 19.
Personnage devant le lune, 1942. Gouache, india ink,
 pastel.
Personnage et oiseau dans la nuit, 1944. Oil. 24 x 19½.
Dessin gouache, 1949. 7 x 5¼.
Gouache-dessin, 1949. 9 x 6¾.
Dessin gouache, 1949. 10 x 12½.
*L'arête rouge transperce les plumes bleues de l'oiseau au
 pâle bec,* 1951. Oil. 18 x 15.
L'oiseau encerclant de l'or étincelant la pensée du poète,
 1951. Oil. 25½ x 32.
Le cri de la gazelle au petit jour, 1951. Oil. 28½ x 39.
Head, 1950. Stone. 10 x 12.

1953 New York. Pierre Matisse Gallery. November
 17-December 12.

Untitled. Oil on canvas. 96 x 66¾.
Untitled. Oil on canvas. 78½ x 78½.
Untitled. Oil on canvas. 96 x 49.
Untitled. Oil on canvas. 78½ x 78½.
Untitled. Oil on canvas. 66¾ x 96.
Untitled. Oil on canvas. 37⅜ x 148.
Untitled. Oil on canvas. 22½ x 196.
Untitled. Oil on canvas. 22½ x 196.
Untitled. Oil on canvas. 49 x 96.
Untitled. Oil on canvas. 76⅝ x 38½.
Untitled. Oil on canvas. 76⅝ x 38½.
Untitled. Oil on canvas. 76⅝ x 38½.
Untitled. Oil on canvas. 76⅝ x 51½.
Untitled. Oil on canvas. 76⅝ x 51½.
Untitled. Oil on canvas. 76⅝ x 148⅜.
Le disque rouge à poursuite de l'alouette. Oil on canvas.
 51 x 38½.
*Les jasmins embaument de leur parfum doré la robe de la
 jeune fille.* Oil on canvas. 39 x 32.

L'oiseau au regard calme les ailes en flammes. Oil on canvas.
 32 x 39.
Paysan catalan inquiet par le passage d'un vol d'oiseau. Oil
 on canvas. 36¼ x 28⅝.
La tige de la fleur rouge pousse vers la lune. Oil on canvas.
 36¼ x 28.
L'oiseau au plumage déployé vole vers l'arbre argenté. Oil on
 canvas. 35 x 55.
Untitled. Oil on canvas. 55 x 35.
Untitled. Objet painting on canvas. 41 x 16¾.
Untitled. Oil on masonite. 42⅜ x 17¼.
Untitled. Oil on masonite. 42⅜ x 21¼.
Untitled. Oil on cardboard. 29½ x 21⅝.
Untitled. Oil on cardboard. 18¾ x 24⅜.
Untitled sculpture. Bronze. 9¾ x 12½.
Untitled sculpture. Granite.
A la lueur de la lune le soleil couchant nous caresse. Oil on
 canvas. 5½ x 7.
Le sourire des ailes flamboyantes. Oil on canvas. 13¾ x 18.
La complainte des amoureux. Oil on canvas. 18 x 15.
*Le ailes de l'oiseau glissent sur la lune pour atteindre les
 étoiles.* Oil on cardboard. 18 x 15.
Le regard fixe vers l'horizon déchiré par les cris de l'aigle. Oil
 on cardboard. 15 x 18.
*L'aigle s'envole vers les sommets des montagnes creusées
 par les comètes annoncer la parole du poète.* Oil on
 cardboard. 18 x 21⅝.
L'oiseau plonge vers le lac où les étoiles se mirent. Oil on
 cardboard. 21⅝ x 18.
Untitled. Oil on canvas. 29¼ x 73¾.
Untitled. Oil on canvas. 29¼ x 73¾.
Untitled. Oil on canvas. 29¼ x 73¾.
Untitled. Oil on canvas. 77¾ x 28¾.
Untitled. Oil on canvas. 77¾ x 28¾.
Untitled. Oil on canvas. 77¾ x 28¾.
Untitled. Oil on canvas. 7⅞ x 58⅞.
Untitled. Oil on canvas. 7⅞ x 58⅞.
Untitled. Oil on canvas. 7⅞ x 127¾.
Untitled. Oil on canvas. 18¾ x 30⅝.
Untitled. Oil on canvas. 12⅜ x 31.
Untitled. Oil on canvas. 12⅜ x 31.
Untitled. Oil on canvas. 31 x 12⅜.
Untitled. Oil on wood. 61¾ x 11¾.
Untitled. Objet painting.
Untitled. Sculpture. Wood. 11¾ x 9½ x 6⅝.
Untitled. Objet painting. 2⅜ x 25⅛.
*Jeunes filles couvrant d'une robe aux rectangles sombres
 leur nudité transparente à l'aube.* Oil on "fibro-ciment"
 10⅝ x 10⅝.
L'arc-en-ciel des plumes du bel oiseau atteint l'horizon. Oil
 on "fibro-ciment". 13¾ x 7⅞.
*Et l'oiseau s'enfuit vers les pyramides aux flancs
 ensanglantés par la chute de rubis.* Oil on "fibro-ciment"
 5⅞ x 22¾.
Les verilles des moustaches face aux oiseaux flamboyants. Oil
 on "fibro-ciment". 6¼ x 8⅝.
L'étreinte du soleil à l'amoureuse. Oil on canvas. 8⅝ x 6¼.
Dame au chapeau en spirale dans la nuit. Oil on canvas.
 8⅝ x 6¼.
L'oiseau déploie son beau plumage. Oil on canvas. 8⅝ x 4¾.
L'oiseau s'enfuit vers l'azur. Oil on canvas. 8⅝ x 4¾.

L'oiseau déploie les ailes pour parer de ses plumes les étoiles. Oil on canvas. 8⅝ x 4¾.
La chanson du bleu de la lune à la verte robe aux étincelles jaunes. Oil on canvas, 8⅝ x 4¾.

1954 New York. Galerie Chalette. February 16-March 13.

1954 Minneapolis. Walker Art Center. May 23-July 2.

1954 New York. The Museum of Modern Art, *Paintings from the Museum Collection: 25th Anniversary Exhibition.* October 19, 1954-January 2.

1955 New York. The Museum of Modern Art, *Paintings from Private Collections: A 25th Anniversary Exhibition.* May 31-September 5.

1955 New York. Brooklyn Museum, *Prints-Fabrics by Picasso, Miró, Chagall, Leger, Dufy.* October 31-November 14.

1955 New York. Pierre Matisse Gallery. December.

1956 New York. Pierre Matisse Gallery. December 4-30. Sculpture in ceramic:

Personage. 27½.
Head on plaque. 15½ x 20½.
Personage. 12¼.
Plaque with figure and sun. 9 x 15¼.
Personage. 39½.
Head. 9½ x 18.
Palm tree. 75.
Pebble. 5⅝.
Pebble. 4¾.
Large standing figure. 38.
Penguin. 7½.
Head. 10½ x 11½.
Plaque. 7¼ x 10¾.
Head. 20½.
Figure with arms up. 7½.
Stone. 33½.
Three plates (A-B-C). 14.
Plaque with figure. 9¼ x 7¼.
The little owl. 7.
Personage. 14¾.
Six tiles (A-B-C-D-E-F). 4½ x 9⅞.
Small jar. 4¾.
Pebble (G). 3¾.
Pebble (H). 3.
Personage and moon on plaque. 11½.
Monument. 8 ft. 5 in.

1957 New York. Knoedler & Company. April 2-20.

1958 Houston. Contemporary Arts Museum. January 9-February 16.

1958 New York. The Museum of Modern Art, *Prints, with Braque and Morandi.* January 29-March 2.

1958 Cleveland. Howard Wise Gallery. September 7-30.

1958 New York. Pierre Matisse Gallery. November 4-29.

Figure, 1934. Pastel. 41½ x 27½.

Femme, October 1934. Pastel. 41½ x 27½.
Tête d'homme, 1935. Oil on cardboard. 41½ x 29⅝.
Deux personnages, April 1935. Oil on cardboard. 41½ x 29⅝.
Les deux philosophes, February 1936. Oil on copper. 13¾ x 19⅝.
Deux personnages amoureux d'une femme, May 1936. Oil on copper. 10 x 14.
Personnages en présence d'une métamorphose, 1936. Egg tempera on board. 22⅝ x 19¾.
Painting, 1936. Oil on roofing paper. 54½ x 38½.
Painting, 1936. Oil on masonite. 30¾ x 42¼.
Femme debout, 1937. Oil on paper. 30 x 22½.
Pour Jackey, Peter et Pauley Matisse, 1938. Oil on canvas. 31⅝ x 10 ft. 4 in.
Tête de femme, 1938. Oil on canvas. 18 x 21⅝.
Le vol de l'oiseau, 1938. Oil on paper. 22¼ x 30.
Femme assise, March 8, 1939. Oil on canvas. 64 x 51.
Femme et fillette devant le soleil, November 30-December 19, 1946. Oil on canvas. 57 x 45.
Painting, 1950. Oil on cardboard. 41 x 29½.
Painting, 1953. Oil on masonite. 42½ x 21¼.
Les échelles en roue de feu traversent l'azur, 1953. Oil on canvas. 45½ x 35.
L'oiseau au plumage deployé vole vers l'arbre argenté, 1953. Oil on canvas. 35 x 45½.
Painting, 1953. Oil on canvas. 18¾ x 30½.
Painting, 1953. Oil on board. 18¾ x 24⅜.

1958 New York. The Museum of Modern Art, *Works of Art: Given or Promised.* October 8-November 9.

1959 New York. F. A. R. Gallery. January 5-24.

1959 New York. Pierre Matisse Gallery. Spring. (Constellations)

Le lever du soleil, 21-1-1940.
L'échelle de l'evasion, 31-1-1940.
Personnages dans la nuit guidés par les traces phosphorescentes des escargots, 12-2-1940.
Femmes sur la plage, 15-2-1940.
Femme à la blonde aisselle coiffant sa chevelure à la lueur des étoiles, 5-3-1940.
L'étoile matinale, 16-3-1940.
Personnage Blesse, 27-3-1940.
Femme et oiseaux, 13-4-1940.
Femme dans la nuit, 27-4-1940.
Danseuses Acrobates, 14-5-1940.
Le Chant du Rossignol à minuit et la pluie Matinale.
Le 13 L'echelle à frole le firmament, 14-10-1940.
La poétesse, 31-12-1940.
Le reveil au petit jour, 27-1-1941.
Vers l'arc-en-ciel, 11-3-1941.
Femmes encerclées par le vol d'un oiseau, 26-4-1941.
Femmes au bord du lac à la surface irisée par le passage d'un cygne, 14-5-1941.
L'oiseau migrateur, 26-5-1941.
Chiffres et constellations amoureaux d'une femme, 12-6-1941.
Le bel oiseau dechiffrant l'inconnu au couple d'amoureux, 23-7-1941.

Le crepuscule rose caresse les femmes et les oiseaux,
 14-8-1941.
Le passage de l'oiseau divin, 12-9-41.

1959 New York. The Museum of Modern Art, *Joan Miró.*
 March 18-May 10.

 Paintings:

Self-portrait, 1917. Oil on canvas. 24 x 19⅝.
The Farm, 1921-22. Oil on canvas. 48¼ x 55¼.
Harlequin's Carnival, 1924-25. Oil on canvas. 25¼ x 37⅞.
Nude, 1926. Oil on canvas. 51⅜ x 38¼.
Spanish Dancer, 1928. Paper, string, metal. 41¾ x 26¾.
Seated Woman, October, 1937. Oil on wood. 18⅛ x 15.
Nursery Decoration, September 1938. Oil on canvas.
 31⅝ x 10' 4''.
Woman and Bird in the Night, March 8, 1945. Oil on canvas.
 51¼ x 64.
*A Ballet Dancer listening to organ music in a Gothic
 Cathedral,* May 26, 1945. Oil on canvas. 77 x 51½.
Painting, 1953. Oil on canvas. 75⅞ x 51.
Painting, 1953. Oil on canvas. 6 ft. 4¾ in. x 12 ft. 4¾ in.
A Toute Epreuve, book by Paul Eluard containing 80 color
 woodcuts, some with collage. Page size: 12⅝ x 9⅞.

 Sculpture:

Large Standing Figure, 1956. Ceramic. 38.

1961 New York. Knoedler & Company, *The James Thrall
 Soby Collection of Works of Art.*

1961 New York. Perls Gallery, *Alexander Calder-Joan Miró.*
 February 21-April 1.

1961 Boston. Museum of Fine Arts, Boston, *The Artists and
 the Book, 1900-1960, in Western Europe and the
 United States.*

1961 New York. Pierre Matisse Gallery. October 31-
 November 25.

 Paintings:

Peinture IV/V, 1960. Oil on canvas. 92 x 73.
Femme et oiseau V/X, 1960. Oil on canvas. 61 x 46.
Le Reveil de Madame Boubou a l'aube, 1939-60. Oil on
 canvas. 130 x 162.
Bleu II, 1961. Oil on canvas. 270 x 355.
Femme et oiseau, 1959. Oil on canvas. 116 x 89.
La baigneuse de calmayor, 1960. Oil on canvas. 114 x 146.
Femme et oiseau IV/X, 1960. Oil on canvas. 75 x 37.
Femme et oiseau I/X, 1960. Oil on canvas. 51 x 46.
Femme et oiseau VI/X, 1960. Oil on canvas. 54 x 42.
Peinture II/V, 1960. Oil on canvas. 92 x 73.
Peinture V/V, 1960. Oil on canvas. 92 x 73.
Autoportrait, 1937-60. Oil on canvas. 92 x 73.
Femme assise III/V, 1960. Oil on canvas. 100 x 81.
Bleu I, 1961. Oil on canvas. 270 x 355.
Peinture, 1960. Oil on canvas. 37 x 30.5.
L'aube, 1959. Oil on canvas. 46 x 37.
Bleu III, 1961. Oil on canvas. 270 x 355.
Peinture IV/V, 1960. Oil on canvas. 92 x 73.
Femme II/VI, 1960. Oil on canvas. 27 x 16.

Femme III/VI, 1960. Oil on canvas. 27 x 16.
Femme VI/VI, 1960. Oil on canvas. 35 x 22.
Ecriture sur fond rouge, 1960. Oil on canvas. 195 x 130.
Oiseaux dans l'espace, 1959. Oil on canvas. 130 x 81.
Peinture Murale, 1960. Oil on canvas. 16 x 358.
Peinture, 1960. Oil on canvas. 81 x 65.
L'odeur du blé, 1960. Oil on canvas. 34 x 30.5.
Femme et oiseau. Oil on canvas. 92 x 60.
Le disque rouge, 1960. Oil on canvas. 130 x 164.
Femme assise V/V, 1960. Oil on canvas. 100 x 81.

1961 New York. The Musem of Modern Art, *The Art of
 Assemblage.* October 2-November 12.

1962 Houston. The Museum of Fine Arts, Houston, *Three
 Spaniards: Picasso, Miró, Chillida.* February 6-March 4.

1962 Beverly Hills. Paul Kanter Gallery, *Drawings by Joan
 Miró.*

1963 New York. Pierre Matisse Gallery. November 5-30.

Tête d'homme. Ceramic. 33½ x 29½ x 23⅝.
Tête de femme. Ceramic. 19¾ x 35½ x 13¾.
Femme et oiseau. Ceramic. 126 x 23⅝ x 18.
Masque. Ceramic and wood. 69¼ x 22½.
Tête de femme. Ceramic. 33½ x 23⅝ x 9½.
Femme. Ceramic. 38½ x 21¼ x 13¾.
Monument à la maternité. Ceramic. 31½ x 18½ x 13⅜.
Tête. Ceramic. 23⅝ x 25⅝ x 7.
Femme. Ceramic. 24¾ x 17¾ x 10⅝.
Femme. Ceramic and wood. 63¾ x 24¾.
Homme et femme. Ceramic and wood. 98½ x 23¼ x 13¾.
Architecture. Ceramic. 6 x 24¾.
Etude pour le grand arc. Ceramic. 22 x 25⅝ x 8¼.
Grande jarre. Ceramic. 28¾ x 17¾.
Vase. Ceramic. 13⅜ x 9⅞.
Femme. Ceramic. 24¾ x 17¾ x 10⅝.
Grande peinture murale, 1950-51. Oil on canvas.
 6 ft. 2¼in. x 19 ft. 5½in.

1965 New York. Pierre Matisse Gallery. October-November.

 Cartones:

L'oiseau bleu, October 27, 1959. 75 x 105.
Personnage, January 27, 1960. 105 x 75.
Tête et oiseau, February 4, 1960. 105 x 75.
L'étincelle jaune, February 9, 1960. 75 x 105.
Solitude III/III, April 20, 1960. 74.8 x 105.
Peinture, October 27, 1960. 105 x 75.
Peinture, December 3, 1960. 105 x 75.
Personnage, February 5, 1960. 75 x 105.
Personnage et oiseau, January 10, 1962. 105 x 75.
Tête bleue, March 2, 1962. 75 x 105.
Oiseaux (double face), March 18, 1962. 69 x 54.
Personnages et oiseaux au lever du soleil, March 29, 1962.
 75 x 105.
Oiseaux dans un paysage, May 29, 1962. 75 x 105.
Paysage, January 3, 1963. 75 x 105.
Peinture, January 30, 1963. 105 x 79.
Oiseaux dans un paysage, January 31, 1963. 75 x 105.
Personnage et oiseaux, February 4, 1963. 105 x 75.
Personnage et oiseaux, February 12, 1963. 75 x 105.

Femme en prière devant le soleil, March 6, 1963. 75 x 105.
Femme, March 20, 1963. 105 x 75.
Oiseau emprisonné par un personnage, July 28, 1963.
 105 x 75.
Femme et oiseau, March 4, 1963. 105 x 75.
Femmes et oiseaux dans la nuit, March 25, 1963. 105 x 75.
Femme, February 3, 1965. 105 x 75.
Personnage et oiseau, July 27, 1963. 105 x 75.
Personnage, March 8, 1963. 105 x 75.
Oiseaux au lever du soleil, March 23, 1962. 75 x 105.
Solitude II/III, April 29, 1960. 103 x 75.
Personnages et oiseaux devant le soleil, February 6, 1963.
 105 x 75.
Femme et oiseau, April 6, 1963. 104 x 75.

1965　Detroit. Donald Morris Gallery, *Joan Miró: Watercolor and Gouache.* February 14-March 13.

1965　Washington, D. C. Corcoran Gallery of Art, *Paintings and Sculpture from the Collection of Mr. and Mrs. David Lloyd Krieger.*

1965　New York. The Museum of Modern Art, *The School of Paris: Paintings from the Florence May Shoenborn and Samuel A. Marx Collection.* November 2, 1965-January 2, 1966.

1966　Chicago. Allan Frumkin Gallery, *Miró: Watercolors, drawings, collage.*

1966　Philadelphia. Philadelphia Museum of Art, *Joan Miró: Prints and Books.* September 15-October 23.

1967　New York. Pierre Matisse Gallery. *Oiseau solaire; oiseau lunaire; etincelles.* November.

Femme II, 1-7-67. Oil on canvas. 13¾ x 8¾.
Femme et oiseau II, 1-5-67. Oil on sand paper.
Femme et oiseau I, 1-7-67. Oil on sand paper.
Personnage et oiseau II, 12-17-65. Oil and collage on paper.
 30¾ x 22.
Study for an engraving, 1967. 12⅝ x 28⅜.
Oiseau Lunaire, 1966. Bronze cast. 90 x 90 x 63.
Oiseau Solaire, 1966. Bronze cast. 48 x 71.
Femme dans la nuit, 7-6-65. Oil on canvas. 13 x 17¾.
Femme et oiseau, 4-18-66. Oil on canvas. 50¾ x 37¾.
Tête de femme, 3-11-67. Oil on paper. 29 x 35⅜.
Femme et oiseau, 1-17-67. Oil on canvas. 28¾ x 23¾.
Femme et oiseau, 12-29-65. Gouache on paper. 39⅜ x 27½.
Personnage et oiseau, 12-29-65. Oil on canvas. 51 x 35.
Personnage et oiseau, 11-17-67. Oil on paper.
Tête I, 6-2-65. Oil on canvas. 19½ x 28¾.
Personnage et oiseaux, 1966. Gouache on paper.
 27¾ x 39⅜.
Tête bleue et oiseau fleche, 12-31-65. Oil on canvas.
 39¾ x 32.
Personnage et oiseau, 1966. Gouache on paper.
 27¾ x 39⅜.
Femme pleine de joie par l'arrivée des oiseaux fleches,
 7-10-65. Oil on wood. 31½ x 25½.
Personnage, 6-7-65. Oil on canvas. 18 x 14½.
Tête de femme, 4-9-66. Gouache on paper.
 39¾ x 27½.

Personnage et oiseau, 1966. Gouache and collage
 on paper.
Femmes et oiseaux, 1966. Oil on paper. 39½ x26.
Femme, 7-9-65. Oil on canvas. 16 x 13.
Tête de femme, 3-12-67. Oil on blotting paper.
 44 x 30.
Femmes oiseaux étoiles I, 1-11-67. Oil on canvas.
 31 x 21½.
Homme et femme, 4-9-66. Gouache on paper.
 39½ x 27½.
L'étincelle, 12-31-60. Oil on wood. 15½ x 24⅜.
Tête de femme dans la nuit, 3-11-67. Oil on canvas.
 16 x 9⅝.
L'envolée II, 7-31-63. Oil on board. 9½ x 13.
Accent blanc IV, 8-7-63. Oil on canvas. 9½ x 7½.
Chant D'Amour des Oiseaux, 3-7-67. Oil on canvas.
 10¾ x 16⅜.
Femme et Oiseau, 11-18-66. Oil on canvas. 26 x 22.
Dans une ile à Cinq Heures de L'Apres-Midi, 1-3-60.
Accent Blanc I, 8-7-63. Oil on canvas. 10⅝ x 8⅝.
Untitled, 11-23-60. Oil on board. 16¼ x 13.
Untitled, 3-1-62. Oil on board. 14 x 10½.
Accent vert, 4-4-60. Oil on board. 14½ x 14½.
Après la pluie, 11-4-59. Oil on wood. 8⅝ x 15¾.
Accent blanc VI, 8-7-63. Oil on canvas. 9½ x 7½.
Untitled, 8-6-63. Oil on board. 8⅝ x 12¼.
Untitled, 4-16-60. Oil on board. 5 x 8.
Femme et cheval, 5-6-60. Oil on canvas and wood.
 9 x 21½.
Personnage et oiseau dans la nuit, 7-26-63. Gouache
 on paper. 27½ x 39.
Personnage et oiseau II, 12-17-65. Gouache and
 collage on paper. 20 x 30.
Femmes dans la nuit, 3-18-63. Drawing on paper.
 20 x 30.
Peinture murale, 4-25-60. Oil on canvas and wood.
 6¾ x 29.
Personnages, 4-19-60. Drawing on paper. 20 x 30.
Personnage dans la nuit IV, 7-17-65. Collage on paper.
 30 x 20.
Personnages et oiseau dans la nuit, 7-26-63.
Femme-étoile, 5-11-65. Oil on paper. 28¾ x 12.
Personnage et oiseau aux ailes deployées, 3-25-63.
 Drawing on paper. 20 x 30.
Untitled watercolor, 10-1-63. 10⅝ x 8½.
Untitled watercolor, 7-2-64. 11¼ x 14⅜.
Oiseau picorant un fruit a la lueur des etoiles I/II,
 12-28-59. Oil on board. 12½ x 11.
Untitled watercolor, 7-2-64. 11⅝ x 14⅜.
Untitled watercolor, 10-1-63. 10⅝ x 8½.
Untitled watercolor, 5-27-64. 12¾ x 19½.
Personnage, 8-2-63. Gouache on paper. 30 x 20.

1968　New York. The Museum of Modern Art, *Dada, Surrealism, and Their Heritage.* March 27-June 9.

1969　New York. The Museum of Modern Art, *Twentieth-Century Art from the Nelson Aldrich Rockefeller Collection.* May 26-September 1.

1970　New York. The Museum of Modern Art, *Joan Miró: Fifty Recent Prints.* March 9-May 11.

1970 New York. Pierre Matisse Gallery. May-June.

Femme et oiseau, 1968. Bronze cast. 12¾ x 10 x 6.
Personnage et oiseau, 1968. Bronze cast. 41 x 25¼ x 7⅛.
Tête, 1968. Ceramic. 20 x 32½.
Femme, 1968. Ceramic. 29.
Le rebelle, 1968. Etching. 36⅞ x 25¹⁄₁₆.
L'equinoxe, 1968. Etching. 41¹¹⁄₁₆ x 29.
Le magnétiseur sur fond blanc, 1969. Lithograph. 31½ x 23.
Le bagnard, 1969. Lithograph. 34¼ x 23⅝.
Samourai, 1970. Etching. 30⁵⁄₁₆ x 22⁷⁄₁₆.
Tête au soleil couchant, 1968. Etching. 10⁵⁄₁₆ x 14⅞.
La conque, 1969. Bronze cast. 43¼ x 31½ x 19¾.
L'oiseau se niche sur ses doigts en fleur, 1967. Bronze cast.
 31⅞ x 18⅛ x 9⅞.
Moon, sun and one star, 1967. Bronze cast. 51¼.
Personnage, 1967. Bronze cast. 58¼ x 16⅞ x 13¾.
Femme, 1968. Bronze cast. 27⅜ x 12⅝ x 9¼.
Les trois cheveux de la belle blonde attirent les papillons,
 1967. Bronze cast. 16½ x 7⅞ x 7⅞.
Oiseau perché sur un arbre, 1967. Bronze cast.
 17⅞ x 4¾ x 4¼.
Personnage, 1967. Bronze cast. 9½ x 3⅛ x 3⅛.
Projet pour un monument, 1967. Bronze cast.
 20⅞ x 4½ x 5⅛.
Tête et oiseau, 1967. Bronze cast. 11⅜ x 24¾.
Personnage, 1968. Bronze cast. 14⅝ x 4¾ x 3½.
Tête, 1967. Bronze cast. 22 x 11¾ x 4.
Femme dans la nuit, 1967. Bronze cast. 25¼ x 4 x 5⅛.
Personnage et oiseau, 1967. Bronze cast. 18½ x 13 x 6¾.
Personnage, 1968. Bronze cast. 17¼ x 7½ x 4.
Tête, 1968. Bronze cast. 13⅜ x 4¾ x 3½.
Femme, 1968. Bronze cast. 17½ x 4¾ x 4.
Fillette au chapeau nid d'abeille, 1967. Bronze cast.
 18⅞ x 7⅞ x 4.
Femme (Forme Chapeau), 1968. Bronze cast. 12½.
Personnage, 1968. Bronze cast. 21⅝ x 19⅝ x 2.
Femme, 1968. Bronze cast. 68 x 28⅜ x 14⅝.
Tête, 1968. Bronze cast. 15½ x 10⅜ x 4¾.
Maternité, 1967. Bronze cast. 32⅝ x 17¾ x 10⅝.
Tête, 1968. Bronze cast. 11 x 8⅝ x 3¾.
Femme, 1967. Bronze cast. 13⅜ x 5¼ x 3⅜.
Femme, 1967. Bronze cast. 11 x 7 x 4¼.
Tête, 1968. Bronze cast. 17⅛ x 9½ x 3½.
Tête, 1968. Bronze cast. 21½ x 11½ x 7.
Maternité (Forme Chapeau), 1968. Bronze cast . 9¾.
Femme, 1967. Bronze cast. 10⅝ x 5¼ x 11¾.
Monument dressé en plein océan à la gloire du vent, 1967.
 Bronze cast. 52¾ x 24¼ x 5⅛.
Jeune fille rêvant de l'évasion, 1967. Bronze cast.
 39⅜ x 10⅝ x 7½.
Femme, 1967. Bronze cast. 27⅛ x 26¾ x 4¼.
Femme aux beaux seins, 1967. Bronze cast.
 16⅛ x 5⅛ x 4.
L'équilibriste, 1967. Bronze cast . 35¾ x 15⅝ x 7.
Personnage, 1968. Bronze cast. 23⅜ x 9¾ x 6⅝.
Horloge au vent, 1967. Bronze cast . 19¼ x 11¾ x 6.
Tête, 1967. Bronze cast. 10¼ x 7⅞ x 7⅞.
Bas relief, 1967. Bronze unique cast. 13¼ x 8⅝ x 1⅛.
Tête et dos de poupée, 1967. Bronze cast. 13¼ x 8 x 7.
Tête dans la nuit, 1968. Bronze cast . 26½ x 13⅝ x 12¼.

Personnage, 1967. Bronze cast. 13½ x 15½ x 5⅞.
Personnage, 1967. Bronze cast . 84¾ x 21⅝ x 19¾.
Sa majesté, 1967. Bronze cast . 47¼ x 11¾.
Tête et oiseau, 1967. Bronze cast . 78¾ x 45¼ x 27½.
Femme et oiseau, 1967. Bronze cast . 53 x 19¾ x 16½.
Femme assise et enfant, 1967. Bronze cast .
 53 x 23⅝ x 13¾.
Astre et fumée, 1968. Etching. 29⅞ x 22⅛.
Petite barrière, 1968. Etching. 10⅜ x 4⅛.
Le bijou, 1969. Etching. 9 x 11¼.
Sumo, 1969. Etching. 18¾ x 14⁷⁄₁₆.
Le femme au bijoux, 1969. Etching. 18⅜ x 13⅝.
Le règne végétal, 1968. Etching. 18⅜ x 13½.
Le dandy, 1969. Etching. 16⅜ x 17.
Le jardin de mousse, 1969. Etching. 15⅝ x 18⅛.
Emehpylop, 1969. Etching. 41³⁄₁₆ x 28¹³⁄₁₆.
Le scieur de long, 1969. Etching. 31¼ x 23¼.
Magnetiseur orange, 1969. Lithograph. 33⅜ x 27⅞.
Le lettre vert, 1969. Lithograph. 33⅜ x 27⅞.
Le lettre rouge, 1969. Lithograph. 33⅜ x 27⅞.

1971 San Francisco. John Berggruen Gallery, *Joan Miró: La
 bagne d'aurore*. June 24-July 27.

1971 Minneapolis. Walker Art Center, *Miró Sculpture*.

1972 New York. Acquavella Galleries, Inc., *Joan Miró-Exhibit
 for the benefit of the Pediatric Pavillion of
 Sloan-Kettering*.

1972 New York. Pierre Matisse Gallery. March-April.
 Sobre Papel in various media:

The Palette of the Artist, May 1971.
Woman, 1970. Oil and mixed media. 20⅜ x 40½.
Personage, 1970. Mixed media. 25 x 18¾.
Head, 1970. Oil on paper. 34¾ x 25.
Personage and Bird in the Night, 1970. Gouache.
 34⅝ x 22⅞.
Untitled, 1970. Gouache on black paper. 28½ x 42.
Untitled, 1966. Gouache on Japanese paper. 18 x 24⅛.
Personage and Stars in the Night, 1965. Collage and
 gouache on black paper. 42⅜ x 28¾.
Woman Surrounded by Birds, 1970. Oil on paper. 35 x 23.
Woman Attacked by Birds in the Moonlight, 1970. Oil on
 paper. 38¾ x 27.
Woman, 1969. Oil on paper. 28 x 21¼.
Man and Woman in Front of the Sun, 1969. Gouache.
 24⅝ x 16⅛.
Woman and Bird, 1971. Oil on paper. 16¾ x 24.
Woman and Bird in the Night, 1971. Gouache. 35 x 23⅛.
Untitled, 1969. Gouache. 16⅞ x 21¾.
Personage and Bird in the Night, 1970. Mixed media.
 28⅜ x 25¼.
Man and Woman, 1969. Oil on paper. 26¾ x 35¾.
Head, 1970. Mixed media on newsprint. 19½ x 26.
Head of a Woman, 1970. Mixed media on newsprint.
 19½ x 26.
Personage, 1970. India ink wash and crayon. 13¼ x 12⅝.
Personage, 1967-70. India ink wash. 13¼ x 12⅝.
Young Woman and Child, 1969. Oil on paper. 23 x 17¼.
Bird Guided by the Burst of Dawn Attacks a Woman, 1970.

Oil on paper. 38⅞ x 27⅛.
Personages and Star in the Night, 1964. Collage and gouache. 28¾ x 42½.
Personage and Bird, 1966. Mixed media. 29¼ x 21¼.
The Call of the Bird at Daybreak, 1970. Gouache. 24 x 17¾.
Personage, 1970. Gouache. 24¾ x 16⅛.
Head, 1970. Oil on paper. 35 x 24¼.
Personage and Bird, 1968. Gouache. 21⅞ x 17⅛.
Head, 1967-70. Gouache. 13¾ x 10¾.
Woman and Bird in the Night, 1965. Gouache. 33¼ x 23¼.
Personage and Star, 1970. Gouache. 24¼ x 16⅝.
Personages Running, 1970. Gouache. 21½ x 30.
Head and Bird, 1970. India ink wash. 41 x 28⅛.
Head, 1965-70. India ink wash. 13⅜ x 12⅝.
Personages Running, 1970. Gouache. 17 x 21¾.
Woman and Bird in the Moonlight, 1966. Gouache. 33¾ x 27⅛.
Untitled, 1967. Gouache on Japanese paper. 13⅝ x 19⅝.
Untitled, 1970. Gouache. 10¾ x 30.

1972　New York. The Solomon R. Guggenheim Museum, *Joan Miró: Magnetic Fields*. October-January.

1972　New York. The Museum of Modern Art, *Philadelphia in New York: 90 Modern Works from the Philadelphia Museum of Art*. October 18, 1972-January 7, 1973.

1973　New York. Pierre Matisse Gallery, *Sobreteixims*. October-November.

Sobreteixim Number VIII, 1973. 82¾ x 82¾.
Sobreteixim Number IX, 1973. 73¼ x 78¾.
Sobreteixim Number X, 1973. 86½ x 65¾.
Sobreteixim Number XII, 1973. 89¼ x 70¾.
Sobreteixim Number XIII, 1973. 98½ x 70¾.
Sobreteixim Number XIV, 1973. 86⅝ x 71.
Sobreteixim Number XV, 1973. 86½ x 104¾.
Sobreteixim Number XVI, 1973. 74½ x 124.
Sobreteixim Number XVII, 1973. 94½ x 56.
Sobreteixim Number XVIII, 1973. 78¾ x 78¾.
Sobreteixim Sac Number III, 1973. 78¾ x 19¾.
Sobreteixim Sac Number IV, 1973. 74¾ x 19¾.
Sobreteixim Sac Number V, 1973. 89¾ x 31½.
Sobreteixim Sac Number VI, 1973. 90½ x 15¾.
Sobreteixim Sac Number VII, 1973. 54 x 27½.
Sobreteixim Sac Number VIII, 1973. 61 x 23½.
Sobreteixim Sac Number IX, 1973. 70¾ x 21½.
Sobreteixim Sac Number X, 1973. 55 x 31½.
Sobreteixim Sac Number XI, 1973. 94½ x 32½.
Sobreteixim Sac Number XII, 1973. 65 x 29.
Sobreteixim Sac Number XIII, 1973. 82¾ x 22⅝.
Sobreteixim Sac Number XIV, 1973. 50 x 8¼.

1973　New York. The Museum of Modern Art, *Miró in the Collection of the Museum of Modern Art*. 1973-1974.

1973　New York. Pierre Matisse Gallery. *Paintings, gouaches, sculpture, Sobreteixims and etchings*. May.

Paintings:
Personage, 1960. Oil on cardboard. 29 x 41.
Landscape, 1963. Oil on cardboard. 29½ x 41¼.
Homage to Corot, 1966. Oil on canvas. 69 x 81.

Woman with windblown hair in front of an eclipse, 1967. Oil on canvas. 94¼ x 76¾.
Woman and birds in the night, 1968. Oil on canvas. 63½ x 51.
Woman and birds in the night, 1968. Oil on canvas. 57½ x 44¾.
Woman and bird, 1969. Painting on sheepskin. 51 x 39½.
Birds at daybreak, 1970. Oil on canvas. 89⅝ x 103.
Woman and bird, 1972. Oil on burlap. 28 x 15¾.

Gouaches:
Femme étoile, 1965. Gouache. 28¾ x 11.
Untitled, 1967. Japanese paper. 13⅝ x 19⅝.
Untitled, 1967. Japanese paper. 16¾ x 11.
The cry of the bird at daybreak, 1970. Gouache. 24 x 17¾.
Personages Running, 1967. Gouache. 21½ x 30.

Sobreteixims:
Sobreteixim Number 4, 1972. 71 x 59.
Sobreteixim Number 5, 1972. 69 x 69.
Sobreteixim Number 14, 1972. 86⅝ x 71.

Sculpture:
Standing figure, 1956. Ceramic. 38.
Maternité, 1967. Bronze. 32⅝.
Personage, 1967. Bronze. 13½.
Head in the night, 1968. Bronze. 26½.
Woman, 1969. Bronze. 41¾.
Woman, 1969. Bronze. 75½.
Personage, 1970. Bronze. 46¼.
Woman, 1970. Bronze. 22½.
Monument, 1971. Bronze. 99.

Etchings:
Drawn on the Wall II, 1968. Etching. 22⅞ x 36⅜.
The great sorcerer, 1968. Etching. 35⅛ x 26⅝.
Fanatic, 1968. Etching. 34⅞ x 23½.
The moss garden, 1969. Etching. 15⅝ x 18⅛.
Album composed of one etching printed in color with a suite of three plates executed by the artist in April 1973. Edition of 75 copies.

1975　New York. Pierre Matisse Gallery. April-May. *From the Grand Palais: Paintings and Sculpture, 1969-74:*

Paintings:
Femme, 1969. Oil on canvas. 25½ x 21⅜.
Femme, 1969. Oil on canvas. 24 x 20.
Femme, 1969. Oil on canvas. 16⅛ x 10⅝.
Femme I, 1969. Oil on canvas. 9⅞ x 7⅞.
Objet, 1969. Oil on cork. 14 x 10¼.
Femme à la voix de rossignol dans la nuit, 1971. Oil on canvas. 51 x 77.
Femmes, oiseaux II, 1972. Pencil, oil and newspaper collage on canvas. 16⅛ x 12¾.
Le sourire nacre devant l'azur, 1972. Oil on canvas. 51 x 77.
Oiseaux, 1972. Oil on canvas. 32 x 7¼.
Personnage, 1973. Oil on canvas. 18½ x 23.
Tête, 1940-1973. Oil on canvas. 31¾ x 25½.
Tête, 1940-1974. Oil on canvas. 24 x 19¾.
L'espoir du navigateur V, 1968-1973. Oil on canvas. 9⅝ x 16⅛.

L'espoir du navigateur VII, 1968-1973. Oil on canvas. 9⅝ x 16⅛.

Le chant du coq reveille les fermiers catalans, 1973. Oil on canvas. 71 x 9' 10½''.

Femme, oiseau, 1973. Oil on canvas. 79 x 79.

Le sourire d'une larme, 1973. Oil on canvas. 79 x 79.

Tête, 1973. Oil on canvas. 46½ x 41½.

Toile brûllée III, 1973. Oil on canvas. 77 x 51.

Femme oiseau II, 1972-1973. Oil on canvas. 103 x 25½.

Tête, 1973. Oil on plywood. 52¾ x 36½.

Femme, 1973. Oil on canvas. 45¼ x 35.

Tête, 1973. Oil on canvas. 39¾ x 28¾.

Peinture 7, 1941-1973. Oil on masonite. 30¾ x 5½.

Peinture 13, 1941-1973. Oil on masonite. 30¾ x 5½.

Oiseau, insecte, constellation, 1974. Oil on canvas. 51 x 38.

Paysage dans la nuit, 1966-1974. Oil on canvas. 51 x 76¾.

Sculpture:

Bas-Relief, 1967. Bronze. 16½.

Le coq, 1970. Bronze. 21.

Tête de femme, 1971. Bronze. 54 x 35 x 29.

Personnage, 1971. Bronze. 10½.

Homme et femme, 1972. Bronze. 22¼.

Personnage, 1972. Bronze. 103.

Femme et oiseau, 1972. Bronze. 34.

Chien, 1974. Bronze. 12.

Le Chien, 1974. Bronze. 21.

Porte, 1974. Bronze. 98 x 29 x 38.

1976 New York. Pierre Matisse Gallery. April-May.

Sculpture:

Femme assise et enfant, 1967. Painted bronze. 52⅜.

Femme et oiseau, 1967. Painted bronze. 52⅜.

Personnage, 1967. Painted bronze. 83¾.

La caresse d'un oiseau, 1967. Painted bronze. 121½.

Sa majesté, 1967-68. Painted bronze. 47¼.

Jeune fille s'échappant, 1968. Painted bronze. 53½.

Femme, 1969. Bronze. 26¾.

Monsieur et Madame, 1969. Bronze. 32⅝.

Oiseau migrateur posé sur la tête d'une femme en pleine nuit, 1970. Bronze. 18¼.

Oiseau, 1970. Bronze. 24⅜.

Personnage et oiseau, 1970. Bronze. 27½.

Personnage et oiseau, 1970. Bronze. 63.

Oiseau sur un rocher, 1971. Bronze. 25¾.

Personnage, 1972. Bronze. 14¼.

Personnage, 1972. Bronze. 20¼.

Untitled, 1972. Bronze. 25.

Femme au chapeau, 1972. Bronze. 34⅝.

Femme, 1972. Bronze. 37.

Constellation, 1972. Bronze. 56.

L'oiseau au plumage rougeâtre annonce l'apparition de la femme éblouissante de beauté, 1972. Bronze. 88¼.

Personnage dans la nuit, 1974. Bronze. 39⅜.

Personnage, 1974. Bronze. 42½.

Tête, 1974-75. Bronze. 92.

Femme oiseau, 1974-75. Bronze. 43¼.

Statue, 1974-75. Bronze. 119.

Mère Ubu, 1975. Bronze. 67.

Prints:

Le hibou blasphémateur, 1975. Etching. 47¼ x 63.

La ruisselante solaire, 1975. Lithograph. 63 x 47¼.

Le ruisselant lunaire, 1975. Lithograph. 63 x 47¼.

1976 New York. Pierre Matisse Gallery. November-December. Grands Formats, Aquatints, 1974-75:

Aquatints:

Tir à l'arc, 1972. Aquatint. 41½ x 29½.

Chef d'orchestre, 1974. Aquatint. 55 x 36½.

L'étrangle, 1974. Aquatint. 55 x 36½.

La femme touple, 1974. Aquatint. 55 x 36½.

Le permissionnaire, 1974. Aquatint. 55 x 36½.

Le pitre rose, 1974. Aquatint. 55 x 36½.

Le somnambule, 1974. Aquatint. 55 x 36½.

Pic de la Mirandole, 1975. Aquatint. 41½ x 29¼.

La souris rouge à la mantille, 1975. Aquatint. 54½ x 37¾.

La souris noire à la mantille, 1975. Aquatint. 54½ x 37¾.

Le rat des sables, 1975. Aquatint. 37¾ x 54¼.

Le hibou blasphémateur, 1975. Aquatint. 47½ x 59¾.

Le pierre philosophale, 1975. Aquatint. 63 x 47½.

La reine des éphémères, 1975. Aquatint. 63¼ x 47½.

Inceste au Sahara, 1975. Aquatint. 63¼ x 47½.

Le bagnard et sa compagne, 1975. Aquatint. 47½ x 63.

Lithographs:

La ruisselante solaire, 1975. Lithograph. 61¾ x 46½.

La ruisselante lunaire, 1975. Lithograph. 62 x 45½.

1978 New York. Pierre Matisse Gallery. November 21-December 16. Recent paintings, gouaches and drawings:

Unititled, September 11, 1969. Oil on canvas. 12½ x 8¼.

Femme, October 31, 1969. Oil on canvas. 21½ x 18.

Femme à l'aube, October 31, 1969. Oil on canvas. 18 x 21½.

La femme grenouille et les oiseaux poussant des cris à la naissance du soleil, March 25, 1970. Gouache, India ink on paper. 35 x 23¼.

Tête, November 26, 1970. Oil on canvas. 16¼ x 9¾.

Untitled, March 22, 1972. India ink on paper. 25½ x 19¾.

Untitled, May 6, 1972. Gouache, pastel, India ink on paper. 25¼ x 15¾.

Untitled, May 6, 1972. Gouache, India ink, pastel on newspaper. 10 x 13.

Untitled, May 6, 1972. Gouache, India ink, pastel on newspaper. 10 x 13.

Untitled, May 6, 1972. India ink on paper. 25½ x 19¾.

Vers l'evasion, May 29, 1972. Oil on canvas. 36½ x 28¾.

Untitled, May 30, 1972. India ink on paper. 25½ x 19¾.

Femme I, September 2, 1972. Oil on canvas. 36¼ x 19¾.

Untitled, October 21, 1972. India ink on paper. 25½ x 19¾.

Untitled II, January 22, 1973. Pencil, pastel on paper. 17¾ x 19.

Untitled XIV, July 18, 1973. Pencil on paper. 11½ x 9.

Untitled VII, July 18, 1973. Pencil on paper. 11½ x 9.

Untitled IV, July 18, 1973. Pencil on paper. 11½ x 9.

Untitled III, July 18, 1973. Pencil on paper. 11½ x 9.

Femme, August 4, 1973. Oil on canvas. 28¾ x 23½.

Femme, oiseau, February 21, 1974. Oil on canvas. 25½ x 19¾.

Femme, oiseaux dans la nuit, January 30, 1975. Gouache, pastel, crayon on paper. 13½ x 12¾.

Tête, March 10, 1975. Pencil, watercolor, gouache,

pastel on paper. 17¾ x 25¾.
Personnage, oiseau, March 12, 1975. Mixed media on corrugated paper. 15½ x 12½.
Femme, May 3, 1975. Ink, crayon on Japanese paper. 16 x 16.
Femme dans la nuit, May 3, 1975. India ink, crayon on Japanese paper. 16 x 16.
Femme, May 3, 1975. Ink, crayon on Japanese paper. 16 x 16.
Danseuse devant les 13 constellations, May 13, 1975. Ink, gouache, pencil, pastel on paper. 15 x 12.
Tête, May 30, 1975. Ink, crayon on Japanese paper. 16 x 16.
Tête, August 11, 1975. Mixed media on cardboard. 26 x 20½.
Femme, oiseaux, August 12, 1975. Mixed media on cardboard. 41½ x 29.
Femme, oiseaux, August 26, 1975. Mixed media on cardboard. 29½ x 41¼.
Interieur Paysan I, October 5, 1975. Mixed media on paper. 30½ x 22½.
Interieur Paysan IV, October 5, 1975. Oil, watercolor, ink, pastel on Japanese paper. 25¼ x 19¾.
Interieur Paysan V, October 5, 1975. Oil, watercolor on Japanese paper. 26 x 20.
Tête, January 5, 1976. Crayon, oil on cardboard. 20½ x 13¾.
Femme, oiseau, February 5, 1976. Oil on canvas. 13¾ x 9½.
Personnage, lune, oiseau, March 5, 1976. Oil on canvas. 9½ x 13¾.
Personnage dans un paysage, March 5, 1976. Oil on canvas. 13¾ x 9½.
La fumée du paysage atteint les constellations, 1976. Oil on canvas. 13¾ x 9½.
Tête, oiseaux, constellations, April 27, 1976. Oil on canvas. 13¾ x 9½.
Femme à la chevelure defaite, oiseaux, constellations, July 1, 1976. Pencil, watercolor, ink on paper. 11 x 15.
Femme et oiseau dans un paysage, July 1, 1976. Pencil, watercolor on paper. 11 x 15.
Personnage, oiseaux, July 13, 1976. Mixed media on cardboard. 14½ x 12¾.
Après les constellations, July 19, 1976. Mixed media on masonite. 5½ x 31.
Après les constellations, July 19, 1976. Mixed media on masonite. 5 x 30½.
Après les constellations, July 19, 1976. Mixed media on masonite. 5½ x 31.
Tête, oiseau, July 25, 1976. Mixed media on cardboard. 19 x 17¼.
Femme, oiseau, July 26, 1976. Mixed media on cardboard. 19¾ x 16¾.
Tête, July 26, 1976. Oil on canvas. 7½ x 13.
Femme dans la nuit, July 26, 1976. Oil on canvas. 10¾ x 7½.
Femme, September 3, 1976. Crayon, gouache on corrugated cardboard. 17 x 8½.
Femme, oiseaux, July 1977. Oil on canvas. 13¾ x 8¾.
Personnage, November 15, 1977. Oil on canvas. 13¾ x 9½.
Personnages et oiseaux dans la nuit, November 15, 1977. Oil on canvas. 18 x 10¾.

Paysage, November 27, 1977. Oil on canvas. 10¾ x 8¾.
Personnage, November 27, 1977. Oil on canvas. 10¾ x 8¾.
Femme devant la lune, February 1, 1978. Oil on canvas. 10¾ x 8¾.
Personnage, February 1, 1978. Oil on canvas. 10¾ x 8¾.
Femme, etoile, February 8, 1978. Oil on canvas. 10¾ x 8¾.
Femme, etoile, February 8, 1978. Oil on canvas. 13¾ x 8¾.
Oiseau dans un paysage, March 1978. Oil on canvas. 39¼ x 31¾.

1980 Washington, D.C. Hirshhorn Museum and Sculpture Garden, *Selected Paintings.*

1980 New York. Pierre Matisse Gallery. May 13-June 7.

Painted Sculpture:
La Caresse d'un oiseau, 1967. 124 x 44 x 16½.
Tête et oiseau, 1967. 78¾ x 45¼ x 28¼.
Personnage, 1967. 84¾ x 21½ x 19¾.
Femme assise et enfant, 1967. 63¼ x 23½ x 13¾.
Femme et oiseau, 1967. 53¼ x 19¾ x 16½.
Femme et oiseau, 1967. 102½ x 33½ x 19.
Sa majesté, 1967-68. 47¼ x 12 x 12.
Jeune fille s'évadant, 1968. 53 x 23½ x 13¾.
Personnage, 1968. 65 x 25½ x 15¾.
Monsieur et Madame, 1969. 39½ x 12 x 12 and 26¾ x 15 x 15.
Homme et femme dans la nuit, 1969. 30¾ x 17¾ x 17¾ and 34 x 12½ x 12½.
Femme échevelée, 1969. 27½ x 28½ x 16.

Ceramics:
Grande figure debout, 1955-56. 38.
Personnage, 1956. 39½.
Monument, 1957. 101.
Tête d'homme, 1962. 33½ x 29½ x 23⅝.
Architecture, 1962. 6 x 24¾.
Tête, 1968. 20 x 32½.
Femme, 1968. 29.

Drawings and mixed media:
Tête, 12/30/70. India ink on paper. 41 x 29¼.
Femme éloignant l'oiseau porte-malheur, 3/30/71. Crayon and watercolor on paper. 25½ x 20½.
Untitled, 7/29/72. Oil, crayon, pastel on newpaper. 26 x 19¼.
Untitled, 9/2/72. Oil, ink and pastel on newspaper. 26 x 19¼.
Chien II, 11/10/72. Oil and gouache on paper. 16½ x 29½.
Personnage, 3/9/73. Ink, gouache and pastel on paper. 25¼ x 19¼.
Untitled, 3/24/73. Gouache, ink, crayon on paper. 17¾ x 19.
Untitled, 10/4/74. Gouache and ink on Japanese paper. 16 x 16.
Femme, oiseaux, 1/13/75. Gouache, pastel, ink on board. 12½ x 10.
Femme, 1/30/75. Ink, gouache, pencil and watercolor on paper. 19¾ x 16½.
Tête, 3/14/75. Mixed media on cardboard. 29½ x 41½.
Personnages, oiseaux, 8/12/75. Mixed media on cardboard. 29½ x 41¾.
Femmes, oiseaux, 9/26/75. Crayon, pastel, oil and gouache on paper. 30 x 22.

Personnage, oiseaux dans un paysage, 7/1/76. Pencil and
gouache on paper. 10 x 13.
Paysage dans la nuit, 8/1/76. Pencil on thin cardboard.
7½ x 9.
L'Evasion, 7/1/76. Pencil on thin cardboard. 7 x 11.
Unititled, 9/24/76. Watercolor and pencil on paper.
6¾ x 14½.
Personnage, étoile, 3/78. Mixed media on cardboard.
23 x 16.

1980 St. Louis. Washington University. *Joan Miró: The
Development of a Sign Language.*

1981 Chicago. Inauguration of monumental sculpture, *Miss
Chicago.*

1982 Houston. The Musuem of Fine Arts, Houston, *Miró in
America.* April-June.

Dimensions are given as they were listed in the
catalogues.

INDEX

ILLUSTRATIONS

PHOTOGRAPH CREDITS

Duncan Macmillan, "Miró's Public Art"

55. Joan Miró. Cincinnati mural, 1947.
56. Joan Miró. *Mural Painting*, 1950-51. Oil on canvas, 74¾ x 233¾ in. Collection, The Museum of Modern Art, New York, Mrs. Simon Guggenheim Foundation.
57. Joan Miró and Joseph Llorens Artigas. *Alicia,* 1967. Ceramic wall, 97 x 228 in. Gift of Harry F. Guggenheim, in memory of his wife, Alicia Patterson Guggenheim. The Solomon R. Guggenheim Museum, New York.
58. Joan Miró. Osaka mural, 1970.
59. Joan Miró. IBM ceramic wall, 1970. Barcelona.
60. Joan Miró. Mural, 1980. Palace of Congresses and Exhibitions, Madrid.
61. Joan Miró. Ramblas, 1976. Barcelona.
62. Joan Miró. *Miss Chicago,* 1981. Chicago.
63. Joan Miró. *Personage and Birds,* 1970. Bronze, 63 x 48 in. Pierre Matisse Gallery, New York.

William R. Acquavella, New York: 20
Acquavella Galleries, Inc., New York: 33, 55
Andover Art Studio, Andover, Mass.: 23 bottom left
F. Catalá-Roca, Barcelona: ii, 42 bottom left and bottom right, 43, 47, 106, 107 top and bottom, 108, 125 bottom left and bottom right, 126 bottom right, 127 top right, bottom left and bottom right, 128 top right, center right, bottom right, 129 bottom left
Geoffrey Clements, New York: 19, 30
Martin Diamond Fine Arts, Inc., New York: 8 top left
Stefan Edlis, Chicago: 9 bottom right
Eeva-Inkeri, New York: 25 top right
Roger Gass, San Francisco: 40 top left
The Solomon R. Guggenheim Museum, New York: 9 bottom left
Hamilton Gallery of Contemporary Art, New York: 39 bottom right
Hickey and Robertson, Houston: 3
High Museum of Art, Atlanta: 29 top right
Hirshhorn Museum and Sculpture Garden, Smithsonian Institution, Washington, D. C.: 10 bottom left, 24 bottom center
Indiana University Art Museum, Bloomington: 57
William Janns, California: 24 top right
Bruce C. Jones, New York: 26 bottom right
Alexander Liberman, New York: 128 top left
Robert E. Mates, New York: 11 top center, 103
Courtesy Pierre Matisse Gallery, New York: 63
Allen Mewbourn, Houston: 35, 39 bottom left, 40 top right
The Museum of Modern Art, New York: 6, 8 top right, 11 top left, 32, 49, 60
National Archives, Washington, D. C.: 25 top left
National Gallery of Art, Washington, D. C.: 53
New Orleans Museum of Art, New Orleans: 61
Arnold Newman, New York: 3, 46, 101, 126 top right
Perls Galleries, New York: 52
Philadelphia Museum of Art: The A. E. Gallatin Collection: 51
The Phillips Collection, Washington, D. C.: 27
Eric Pollitzer, Hempstead, N. Y.: 103, 111
Courtesy of Lee Krasner Pollock: 23 bottom right
Courtesy Juliet Man Ray, Paris: 11 top right
Mark Rothko Estate, New York: 24 bottom left
San Francisco Museum of Modern Art: 24 top left
John D. Schiff, New York: 41
Skidmore, Owings and Merrill, Chicago: 110
Courtesy Steven Sloman Fine Arts Photography, New York: 10 bottom right
Ken Strothman and Harvey Osterhoudt, Bloomington: 24 bottom right
Eugene Victor Thaw, New York: 14
Malcolm Varon, New York: 29 center right
Xavier Fourcade, Inc., New York: 28
Yale University Art Gallery, Collection Société Anonyme: 15